The Photographic Legacy of
Frances Benjamin Johnston

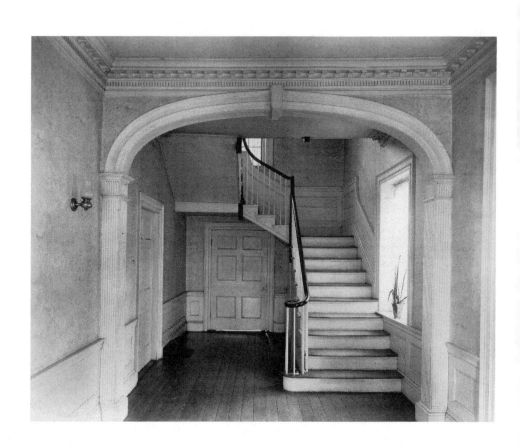

The
PHOTOGRAPHIC
LEGACY
of
FRANCES BENJAMIN
JOHNSTON

Maria Elizabeth Ausherman

THE UNIVERSITY OF ALABAMA PRESS

Tuscaloosa

The University of Alabama Press
Tuscaloosa, Alabama 35487-0380
uapress.ua.edu

First edition published 2009.
University of Alabama Press edition published 2022.

Inquiries about reproducing material from this work should be
addressed to the University of Alabama Press.

Typeface: Adobe Garamond

Cover image: Graham House stairway, Lincoln County, North Carolina, c. 1936;
photograph by Frances Benjamin Johnston, Library of
Congress, Prints and Photographs Division
Cover design: Michele Myatt Quinn

Frontispiece: Stair passage of the Smallwood House,
New Bern, Craven County, North Carolina.

All photographs of or by Frances Benjamin Johnston are from the Frances Benjamin Johnston
Collection, Prints and Photographs Division, Library of Congress, Washington, D.C. The
Bayard Wootten photographs are from the North Carolina Collection, University of North
Carolina at Chapel Hill, North Carolina. The Dudley Arnold photograph is from the Chicago
History Museum, Chicago, Illinois. Photographs taken by James Walter Collinge and Hiller are
found in Winfred Dobyn's book, *California Gardens*, provided by the New York Public Library.

Cataloging-in-Publication data is available from the Library of Congress.
ISBN: 978-0-8173-6051-1
E-ISBN: 978-0-8173-9417-2

For Chloe and Lydia

Contents

Illustrations

Abbreviations

FSA/OWI Farm Security Administration/Office of War Information Collection

HABS Historic American Buildings Survey

HAER Historic American Engineering Record

MDLC Manuscript Division, Library of Congress, Washington, D.C.

PAEAA Pictorial Archives of Early American Architecture

PPDLC Prints and Photographs Division, Library of Congress, Washington, D.C.

Acknowledgments

The idea for this book first came about during a conversation with John Linley, an architect and professor at the School of Environmental Design of the University of Georgia and a family friend. He was talking about how his friend and colleague, Frederick Doveton Nichols, at that time a young architect and architectural historian at the University of Virginia, had the opportunity to work with this great photographer who was conducting a survey of historic buildings in Virginia. Nichols was amazed at how she would adjust the aperture, press the button to expose the subject, and then casually pour herself a shot of whiskey and empty the glass before closing the shutter of the camera. The photographer was none other than Frances Benjamin Johnston, who knew how to take pictures so well that the manual exposure process had become intuitive for her.

After talking with John Linley, I browsed through some of the publications showcasing Johnston's work, particularly *The Early Architecture of North Carolina* (1941), *Plantations of the Carolina Low Country* (1945), and *The Early Architecture of Georgia* (1957), which was a collaboration between Nichols and Johnston and the foundation of Frederick Nichol's well-deserved reputation. Realizing how strikingly beautiful Johnston's photographs are and how little has been written about them, I decided that Johnston's work would be the focus of my research.

Many people helped me with my work. I would like to thank Susan Morris at the University of Georgia library; Marilyn Ibach, Mary M. Ison, and C. Ford Peatross at the Library of Congress Prints and Photographs Division; Keith Longiotti and Fred Stipe at the University of North Carolina Library for their professional assistance; the members of the Garden Club of Georgia for the Cherokee Rose Award; Margaret Growe, Erich Schneiderman, Cathy Minaudo, Lowell Angel, Mike D'Anna, and Steven

Taylor for their editing and computer assistance; and John Maynard, English professor at New York University, and Ian Firth, professor emeritus of landscape architecture at the University of Georgia, for their fine-tuning. I am grateful for the guidance of Lew Andrews, professor of art history at the University of Hawaii, whose knowledge about photography is unsurpassable; and for the support of Heather Turci, Eli Bortz, Susan Albury and Dennis Lloyd at the University Press of Florida, and the book's designer, Louise OFarrell. Most of all, I would like to thank my parents, Charles and Rieneke Ausherman, Mary Jane Chapman, my lovely daughters, Chloe Amelia Chapman and Lydia Marie Chapman, and Bill Chapman, American Studies professor at the University of Hawaii, who has done so much in the field of historic preservation.

The Photographic Legacy of
Frances Benjamin Johnston

CHAPTER I

Introduction

FRANCES BENJAMIN JOHNSTON (1864–1952) was among the first American photographers to achieve a successful long-term career in photography, one that spanned nearly seventy years. Before the tenets of photography had been laid down and while debates over its merits as an art form were still raging, Johnston showed her work in international artistic exhibits and organized comprehensive historical photographic surveys throughout the southeastern United States. Photography had been invented less than fifty years before Johnston began taking pictures, so she was among those who helped define the medium, create the standards of the profession, and inspire the professional development of others in the field—including women. In an article for *Ladies' Home Journal*, Johnston encouraged other women interested in photography to "learn early the immense difference between the photograph that is merely a photograph, and that which is also a picture."[1] This distinction between photography as mechanical production and photography as art was hotly debated during Johnston's time.

Johnston's belief in the importance of photography as art is evident in all her work, including her monumental architectural survey that can be seen in its entirety in the Frances Benjamin Johnston Collection at the Library of Congress. This meticulous nine-state photographic record of southern American architecture, undertaken between 1927 and 1949, yielded a total of over 20,000 negatives of historic structures within their surroundings. The survey constitutes a major contribution to the history and develop-

ment of photography, both as art and as documentary. Through this work Johnston brought a new sensibility to the art of architectural recording, one that was precise and scholarly, romantic and aesthetically appealing.

Today, however, Johnston is remembered best in the art world for her photographs of the Hampton Institute, first exhibited in Paris in 1900. Other Johnston photographs have appeared in histories of photography, including an occasional portrait such as the famous comic self-portrait of Johnston challenging Victorian conventions by smoking a cigarette and re-vealing her stockings and petticoat. On the whole, most textbooks gloss over the extent of Johnston's lengthy and varied contribution to photography, making little distinction between what she did early in her career and what she did later. But the breadth and complexity of Johnston's photographic career necessarily complicate any interpretive approach to her art. Her work must be evaluated within the context of her career as an artist, professional photographer, journalist, and historian as well as the widespread critical ac-claim that she received as an artist of often traditional images.

Johnston's photography spanned a wide variety of types and uses. Her images, produced in staggering numbers, ranged from portraiture and illus-trations for feature articles and news stories to Progressivist-inspired public relations commissions focusing on the education of African Americans and Native Americans. She also provided extensive documentation of formally designed gardens, historic architecture, and landscapes. Johnston, who be-gan her career as a student of drawing and painting at one of the premier institutes in Paris, participated in numerous art photography exhibitions, including those overseen by Alfred Stieglitz (1864–1946), the leading pro-ponent of photography as art in the late nineteenth century. Throughout the early part of her career Johnston was involved with Stieglitz's circle in various ways, and she remained proud of this association throughout her life. Nevertheless, Johnston's photography never conformed strictly to the aesthetic conventions he advocated, and her career incorporated pathways that diverged from those of his pictorialist school.

Members of pictorialism were more concerned with truths beyond ap-pearances expressed through dreamier, more generalized compositions. Through Stieglitz, who is most responsible for the acceptance of the au-tonomous value of photography, the early work of his circle involved much manipulation of the negative and print as well as the initial focus to achieve

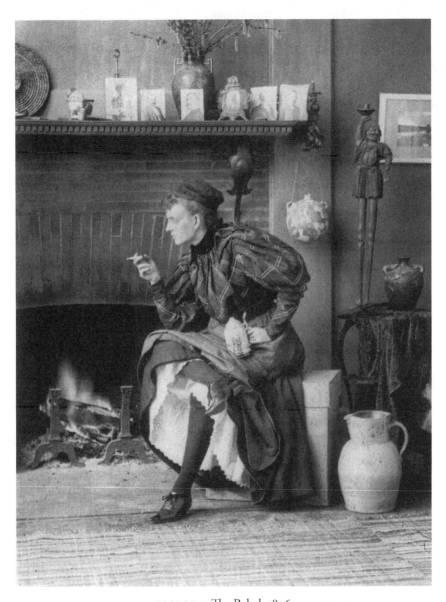

FIGURE 1. The Rebel, 1896

painterly or graphic effects. To emphasize artistic content more than the precise renderings of objects, landscape arrangements, regardless of their origin, were enveloped in fog and punctuated at times by a sunset not unlike an Impressionist painting. Another common feature of pictorialist photographs from this period was a growing sense of intimacy and charm. Youth and beauty were personified through images of graceful children and grave, nude maidens in harmony with nature. The majority of photographic entries at exhibitions consisted of portraits, genre scenes, and costumed figure studies that tended to resemble painting through the use of a soft focus lens and romantic and sentimental themes based on the application of Aestheticism and Symbolist styles borrowed from the more traditional fine arts.

While the pictorialist school was important for Johnston's work, particularly if seen within the context of her earlier career in Washington, D.C., she herself understood that many of her photographs could be considered in more than one artistic category, and throughout her photographic career she tried to conform to whatever labels and rules were used in exhibitions so that she could participate accordingly. Her reliance on artistic exhibitions in the United States and abroad, as well as on newspaper journalism, a relatively new field that at times complicated the recognition of her photography as art, shows her desire to challenge traditional conventions about art and society. The subject matter she at times portrayed, such as private educational institutions and public schools for African Americans, while innovative topics, were not always perceived as artistic material by the American public. Her subsequent work in garden photography was a return to less politically charged subject matter and a more direct appeal to traditional aesthetic values through conventional use of the picturesque. As to more traditional images, the importance of Johnston's impressive work in recording historic architecture becomes clearer when compared with her other work undertaken for both private and public patrons.

With her later extensive architectural photography of the Southeast, Johnston resolved to some degree the competing tendencies of tradition and innovation by relying on traditional architectural recording techniques to reveal a variety of altered, modern-looking, and genuinely historic landscapes. Furthermore, the publicity and recognition of her work as art made architectural photography more acceptable as a discipline. Johnston was a

dedicated and early historic preservationist, with a keen interest both in eighteenth-century buildings and in the work of high-style American architects. Through her recording efforts Johnston anticipated and helped create accepted procedures today: to inventory historic buildings as a preliminary step toward preservation itself. Featuring her photographs in art museum exhibitions, scholarly architectural publications, and collections such as at the Library of Congress, Johnston's interdisciplinary approach allowed her architectural photographs to be viewed as art as well as architectural and historic documents.

Through a chronological examination of Johnston's work in various fields, the continuity of her oeuvre is revealed in terms of its aesthetic qualities and point of view. Her portraiture and news photography as well as her landscape and architectural photographs reinforce one another. In Johnston's photographs of people, buildings appear in significant ways, clearly supporting the messages of the photographs. Gardens and landscapes, in turn, are shown in their relationship to people. A profound human presence enters these photographs, continually reminding us of the crucial distinction between husbanding and destroying the environment. Johnston's pictures of buildings, finally, are colored by their surroundings, whether gardens or streets, and by the images of the people who inhabit them.

For Johnston, portraiture was a kind of rehearsal for her later architectural work. There is a striking continuity between her portraiture and her architectural photographs in the stateliness with which she presents her subjects. Both the framing of her early photographs of buildings and the architectural styles she chose for her portraits are imbued with a mixture of classicism and romanticism. She showed her deep understanding of architecture by emphasizing the most salient features of architectural style in black and white photographs so that porches, columns, eaves, and classical detailing such as swags and urns can be observed in carefully modulated light and shadow. In photographs of often dilapidated building in their rural settings, she showed how character is imbued across the ravages of time, meanwhile animating architecture and landscape with the spirit of portraiture. Although the buildings that Johnston photographed were masterpieces of an earlier era, her architectural photographs became a gallery or album of what was significant in her own life, one in which the structures became cultural icons and sisters from the past.

Johnston's photographs demonstrate a subtle reverence for artistic principles. They appear at first straightforward and full of information, but looking beyond the surface of her pictures, the viewer can see a more sophisticated agenda at work. Johnston understood lighting and how to frame a subject to introduce dynamic relationships on the surface of her photographs. Throughout her photographs there is a sense of balance, depth, and clarity. Many of her detailed images have the qualities of pure abstraction. But always she returned to her subjects; and always content and meaning won out over pure composition and form.

Johnston thoroughly understood that the camera was well suited for precisely recording places and events and that large quantities of images, seen as a whole, were essential for their subject matter as much as their aesthetic value. Although she believed in photography as art, her photographs usually did not resemble typical pictorial schoolwork. Like Jacob Riis (1849–1914), the American photographer famous for his portrayals of poverty in New York City, Johnston tended to dwell more on social issues. In her case, these included racial equality, beautification of the environment, and the preservation of historic vernacular architecture. The intent behind much of her photographic commissions was to restore the moral fiber of the country through documentation of places and people she knew best. Her work overall demonstrated a strong empathy for the working classes, women, African Americans, and the natural environment as well as prominent political and artistic leaders. Her photographic and written essays focused on women shoe factory workers in Lynn, Massachusetts (1895), the Kohinoor coal mines in Shenandoah City, Pennsylvania (1891), mining operations at the edge of northern Lake Superior producing one sixth of the world's iron ore (1903), and women working in a cigar-box factory (1910). Her Progressive ideals complicated the intent of her photography so that her straightforward documents were not always perceived as straightforward art.

Such compelling issues for Johnston were better served by less-stylized compositions, so that the subject matter took on more meaning rather than being lost in abstraction. Perhaps for this reason, Johnston did not retouch her photographs. How the real world appeared was essential to her subject matter. The camera was a way for her to express her concerns, as far as she understood them, so that her audience could be educated and moved

to action. Johnston, a privileged member of Washington, D.C., society as the daughter of a political journalist and head bookkeeper of the Treasury Department, was comfortable saluting the status quo through her portrayal of important American figures living in the nation's capital, although her photographs show that she does not always approve of their politics.

Johnston's photographs of the late 1880s and early 1890s were more than serviceable records of people or institutions because her artistic training and her own sensibilities demanded a more aesthetic orientation. Such an understanding was endemic among photographers who were artists knowledgeable about traditional aesthetic composition, lighting, and subject matter. Johnston's own interests extended beyond mere borrowing of artistic techniques. She was interested in pictorial effects, in the manipulation of images, and in the unique attributes of photography itself as an artistic medium. This was evident in her portraiture, her journalistic documentary photographs, her sometimes self-consciously artistic studies, and her writings, commentaries, and associations. Her Progressivist ideals inspired the subject matter of her photographs and were a means for her art. Simultaneously, her desire for social reform enabled her to create art that became essential for historic preservationists. As a result, while Johnston was making a living as a photographer, she straddled various aesthetic roles and circles so that not only did she become one of the pivotal figures in the beginnings of what has come to be known as pictorialism, a movement with adherents that embraced a wide variety of approaches and standards in which to measure artistic merit, but also a prolific photographer of clearly rendered portraits and architectural images that were useful for many types of clients, including architects and artisans restoring the original appearances of aging buildings.

Professional Development
and Early Work

Portrait of Frances Benjamin Johnston

FRANCES BENJAMIN JOHNSTON's self-portrait, known as "The Rebel," is now almost iconographic in status (figure 1). In this picture, a young woman wearing stockings holds a cigarette in one hand, a beer mug in the other. She sits with her dark skirt hooked up so that her white petticoats and the calves of her legs are visible. With her legs crossed in unladylike fashion, Johnston is seen in profile, determined and thoughtful, looking into space. Arranged on top of the mantel of a large brick fireplace containing glowing embers behind her is a set of male photographic portraits: perhaps teachers, friends, or jilted suitors. There are also a hanging ceramic North American Indian container; a basketry mat, also North American; an Arts and Crafts style flower vase; a salt-glazed pitcher set on the floor; a water-color landscape painting; a second folk-ware jug; and a curious long-legged candle holder in the form of what appears to be a costumed devil. This portrait suggests the values and accouterments of Johnston's life. It has also been adopted as a symbol of nascent feminism, as a bold statement of independence in a male-dominated world in which Johnston made a place for herself as a photographer and artist. But as in all things, this interpretation is too simple, and at the same time, it ascribes values that were not intended. Johnston, as the photograph indicates, was a person of artistic

tastes. The cigarette and beer mug demonstrate her essential bohemianism—her commitment to breaking conventions. The men portrayed along the mantelpiece are meant to be a joke that could be shared with the public—that she has rejected a husband for a more independent artistic life. To those who knew her intimately, the irony was that she was a lesbian who was very discreet about her personal life. Regardless of her sexual preference, feminism was part of her creed, her temperament, and the times in which she lived. But her feminism was tempered as well by a wish to belong—to be one of the men, drink and smoke "with the boys," and establish herself in her own right, not to serve simply as a pioneer for other women. Known for her feistiness and her drive, Johnston depicts her independence and sense of humor, qualities that would sustain her throughout her career in a male-dominated profession.

There are other indicators in this portrait that should not go unnoticed. The antiquarianism represented by the jug, the pitcher, and the Colonial Revival fireplace with its arched, brick firebox and denticulated wood mantel are also important features. The Arts and Crafts vase points toward her regard for the handmade, a credo of this artistic and social movement. The American Indian pieces show her kinship to the original people of the continent, a recognition shared by contemporaries such as the artistic designer Gustav Stickley (1858–1942) and the photographer Edward Curtis (1868–1952). All of these elements are combined in a way that now might seem contradictory and confusing: American Indians and the Colonial Revival, a Louis XV occasional table, and a salt-glazed pitcher. But contradictions such as this are part of life and also provide insights into connections we might no longer sense or appreciate.

This book is an attempt to understand these contradictions and unities in Johnston's life and work. Most important, it is an attempt to both isolate and elucidate a particular aspect of her career: the corpus of work represented by Johnston's architectural and garden photographs. There is a hint of this intent in the brick fireplace and mantel in Johnston's self-portrait. But this is only part of the story. The brick fireplace and mantel suggest that architecture is a part of her life. The other elements in the portrait's background show that her appreciation of architecture is bound up with other aspects of her personal history, her values, and the community of which she was a part.[1]

Johnston's studio, the setting of her self-portrait, was the perfect place for her work in portraiture. It was "a thoroughly artistic room, which does not suggest in any way the bare chilliness of the usual gallery."[2] Also serving as a salon for literary and artistic members of Washington, D.C., society, Johnston's studio was a place where she gave her sitters plenty of time, "a half dozen sittings if necessary, to study . . . pose, expression and lighting: to give unlimited care to detail, to see the very best in a sitter and capture that if possible. This I am confident is the beau ideal of photographic portraiture."[3]

Johnston's philosophic approach made her work unique from the beginning. She was not just another woman dabbling in the field as a hobby, nor was she a typical male photographer following formulaic routines to make a quick profit. Her philosophy elevated her photographs from being amateurish, yet made them more artistic than those of the average professional photographer. In this way she consciously broke from the confines of traditionally masculine and feminine aspects of photography. Her self-portrait illustrates the realization that she would have to assert her own style, one that would emphasize artistic considerations along with commercial success. She was outspoken about the demands and challenges of her profession and advised women photographers to possess qualities they must cultivate to become professional photographers, including attention to detail, tact, affability, hard work, patience, a strong sense of identity, discriminating taste, endurance, resourcefulness and flexibility—qualities Johnston exemplifies ironically in her self-portrait.

Early Life

Frances Benjamin Johnston was born on January 15, 1864. Although there currently is no birth certificate to validate where she was born, it is common knowledge that her birthplace was the small town of Grafton, located in the northern part of the then newly formed state of West Virginia. The small Appalachian settlement had begun before the Civil War when it had served as an important rail junction for timber transportation. Johnston's mother, Frances Antoinette Benjamin, had married Frances's father, Anderson Johnston, in 1860. How they first met has not been recorded although there is evidence that they married in Ohio. Johnston's father's forebears were from

Scotland, or probably Scots-Irish from Northern Ireland. They later settled in Virginia and Kentucky. Johnston was drawn to her family's history, and during a hiatus in her photographic career in 1940, she researched the genealogies of both parents' families. Through her father, Anderson Domiphan Johnston, she claimed to be the great-great-granddaughter of the Reverend Lewis Craig. A militant Baptist preacher, Craig had led his congregation of six hundred people, known as "the Traveling Church," from the Blue Ridge trail through the Cumberland Gap to Kentucky in 1781.[4] Johnston also was pleased to be able to trace (ostensibly) her father's lineage back to Pocahontas, the Virginia Indian princess. Her mother's family, the Clarks, was more prosaically of English descent from Massachusetts. But they had arrived prior to the American Revolution, which was a significant fact for Johnston herself. The Reverend Jonas Clark, her mother's ancestor, and family members from Lexington, Massachusetts, had known Revolutionary War leaders such as Hancock and Adams, and according to documentation prepared at the time of Johnston's later application for membership in the Daughters of the American Revolution, had helped care for wounded patriots who had fallen in the early battles of the War of Independence.[5]

Whether she was born in West Virginia or not, Frances, the only surviving child of her mother's four live births, lived as a young girl with her family in Rochester, New York, the home of her maternal grandmother, Joanette Clark. Johnston's father was an educated man with social and political connections in the post–Civil War world. The family moved to Washington, D.C., sometime before 1875, where her father worked at the Treasury Department, serving eventually as head bookkeeper. Significantly for Frances's later career, her mother worked as a political journalist, covering congressional news. This was certainly an unusual circumstance, suggesting a strong parental respect for women's rights and the value of women's contribution in the marketplace. That Frances would be given both her mother's first name and her family name also indicates a commitment to progressive and feminist ideals.

Frances's parents and especially her aunt, Cornelia Hagan, her mother's sister, would remain emotionally, and at times financially, supportive to her throughout her life. She was brought up in an atmosphere of privilege and encouragement. Her early education began in her home, with additional studies in a private school. She graduated from Notre Dame Academy, a

two-year women's school at Govanston, Maryland, in 1883. Her hope, she later explained, was to be a writer. But soon afterward her career ambitions shifted and she indicated a preference for art. At her own request her parents then sent her to Paris to study drawing and painting for two years at the Academie Julian, a well-known school for international students.[6]

Paris Education

The Academie Julian was a logical choice for someone with Johnston's interests and background. The private institution founded in 1868 by Rudolphe Julian was opened to women in 1873. This was significant since women were not permitted to enroll at the Ecole des Beaux-Arts, considered the most prestigious of the Parisian art academies and really, the best-known school of art in the world at the time. At the Academie Julian, mixed male and female classes were conducted until 1877, in which year a separate women's studio was first arranged in the building on the Rue Vivienne. For uncertain reasons, female students paid twice as much as their male counterparts—one hundred francs weekly in contrast to the male students' fee of fifty francs, which is about twenty dollars. They also received half the supervised instruction, reflecting a common prejudice that women's education was somehow less serious than that of a man. Still, the Academie Julian required paying students, and for both men and women this was the most important prerequisite for admission. Students had separate spaces assigned to them, chalked out on the floor to prevent encroachment by their neighbors. The studio sessions were held weekly for women and semi-weekly for men. One weekly studio visit instead of two was standard, a situation typical of most ateliers throughout Paris. Many of the students were American, and most came from similarly privileged backgrounds as Johnston. All accounts suggest that the Julian was a lively and popular school, where instruction allowed time for interaction and an active social life. According to a student, American portraitist, Cecilia Beaux (1863–1942), the Academie itself was boisterous and crowded. When Johnston studied at the Academie Julian from 1883 to 1885, over six hundred students were enrolled. It was clearly an exciting environment and one that Johnston valued highly.

In 1883 the studio teachers included Adolphe William Bouguereau (1825–1905), Gustave Boulanger (1824–88), Benjamin Constant, and Jules

Lefebvre, all noted academic painters of the period. The teachers at the Academie Julian tended toward traditional subjects and treatments that would be later dismissed by critics as having appealed to bourgeois tastes, although more recently their reputations are beginning to be reappraised. One of the primary instructors in the woman's studio was Tony Robert-Fleury, one of a family of well-known artists prominent in this period of the nineteenth century, most famous of whom was Joseph Nicolas Robert-Fleury (1797–1890). Overall, instruction at the Academie Julian followed long-accepted methods. Students were taught by working from human models, sometimes nude, followed by criticism by instructors who would stroll through the studios viewing their work. Extended afternoon hours allowed students to work additional hours. Nonetheless, the Academie Julian was more informal than the far more rigid and restrictive Ecole des Beaux Arts. This, together with the lack of entrance examinations, probably made it more popular with young American students such as Johnston.

Despite the predominance of classical training at the school, Julian students were encouraged to keep up with the latest trends. The 1880s was a period of great artistic creativity in France. Impressionism, initiated by the loose association of Paris-based artists, including Claude Monet, Camille Pissarro, Berthe Morisot, and Pierre Auguste Renoir, was still very much at the forefront of art at the time, which was significant for many American students at the Academie Julian, most notably John Twachtman (1853–1902) and Childe Hassam (1859–1935), American Impressionist painters. No doubt Johnston appreciated this liberating Parisian climate of aesthetic exploration to some extent. Although her exposure to this aesthetic freedom was much more limited as a female American student, and though she did not practice photography at this time, her eventual profession would benefit from casual exposure to this relatively new aesthetic style devoted to the study of light and shadow.

Johnston understood that her formal instruction there gave her credentials beyond other young artists of her generation. It is significant that thirty-five of the Paris-trained American painters who exhibited at the World's Columbian Exhibition in 1893 studied at the Academie Julian, while only twenty-five painters studied at the Ecole des Beaux-Arts. In addition to Johnston, American artists during this period whose careers benefited from studying at the Academie Julian included William MacGregor

Paxton and landscape architect Charles Adams Platt, whose landscape designs Johnston would later photograph.[7]

All American artists, regardless of where in Paris they studied, be it the Ecole des Beaux-Arts, Academie Julian, or another popular school called the Petite Ecole, would enjoy a certain amount of prestige over non-Parisian-trained American artists. The competitive practice of evaluating student projects in class served as a testing ground for young artists at the school. In addition to training, students were assisted by their teachers, powerful members of the established art community, who in turn exerted pressure on members of the juries when pictures needed to be admitted or shown. Most important, students from the Academie Julian, particularly the American students, bonded with one another, forming communities back home; and the returning Johnston would be part of this, proudly reciting her credentials. Johnston relied on the Academie Julian and her connections made there and used this background to help establish her career. Maybe even more significantly, the kind of formal training represented by the Academy's somewhat traditional curriculum would continue to permeate Johnston's work, including her choice of subject matter. The Academie Julian, then, could be seen as the foundation for the formal architectural studies that were later to dominate her work.

Johnston returned to Washington, D.C., in 1886. Her ambition, she later recorded, was to become a magazine illustrator. There is no indication that she had a particular interest in architecture at the time. Nor do her interests in photography seem to have found root. She had been trained as a conventional artist, essentially in the more traditional Beaux Arts system of the time. She could draw from models, paint, and had a broad education. She also had traveled and learned from experience. Now it was time to find a context in which to work.

Washington, D.C., and the Art Students' League

Upon returning from Paris, Johnston became active with the Art Students' League, a membership-based organization for Washington area artists.[8] Begun in 1884, the Art Students' League was an outgrowth of the early Washington Art Club, itself founded in 1877. Two of its principal organizers were Edmund Clarence Messer and Richard N. Brooke, both local

studio artists and later influential figures at the Corcoran School of Art near the mall. The Art Students' League was intended to be both a place of association for artists and a teaching institution. Art instruction in Washington after the Civil War had been largely a private activity. Several artists provided space in their studios and occasional instruction to students. The Art Students' League was an attempt to remedy this situation and provide more regular instruction in line with older European methods. At first, classes were held in a townhouse on Vernon Row, which stood between Pennsylvania Avenue at Ninth and Tenth Streets. The actual headquarters for the league was located nearby, at 808 17th Street, in a former private mansion. Support for the organization came primarily from subscriptions and by fees paid by students for instruction.

The basic course at the Art Students' League followed roughly the format of that at the Ecole des Beaux Arts and Academie Julian. Courses included figure drawing, painting, and sculpture. Most of the teachers, such as James Henry Moser, a noted D.C. artist, were portrait artists, although a few also did landscape and still-life renderings. In general, instruction was probably not of the highest caliber, and for someone like Johnston, it would have represented something of a step down from her previous European education. We can only assume that she joined to make contacts and to further her artistic career.

All members of the league were required to submit to three months of training, whatever their previous levels of knowledge and skill. For admission into a course, potential members had to submit a letter of application together with a "signed drawing in black and white made directly from a cast or model, in whole or in part."[9] Johnston joined the league early in 1886. She was one of twelve new members admitted that year. In any one period, the league included between fifty and sixty members and approximately five to six professional artists, most of them part-time teachers, to provide instruction. The league offered lecture rooms, larger studios for instruction, and smaller studios rented to individual artists.[10]

There is a photograph of Johnston and other art students at the league, including over forty women posing with their art materials.[11] Johnston appears in the second row, third from the left. One woman holds a long pointer. Some students hold writing or drawing pads and bags. Framed portraits have been hung along the back wall, and a skeleton can be seen

behind the students. Around the same time the *Washington Post* published an article on the Art Students' League. Johnston is mentioned in this article as a student who worked on pastel crayon portraits.[12]

During the late 1880s and early 1890s, Johnston made the Art Students' League her second home. She maintained a studio space, attended lectures, and played an active role in the organization of the society. During her time there she served on most of the committees and was the league's treasurer for a term. She was also charged with hiring models during one season. Never a full-time lecturer or instructor, she nonetheless taught beginning artists whenever required. Johnston herself explained that she taught only "in an emergency, and incidentally studied in her other classes at the same time."[13] Later credited with being one of the league's instructors, she explained in 1893 that she had taught "for a short season but not long enough to deserve mention."[14]

But whatever the degree of her commitment to teaching, Johnston found the Art Students' League extremely useful to the development of her career. Here she was able to re-create on a smaller scale the kind of life she had enjoyed in Paris. It also gave her access to the art world of Washington, introducing her to many in the capital's artistic community. Most important, it gave her a first step in her professional career. It was, in fact, through one of her closest league friends, Elizabeth Sylvester, that she would secure her first job as a freelance journalist.

The Art Students' League, despite its deficiencies in comparison to the far larger Academie Julian, was an important way station for Johnston. The league gave her a base from which to work and provided a kind of stamp of legitimacy for her as an artist. Although she studied and continued with her work, she admitted that it was at the league that she began to recognize that her heart was not in painting or sketching. As she explained, "All hope departed, I know how perfectly terrible my sketches and drawings were."[15] In part, she blamed the level of instruction, suggesting too that she had received little encouragement in these areas. But the league was not entirely responsible for her changing interests. The increasing appeal of journalism and toying with a new gadget, the compact Kodak camera, also attracted her.

But even with her new interests, Johnston remained active in the Washington, D.C., art world and supportive of the league. She well understood

that such organizations were critical to her and to her contemporaries' professional development. Leila Mechlin, who would later help introduce Johnston's photographic work to the art editor of the *Washington Star*, wrote of the enthusiasm the league and other organizations engendered within the city in the latter decades of the nineteenth century and also of the high level of commitment of teachers within this community:

> These schools were something more than student organizations, they were gathering places of artists—men and women of high ideals and lofty aspirations. There was a sweetness and fineness, a robustness and purity about the outlook on art on the part of these painters and illustrators that was reflected in their work and which made the art life in Washington peculiarly delightful. These men [and women] were not amateur artists. They were not feeble producers. They were men [and women] of unusual capability and vigor, men [and women] of promise, men [and women] who did not lead narrow lives, but who saw more broadly and deeply and got more joy out of life than those who possessed many times as much in worldly wealth. To them we owe a great deal and to them we should pay highest tribute.[16]

Similarly, Everett Warner, one of Johnston's cohorts at the Art Students' League, wrote fondly of Edmund Clarence Messer, a teacher who had previously taught Johnston, noting that Messer taught not only art but ethics and morality as well. Students were invited to Messer's home on Sunday afternoons for refreshments and occasional lectures on the public role of artists and the broader values of an artistic career. Warner explains more fully:

> [Messer] was my teacher in the Art Students' League . . . but he was much more than that to me. Not what most people would consider a very good painter, he expressed his artistic greatness in inspirational teaching, not solely confined to the field of art, but including the realm of professional ethics, and personal beliefs. The Messers lived in Anacostia, and almost every Sunday afternoon a group of us would go over there and engage in discussions on every conceivable subject. When it grew late, there was no such thing as an invitation to remain—it was an assumption—and Mrs. Messer would come in to interrupt the talk by saying, "it is time to come out to tea now." No other of my teachers ever gave so much of himself to his students, or had so much to give.[17]

It is perhaps Messer and teachers like him to whom we can credit Johnston's growing social commitment and her belief that art must have a purpose beyond mere beauty or representation for it to have value.

In addition to the Art Students' League, Johnston also became active with the Corcoran Gallery and with the associated Corcoran School of Art. The Corcoran Gallery had been established through provisions made by the prominent Washington banker William W. Corcoran. Housed in a building designed by James Renwick, Jr. (1818–95), one of America's most significant architects and the designer of the Smithsonian Institution, the Corcoran was really a private house, turned museum. The collection, opened to the public in 1859, was noted for its comprehensive display of American paintings from the colonial period through the late nineteenth century.[18]

The Corcoran Gallery, closed during the Civil War, when it was occupied by the Quartermaster-General's Department, was reclaimed in 1871 and renovated over the next three years. Chartered by Congress in 1870, the collection was a regular haunt of Johnston and other art students during the 1880s. The National Gallery of Art was not yet open as a teaching center, so that the Corcoran Gallery really was the only public museum of its kind in Washington, D.C.[19]

In 1877 the Corcoran began its own school, paralleling the Washington Art Club, which began in the same year. Along with the Art Students' League, these three schools formed the core of art institutions during the 1880s. The Corcoran remained a key site for the study of art, and remained on its location at the corner of 17th and E Streets until 1897, when the collection was moved to a new neoclassical building.[20] Johnston kept clippings about progress on the new building. She also visited the gallery throughout the 1880s, and once her photographic career had begun, she took photographs of the collection both for magazines and her own interest.[21]

This, then, was the artistic context of Johnston's early career: a young woman educated in private schools in the Washington, D.C., area, with a three-year art background in France. The Corcoran School and the Art Students' League were associations that included artists and students at the Washington Art Club. Johnston also spent free time studying art at the Corcoran, looking at collections in private hands—many of which she would later photograph—and occasionally visiting the "cabinet of curiosities" housed in the Smithsonian Institution, located across the mall. It was

a rich and stimulating environment, one not too demanding, but one she could navigate and, more important, make a strong impression within.

Johnston's career began not only within the context of art instruction in Paris and Washington, D.C., but also in the broader domain of a burgeoning national capital. Washington at the time of Johnston's return, was a place being reborn. Long characterized as a somnolent southern village, the city of Washington emerged as a modern metropolis in the aftermath of the Civil War. Indeed, as historians have long recognized, it was the Civil War itself that transformed both the city and the country as a whole and introduced a new period of urban expansion. Growth of the city was particularly dramatic in the 1870s and 1880s. Sensing the need for a progressive and strongly symbolic capital city, the Grant administration had initiated an ambitious program of street paving, the addition of water and sewage lines, new lighting, and the infilling of outmoded canals. Under the tutelage of Alexander "Boss" Shepherd the city witnessed a construction boom unparalleled in its history. In 1872 alone over 1,200 buildings had received permits.[22]

By the 1880s attention had turned increasingly to the beautification of the city as well—a fact of significance for those with artistic interests such as Johnston and her contemporaries at the Art Students' League. With a return in part to the intentions of the original L'Enfant Plan of 1791, steps were taken to enhance vistas and to improve and install new parks, including Frederick Law Olmsted's Capitol Park. Public sculpture also found public support, in part to embellish the parks but also to provide a new level of sophistication and splendor to the city. Similarly, public buildings emulated those of ancient Rome and of Second Empire Paris, much as the Corcoran Gallery was to be transferred from a Second Empire style private house to a neoclassical pile.[23] These were important changes in light of Johnston's life and career. A Washington "insider" with longtime family connections, Johnston inhabited a familiar place, but one that increasingly offered new artistic stimulation and opportunities.

This, then, was the world into which Frances Benjamin Johnston was emerging. It was a time of hope and ambition for young students such as Johnston. Still, their opportunities were limited. Johnston's age group at the Art Students' League included twenty-eight women and ten men. Only a few of the students and members of the league were full-time artists. Most of

the male members were employed by the government, working for agencies such as the U.S. Geological Survey, the Coastal Survey, or the Smithsonian Institution. Nearly all the female members were unemployed.[24]

Introduction to Photography

Johnston was fascinated by her own city. Her records include many newspaper clippings, brochures, and postcards, documenting changes to the city, new buildings, and exhibits. These suggest the direction of many of her later interests: American history; figures significant in politics; military and naval leaders; forms of commemoration, especially portraits and statues; and most important, old and new buildings, parks, and changes in the overall urban environment. Her collection of clippings suggests her interests and her prejudices: formality, classicism, timelessness—all conveyed in her later photographs and the choice of subject matter, especially her portraits of historic American buildings.

Johnston was led to photography through an interest in journalism. This was not a surprising course of events. Her mother, it should be remembered, was a well-connected political journalist, covering congressional hearings and speeches as a correspondent. An unusual vocation for a woman at this time, her mother's career clearly opened doors for young Frances. As early as 1882 or shortly before the time of her study in Paris, she was submitting news items to local papers and occasional articles to magazines. Her first recorded article is called "Old Things Have Passed Away," published in *Saint Nicholas Magazine* in 1882.[25] While studying and working at the Art Students' League, Johnston continued to submit articles, mostly short pieces on famous people, which she typically illustrated with pen and ink sketches. Sometime around 1887, Elizabeth Sylvester, a friend from the Art Students' League, asked Johnston to stand in for her temporarily as a Washington correspondent for a New York paper. This was a short-term commission, but it led to more regular offers with other newspapers and periodicals. Following the pattern of her earlier work, Johnston's pieces were primarily short descriptions, still illustrated with sketches.

According to her own later account, Johnston sometime in 1887 wrote to the famous inventor and businessman George Eastman at his business in Rochester, New York. Eastman, a family friend while Johnston's family had lived in Rochester in the early 1870s, would meet with Johnston much

later during a tour abroad. Johnston requested a camera to use for her journalistic pieces. Eastman responded by sending in the mail what Johnston claimed was his first roll-film Kodak model camera as soon as it became available in early 1888. Whether Johnston's story embellished the truth or not, this was an important step in her career. A dramatic improvement over earlier, heavier cameras, the compact Kodak roll-film camera was ideally suited for press photography, which was becoming Johnston's interest at this time. Lightweight and strong, the camera, which relied on flexible celluloid film instead of more cumbersome glass plates, had been in development since 1884.[26]

In an age in which celluloid film is almost a thing of the past and digital cameras line the shelves of camera shops inside malls, it is difficult to fully appreciate the impact of Eastman's invention. But even this represented just one more step in a succession of improvements in the apparatus of photography just before Johnston entered the field. Until the 1870s professional photographers—and until this time nearly all photographers were professionals—had to use collodion plates that were coated wet in the field. The images had to be fixed and printed immediately, requiring movable dark rooms, such as that made famous by Matthew Brady during the Civil War. In the 1870s a number of inventors and manufacturers began to experiment with pre-coated dry-plates, a process perfected by Eastman around 1880. Dry-plates made photography more practical, since the image could be stored and the plate then transferred to paper in a permanent studio darkroom.[27]

Eastman's invention and introduction of the roll-film camera created an alternative approach to photography. The film, which was contained on two spools within the camera, could store approximately one hundred images. When completed, the rolls would be sent to Rochester for processing and photographic prints could also be made. This innovation introduced the possibility of the more casual, amateur photographer. It also provided a convenient method for taking news photographs, recording ephemeral events, and illustrating magazine articles, as Johnston was to find. While Johnston clearly used larger formal cameras, which relied on larger pre-coated glass plates, the roll-film camera became a useful part of her equipment. It also facilitated her quicker, more journalistic work, which became an important source of income.

The introduction of the roll-film camera underlines a significant aspect of Johnston's career. Johnston had entered the field of photography at a time of staggering technological innovations in the field. As a result of widespread marketing of dry plates, photography no longer required extremely heavy equipment, such as was common in the 1860s and 1870s, or a close knowledge of often difficult processing techniques. Because it became an increasingly simple endeavor, photography was advertised as an ideal hobby, and one especially suitable for women. A number of articles were written during the period explaining how women performed well as photographers, with, as one writer put it, their "keenly developed instinct for the decorative and picturesque, their delight in the mere manipulation with their delicate hands of fragile objects, their love of finish in details, their well-known patience."[28]

A growing number of amateur photography clubs further helped encourage other photographers; many of these allowed and even encouraged women to join. Visualized as less rigorous than painting or drawing—and indeed increasingly easier to accomplish—photography captured the interest of thousands of eager amateurs. According to U.S. Census Reports, there were 7,600 amateur and professional photographers in 1870. By the end of the century the number had increased to nearly 30,000. Women photographers had increased from 228 listed in 1870 to a total of 3,580.[29]

In this context it is not entirely surprising that Johnston should have changed her medium from drawing to photography. She had never felt comfortable drawing, as she later admitted. She also claims she was impatient and saw her art foremost as something needed to illustrate her written articles. Perhaps most important, it was obvious to all of those in the field of journalism that photography would soon supersede drawing and other means of illustration—particularly in periodicals, where experience was a primary consideration. Johnston, being a practical young woman stepping into a journalistic career, made the transition quickly.

Looking back on the history of the illustration technology, Johnston's shift becomes even more understandable. In fact, by 1886, or just as she was entering the field of journalism, the advent of photography as a means of illustrating journals and books was well in evidence. This development had occurred over a period of about fifty years, with accelerating improvements during the 1880s, or just as Johnston began her career. The first extensive

CHAPTER 2

use of photography was as a basis for woodblock prints, a process that became popular by 1850, replacing earlier lithographic prints themselves, some of which were based on some of the earliest photographs. In 1880, the *New York Daily Graphic* revolutionized newspaper illustration through the introduction of the half-tone process in which the image of photographs could be screened or reproduced directly from the photograph, thereby eliminating the need for intermediary cutting or engraving. In this process, developed in part by Johnston's future mentor, Thomas William Smillie (1843–1917), a photographic image was broken into a series of lines and dots, which in turn could be transferred to a printing block.[30]

This technical innovation was just being introduced into widespread usage when Johnston began her journalistic career. As with the Internet today, it represented a cultural revolution because for the first time, photographs could be reproduced almost instantaneously. News became accessible and immediate, as many in the field of journalism recognized, including Jessie Tarbox Beals, another pioneering female news photographer whose career parallels that of Johnston's in many ways.[31] Stephen Henry Horgan (1854–1941), then manager of the *New York Daily Graphic*, explained excitedly in an 1886 address to the American Institute in New York:

> Let the public see it [their photographs]. Now, the best medium to bring it before the public is the newspaper, and the latter is gradually reaching a position to use the contribution of a camera. Address a letter to the managing editor of the paper, stating that you have or contemplate making this subject and will furnish descriptive matter; or, if it is a subject of "news" interest liable to become valueless by delay, mail your print immediately, and you will receive credit or pay for your trouble.[32]

This was the challenge to which Johnston responded; and we can imagine her own enthusiasm.

The roll-film camera, then, might be considered one of the reasons for Johnston's change of illustrative focus and approach. This, certainly, was to become her own version of her transformation. While it is possible, in fact, that Johnston's first illustrations for some of the sketches of prominent people may have relied on the roll-film camera, it is clear that by the time of her first, more in-depth articles in the 1890s, she was familiar with more traditional, large-format, glass-plate cameras and only used this format for her

work. This is evident especially in her large, sometimes almost panoramic views of building interiors and exteriors. Only a larger camera, with a fully adjustable lens, would have allowed for such precise images, lacking in distortion of horizontal and vertical lines, a phenomenon known as parallax, a typical shortcoming of images taken with smaller, more portable cameras.

Johnston appears first to have taken formal instruction in photography at the Smithsonian Institution through a course offered by the director of the Institution's Division of Photography, Thomas William Smillie. As pointed out, Smillie had helped develop the halftone process for transferring photography to print media and approached the subject of photography as a true scientist. His contemporaries regarded him in that light, and he was viewed as the most important scientific researcher in photography during the late nineteenth century. He had begun his research during the 1860s, when he served under Assistant Secretary Spencer Fullerton Baird. In 1871 he was appointed head of photography at the Smithsonian, a position he held for over forty years.[33]

In Johnston's time, Washington, D.C., was still really a small town, and it is not surprising that Johnston should have had access to an authority as eminent as Smillie. He was then still in his thirties and served respectively as clerk, curator, and research scientist. In his spare time, he taught regular classes to his associates and others in Washington society interested in the new science and art. To help educate the public and his students, Smillie assembled a representative collection of older and newer photographs, as well as older photographic apparati for a small exhibit in the photography gallery.[34]

In 1888, or around the time Johnston and Smillie became acquainted, he purchased a daguerreotype camera first used by the artist and inventor, Samuel F. B. Morse. Unable to develop the collection into a permanent exhibit, Smillie created a cataloging system and committed himself to the responsible presentation of older photographic prints and negatives. This careful attention to established procedures, knowledge of chemistry, and problems of presentation helped set standards for archivists around the country, once photographic images became a more important part of their collections.[35]

Johnston's extended association with Smillie was a first exposure to scientific dedication on this order. Smillie's example clearly set the precedent

for the kind of systematic enterprise she undertook in her more mature period, when architectural recording became the most significant part of her career. Cataloging, numbering, listing, and recording would all become implicit to her technique.

While there is little in the record about her earliest work with Smillie, Johnston, nonetheless, was grateful for Smillie's instruction and advice. In an interview recorded in 1935 she admitted that she, as she put it, barely knew the difference between a tripod and a plateholder when she began taking photographs. Smillie helped her straddle this chasm, and her instruction with him gave her a new sense of purpose. As she explained:

> I centered upon my new vocation with an ignorance of photography that was dense as my self confidence was unbounded. I cheerfully undertook things, and strange to say was frequently successful, which the average amateur would consider impossible, simply because I did not know such things could not be done in photography.[36]

In short, photography opened a new world for Johnston.

An immediate result of Johnston's association with Smillie was her receipt of a special commission from him at the Smithsonian Institution to study photographic collections in Europe. Smillie, who could not take time away from his duties in Washington, provided Johnston with letters of introduction to a number of European photographers and collectors.[37] Johnston visited other historical collections, especially in Paris and London, and purchased some older photographs and some early photographic equipment for the Smithsonian collection. Smillie encouraged her to spend more time on her own photographic interests rather than devoting herself solely to the Smithsonian commission, which was largely undertaken gratis on Johnston's part.[38]

By the early 1890s, Johnston, as a result of her friendship with Smillie, was developing a reputation as a photographer. This combined with her journalistic interests made her unusual at the time. T. J. Burton, secretary of the American Photographic Conference and a colleague of Smillie's, wrote to Johnston as early as the early 1880s, asking for advice on the sale of photographic journals, an exchange that suggests her growing knowledge and skill and the regard in which she was held by professionals.

Johnston later explained that she enjoyed working for magazines because

it allowed her to write as well as illustrate. In her early work it appears that writing took precedence over the illustrations, whether drawn or photographed. Assessing her first professional efforts, it is evident that Johnston wrote competently, and, in keeping with her era, provided lengthy written commentaries on her subjects. The photographs themselves, once they became a more important part of her articles, were typically accompanied by descriptive texts. Johnston considered these necessary to provide context and explanation to the illustrations. The link between the written text and the printed image, evident in her magazine articles and then later in her architecture books, would always be important for Johnston. Even in her mature work, and especially her architectural recording efforts, Johnston never abandoned the printed word for photography alone. Both text and image remained important.

Johnston's Early Journalistic Career

Johnston had begun her publishing career with a series of short, now relatively forgotten articles in newspapers and journals in the mid 1880s, before her move to France. These written sketches, sometimes illustrated by drawings, are referred to in her later correspondence. A few remaining examples, such as the articles in 1882, were submitted to *The Illustrated American*, and in 1887 she was asked to provide articles and perhaps stood in for her art school friend Elizabeth Sylvester as Washington correspondent for a New York paper.

Johnston's first important article, however, was for *Demorest's Family Magazine*, published in 1889. A two-part piece, printed in December 1889 and January 1890, this article, entitled "Uncle Sam's Money," was a short study of the production of currency. In addition to a text describing the manufacturing process, the article included photographs and a series of engravings, themselves copied from photographs. The illustrations included the U.S. Mint in Philadelphia, the Bureau of Engraving and Printing in Washington, D.C., and steps in the process of producing coins and paper money. The photographs appear all to have been taken by Johnston, who chose as her subjects both buildings and people working in them. One of the engraved images is a composite of a photograph of a flagpole, overlaying a foreshortened view of a building. To provide a sense of scale, the photograph of the building includes pictures of people, standing and

strolling along the front. This image, along with the article, suggests two of Johnston's major interests: architecture and people at work.[39]

Johnston continued to make contributions to *Demorest's Family Magazine* throughout the next four years. These included studies, accompanied by her photographs, of the houses of well-known individuals, mostly Washington politicians. Indeed, houses and their occupants became an important subject matter in Johnston's work. Among her subjects were Vice-President Levi P. Morton, seen in 1890; the famous Philadelphian John Wanamaker; the postmaster-general; Senator Hearst of California; and Senator Sawyer of Wisconsin. She also contributed illustrated articles of the Mexican and Brazilian ministers.

In 1890 and 1891, she made similar contributions to *Cosmopolitan* magazine. Although originally ascribed to author George Bain, Johnston later claimed to have written the articles herself; in them she provided a multipart study entitled "The Executive Departments of Government," focusing on departmental administrators and their offices.[40] Again, as with her article "Uncle Sam's Money," she included formal portraits of office buildings and their settings.

Two of Johnston's most important and longer articles were a study of the White House and another of Annapolis midshipmen. The first was published in *Demorest's Family Magazine* in 1890, with a second version appearing three years later in *Harper's Weekly*. The second article appeared in the *Illustrated American* in 1894. The White House article, later published as a small book in 1893,[41] was her most in-depth study to date. Showing her scholarly and antiquarian inclinations, she places the White House in its historical context, describing the design and early development of a city, the place occupied by the White House, and its significance to the overall plan. Her study includes exterior views of the White House, its grounds and setting. Almost a catalog, the article also gives a lengthy account of the interior, accompanied by photographs of all the principal public rooms. The Annapolis article, entitled "Students in the Art of War," is an in-depth look at midshipmen artists. She shows the students at work in their studies and describes their courses and methods of instruction. She also provided photographs of buildings and grounds of the Naval Academy, then more modest than the Baroque Revival complex that now stands on the site, built in the 1920s.

The White House articles and the one on Annapolis pointed Johnston toward her later interests in architectural photography. Both series included building exteriors and interiors and demonstrated too that Johnston was developing a sensitivity to issues inherent in this field, including techniques in composition, parallax, and lighting. She obviously was gaining mastery of her equipment and beginning to understand how photography could enhance different types of architectural views, giving even contrasting fields of light, and, in a sense, color.

But it would be misleading to say that her work of the early 1890s focused exclusively on buildings. Architecture was only a part of the story in the White House articles, even less so in the Annapolis pictures, where the cadets themselves were the subject of her work. Her other photographs and articles of the same period suggest a similar range. In 1892, she published one of her first examinations of the coal industry. This was followed by an article on the planning of the World's Columbian Exposition to be held the next year in Chicago, and then an article called "Mammoth Cave by Flashlight," all published in *Demorest's Family Magazine*.[42] In 1893, she wrote "The Foreign Legations of Washington," "A Day at Niagara," and "Small White House Orchids," all published in *Demorest's* with her photographs.[43]

In addition to magazine work, Johnston also completed a number of important commissions. Here again, her most important contact was Thomas Smillie. Almost as soon as she began working and studying under Smillie, he sent small projects her way. In 1889, Johnston undertook a number of photographic studies of pieces in the Smithsonian collection. She also completed projects for the U.S. Fish Commission, the U.S. Navy Department, and other government programs. Again, in anticipation of the World's Columbian Exposition, she completed work for the Latin American Department of the Smithsonian as part of its exhibition.[44]

Smillie and Johnston worked together on an even larger commission to document the National Zoological Park in Rock Creek Park. Begun in the 1890s, Rock Creek Park was one of the largest naturalistic parks to be established to that date. It followed in the wake of the more famous Central Park in New York and the Fens in Boston. This project, which focused on the 106-acre zoological park site, was a first effort to record a park landscape in such detail. It was an important rehearsal for Johnston's later work for owners of large estates, which included vast gardens and countryside.[45]

Portrait Photographer

It was during her work for *Demorest's* and other magazines and her first important photographic commissions in 1893 that Johnston opened her first commercial studio.[46] This was an important step for Johnston, and helped establish her reputation as a truly professional photographer. Portraiture, which required a studio space, was still very much the bread and butter of a professional photographer's work. Located behind her family home at 1332 V Street in the northwest section of Washington, the studio consisted of six rooms within a two-story brick structure, built especially for this purpose by the noted architectural firm of Hornblower and Marshall. It was located at the end of a walled rose garden, itself laid out for the family by the famous naturalist John Burroughs. It seems appropriate now, in retrospect, that Johnston should have been surrounded by good architecture and also an ornamental garden, both critical to her later work. The lower floor of Johnston's studio building consisted of a business office, a dark room, a printing room, and storerooms. On the second floor was the reception room and photographic studio, itself covering approximately seven hundred square feet. The interior of her studio, clearly influenced by Arts and Crafts sensibilities as later photographs show, consisted of green painted rafters and terra-cotta-colored walls. A twelve by sixteen-foot skylight provided lighting for her subjects. A large brick fireplace with a carved wood mantel and irons was located on the east wall. A custom-designed cloth shade could be adjusted to control the lighting. English windows punctuated the south side of the studio, and a cushioned window seat was located beneath the bay window. Furnishings included a few Japanese prints, a piano, easy chairs draped with cashmere paisley shawls, pillows, pottery, and a tiger skin rug, replete with head, open mouth, and teeth. Following the dictates of Arts and Crafts publicists such as John Ruskin (1819–1900) and William Morris (1834–96), Johnston emphasized that everything not strictly artistic in character was hidden when not used. For example, the window seat could be flipped over to become a worktable for camera gear.

Johnston was emphatic about having a personable, intimate workplace where people she photographed would feel comfortable. This was a common expectation for artists and photographers at the time. Indeed, the topic of studio design, furnishings, and overall setting was written about

frequently during this period. Many artists perceived their studios as an inherent part of their art. Johnston's studio suggests the same preoccupations and also underlines her particular interests in architecture and interior design. Her attention to the interior demonstrates her understanding that an architectural setting enhanced portraiture—not only the general ambience for the comfort of the sitters but also as a way of conveying character.

With her studio, Johnston began a successful business as a portrait photographer. Her subjects were principally members of Washington society, including governmental leaders and foreign diplomats as well as other prominent literary, artistic, and scientific figures. Johnston, as it should be remembered, was well connected in this world; and many of her sitters were people with whom she was familiar—family friends, contacts made through governmental commissions, relatives of artists, and other acquaintances. Washington in many ways provided the perfect environment for Johnston's work as a familiar and comfortable backdrop. It was evident too that Washington society looked upon her efforts with affection and with an almost indulgent pride, which was extremely uncommon for women photographers at this time. In 1895, the *Washington Times* pointed out, in "Washington Women with Brains and Business," that "Miss Frances Benjamin Johnston is the only lady in the business of photography in the city, and in her skillful hands it has become an art that rivals the geniuses of the Old World."[47]

There is a sense that Johnston was coming into her own at this time as a professional photographer. Through her family's comfortable social connections she pursued portraiture at a feverish pace in her hometown. On a daily basis, she took pictures at her studio. She developed negatives and printed photographs on the premises, later returning them to clients and discussing points of composition and lighting with colleagues. Her studio became a meeting place for her artistic friends as well. Her social set tended toward the unconventional, and a favorite pastime was costume parties, often held in her studio. Johnston's circle of close friends, affectionately known as "The Push," shared her professional pattern of hard work, discipline, and conviviality. With them, she could relax and poke fun at stereotyped conventions of the Victorian society she belonged to and depended on for her work.

Johnston was always proud of her professionalism. She later admitted

that many of her assignments were taken for the money, not because of prior interest on topics. For example, the books based on her White House and Mammoth Cave articles, both published in 1893, were strictly commercial efforts, even though each in its own way suggests some of the direction of Johnston's later work. Johnston took pleasure in noting the price of things, recognizing that work for pay was work recognized and compensated. As with other photographers and artists of her time, there was no contradiction between art and commerce. Art was a way of making money, and to work professionally one had to be paid. This simply realistic stance emphasized the seriousness of her work.

For a brief period she also developed and printed the work of other photographers. This aspect of her work increased during the time of her involvement in the World's Columbian Exposition, when she worked as one member of a group of photographers documenting the event and exhibits. Some of the negatives were sent directly to the Eastman Kodak Company for developing and printing, with Johnston receiving commissions as an intermediary. Other photographers were developing or printing on site in her studio. Johnston during this period was becoming very much a businesswoman, expanding her work and involvement in the growing field of professional photography.

Early Portraiture Enhances News Career

Although Johnston never published her portraits as a series, together they represent a significant visual document of American society during the Gilded Age and Progressive Era. A photograph of Johnston, taken by an unknown photographer at a Virginia state fair just after the turn of the century, suggests the entrepreneurial spirit of the evolving profession and illustrates the essentially conflicting formal and casual sides of photography. In the photograph, Johnston poses outdoors with others in front of a tent serving as her temporary portraiture studio. The tent appears to be made out of an American flag. The well-dressed people assume dignified poses amid flimsy poster board signs lavishly advertising Johnston's business. One sign reads, "Elite Tintype Gallery, Frances Benjamin Johnston Manager," and another says, "Look! Look!! Look!!! Tintypes. Cheap. Beautiful. Lasting." Yet another poster board, beneath a bulletin board dis-

play of tintypes, reads, "Gents! Have Your PICTURE TAKEN with your Lady Friend. Place of Portraiture." The photograph documents how many Americans at the turn of the century were concerned about having distinguished portraits of themselves at affordable prices.[48]

Around the time Johnston began her photographic portrait work during the 1870s and 1880s, Washington, D.C., was attracting portrait photographers who wanted to manage their own private studios. The competition for commissions was fierce. The city was becoming more metropolitan, creating a new market, for example, as congressmen became willing to move their families into the city for winter congressional sessions. Photographers also came to Washington hoping to find employment with the government. Of the total number of photographers listed in the capital in the 1870s, sixty-one of about three hundred forty were recorded in the city directories as government employees.[49]

Being a permanent Washington resident was essential for Johnston's commercial and aesthetic success as a photographer of people and events. Government departments requiring the service of photographers included the Army Medical Museum, the Treasury Department, the United States Geological Survey, and the Smithsonian Institution, where Johnston received her photographic training and early commissions through Thomas Smillie.[50]

Above all, Johnston's holistic approach to portraiture made her extremely popular. "Studio portraiture was almost an accident with Miss Johnston," recorded one of her contemporaries. "Patrons liked pictures of themselves in their homes, and asked her to make professional portraits of them."[51] A few years earlier, the "Capital Society Notes" correspondent of the *Pittsburgh Post* had complimented Johnston, widely considered the premiere woman in the business of photography in Washington, for not being too busy to take time for her friends: "Washington society, artistic and literary folk, drop in to see her latest pictures and chat." That she was a "hostess of brilliant conversational powers" was thought to be as important as her photographic work.[52]

Johnston's portraiture, with its emphasis on clarity and detail, successfully met the demands of a popular market in Washington and was frequently published in magazines and newspapers. In Johnston's widely published portrait of Alice Roosevelt in 1905, for example, the young lady is featured

at full length looking majestic and dignified in a satin evening gown, not unlike a celebrity in a fashion magazine today.

Johnston's portraits also show that she was acutely aware of the process of making American history. A clipping that Johnston kept of an 1882 review written by I. Edwards Clarke in the *Washington Post* concerning a book entitled *Original Portraits of Washington* written by Johnston's aunt, Miss Elizabeth Bryant Johnston, helps to explain Johnston's own concerns about the portrayal of those living in the nation's capital.[53] She seems to have understood the words of General James A. Garfield to whom the book was dedicated: "Washington reverses the role of perspective in history for the farther one recedes the nobler and grander does his figure become!"[54] As chronicles of a contemporary city, Johnston's portraits appear to have been an effort to chart the unique growth of Washington, D.C. For example, she showed some people close-up, such as the daughter of Secretary of State John Hay in front of a door. Other times, she showed people at a distance, such as the secretary himself behind his desk holding papers, with a portrait of Lincoln on the wall at his back. In both these photographs Johnston portrays the subjects as members of prominent families and busy administrators.

Johnston's other portraits of prominent Americans, such as those published in *Cosmopolitan* of members of President Harrison's administration in their offices,[55] also display proof of the subjects' industry and public service. Unlike the men Thomas Eakins painted engaged in physical labor, those photographed by Johnston face the camera, temporarily suspended from their work as they sit behind desks piled with papers and surrounded by their private libraries. Johnston's portrait of Booker T. Washington taken at the turn of the century, for example, resembles these earlier interior portraits (figure 2). Sitting at his desk, he holds a pen. On his desktop are scattered papers and a vase of roses. Light falls prominently on the top of his desk, along one side of his head and hand, catching a part of his wooden chair. The similarity of Washington's gesture and setting to those of the Harrison's administration members acknowledges him as yet another distinguished government official.[56]

Johnston's documentation of Booker T. Washington and of other administrators presents formal portraits of men without describing their political beliefs or personal lives.[57] Johnston's portraits were often used by newspa-

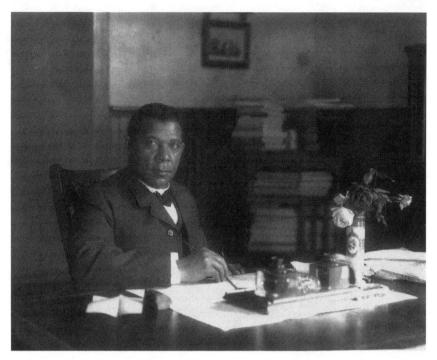

FIGURE 2. Booker T. Washington, 1906

pers and magazines to cultivate interest in current events and governmental actions behind the scenes. Helen Demorest, of *McClure's Magazine*, for instance, asked Johnston to take photographs of government employees' wives in their apartments as Johnston had previously shown their husbands, thus, in a sense, opening up their homes to the public in a formal way. E. P. Brown, manager of the publicity department for *Sun and Shade Magazine*, requested portraits of first ladies in 1895.

Bain News Service

Toward the end of 1890, Johnston would become professionally connected with George Grantham Bain, which marked another important step in her career. In New York, Bain founded Bain News Service, also known as Bain's Correspondence Bureau, the first photographic news service or

news picture agency in the United States. The syndicate furnished articles and photographs from Washington, D.C., to approximately fifteen newspapers including the *New York Sun, Philadelphia Times,* and *Kansas City Times.* Starting slowly with only a few papers, Bain expanded his business throughout the 1890s, which was the period of his association with Johnston. He collaborated with Johnston in 1890 on a series of articles for *Cosmopolitan* magazine, and in 1893 had an exchange of correspondence with her over a number of publication ideas. By this period he was acting essentially as an agent for Johnston and a number of other emerging photographers. Johnston would work with Bain until around 1910. As a result, Bain would be an important collaborator in her earlier work, both commissioning photographs and selecting examples to send to the press.[58]

Johnston's photographs, letters, and other documents reveal that she was extremely busy completing numerous freelance projects throughout the 1890s. The nature of her projects varied, but it was necessary for her to travel within the United States and occasionally to Europe to complete assignments and more speculative ventures. While Johnston's work provided her with an income, she tried to direct her projects from her own perspective. Though much of her actual business derived from portraits of Washington society, she also was involved in a journalistic environment at odds with the political establishment she portrayed. As a result, her photographs and photographic essays begin to suggest during this period a broader social agenda. Johnston was part of a political and social establishment that valued activism. Her family supported such an approach to life as well. But as a businesswoman, she was careful to balance her journalistic photography with paying customers. During her career, she knew and photographed five successive presidents: Grover Cleveland, Benjamin Harrison, William McKinley, Theodore Roosevelt, and William Howard Taft. President Cleveland's wife was also a distant relative, suggesting something of Johnston's social status. She was aware that through her family connections she had access to high government officials. Her portraiture of these clients appealed to magazine editors who published her work. She was a favored child of the Washington establishment, but as with other reformers of her period, including patrons such as Theodore Roosevelt, she also was a staunch advocate of political activism and social consciousness.

Turning to the News

Establishing a traditional career in portraiture early in her professional life, Johnston used her contacts to develop an occupation in news-documentary photography that continued to evolve throughout her life. News photography, unlike portraiture, was a new field of work. Hence, Johnston was able to help define the nature of American news photography at its inception. Inspired in part by her mother, Frances Antoinette Johnston, who had been a pioneering newspaper correspondent,[59] Johnston brought innovation to both news photography and portraiture by valuing subject matter more than pure style and using accompanying text to effectively explain each photograph. While Johnston's coverage of people and events was often the result of assignments, directed by news service manager George Grantham Bain, magazine editors, and others, she ultimately decided what to write and how to photograph her subjects.

Johnston often took advantage of sensational moments to publicize her photography. For example, she took an aggressive tack with her photograph of President McKinley, stressing the fact that it was the last photograph made of McKinley taken just seventeen minutes before he was shot at the 1901 Pan-American Exposition in Buffalo, New York. She sold the photograph to newspapers for the then unprecedented fee of fifteen dollars and apparently insisted that she receive printed credit for the photograph. Johnston received so much publicity for the McKinley photograph that the Kodak Company wanted to use it for advertising purposes, noting that for the photograph she had used a "Number 4 Bulls Eye Special" Kodak camera and Kodak transparent film. The offer was dropped, perhaps fortunately for Johnston's reputation as an artist, after further negotiations with Eastman over the use of the negative.[60]

As a news correspondent, Johnston was able to make advances for other women in the field, an endeavor of which she was fully and outspokenly conscious. While in Washington, she helped organize the Women's Professional Business Club to make contacts, publicize her work, and inspire other women photographers to work together to advance their careers as well as "to bring business women together to afford relaxation to tired brains and hands."[61] Members, women with incomes between $1,500 and $10,000, met at 606 11th Street, and Johnston's photographs of the World's

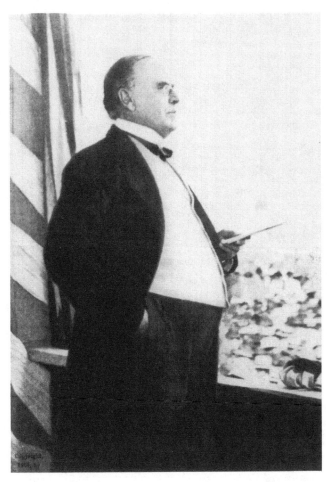

FIGURE 3. McKinley, the Buffalo Pose, 1907

Fair were exhibited at their inaugural meeting on January 20, 1894. Only six days afterward, she made news by securing permission from the Committee on Rules of the Senate to take photographs inside the Senate chamber.[62]

Johnston maneuvered as quickly for news photography opportunities as she had for her studio portraiture in order to create publicity for herself. She intercepted Admiral Dewey's flagship, the *Olympia*, at Naples upon his return in 1899 from the Battle of Manila in the Philippines. On board she took 107 photographs of the admiral and his crew, depicting them off duty on the ship, relaxing, and entertaining themselves, sometimes in a light-hearted, self-mocking way. Her photographs were published in the

September 1899 issue of *Harper's Weekly* and in two consecutive issues of *Collier's Weekly*.[63] *McClure's Magazine* reporter and friend Ida Tarbell wrote to Johnston,

> I have been chuckling all summer over the bits that have reached me. It was beautiful the way you opened up the Admiral to the illustrated press of the country. You ought to charge every illustrated journal in America a commission.[64]

Tarbell recognized that the informal depictions of Admiral Dewey and his crew were at odds with the troop's military duties, and it is probable that Johnston understood Tarbell's amusement. However, Johnston publicly would say that her shots aboard the *Olympia* were "the only ones history has of the signing of the peace protocol with Spain."[65] The end of the war, and business, mattered most.

The signing of the peace protocol was indeed one of the most prized photographs in the series. It became the basis of Theobald Chartran's painting of the historic moment, and Johnston was paid $200 for the first print. Made famous through repeated publication in newspapers and magazines, this portrait of Dewey became in great demand. Veerhoff's Galleries in Washington asked for a dozen copies at $1 each. Lothrop Publishing Company used Johnston's portrait of Dewey in what was then the standard biography of his life.[66]

Other photographs of Washington government officials, as well as of nationally recognized cultural leaders, often became the standard representations of these individuals. For example, her photograph of McKinley, commonly referred to as the "Buffalo pose," was used to make the McKinley Monument in Canton, Ohio. Her portrait of Joel Chandler Harris taken in April of 1905 was the basis for the picture of him on the cover of *Uncle Remus' Home Magazine* as well as on the Harris commemorative postage stamp issued in 1948 and the dust jacket photograph for Robert L. Wiggins's *The Life of Joel Chandler Harris*. Johnston's portraits of Susan B. Anthony, taken in 1900, were used for the Anthony calendar the next year, a forerunner of the women's liberation calendar.

Johnston's news photographs typically included portraits of important political figures, including the portraits she took of the Roosevelt family beginning in 1902. Just as her news photographs of Dewey and McKinley had

increased the sales of her studio portraits, Johnston's portraiture and news photography of the Roosevelt family also were dependent on each other. Jacob Riis, a friend of President Roosevelt, gave Johnston the assignment of taking photographs to accompany the article he wrote for the *Ladies' Home Journal* entitled "Mrs. Roosevelt and Her Children." She photographed the children at play, on walks, and caring for pets, informal renderings that contrast with her more self-conscious portraits of the family.

Johnston's news photographs frequently show a more amusing and intimate side of events, emphasizing ordinary daily routines as subject matter relevant to official actions. While she understood the importance of making news more appealing to the public through informality and immediacy, Johnston also understood the necessity of a more lasting visual statement, one that would emphasize the relevance between the American public and whatever she chose to document, whether it was a current event, a nationally prominent figure, a place, or an industry.

Early Exhibitions

During the late 1880s and into the early 1890s Johnston's work was primarily made known through publications. Many of her government commissions remained the property of the department or agency that hired her. Her portraits largely became the property of her sitters and occasionally were used for newspaper and magazine articles and sometimes books.

The first exhibition of her work was held in May 1891 at the Cosmos Club in Washington.[67] Located at 1518 H Street Northwest, the Cosmos Club was a meeting place especially for prominent Washingtonians, including businessmen and political leaders. But it had a reputation for public service, with many higher ranking scientists and government employees listed among its membership. Most of her pictures featured in the show were interior views of Washington houses as well as street views and portraits of individual buildings, some of which were also featured in her journal articles. Including these pieces in more artistically oriented exhibitions, Johnston never intended them strictly for magazines, for they consistently were a part of her artistic production. Johnston's work was well received in the exhibition. A reviewer in the *Washington Evening Star* explained that Johnston was the most successful exhibitor in the show, praising her inte-

rior views, the details of furnishings, and her genre scenes.[68] This was an important first step for Johnston because it marked a transition from the world of pure journalism to a more artistic context.

The exhibition at the Cosmos Club had been put together by the Washington-based Camera Club, an arbiter of photographic production during this period. Founded in 1883 by Johnston's friend Thomas Smillie, the club was originally called the Argents, after the silver salts used on photographic negatives. In 1887, the club was renamed to better reflect its broader purpose, which was in part to make photography more accessible to lay people for whom even the name would have been a mystery. Originally limited to a membership of twelve, the club's numbers expanded under the new name. Johnston joined as the first female member in February 1889.[69]

Smillie would remain the leading light of the Cosmos Club during the late 1880s and early 1890s. But gradually he allowed himself to retreat into the background, letting newer members, such as Johnston, play more prominent roles in steering the direction of the organization. Members met twice a month to discuss new photographic techniques and processes. They brought examples of their work and also viewed lantern slides, often chosen because members were interested in the subject matter.

The club also featured exhibitions for members. On occasion, members would travel outside Washington to take photographs, much like the plein air painters of the same period. The club kept an album of outstanding examples of members' work, to which Johnston contributed a number of photographs. Many members, including Johnston, were also associates of the contemporary Postal Camera Club. This organization maintained a kind of circulating library of photographs, volumes of which would be mailed from one member to another, so they might view the work of their peers and study new advances in photography. The work would then be discussed at meetings, both at the Postal Camera Club headquarters on Pennsylvania Avenue and at the Camera Club. Photographers such as Johnston advanced their technique and expanded their knowledge through club meetings, exchanges of photographs, publications, and, increasingly by the 1890s, exhibitions that best promoted the idea that photography was a form of art in its own right that went beyond direct representation of the subject matter. Among serious photographers, Johnston's photography was promoted and became recognized through exhibitions.[70]

Johnston's second important exhibition was held in New York City in the late spring of 1891. Sponsored by the Photographic Society of Philadelphia, the Society of Amateur Photography of New York, and the Boston Camera Club, the well-attended exhibition mounted at the Fifth Avenue Art Galleries was the fourth in a series of exhibitions that had begun in 1887 and the largest of its kind in the country. Johnston's submissions, similar to what she had exhibited at the Cosmos Club the previous year, included building interiors, mostly from her *Demorest's* sketches, some portraits, examples from her travel photography, and building exteriors. Singled out by the press, Johnston was referred by the New York newspaper the *Sun* as one of the foremost women photographers working in the country.[71]

Another artist featured in the Cosmos Club and at the 1891 New York exhibition was the well-known pictorial photographer Catherine Weed (1851–1913).[72] Like Johnston, Weed, who had been a recognized painter before turning to photography, was mentioned in the *Sun*. Johnston and Weed would have strikingly similar careers, both becoming active in photographic organizations around the same time, helping to promote photography as an artistic as well as a scientific category and establishing a place for women within the relatively new field. Weed would subsequently move to London with her husband H. Snowden Ward, a well-known writer, pictorial photographer, and editor of the influential photographic journal the *Photogram*. Johnston and Weed remained in contact and valued each other as fellow artists. Their connection underscored Johnston's rising status as an artist and the growing seriousness of her efforts.

In this regard it is important to note some of the other photographers participating in the New York exhibition: Alfred Stieglitz, H. P. Robinson, Frank M. Sutcliffe, W. H. Jackson, Charles I. Berg, and John H. Tarbell. Johnston was clearly in good company; and her participation—although she won no prize in the event—shows the regard in which she was coming to be held in this period. The judges included two of the most famous painters of the previous generation known for their western wilderness scenes: Thomas Moran (1837–1926) and Albert Bierstadt (1830–1902). Photography was becoming the new art form of what was soon to be a new century, and Johnston was among the significant contributors.[73]

Throughout the 1890s Johnston played a greater professional and organizational role in the field. In June of 1891, she represented the Washington

Camera Club at the annual Convention of Amateur Photographers, held in New York. The Washington Club was one of twenty-one clubs represented, suggesting the growing popularity of photography in the country. In 1892, Johnston was elected Second Vice President of the then newly organized American League of Photographers. The league's publication, *American Amateur Photography*, was published by the dean of photographers, Alfred Stieglitz, a figure with whom she would interact periodically.

Soon afterward, a second club, called the Capital Camera Club, was founded in Washington, with Eugene Lee Ferguson as the first director. Johnston soon became active in this organization while retaining her membership in the older club as well. Thomas Smillie, Johnston's mentor, would also remain active in both organizations, although gradually his involvement became only honorific, as newer members, such as Johnston, became more prominent.

Johnston never wanted to see herself simply as a woman photographer, though being singled out in this way was perhaps inevitable at the time. Exhibition organizers and editors encouraged the participation and contributions of women to both exhibitions and journals. H. Snowden Weed, husband of Catherine Weed, wrote to Johnston to say their journal, the *Photogram*, would "naturally take a great deal of interest in the work of women."[74] There is evidence that Johnston did not wish to be separated in this way. Her guide, Thomas Smillie, had been a leading American photographer, and she wanted to make a contribution of her own comparable to his. Her memberships, her work on behalf of organizations and exhibitions, and her own photography were all pieces in a broader ambition to make a name for herself as an American, not just a female, photographer.[75]

The World's Columbian Exposition

Johnston's work of the early 1890s was to culminate in her position as one of the principal photographers at the World's Columbian Exposition, held in Chicago in 1893. Originally planned for the previous year, the World's Columbian Exposition was the brainchild of a group of Chicago businessmen and architects who wished to showcase the growing stature of their city as well as commemorate the four-hundredth anniversary of the discovery of America. The Chicago exposition was to set new directions for American art and architecture.

After a great deal of debate, the exhibition's organizers chose Beaux Arts neoclassicism as the guiding principle for the layout and design of the exhibition grounds. The exposition was to include fountains, promenades, bridges, and a gigantic artificial lake surrounded by enormous exhibition buildings, all painted white and most decorated with columns, urns, garlands, and other elements suggestive of the ancient world. A huge statue of the Republic dominating the scene spread her arms toward the future.[76]

Johnston, enlisted to serve as one of the official chroniclers of the event as early as November 1891, traveled to Chicago and recorded the grounds of the future exposition. The World's Columbian Exposition's chief photographer was Charles Dudley Arnold. He and Johnston remained in close contact that year after an official photography division was established with Arnold in charge of it. Johnston was admitted as one of the certified photographers in an exposition that was one of the first to exclude those who were not selected. It is clear from their correspondence that Arnold was fond of Johnston and that the two became friends as a result of the experience.

Johnston traveled to Chicago again in 1892, this time to record the construction of the temporary plaster exposition buildings. A year later, an article was published in *Demorest's Family Magazine*, one of a series on the exposition buildings written and illustrated by Johnston. During the exposition, Johnston traveled again to Chicago to take photographs of the fair itself. Accompanying Johnston as part of a three-person team were Thomas Smillie and Henry Harris. Among them, the team made a total of over 730 photographic negatives, in both large and smaller formats (20 x 24 inches to 8 x 10 inches and 11 x 14 inches). She would later show her contributions at a Capital Camera Club in 1894. Johnston's views of the exposition buildings were among the hits of the show, where more than four hundred platinum and silver prints were presented. The *Washington News* later called it "among the best of the many efforts to reproduce the White City on paper."[77]

The World's Columbian Exposition did much to promote Johnston's career. It had been a singular honor to be accepted as an official photographer. Her photographs were widely recognized as among the best taken at the fair. Only through Alfred Stieglitz's pressure on the organizing committee did other photographers have an opportunity to contribute, too. For example, William Henry Jackson (1843–1942), well known for his images

of western landscapes, would finally take the official closing photographs only after Stieglitz and other photographers protested that he should be included. Johnston's, Smillie's, and Harris's photographs were the other official records of this event. In recognition of her contributions, Johnston accepted a Diploma of Honorable Mention, an award made by Virginia C. Meredith, chairperson and the exposition's "Lady Manager" in 1895.[78]

Johnston's association with the World's Columbian Exposition also underscored the tenor of her growing commitment to architecture as a subject for her work. Buildings and architecture figuring prominently in her work included houses of Washington, D.C., luminaries, interiors of public buildings and ornate houses, and educational institutions such as the Naval Academy. At times, her numerous opportunities to photograph buildings were due to rebuilding within the city. In keeping with American imperialist ambitions, manifested in the Philippines, Hawaii, Panama, and the Caribbean, neoclassical vocabulary was becoming the standard for public buildings. Particularly from the late 1870s to 1914, neoclassicism signified renewed self-confidence that the United States was indeed a civilization that had come of age and was the heir to Greek democracy, Roman law, and Renaissance humanism. The neoclassical dream presented at the World's Columbian Exposition set the tone for the end of the century—a dream that Johnston captured in her photographs of the event.

Johnston's Early Architectural Photographs: An Assessment

Johnston in 1893 was far from being an architectural photographer as is understood today. The appellation had yet to be invented, and while some photographers had begun to specialize in scenes of houses, streets, and buildings, generally, a separate profession of architectural photography had yet to emerge. Johnston herself would help delineate the rules, vocabulary, and aesthetic values of the genre. In terms of historic buildings she would act as a true pioneer, helping to define the medium of architectural recording, much as photographers such as Eugene Atget (1857–1927), Thomas Annan (1829–87), Henry Dixon (1820–93), and Charles Marville (1816–80) had initiated the effort to document older buildings in England and France.

Still, Johnston's photographic production during the early 1890s points clearly to her later specialization and commitment. Many of her earliest

sketches for *Demorest's Family Magazine* featured photographs of building exteriors and interiors. In a manner, she came to equate buildings with their owners—to show how a person's surroundings both helped define his or her personality and also reflected his or her inner character. Buildings, for Johnston, were becoming not merely objects but something lifelike and animated.

Johnston's early photographs also demonstrate her growing competency as a photographer. Her interior and exterior views were often quite difficult to obtain and required an ability to judge varying lighting conditions, problems of perspective, and depth of field. Her photographs are clear and precise and show a profound technical competency, especially for someone relatively new at the profession. Her interior views, such as those of Vice-President Morton's residence, suggest a creative and innovative approach to capturing the maximum amount of detail and information. In one photograph, Johnston frames her view through doorways, the rooms telescoping beyond, but with consistent clarity. Besides photographs showing hallways and vistas, her room views are taken from the corners of rooms, using wide-angle lenses, for which she corrects distortion. Often, she captures three of four walls, furniture, pictures, bric-a-brac, all the paraphernalia of late nineteenth-century upper-class households, in great and precise detail. In this way, she helps the viewer to understand the sequence of rooms and the movement within space.[79]

Johnston also shares her vast knowledge of architecture and architectural styles. This is evident especially in her treatment of the Hearst residence in Washington described by Johnston as "an impressive structure of red brick relieved by a handsome decoration of brownstone, carrying here and there gracefully carved designs in relief."[80] The attributes of different styles are reflected in her photographic treatments such as the massiveness of the Romanesque Revival building. The textured surface of the exterior, the coarsely faced stone, is brought out by harsh, natural light. The high relief of the tiled roof is similarly emphasized by means of lighting. Materials have been brought to life in this way. The viewer understands the distinguishing features of the architecture. In turn, these qualities become associated with the building's owner. The qualities of stability, strength, and honesty, for instance, are attributed to Hearst's own character.

Equating buildings with personalities, especially those of their owners,

FIGURE 4. Hearst Home, Washington, D.C., 1890

became typical of Johnston's work. She explained that buildings themselves had their own identities. Hearst's mansion suggests strength and stature; Morton's refinement, sophistication, and taste. The John R. Wanamaker house, with its profusion of decorative additions, epitomizes both the source of the owner's fortune, a Philadelphia department store, and his personal eccentricities.[81] This playful association of buildings and people would continue in Johnston's late work, especially her later portraits of historic houses and public buildings. When people were absent, Johnston used buildings to evoke a sort of personification long departed, so that a human presence still exists through the historic structures.

Johnston's early work also set the standard for her later, more scholarly studies of historic architecture. The written text was critical to Johnston's journalistic work. When she turned to photographs of historic buildings, text would remain a central aspect of her work. For Johnston the two parts of the creative work remained inseparable.

The first of her photography to concentrate on a historic building was her extensive treatment of the White House. This project began as one of

CHAPTER 2

her *Demorest's* sketches but developed over the years into her first published monograph on a single subject. Here again text and photographs merged to tell a simple story. Her White House photographs set the strategy for her later documentary work: to show clear, unobstructed views of each façade; a careful catalog of rooms, corridors, and decorative elements as well as furniture, pictures, and other more ephemeral features of a building. As with her later photographs of southern mansions, Johnston takes pains to show the urban and landscaped settings of her subject. Long expansive views captured by her large format camera illuminate the detail of the cobblestone street at the north entrance and also the shadows cast by the stylized floral ornamentation of the column capitals with clarity and emphasis. On the south side she shows the building portico facing the mall and the gardens across from the elliptical portico. All of this underlines her appreciation of architectural detail as well as her understanding of the building's place in a larger setting.

A good way to understand the depth of Johnston's knowledge and skill at this point in her career is to compare her photographs with those of her contemporaries. Charles Dudley Arnold's overall influence on Johnston can be seen when comparing his large format, platinum prints of the World's Columbian Exposition buildings and views with hers. Both bring out an

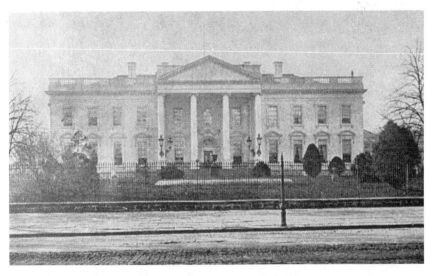

FIGURE 5. White House, north front, 1893

Professional Development and Early Work 47

immense amount of clearly identifiable architectural detail within pictur-esque symmetrical compositions. Johnston, like Arnold, appreciated the wide range of gray tones made possible by platinum prints. Platinum paper, considered the most delicate and expensive of printing materials, allowed for the reproduction of the brilliant light on the surfaces of buildings and grounds. Both photographers appreciated the large size of their photo-graphs because it invoked a sense of awe and grandeur. Few if any people are pictured, always anonymously, on the relatively uncluttered grounds to emphasize the monumental scale of the buildings. Both Johnston and Arnold moved their cameras back for more expansive views. To emphasize spatial depth, both used waterways and paths as diagonals, directional cues leading the eye of the viewer from one structure to another.

Johnston's views of the World's Columbian Exposition say much about the sensitivity and sophistication of her work. Arnold's view of the "Basin Seen from [the] Peristyle" shows the Administration Building and the one-hundred-foot-tall Statue of the Republic in front of it. Without any ap-parent effort made to frame the view, both objects, despite their distance from one another, stand in equal clarity, the statue overlapping the larger building so that part of it is not visible. Johnston, on the other hand, takes her photograph from a slightly different angle, moving the statue to the side slightly. As a result, the Administration Building assumes its proper prominence with the statue of the Republic clearly in the foreground, in a sense, looking toward the larger, more central structure.

Johnston also places the architectural subjects beneath a dome-like sky so that the airy background imparts a sense of grandeur to the scene, a quality of timelessness that matches the intention of the formal, classical style. While Arnold's suggests a stage set with buildings flattened by the loss of depth and perspective, the two structures featured in Johnston's version of the scene, seen in relation to one another in detail, are not so far apart. There is more dramatic tension between them, framed below a huge and serene expanse of sky. Although Arnold's photograph depicts more build-ings, all have equal secondary stature along the edges of the composition, oddly framing water, the most prominent feature, which contributes an overabundance of space. Johnston, in turn, was beginning to show her tal-ent—stepping beyond her early teachers—in the way she keeps her focus amid an aesthetically pleasing setting. This was truly a remarkable achieve-

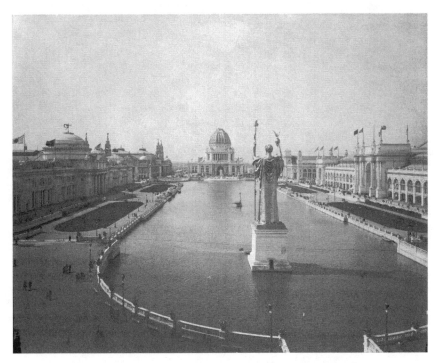

FIGURE 6. World Columbian Exposition (Dudley Arnold)

ment for a young woman, then only twenty-nine years old, embarking on a new career in a field still lacking clear rules and boundaries. By the early 1890s she had made her mark as a prominent young photographer, mastering the techniques of an enterprise that was both a science and an art. She had demonstrated some of her growing interests: history, prominent figures in the nation, and, especially, architecture, such as the White House and the buildings associated with the World's Columbian Exposition.

Over the next four years, she would further develop her talents and interests. These would include architecture but also portraits, the depiction of social problems, landscapes, and important events in American history. It was during this period too that she would better define the direction of her work and test her talents in the arena of the emerging photographic establishment. She won first prize at the 1894 Cosmos Club show for her portrait of a seated, dark-haired girl in a striped dress. Her contribution also included her World's Columbian Exposition photos; "The Convalescent," a portrait of an invalid in an easy chair; and "A Serenade to Flora," a photograph that

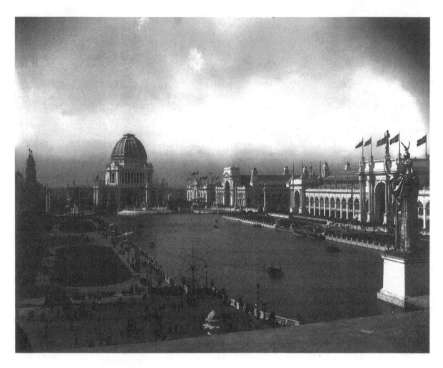

FIGURE 7. World Columbian Exposition, 1893

showed a veiled marble figure of the goddess of flowers on a pedestal. These photographic portraits already suggest an aesthetic that is ironic about the contradictions between life and art. Awards at the Cosmos Club show were given in the following branches of photography, all of which were considered to be traditional for artistic subjects: landscape, portrait, interior, and genre. Most likely, Johnston's World's Columbian Exposition photographs—which received most attention by the press—were not considered in this regard since architectural photography was not one of the categories being judged. The judges included Dr. Francis Barbarin, DeLancy Gill, and Charles Parker.[82]

The Washington Salon

By the late 1890s, Johnston was making a name for herself within the local photographic establishment. She was identified at this point as a Washington, D.C., photographer, and other Washington photographers who were recognized at this time, including E. L. Ferguson, H. G. Douglas,

Charles Richard Dodge, and a certain Mr. Fairman, were among Johnston's friends and collaborators. Their strong showing says much about the prominence of Washington-based photographers during this era, a fact often overlooked by historians of American photography, who have traditionally placed their emphasis on New York, Boston, and other northeastern photographic circles. Johnston was clearly grounded in the Washington, D.C., photographic scene of this period, and this fact has important bearing on the development of her own photographic viewpoint and intentions. She was not singled out as a female, but was referred to as another Washington photographer and as a member of the Capital Camera Club. This comraderie made her comfortable enough to use the aesthetics of portraiture for her photography more generally. Unlike other artists, who promoted themselves as struggling individuals, Johnston preferred to see herself as a responsible member of a professional community.

As an indication of the strong showing of Washington photographers at the 1895 annual exhibition of the Capital Camera Club, a total of five hundred to six hundred photographs were exhibited by approximately sixty-eight members. The exhibit was well received by the critics and the press, which largely praised the progress of local work as well as American photography generally for the range of technical expertise, the varied viewpoints of contributors, and the breadth of each individual's efforts. Many landscape photographers, including Johnston, also experimented with portraits and other kinds of work, and this showed in their contributions to the exhibit. Johnston's work was praised by the *Washington Post*, the *Washington Times*, and the *Pittsburgh Post*. Critics noted Johnston's platinotype of her portrait of the British ambassador, Sir Julian Pauncefote, as well as a carbon print of Miss Helen Brice, one of the daughters of an Ohio senator. Critics also praised Johnston's photograph "Bereft," which was described as a more sentimental genre photograph of a sitting figure, her head covered with drapery.[83] A reviewer for the *Washington Times* noted that it was so perfectly lit and clearly focused that it gave the entire picture an "exquisite softness, while happily suggesting the texture of the drapery fabric."[84] In addition to taking portraits for those who requested them, Johnston followed more traditional aesthetic requirements for photographs that artists could use as the basis for paintings. Models, posed and arranged in drapery, would be photographed to make a record so that subsequent sittings could be elimi-

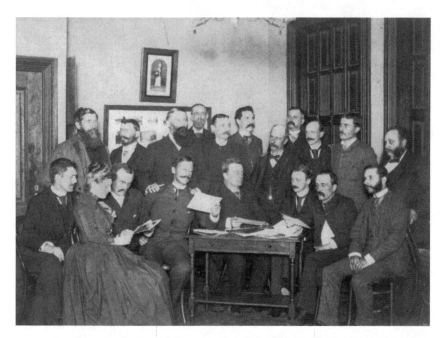

FIGURE 8. Capital Camera Club, Washington, D.C., 1895

nated or aided. Johnston noted that this kind of photography for artists was more popular in other cities, such as New York. Although there was not a large commercial demand for these drapery studies in Washington, where she worked, these and her portraiture were accepted as artistic studies of light and texture in photographic exhibitions.

Along with other photographers, Johnston attempted to strengthen local interest in photography, still working with the local camera clubs but also helping to promote a new forum, known as the Washington Salon, for discussions and exhibitions. Considered to be the first true photographic salon in the United States, the Washington Salon show was first held May 26–29, 1896. Modeled on the longtime European precedent for the display of paintings, such as the annual show of the English Royal Academy, the photographs in the salon could be seen by the general public as well as by critics. The principal organizer was Eugene Lee Ferguson, who would later become secretary of the Camera Club of New York.[85] Local photographers, including Ferguson and Johnston, hoped that a regular salon would help advance the quality of American pictorial photography.[86]

Although the first salon went well according to the press, Alfred Stieglitz,

then considered the main authority on what is now called pictorial photography, dismissed the Washington Salon because it offered prizes. Particularly in this period, Stieglitz believed that money was an obstacle for the true creative spirit. He also criticized the fact that there were few representative works from outside the United States, and that the salon had two separate categories for judging: one for those photographs thought to possess special artistic merit, and another for photographs that had merit but did not possess sufficient artistic excellence to be admitted to the Salon. Stieglitz felt that photography could only become recognized as a fine art if photographs were judged on the same high values and standards as those of the other graphic arts, a stance that Johnston and her Washington-based colleagues tended to downplay by not writing extensively about the medium of photography as art.[87]

Stieglitz, already a member of the Society of Amateur Photographers of New York, of which Johnston was also a member, helped to merge the organization in 1896 with the New York Camera Club in order to form the better financed and more powerful organization known as the Camera Club of New York. Stieglitz hoped that this new organization would be able to mount a fully international salon show to bring together the best photographs from around the world. Although this goal was never realized, some members became more enthusiastic about displaying their work, and in 1897 Stieglitz inaugurated a series of exhibitions at the Camera Club rooms, each exhibit featuring one artist.[88]

Busy as a photographer, Stieglitz first wrote to Johnston from Lake George on August 22, 1896, encouraging her to send her photographs. He carefully explained the requirements of the exhibition:

I exceedingly regret having missed you again, but perhaps sooner or later the fates will be kinder to us—As for the Salon pictures, they *must* be framed, and ought not leave N.Y. later than *August 28* by Wells Fargo express. The frame maker can attend to all that for you. All you must do, give him the address and prepay expressage. . . . The entry form fill out according to instructions and send that also to the above address. I send you under separate cover another entry form in case you may have misplaced the one I sent you in Washington some weeks ago. Hoping that you will get your pictures off in time about which there ought to be no trouble, and that they will be liked on the other side.[89]

Other Exhibitions at Home and Abroad

Despite Stieglitz's micromanagement, no Johnston exhibition took place at the Camera Club until several years later. Late in 1896, however, Johnston exhibited a number of photographs in London at the invitation of the Royal Photographic Society in a prestigious show held at the Dudley Gallery in Piccadilly. Three hundred photographs by Americans were submitted for consideration, but only nineteen passed the Society's initial review. Johnston was the only woman who exhibited her work at the show. Three of her works were exhibited, including "Mignon," a portrait of a young Georgetown girl; "Wind Swept Ledges," a view of a portion of the banks of the Potamac River; and "Pepita," which showed her friend Corinne Parker dressed, as one reviewer explained, as "a haughty-eyed girl in a wide brimmed hat, who might belong to Calabria if not of the Washington stage."[90] While the majority of Johnston's photographs remained devoted to traditionally acceptable subjects for women photographers, such as portraits and landscapes, choices like "Pepita" signified a public break with traditional images of women as either nurturing mothers or sexual objects.

This initial foray into the international arena was followed shortly by other exhibitions. Johnston participated in the Royal Photographic Society's 1897 Exhibition, this time submitting two photographs: "The Chrysanthemum Lady," a portrait of a woman; and "Fleur de Lis," a portrait of a young girl. In September of the same year, the art editor of the journal *Black and White* asked Johnston for a reproduction of "Fleur de Lis" for the front cover of a monthly issue.[91] The October 1897 issue of the *Photogram*, one of England's most prestigious photographic journals, featured Johnston's photography in a discussion of the science of photography.[92]

Both of Johnston's portraits exhibited at the 1897 Royal Photographic Society Exhibition were innovative in that they were strongly influenced by the Art Nouveau movement that was predominant from the early 1890s to the 1910s. Organic, curvilinear forms predominate in "The Chrysanthemum Lady" and "Fleur de Lis." Similarly, shadows and light combined with dark and light clothes and other objects to form bold arabesque designs that distinguish these works from the typical purely representational portrait photography of the day. The older, veiled woman in "The Chrysanthemum Lady" is pictured all in black except for a white hat, the mums she holds,

and the edges of her knuckles. The head and shoulders of the young girl holding a white iris in "Fleur de Lis" are placed in front of a large round black plate or disk. Light comes from an angle above, so that no shadows are cast behind her, further reducing her figure to a two-dimensional, decorative form. Emphasis on plants, essential to the decoration, pattern, and overall composition, enables Johnston's two portraits of women displayed in the 1897 show to become metaphors of vitality and generative power.

Camera Notes, the photographic journal conceived by Stieglitz as another way to publicly exhibit photographs exemplifying high standards of artistic excellence, began publication the same year as the Royal Photographic Society exhibit, one year after he first wrote to Johnston. In the same year, Charles I. Berg, chairman of the Camera Club of New York Print Committee, invited Johnston to exhibit her photographs along with other well-known pictorial photographers:

> Invitations are being extended to the following beside yourself . . . Mr. Ferguson, Mr. Henry Troth, Mr. W. B. Post, Mr. Alfred Clements, Miss E. F. Farnsworth, Mr. Alfred Stieglitz, Mr. R. Eickmeyer, Mr. Clarence B. Moore, Mr. F. H. Day, Miss Emile V. Clarkson, and Mr. Charles I. Berg. All expenses to shipment to and from New York will be born by the Camera Club. Will you kindly let me know as early as possible if I can count on an exhibit from you, and if so, which month do you prefer between October 1897, and April, 1898?[93]

Stieglitz was charged with making further arrangements with Johnston, and he wrote to her again in June of 1898, two months after the aforementioned exhibit ended, this time to ask her to send negatives with a print, or a reversed transparency, for an insert in *Camera Notes* as well as a few prints for halftone reproductions for any later reviews.[94]

Johnston's work finally was exhibited at the Camera Club during November of 1898, along with the work of Miss Zaida Ben-Yusuf. After Johnston was invited to exhibit her work in New York by Charles I. Berg, chairman of the Camera Club Print Committee, Stieglitz made further arrangements with Johnston, writing on June 1, 1898, to ask her to send negatives with a print or a reversed transparency for an insert in *Camera Notes*, as well as a few prints for half-tone reproductions for any later reviews.[95] The next month the photographs were in place. Stieglitz wrote on July 21,

1898: "Your work is capital, and I shall be glad to see more of it when you get to New York. I am at the Club daily."[96] Stieglitz had chosen Johnston's photograph "Gainsborough Girl" for a feature article in the photography journal, *Camera Notes*, which was used to promote photographs exemplifying high standards of artistic excellence. In this manner, Johnston was receiving recognition from the man who increasingly saw himself as both the arbiter and master of the new art photography.

In "Gainsborough Girl," the sitter appears without painted screens and artificial props.[97] Light is used for dramatic effect, a technique similar to that inspired by Johnston's predecessor, the Romantically inspired photographer, Gaspard Felix Tournachon (1820–1910) known as Nadar. Anticipating Johnston's own view of how to depict personality through the use of light, Nadar emphasized that an artist must capture how light lies on the subject's face. In communion with the sitter, the artist can size up her thoughts and her very character to produce an intimate likeness rather than "a banal portrait." Johnston grasps the personality of the sitter in the way the young woman illuminates optimism, friendliness, and charm through her open, peaceful gaze.[98]

Johnston was able to conform readily to what she perceived was the taste of her audience, and she did not adhere to any one category or style. That a variety of her work was well received reveals that art photography had many, often contradictory meanings. For instance, most of the portraits that she submitted as entries to exhibitions could be classified as pictorial or art photography. For some of these portraits, no props or accessories were used so as to place focus directly on facial features. In "Gainsborough Girl" the sitter is not wearing classical garb or depicted as a nude, as was common at this time for pictorial photographs of women. The face is mostly in shadow, with highlights only on one side of the neck, cheek, and nose. The outline of the head blurs into the dark background. Neither is her hat discernible except for a few curved lines of light. While the hat hints that the sitter is an affluent member of modern society, detail here is clearly subordinated to rendering a more generalized impression of character. Little information is given about the context of the sitter, such as where she is from, what she does for a living, or what she hopes to accomplish during her lifetime. What matters most is how the sitter appears relaxed and natural, without gimmickry.

FIGURE 9. Gainsborough Girl, 1898

Johnston believed that when sitters were relaxed their essences could be seen: "Watch them, and help them into poses that are natural and graceful. Study their individuality, striving to keep the likeness and yet endeavoring to show them at their best . . . try to make the interest in the picture center upon that which is most effective in your sitter."[99]

Stieglitz himself believed that Americans would learn best about the ar-

tistic value of photography through the establishment of an international photographic salon to be held in New York. As visionary leader, he was ready to direct the challenges of a movement that strove to enhance the status of photography as art worldwide. After a number of prominent members of the Camera Club of New York became less enthusiastic about organizing such an international salon, Stieglitz, working with members of the Photographic Society of Philadelphia, contributed to the development of the Philadelphia salon movement. The Photographic Society of Philadelphia, spearheaded by Robert S. Redfield and John G. Bullock, advertised in 1898 for an exhibition purely on artistic lines, such as those envisioned by Stieglitz and the Linked Ring, an international society of artistic photographers established in London six years earlier by Henry Peach Robinson, Frank Sutcliffe, Frederich Evans, Paul Martin, and Alfred Stieglitz, all of whom seceded from the Royal Photographic Society.

Held from October 24 to November 17, 1898, the first Philadelphia Photographic Salon, considered to be the second salon ever to take place in the United States following the Washington Salon of 1896, was to be a significant exhibit in the development of art photography, and again Johnston played a central role. Attended by over 13,000 people, the 1898 salon was held at the Pennsylvania Academy of the Fine Arts, the city's premier art school. The jury consisted of three painters and two photographers, with Stieglitz as one of the photographers. Johnston entered her photograph "Gainsborough Girl" among several other unrelated photographs.[100]

A favorable review written by William M. Murray praised the work's artistic merit. Murray appreciated the lack of detail and considered "Gainsborough Girl" the best of several portrayals of the same youthful model:

with various studio devices for creating a fanciful interest, such as posing against placques or crowned with the large hats of the period. . . . But it is in the portraiture, pure and simple, that Miss Johnston's talent is most happily displayed; and it is to her credit as an artist that, practicing her own individuality so well, where there must be considerable temptation to yield to the prevalent demand for portraits of expensive costumes and luxurious accessories rather than characteristic pictures of men and women. In certain examples of her exhibit, may be seen a slight concession to fashion in the brilliant contrasts of a showy print accentuating the

adornments of some society belle; but as a rule, Miss Johnston paints her portraits in quiet and subdued tones, and while presenting the principal features in her compositions with due appreciation of artistic values, leaves a comfortable impression on the beholder by her apparent possession of large reserve force.[101]

Murray judged Johnston's art photograph favorably by contemporary standards of pictorial photography. He appreciated the lack of sharp focus in Johnston's photograph so that it resembled an Impressionist painting more than a snapshot. The photograph emphasized more generalized aspects of portraiture: the universal traits epitomized by the facial expression of the sitter, features that transcended time.

The forthright optimism, beauty, and vitality of the youthful face in Johnston's "Gainsborough Girl" epitomized Stieglitz's scheme for promoting photography as art. Johnston admitted that she drew inspiration from Rembrandt (1606–69) and eighteenth-century portraiture, particularly that of Joshua Reynolds (1723–92), George Romney (1734–1802), and most of all, Thomas Gainsborough (1727–88), hence the title "Gainsborough Girl" rather than the name of the sitter.[102] She shared Gainsborough's emphasis on observing nature rather than following a formal application of rules.

Murray appreciated how Johnston expressed herself through the sitter. He called attention to Johnston's naturalness and individuality. Johnston was also praised in the *Philadelphia Times* as "the clever photographer, whose camera reflects the facial lineaments of the members of Washington's official circles, and adds to the strength and attractiveness of the effective display made by women at this salon."[103] Other women photographers represented at the salon included Laura Gerdell, Elizabeth MacDowell, Virginia Sharp, and M. Louise Wood, all from Philadelphia, Gertrude Kasebier of New York, and Sarah J. Eddy of Providence.

Women, Johnston, and the Pictorial Photograph

Women were generally mentioned as a distinct category at exhibitions, and Johnston was counted as one of the new generation of female photographers emerging at this time. By the 1880s, women were entering the profession in greater numbers as opportunities for training and employment

increased. Many of these women were attracted through American pictorial photography. For example, in Fred Holland Day's 1900 show of American pictorial photographs in London, half of the photographers were women.[104] Some of the most successful women photographers, such as Catherine Weed and Sarah Jane Eddy, were well-trained painters before they became photographers. They, like Johnston, were also from privileged social backgrounds and had technical expertise as camera club members. However, as art historian Naomi Rosenblum has pointed out, the photographs of American photographers influenced by the pictorial movement generally represented the work of men and women from a wider spectrum of socioeconomic conditions and aesthetic interpretation than those of European art photographers.[105]

Photography had long been seen as a logical artistic activity for women, and some of the first significant artistic photographers were women, such as Julia Margaret Cameron (1815–79) and Lady Clementina Hawarden (1822–65). The place of women in photography was noted in Johnston's time as well. While the notion of a feminist aesthetic was not yet current, special recognition for the tenets and sensibilities of woman photographers was becoming increasingly common although Johnston was already receiving widespread acclaim for her work by the time of the Philadelphia salon. Other photographers whose work was on display included Gertrude Kasebier, who had a fashionable studio in New York and was considered among the best known of late nineteenth-century and early twentieth-century portrait and art photographers. Other important female portrait and art photographers included Broughton, Mary Deven, Emma Farnsworth, Clara Sipprell, Eva Watson-Schutze, Mathilde Weil, and Louise Deshong Woodbridge. The most notable women photographers were interested in art photography. More than their male counterparts on the whole, they had studied art and had worked as painters and graphic artists before turning to photography. Amelia Van Buren of Detroit, a student and friend of Thomas Eakins, wrote to Johnston in 1900 that she wished her photographs would resemble the portraits of painters:

> I hope to make portraits to stand with Sargent and Watts and the other masters but as I expect to follow that hope all my life without ever overtaking it, it is not as bad as it sounds.[106]

Speaking modestly about her accomplishments and talents, Van Buren confided to Johnston about her ambition to be a famous artist.

Johnston was tied officially and publicly to the rising school of art photography, yet she contributed little in terms of published criticism to the ongoing debate on the aesthetics of photography, a debate that became increasingly heated toward the end of the century. She contributed in a more concrete way through submission of her photographs for display in exhibitions and publications. Increasingly, her work was oriented toward England, which at the time was the center of much of the new artistic photography movement and less entangled in the increasingly esoteric arguments of the struggling American art photographers. In November of 1898, the same month in which she had exhibited her work in Philadelphia, Johnston submitted several of her works to a photographic exhibition promoted by the Yorkshire Affiliated Photographic Societies at the Bradford City Art Gallery. The main object of the exhibit was to show what the jurors of the Yorkshire Affiliated Photograph Societies considered purely artistic photographs. However, contributors demonstrated more attention to technical attributes, such as the inventive use of framing and new types of photographic papers. This was contrary to the pictorialist aesthetic, which elevated the significance of stylistic issues and imagery. One hundred out of four hundred photographs submitted were hung. Contributors, in addition to Johnston, included the well-known English photographers O. G. Reijlander, H. P. Robinson, J. Craig Annan, and Frank M. Sutcliffe, all now considered major figures in English photography of the period. French photographers were well represented at the exhibit by Robert Demachy, Emile Puyo, and Maurice Bremard. Shapoor Bhedwar, an expatriate photographer from Bombay and resident in Yorkshire, also participated. Shortly afterward, Johnston submitted several of her photographs to the 1898 London Photographic Salon. Of five figure studies entered, Johnston's most-praised photograph was the one entitled "The Sphinx," clearly derived from ancient art as opposed to material showing everyday life such as the American pictorial photographers would have appreciated. Yet it was praised on similar terms, specifically for the rendering of transparency and texture in the veil thrown over the model's head. Johnston would continue to submit to shows and competitive salons, and by the end of the century she was making a name for herself in European circles.[107]

Becoming a Recognized Expert and Organizer

In the United States, Johnston became increasingly involved in the administrative side of the photographic community, serving on committees, helping to organize exhibitions, and generally contributing to the life of the photography world, especially in Washington, D.C., and nearby cities. In May of 1899, for example, she served as a member of the awards jury for the eighth annual exhibition of Washington amateur photographers sponsored by the Capital Camera Club. Other jurors included her old mentor Thomas Smillie and F. C. Messer, the well-known Washington artist. It was as if she were breaking into the administration of a largely male club through her professional involvement in prestigious and traditional artistic organizations, which were often amateur clubs as well.

In that same year, Johnston served as a juror at the Philadelphia Salon, the third salon that took place in the United States, which repeated its annual exhibition in October and November. For the first time at one of these newer forums, the jury consisted exclusively of photographers. Previously, awards had been determined by juries composed exclusively of painters or of a combination of painters and photographers. The absence of painters on the 1899 jury of the Philadelphia salon certified photography as an art, suggesting that photographers had reached a point at which they could be considered equal to more traditional painters and sculptors as judges of aesthetic material. Other jurors, along with Johnston, included Henry Troth, Gertrude Kasebier, F. Holland Day, and Clarence H. White, all of whom were affiliated officially with the pictorialist photographic movement spearheaded by Stieglitz. Stieglitz, however, did not approve of Johnston's participation. He wrote to Fred Holland Day in March of 1899:

> I like you as a juror—but Miss Johnston! And even Troth. Why not Day to represent the East, Kasebier the Middle States, and White the West? Of course, that would leave Philadelphia out, which would be a good thing for obvious reasons.[108]

Stieglitz was distancing himself from Johnston because she relied on her photography for commercial success. Furthermore, she did not adhere to pictorialist standards the same way others did. She wanted artistic validation from Stieglitz as head of the art photography establishment, but she would not conform to a single standard.

Johnston's work, nonetheless, was exhibited in the Salon as well. Among her more important contributions that year was "The Critic" (figure 10). This interpretive portrait of Miss Julia Marlowe, an actress whom Johnston knew, was described by one reviewer as one of Johnston's best photographs from a purely artistic standpoint.[109] Ironically, the actor is portrayed as a critic, dressed in classically inspired garb, viewing a painting by Botticelli, which rests on an easel. Through the image of the sitter posing as an art object simultaneously contemplating art, Johnston illustrates how art transforms the viewer. This portrait suggests the way Johnston, aware of the arbitrary limitations being set by infighting within the art photography establishment, separated herself artistically from other pictorial photographers to experience art more directly.[110] Walter P. Stokes of the Photographic Society of Philadelphia relayed something of his reaction to Johnston's photographs as they were first hung at the salon. As he wrote to her that summer: "Your beautiful exhibit is now on the walls of our society and it is being very much appreciated."[111]

Johnston received a check for $8.50 on November 21, 1899, as payment for the copy of "The Critic" sold at the show. As a professional photographer this may have seemed for Johnston the highest form of praise. She may have felt validated because she was a woman and as such not necessarily expected to succeed, or because she was an artist and not necessarily expected to sell her work. In any case, she frequently commented on the pleasure that such sales gave her both as a continuation of her growing professional status and as income for her business. It was, in a modern sense, validating. However, she was far from mercenary, a sore subject for pictorial photographers, and indeed she frequently showed great generosity. Shortly after selling a copy of "The Critic," she gave another copy to fellow photographer and exhibition organizer Robert Redfield for his private photographic collection. Surprisingly, Redfield had to write to her shortly afterward to admit losing Johnston's gift and ask her to send him another copy in exchange for some of his own work. As always in these earlier years, business was bound up with professional fellowship and mutual support.[112]

Johnston's Place in Pictorial Photography Worldwide

To provide a more accurate picture of where Johnston fit into the photographic community at this time, it is worth considering the content of

exhibitions such as that held in Philadelphia in 1899. At this salon, 962 photographs were submitted, of which 182 were accepted—with Johnston's photograph among them. Of the exhibited works, 168 were submitted by the five jurors and by invited European photographers. Thus, Johnston's photograph represented one of the fourteen American works that were displayed. Members of the Linked Ring, the leading European group of pictorial photographers, were among the Europeans who had been invited to show their work. One of the organizers mentioned above, Robert Redfield, rightly believed that if members of the Linked Ring were invited to exhibit without prior submission to the jury, they would be more apt to submit their pictures.[113] The ruse worked and several Linked Ring photographers did send works for the show. This helped set a tone of what was to be perhaps one of the first major salons dominated by pictorial photographers. Viewed with modern hindsight, the Philadelphia exhibition that year included virtually all of the now better-known European pictorialists. The show was widely attended and was recognized at the time as something truly different and important. American photographers were being recognized at the same prestigious level as European photographers, which validated their work as art more clearly than ever, and Johnston was included.[114]

At the same time, recognition of American photographers at this show was limited to a handful. Architect, photographer, and garden club member Charles I. Berg wrote gratefully to Johnston from New York on October 14, 1899, to say that "Through you I am today in receipt of a number of invitations for the Photographic Salon. I thank you."[115] But he also lamented that he had not sent anything to Philadelphia that year. Interestingly, the American newcomer who received the most attention at the show was Eduard J. Steichen, who along with Stieglitz would be active in promoting photography as art in America and who is now considered among the most significant American photographers of the early twentieth century.

The Paris Exhibition

Johnston was not active in the 1900 Philadelphia Salon, which Redfield helped to organize, nor did she participate in the Chicago Photographic Salon that year, though she was invited to participate in both. Her excuse was that she was preparing her work for the 1900 Paris Exposition, where

FIGURE 10. The Critic, 1899

she would be expected to contribute more extensively as the sole organizer of an exhibition on the work of American female photographers—which ironically did not include her own photography—as well as a separate exhibition of her own photographs of schools as part of the Exposition's American Negro photography exhibit. By focusing her attention on these efforts and on the Paris audience, Johnston was turning away from the rigorous standards of the pictorial movement in favor of what promised to be more individual artistic recognition and international publicity and prestige.[116]

Johnston's involvement with the Paris Exposition, dating back to the latter part of 1899 or at least early 1900, grew out of her correspondence with Mrs. Charles (Ellen) Henrotin, then representing the United States Commission. She asked Johnston to supply her with a list of names of American women photographers as well as with ideas for exhibitions. Shortly afterward, Johnston eagerly accepted her invitation to be one of four American delegates to the International Photographic Congress that would be held in conjunction with the Paris Exposition. Johnston was given six weeks to prepare her speech. L. C. Beatrice Tonneson, another professional photographer from Chicago, was also invited to be a delegate and speaker, but the death of Tonneson's mother prevented her from attending. As a result, Johnston would be the only woman delegate at the Congress.[117]

In response to Mrs. Henrotin's request, Johnston wrote down the names of seventeen women. Her list was derived from a circular that she had produced, canvassing the opinions of a number of leading photographers who in turn gave her the names of a number of other photographers. Among those answering her inquiry were the photographer Henry Troth, who sent several names, and Alfred Stieglitz, who was less forthcoming but who was pleased with the results she had already obtained. He wrote from Lake George in June of 1900 that "the list of women photographers you sent me is complete and I can think of no one that you may have overlooked. I'd certainly ask them all."[118]

Further discussions among the organizers of the American Exhibit led to the decision that Johnston would prepare the submission as well as give a speech in French about the work of American women in photography. Traveling to France in June, she quickly supervised the installation of the American Exhibit. The exhibit included works by a number of both well-

known and now lesser known photographers. Among them were Frances Stebbins Allen and Mary Electa Allen, Alice Austin, Mary A. Bartlett, Zaida Ben-Yusuf, Rose Clark, Elizabeth Flint Wade, Sarah Jane Eddy, Fannie L. Elton, Emma Justine Farnsworth, Floride Green, Gertrude Stanton Kasebier, Edith Haggin Lounsbery, Mary F. C. Paschall, Annie K. Pilsbury, Virginia Prall, Addie Kilburn Robinson, Mary F. S. Schaffer, Sarah Choate Sears, Emily Selby, Virginia Sharp, Alta Belle Sniff, Amelia C. Van Buren, Eva Gamble Walborn, Eva Lawrence Watson-Schutze, Mathilde Weil, Myra Albert Wiggins, and Mabel Osgood Wright.[119] Johnston took with her to Paris 142 photographs representing the work of twenty-eight women.[120] Their exhibition, which represented a small sample rather than the whole work of any one artist, was a culmination of Johnston's well-organized administrative efforts. Furthermore, Johnston's own work was not shown in the collection of American women photographers at the International Photographic Congress. Instead, her views of the Hampton Institute and Washington, D.C., schools were on display as part of the separate Negro Exhibit.[121]

Johnston's involvement with the American female photographic exhibition showed her willingness to separate personal ambiguities from the task at hand to help her professional career. Isolating her work from that of her female colleagues was a way to define herself as an artist and photographer. She did not want to be seen simply as an American woman photographer, although she had previously been distinguished as one. Her gradual aloofness from the American pictorial movement had already given an indication of her reluctance to limit herself and her work in this way, especially since her documentary photography was not conventionally pictorial. Some of the women photographers she featured in the exhibition mentioned that they did not wish to be known as women photographers, so that Johnston's inclusion of their work seems contrary to their wishes. It is not entirely clear why she would insist on the inclusion of their work and not her own. Nonetheless, Johnston's American female photographic exhibit expressed her desire to show the work of artists whom she realized were worthy of recognition. The association of the lesser known photographers with more established photographers such as Eva Watson-Schutze and Gertrude Kasebier would cause the work of more women to be noticed and to be regarded more prestigiously as art. Also, the exhibition gave the

more established photographers who participated a new opportunity to publicize their work, and in this new context their images might have new meaning as well.

At the simultaneously convened International Photographic Congress, Johnston's collection was arranged in a case and initially unveiled in her absence at the first official meeting of the international body. Subsequently, she gave a speech at the second official meeting as part of a program in which her photographic series was presented. One of the Russian delegates then arranged for Johnston's collection to be exhibited in St. Petersburg and Moscow in special shows held in the autumn of 1900. In turn, the exhibit of American women photographers arranged by Johnston went to the Photo-Club of Paris in January of 1901 for a second Parisian showing.[122] Thus, the initial distinction between Johnston's work and those of the other American women photographers was maintained as they were displayed later.

Educational Institutions and the Hampton Institute Project

While relatively less well known than her other work today, Johnston's photographic survey of Washington, D.C., public schools, a collection of 350 photographs, deserves recognition as one of Johnston's most significant photo-documentary series. It was completed in 1899, or one year before the Hampton Institute project, the documentary series that gave Johnston a national reputation and international acclaim. In this six-week study of the Washington school system, she took pictures of every scene, producing seven hundred negatives. She agreed to use the school pictures in a series of sixteen booklets, to be called *The New Education Illustrated*. Each booklet was meant to deal with a different aspect of school curriculum. Four out of what originally was to have been sixteen completed booklets issued semi-monthly were eventually published as one volume. The philosophy of the city school system, under the fourteen-year administration of Superintendent Powell, was intended to encourage a large amount of fieldwork, whereby students would spend much of their time away from classrooms in practical activities. Johnston's photographs chronicle schoolchildren, ranging in age from kindergarten through high school, and the schools they attended. The subjects are shown at the zoo, in the Congressional Library, at the Smithsonian Institution, and also in gardens

and fields. The 1901 volume published by B. F. Johnson, who managed his own publishing company in Richmond, Virginia, was designed for administrators and teachers of public and private schools. Although it did not sell well, the photographs received critical attention as part of the exhibit displayed at the 1900 Paris Exhibition. Johnston's photographs were also important in that they led her to photography projects at other educational institutions, including the Hampton Institute in Virginia, a project undertaken in December 1899, as well as a series taken at the Carlisle Indian School in Pennsylvania, completed in 1900. Similar projects were undertaken at Tuskegee Institute, Alabama, a commission finished in 1902, and at lesser known schools modeled after Tuskegee, including those at Snow Hill and at Mt. Meigs in Alabama.[123]

The Hampton Institute photographs, while similar to Johnston's other series in subject matter and format, are the most frequently produced of her images today. Founded in 1868 by General Samuel Chapman Armstrong during the Reconstruction period, the Hampton Normal and Agricultural Institute had become a model school for preparing African American and Native American youth for citizenship and professional careers by the time Johnston was approached to consider the documentary project. General Armstrong's successor as principal, the Reverend Hollis Burke Frissell, wanted Johnston to document the progress of southern African Americans at Hampton, largely for publicity and fund-raising purposes. Johnston took 150 photographs of contemporary life, contrasting conditions at Hampton Institute with conditions elsewhere in rural Virginia, resulting in before-Hampton and after-Hampton sequences. Straightforward narratives, these photographs have a Hogarthian sense of humor, reaffirming the Progressivist values of hard work and education and serving as lessons to both black and white supporters and possibly detractors. At the same time, there seems to be an undercurrent of pervasive racism typical of the time in the way the students are lined up as specimens, similar to the Lay figures in the ethnology exhibitions Johnston would photograph for the 1901 Pan-American Exposition. Some of the more natural and provocative photographs showing children relaxing in the Virginia countryside were not used in the Hampton series.[124]

By portraying people at work, Johnston nonetheless is able to convey more information about individuals than if they were depicted in formal

studio sittings. Her Hampton photos, in particular, are successful because the people she photographs avoid racial stereotypes and misleading sentimental appearances. During the time of Johnston's commission, national debates about a standard compulsory education system focused on the use of public funds to support parochial schools and the mandatory teaching of English. Racism was pervasive in the South after Reconstruction, causing tighter immigration policies. Some Americans questioned whether integration promoted national unity or merely increased Anglo-Saxon nationalism.[125] Johnston's own position about the Hampton photographs is more ambiguous due to her own mixed Anglo-Saxon and Native American heritage, which she proudly claimed as part of her own identity while a member of the Daughters of the American Revolution.

Johnston showed that she was aware of the impossible problem of portraying Native Americans without political connotations through the uncharacteristic ponderousness of the Hampton photograph entitled "Class in American History," which implies that formal education in classroom settings comes at the expense of Native Americans. A young Native American stands in full costume next to a preserved American eagle, both on exhibit before a group of students. On the wall of the classroom is a Remington painting of the U.S. Calvary on its way to subjugate an Indian tribe. This photograph is paired with one of a modern, more acculturated Sioux. While it is not entirely clear whether the Hampton photographs as published by the Museum of Modern Art in 1966 are in the order Johnston originally intended them to be, the inclusion of both photographs documents disturbing aspects of American policies designed to integrate society.[126] While the Hampton photographs generally glorify work and progress, these two, taken together, suggest that the educational process itself perpetuates the oppression of Native Americans. Johnston's photograph of the costumed Native American, while not blatantly critical of the Native American experience, is ambiguous about the fate of this group. The ironic inclusion of the Remington painting further hints that the white race has triumphed. This photograph contrasts sharply with the dynamic composition of the other Hampton photos, which promote education through more morally uplifting, productive activity.

The other more successful photographs of the Hampton series show students engaged in practical skills. They are pictured in groups rather than as

individual portraits—learning arithmetic from a student mason, watering plants and taking notes in a greenhouse, planting seedlings in a cleared plot of land adjacent to a pine forest, making butter, learning physics by observing screws of a cheese press, waiting to sample milk inside a dairy, bricklaying, building a wooden stairway, sewing dresses, making shoes, and mixing fertilizer. These activities are straightforward and convincing as learning experiences, not acts of servitude or domesticity. The students are portrayed in ways that demonstrate the steps involved in recognizable and meaningful activities. For example, Johnston's most published photograph today, and the one for which she is best known, shows several students at work on the interior stairway of a building under construction at the treasurer's residence, a kind of catalog of carpentry techniques redolent of Denis Diderot's *Encyclopédie* (figure 11). This photograph is not unlike her earliest illustrations for the article she wrote in 1889 entitled "Uncle Sam's Money," published in *Demorest's Family Magazine*. In three of the photographs, reproduced as line engravings, various aspects of the coin-making process are illustrated, including the whitening process, destruction of the dies, and the coining press. Emphasis on action and information more than sentimental appearance anticipates the style and substance of the student craftsmen at work on the stairs of the treasurer's residence. Everything in the composition seems very ordered and staged to convey the value of education. The pupils concentrate on various aspects of the stairway construction. One person checks to see that one of the stairs is level. Another man chisels a carving below the balustrade. Another hammers one of the posts. Another inspects the top railing. Another hammers paneling below the stairway, and another man seems to be inspecting the carpet where the stairway has been completed above the landing. Working in harmony, the men are spaced evenly across the photograph. In sharp focus, their bodies effortlessly follow the horizontal, vertical, and diagonal lines of the stairway. This picture is an optimistic statement, using architectural construction as a metaphor for the integration of African Americans into mainstream society, with focus on their attention to the conventional act of building.

Overall, the Hampton series questions aspects of the American education system, which set out to eradicate differences between ethnic and racial groups through the teaching of interpretive subjects such as social studies. Johnston's Hampton photographs, which support Booker T. Washington's

emphasis on the virtuousness of work, emphasize a classical tradition of art, a style that fused naturalism with ideals of beauty originating in antiquity. The emphasis of her photographs, revealing the importance of art in the broadest sense through study and practice, makes it clear that Johnston upheld the same Arts and Crafts sensibilities as Booker T. Washington (figure 12). Both Johnston's photographs and Washington's writings advocated the avoidance of slavery to mechanical, repetitive tasks and encouraged working with the hands to improve the mind, body, and soul, not unlike the teachings of American educational philosopher John Dewey.[127]

Johnston's Hampton Institute photographs show how architecture as a measure of civilized society was a primary concern. In photographs showing students plastering and bricklaying, each person is dedicated to one aspect of the overall task so that together they are working as a team.[128] The full product of student labor can be seen in the Hampton Institute photograph entitled "Students at work on a house built largely by them" (figure 13). A perspective view of the front façade shows the house nearly complete. The small images of students situated in front of the house, on the porch, looking out windows, and on the ladder express their individual competence as they work on different aspects of the construction process.

Similar techniques and devices used at the Hampton Institute are evident in the architectural photographs at Tuskegee. Johnston balances all the components in her compositions so that they are ordered and controlled. Furthermore, she keeps her camera distanced from the subject matter to suggest that these are not personal portraits but illustrations of concepts. In "Architectural Class," thirty-two Tuskegee students observe and measure a brick building, and jot down information in their notebooks (figure 14). Standing in a horizontal line along the foundation, they seem to follow the course line of the building. In this way, the people as a collective are engaged in scholarly activity, presented anonymously amidst the predominant architecture so that the well-choreographed group is greater than any of the individuals standing alone. In the Tuskegee photograph, "Construction by Students," about sixteen people work on the wooden rafters (figure 15). Johnston focuses on the cooperative efforts of the group spaced along the top of the roof under construction rather than on individual carpenters. Her photograph complements Booker T. Washington's observation that the students work without any fixed salary or promise of salary because "they

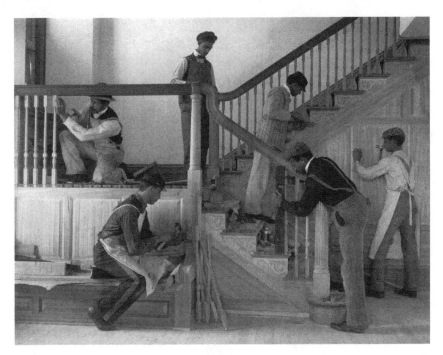

FIGURE 11. Treasurer's staircase, Hampton Institute, Virginia, 1899

have learned that helping someone else is the secret of all happiness."[129]

Johnston willingly accepted commissions documenting educational institutions. No doubt these projects emphasizing moral and civic advancement were refreshing to her after all her work for the elite. Letters and other documentary evidence show that her experience photographing schools was a novelty for her and that she was learning about a segment of society to which she had very limited exposure. Johnston, as a professional woman who was able to compete successfully in a male-dominated field, empathized with the values of the educational institutions she photographed and shared her photographic skills with students at these schools.[130] Her documentation of vocational skills, especially those of carpentry, bricklaying, plastering, and architectural documentation, promoted community peace as well as economic security and equal citizenship. Architecture was not just something to be appreciated aesthetically but to be cared for in a practical way. Building a house was a crucial step toward domesticity, an indicator of social advancement and civilization.

Selections from the Hampton photographs, along with those from John-
ston's Washington, D.C., series formed an exhibition demonstrating the
contemporary life of African Americans. These photographs were eventu-
ally arranged by subject and mounted on the movable leaves of a large
cabinet to form part of the Negro Exhibit of the United States Commission
to the Paris Exposition of 1900. The Negro Exhibit was placed under the
direction of Mr. Thomas J. Calloway, an associate of Booker T. Washington
at the Tuskegee Institute. Calloway made arrangements with Johnston to
substitute platinum prints for each of the original silver prints so that her
photographs, which were done in both processes, might have a more uni-
fied appearance.[131] On May 15, 1900, Calloway reported to Johnston from
Paris that the Hampton Exhibit

is attracting considerable attention and has had many favorable com-
ments. Personally, I regard it as the finest collection of photographs in the
exhibition. After a month's delay, we have just opened the exhibit to the

FIGURE 12. A sketch class at work, Hampton Institute, Virginia, 1899

FIGURE 13. Students at work on a house, Hampton Institute, Virginia, 1899

public, and it will be another month before the entire exposition will be ready.[132]

The photographs, including those previously rejected in educational booklets, were praised for their eloquent silent narration. Calloway's own response was that Johnston was being taken seriously as a professional. Her photographs were seen as innovative due to the absence of text.[133]

The Hampton photographs received the grand prize at the 1900 Paris Exposition, and the exhibition was received favorably in Paris by both the press and the public. Additionally, the French government awarded Johnston a gold medal for her photographs of Washington public schoolchildren, which was presented at a ceremony in St. Petersburg. The other two women receiving gold medals included Philadelphia artist Cecilia Beaux, who along with Johnston showed had received art training at the Academie Julian, and Susan Blow, a kindergarten teacher whose concepts were proven to effectively benefit the St. Louis public school system. An established painter and photographer were being recognized on

FIGURE 14. Architectural class, Tuskegee, Alabama, 1902

equal footing with a kindergarten teacher perhaps for the first time in established art circles. Johnston later received the decoration of "Palmes Academiques" from the French government for her work at the International Photographic Congress and for her services as a French translator on the jury of awards at the Louisiana Purchase Exposition, which enabled the interests of the French jurors to be known. In further recognition of her contribution, she would be given a purple ribbon and become a member of the prestigious French Academie in 1904, truly a rare accomplishment for a woman in this period. Five years later, Johnston's photographs of Tuskegee would be published in *Working with the Hands*,[134] a sequel to the popular book, *Up from Slavery*, the autobiography of Booker T. Washington. Her photographs would appear also in *Tuskegee and Its People: Their Ideals and Achievements*, edited by Booker T. Washington and published in 1905.

The Hampton Institute and Tuskegee Institute, as a result of the publicity received from Johnston's photographs, became better recognized as edu-

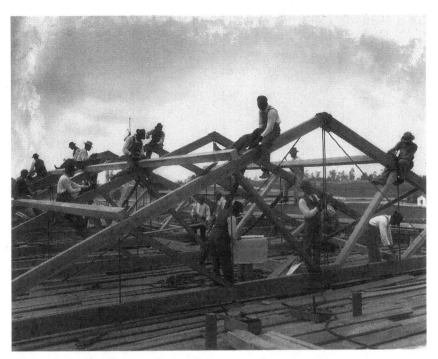

FIGURE 15. Construction by students, Tuskegee, Alabama, 1902

cational institutions that valued academic and industrial training both for moral improvement and economic advancement, corresponding to Johnston's own Progressivist agenda and the prevalent political climate of the nation's capital that she knew so well. Johnston's exhibition of educational institutions, even after the awards and public recognition abroad, did not, however, receive much immediate publicity in the United States. The problems Johnston portrayed were too close to home for Americans to appreciate aesthetically. Rural tranquility and preservation of the past would be more effectively presented in Johnston's photographic documentation of historic architecture thirty years later. Also, she would avoid social ambiguity by focusing even less on people, while making it clear that the architecture and surrounding landscapes were solid expressions of human existence.

Stylistic Controversy

Immediately upon her return from Paris, Johnston began work on a se-

ries of seven one-page articles for the *Ladies' Home Journal,* published between May 1901 and January 1902 under the overall title "The Foremost Women Photographers of America." These efforts were obviously linked to her work at the 1900 exhibition and served as a kind of advertisement and possible substitute for the lack of public attention in the United States. Johnston was paid $150 for each article, a sizable commission at the time. Each piece focused on one photographer from her women's collection. Included among these were a number of photographers, such as Gertrude Kasebier and Eva Watson-Schultz, who continue to be recognized today. Each article contained four or five photographs based on the exhibition she had prepared.

In 1901, Johnston was drawn into the growing controversy at the Fourth Philadelphia Salon over what was art and what was merely recording. The first of the four salons took place in Washington in 1896, followed by three in Philadelphia in 1898, 1899, and 1900. Johnston was again asked to serve as a juror. The differences between the more traditional Old School photographers, then referred to as the Rationalists, and the overt aestheticism of the more progressive New School photographers became increasingly apparent during this exhibition. The traditionalists preferred photographs with sharply focused imagery, interests that proponents of what is now commonly known as straight photography would see as radical and innovative only a few years later. They labeled the blurred, impressionistic photographs of the art photographers as products of "fuzzyography." In 1901, the Old School faction considered that it was staging a coup when the new committee elected for the fourth salon consisted entirely of Rationalists. Those who preferred the newer type of photographic aesthetics refused to serve on the jury. Johnston, still attempting to straddle the chasm, had agreed to serve on the jury despite the controversy and the obvious machinations of the salon organizers. Not the most dedicated practitioner of pictorialism, she was concerned mostly with maintaining her professionalism. Other members were Allen Drew Cook, George W. Hewitt, and Dr. Herbert M. Howe, all well-known Philadelphia photographers.[135]

Eva Watson-Schutze, a friend of Johnston's, who was allied artistically with Stieglitz, wrote to Johnston in July of that year, expressing dismay over Johnston's involvement:

Awfully sorry to see your name on that jury. You'll have a picnic. The Salon this year does not represent the same party in the society which might not *necessarily* be bad—if it did not represent one that has opposed and disapproved of what has been done. Other disapprovals (in the society) being of such an offensive kind that it is out of the question to take any part with them. . . . We shall hope you may get as far as Chicago some time, and come stay with us.[136]

Johnston does not appear to have taken much interest in the infighting within the photographic salon or in the accompanying stylistic arguments. The debating was irrelevant to her work, and she was more eager to help and encourage other artists than to quarrel about artistic principles.

Stieglitz and other art photographers boycotted the 1902 Philadelphia exhibition and through this act began the Photo-Secession Movement. The Fourth Philadelphia Salon of 1902 would thus be the last major salon of its kind, ending an important period of inclusiveness and variety among American photographers—an openness in many ways epitomized by Johnston. The demise of the Philadelphia salons initiated a period of infighting among aesthetic contenders. The result would be a new atmosphere of criticism in which each aesthetic camp imposed its own standards to judge the photographs of others, without allowing for diversity of style and intent. Johnston's fellow photographer and friend, Gertrude Kasebier, perhaps typifies this charged attitude in her criticism of several submittals she rejected at the 1900 salon.[137] She, as well as others, conformed to prejudices cemented by Stieglitz's group. If photographs were sharply focused, they often were considered purely mechanical efforts. Eclectic and essentially tolerant photographers, such as Johnston, were in many ways sidelined, and more glaringly, their work was omitted from the later art history books.

It was not entirely, however, the prejudices of the Photo-Secessionists that brought an end to the photographic salons. For many photographers and those interested in photography, these exhibitions had become moribund and closed to new ideas. A letter from Hudson Chapman, chairman of the 1901 Salon Committee, to Johnston in October of 1901 reveals Chapman's disenchantment with the art establishment he believed had become too crit-

ical. He complained that their overly uniform approach was narrowing their definition and focus and causing them to ignore legitimate art:

> I feel that it is but due you on account of the insinuations against the management of the salon which have appeared in some of the photographic journals to assure you that they are utterly baseless. The purpose of the management is the achievement of the highest possible artistic results at the coming exhibition. The writer, after some art training in his youth, has devoted his life to the study of the history of art and has spent several years in Europe in the pursuit and was over again last year for four months in Italy for the third time, Munich, and at the Paris Exposition and should possess sufficient knowledge of the subject, to, as far as is in his power, aid in carrying on the salon on sound and artistic lines. The only criticism I offered of the last salon was that it was narrow and showed the result of having a jury of artists all working in precisely the same manner. It was altogether inferior to the second salon.
>
> Looking forward to the pleasure of meeting you personally. . . .[138]

With the official formation of the Photo-Secession in 1902, the center of creative photography in the United States moved effectively to New York City. There Alfred Stieglitz founded a new photographic periodical, *Camera Work* (1903–17), and in 1905 founded a gallery for the Photo-Secession photographers at 291 Fifth Avenue. At the gallery, annual exhibitions were mounted, focusing on American and European photography and other modern art. Johnston, moderating attempts to encompass traditional and newer art photography as well as continuing her involvement through the last Philadelphia Salon, became an associate member of the Photo-Secession in 1904. Stieglitz, who was the official director of the Photo-Secession gallery, wrote to Johnston in March of 1904:

> In view of our various talks and the numerous discussions and in order to prevent any further misunderstanding, permit me to say that the Council of the Photo-Secession will gladly welcome you to its ranks as *Associate*. For the present it does not see its way clear in offering you the Fellowship. If you are willing to come in as Associate kindly drop me a line at your convenience. Dues, as you know, are five dollars per year to all members alike. Kindest regards. . . .[139]

Stieglitz, more interested in financing his gallery than changing any established administrative power, was willing to let Johnston be a member if she paid her dues.

Stieglitz and Johnston would continue to correspond over the next few years, due to their similar interests in the areas of photography and collecting. As late as 1923, Johnston would offer to sell Stieglitz her complete set of *Camera Work* comprised of about fifty issues. She would always cherish her "complete and perfect" files of *Camera Notes* as well, and considered both "the darling hobby of Alfred Stieglitz forming a comprehensive history of the art of photography."[140]

In 1904, Stieglitz exhibited along with other art photographers at the Capital Camera Club, where Johnston continued to play a role. The officers of the Capital Camera Club wrote a call-to-action, pleading with members not to lose sight of the fact "that it is a high artistic achievement to have a print receive the sanction of our judges" and to participate in their seventeenth annual exhibition. Recognizing that members were demoralized and apathetic by this point, the notice stated:

> It lies with the members to determine whether it is to be a success or failure. Last year, it became almost impossible to hold an exhibit at all, and the prints were not up to the proud standard of our workers in the past.[141]

Due to the efforts of one or two members, the exhibition was enabled to continue by opening it up to the Photo-Secessionists, a position Johnston would have agreed to professionally. The officers, however, averred that the disappointing involvement of club members placed the existence of the club "on trial."[142] The exhibition, held at the Corcoran Gallery for over a month, strikingly included no works by Washington-based photographers among its 159 photographs. Forty Photo-Secession artists dominated the exhibition, which was primarily supervised by Stieglitz and Steichen and included works by Stieglitz, Steichen, Kasebier, Clark, Wade, Abbott, and Adamson.[143] Local photographers such as Johnston had to stand on the sidelines, showing how much the New York School had come to dominate the American art scene.

Johnston continued to participate in American pictorial photography exhibits outside major art centers, including those held at the Richmond Art Association in Richmond, Indiana, in June of 1903 and 1904. Also in

1903, she exhibited in Rochester, New York, where she had long-term connections with George Eastman. She is known to have exhibited her photographs at a show exclusively for women photographers sponsored by the Camera Club of Hartford, Connecticut, in April of 1906. Two hundred prints by thirty-two women were shown, including works by Jessie Tarbox Beals, Annie W. Brigman, and Adelaide Hanscom. As an established professional, Johnston would remain loyal to her colleagues who were interested in her photographic endeavors. But gradually she drifted away from both the salon tradition and the more exclusive art photography shows of the Photo-Secession, which ended in 1911 to be taken over by straight and cubist photography. Johnston's own intents were less concerned about stylistic differences and more focused on practical matters. Over the next few years her photography would take a new direction back toward realism, though never entirely forsaking the influence of the Photo-Secessionists.

Photographs of individuals, news events, landscapes, and architecture would continue to document Johnston's point of view. As a result, it is difficult to separate Johnston's studio work from her garden and architectural photographs. Even less is it possible to divide her portraits from her often journalistic studies of people and places. There is change and development over time, but also striking unity and continuity as well.[144]

CHAPTER 3

Landscape and Gardens

A New Direction

PHOTOGRAPHS TAKEN BY Johnston throughout her life show that she possessed a keen awareness of the landscape surrounding her. She always had a garden of her own to care for, long before she decided to become a professional garden photographer. Her first studio was placed next to the rose garden of her family's residence, designed and previously occupied by John Burroughs, the famous naturalist. Even the skylight of Johnston's studio was framed by wisteria and roses. Some of her more private snapshots include these features as backgrounds.[1] She was an acquaintance of Louis and Auguste Lumiere, known especially for their short film *Le Jardinier* or "The Gardener," alternatively titled *L'Arroseur arrosse*. In this film, a young boy steps on the hose laid out by a gardener to sprinkle a lawn. While the gardener looks into the nozzle, wondering why the water has stopped, the boy jumps off the hose, an act that results in the gardener getting doused. Johnston shared the Lumieres's comic sense of life in the out-of-doors, and her own photographs show occasional outdoor jest, such as splashing in the ocean while in France or playing shuffleboard on the deck of a ship.[2]

Johnston began taking pictures of Washington, D.C., views and the surrounding Maryland landscape as early as 1889. Snapshots of family and friends taken during excursions include panoramic seaside and mountain views as early as 1890. Some of these excursions included a trip with her family to Bermuda in 1915 and a visit to her friend, the artist Laudon

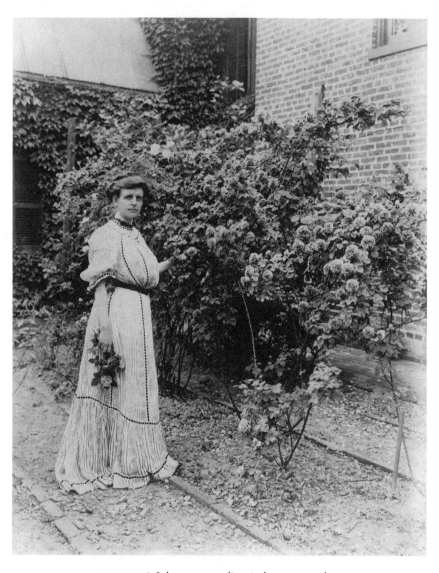

FIGURE 16. Johnston standing in her rose garden,
Washington, D.C., 1895

Rives's, Castle Hill Estate near Charlottesville, Virginia, in 1903. During a tour of the Great Lakes region in Minnesota, Yellowstone National Park in Montana, and places in Colorado, Washington, and California that same year, she took pictures of panoramic landscapes and waterscapes, too. It is clear that Johnston had a firm understanding of the picturesque, gained from her well-grounded education in art. In the picturesque tradition as well is a watercolor Johnston may have received during her commission with the Hampton Institute painted by Hampton Institute teacher Leigh Richmond Miner of a figure in a sailboat being reflected in the water. This watercolor, as well as the late nineteenth-century landscape photographs by other photographers that Johnston collected, show that Johnston appreciated landscape art decades before she was taking photographs of landscapes and gardens for magazines and garden club members.[3]

Picturesque Landscapes

The picturesque aesthetic, as Johnston understood it, emerged from eighteenth-century English gardens, landscape designs, and writings such as landscape designer Sir Uvedale Price's 1794 "Essay on the Picturesque." He argued that gardens should imitate seventeenth- and eighteenth-century landscape paintings, such as those of Claude Lorrain (1600–1682) and Gaspard Poussin (1615–75), to include rocky chasms and rotting trees. The role of the gardener, like the painter, was to improve upon nature. Architectural style and placement were significant considerations for those advocating picturesque aesthetics. Ruins and vernacular structures, for instance, emphasized ruggedness, irregularity, and variety of form so as to appear part of the environment rather than an imposition on it. Picturesque aesthetics, ranging from landscape paintings and photography to garden design and architectural style, permeated nineteenth-century American culture to provide escape from industrialization.

A resident and photographer of Washington, D.C., Johnston well understood picturesque style from places such as the Smithsonian Institution, also known as "The Castle," a red sandstone, Romanesque-Revival-styled building designed by James Renwick, Jr., in 1846. The Romanesque Revival, which appealed to religious fervor and picturesque sensibilities, was a popular prototype for American churches as well.[4] Johnston's early ca-

reer in Washington, particularly her commissions for government scientific agencies and for projects such as the 1893 World's Columbian Exposition, exposed her to a wide range of natural landscape images that she rigorously documented using the latest technological advancements. For the U.S. Fish Commission exhibit she helped arrange for the enlargement of photographs at the Eastman Company. These included a number of Arctic scenes as well as images of the Bering Sea.[5] She was the "middle person" for J. Stanley Brown of the United States Geological Survey and also helped with the administrative aspects of the photography exhibit from the Latin American Department of the World's Columbian Exposition.[6]

Between 1901 and 1910 Johnston continued to work in Washington, submitting photographs to George Grantham Bain resulting from various commissions and photography exhibitions. She also continued her work as a portrait photographer as well as a chronicler of expositions. Both Johnston and Smillie, for example, were commissioned to photograph the U.S. National Museum exhibits at the 1901 Pan-American Exposition in Buffalo, New York, a project commended especially by William H. Holmes, the well-known chief from the Smithsonian Institution Department of Anthropology; Frederick W. True of the Smithsonian Institution and National Museum; and George P. Merrill, chief of the Department of Geology. Among the numerous exhibits they photographed were two series: engravings of twenty-four portraits and reproductions of twenty-four landscape and figure paintings. Other exhibits that were photographed included trephined skulls from Peru and plaster busts of American Indians and Eskimos lent to the Division of Ethnology and Archaeology, lay figures of Sioux Indians lent to the Indian Office Exhibit, and a lay figure of a Filipino girl lent to the Government Commission of the Exposition. For the 1904 World's Fair in St. Louis, Missouri, Johnston received a commemorative medal for her "active interest and efficient cooperation in the Universal Exposition" as a member of the International Jury of Awards.[7]

During the summer of 1905 Johnston traveled with Gertrude Kasebier in Europe, and visited the well-known photographer J. Craig Annan, who tried to make arrangements for Kasebier and Johnston to meet with American photographer Alvin Langdon Coburn as well, but this was impossible due to time constraints. They also visited Baron Adolf de Meyer in Venice and Robert Demachy at his estate on the Normandy coast near Trouville.

Between their visits to these photographers, Johnston and Kasebier separated for a few weeks. During this time, Johnston visited the Lumiere family and learned about their new color photography process. This appears to have been a reflective time for Johnston as well as for Kasebier. Distanced from her busy schedule documenting events and people in the United States, Johnston could more easily make decisions about how she should continue upon her return home. Her trip to Europe had awakened her traditional aesthetic sensibilities, and she became more drawn to classically inspired architectural and landscape photography. Johnston, a serious student of landscape photography, traveled with other world-renowned photographers and took landscape photographs of European country estates, foreshadowing her later work for garden magazines and clubs. This 1905 tour reinforced her earlier interest in landscape photography and in the picturesque tradition.[8]

Mammoth Cave

One of Johnston's earliest photographic commissions for *Demorest's Family Magazine* was her 1892 record of Mammoth Cave of Edmonson County, Kentucky, considered among the natural wonders of the world.[9] As she explained in her article, the caves, five stories high, consist of hundreds of acres, through which wind 223 avenues, with an aggregate length of 200 miles. There are 47 domes, one of which is 300 feet high; 23 pits, 175 feet deep; 8 waterfalls, and several bodies of water including 3 rivers, 2 lakes, and a sea. This photographic series, made possible through the use of magnesium light, was said to be the first successful depiction of the large cave interiors. The initial series of Mammoth Cave was an instant success, largely due to the photographs' widespread coverage. Shortly afterward, a request was made by an honorary member of a newly organized camera club at the University of Nebraska to exhibit the Mammoth Cave pictures. Twenty-five photographs from the series were published as a book in 1893, copies of which were then sent to the American Museum of Natural History and the United States Geological Survey library.[10]

The Mammoth Cave photographs often have traditional picturesque compositions. Johnston invites the readers to visit by giving information on how to travel comfortably to the caves by train. She emphasizes that the

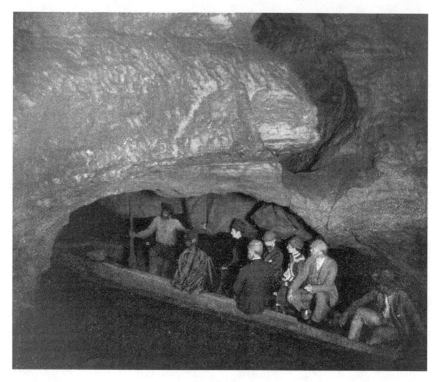

FIGURE 17. Mammoth Cave, on Echo River, Kentucky, 1893

caves are easily accessible. Hence, her focus in the photographs is on welcoming pathways, cave entrances, and the porch of a popular summer resort where visiting men and women can congregate and relax. The region is described as a charming, wild, and picturesque stretch of country. "Ruggedly beautiful, the steep ravines are clothed in rich verdure, and the picturesque Green River winds in and out between rocky cliffs about a thousand yards below the hotel. The air is deliciously pure and bracing, there is abundant game in neighboring woods, while the river affords excellent fishing: all of which, added to the supreme attraction of the cave, render the place unusually inviting for a holiday trip."[11]

A reason the caves are so attractive is that they have many peculiar characteristics ranging from unusual stalactite formations to cave walls encrusted with delicate, florescent mineral traceries to eyeless fish and a few species of white fungus. Picturesque-sounding names of the unusual subterranean landmarks include Rotunda, Broadway, the Pigeon Holes, the

Methodist Church, the Gothic Galleries, the Theater, the Post Oak Pillar, the Catacombs, the Pillars of Hercules, the Bridal Chamber, Joseph's Pit, the Water Clocks, and the Bottomless Pit, promoting it as a place of adventure and exoticism not unlike the world of Hades or Pilgrim's Progress and also suggesting more common regions. It is clear that Johnston was enchanted by this landscape, and she promoted it for its traditional aesthetic qualities, although it was an unfamiliar natural environment.

The photograph "Mammoth Cave, on Echo River" reinforces the accessibility of the caves to the public by showing a group of eight people on a boat at the mouth of the cave. The top of the cave in the foreground dominates our view so that the photograph appears without much spatial depth. Those sitting in the boat all direct their gazes expectantly toward what lies ahead. A guide uses his oar to measure vertically the opening of the cave, a convention of measurement sometimes used in architectural photographs as well. The flashlight illuminates the face of the cave entrance above the people pictured. The visitors are wearing dark clothing, and the majority of their faces are lit. In contrast, the water and the opening of the cave are dark.

Kohinoor Coal Mines, Yellowstone, and the Mesabi Range

Johnston's photography for magazines and newspapers allowed her to leave her studio behind and travel to places considered newsworthy, including landscapes being destroyed by often unfettered industrial growth. For example, she took pictures of the Kohinoor coal mines in Pennsylvania, for which she wrote a "Descriptive Sketch" for *Demorest's Family Magazine* in 1891. That same year, she photographed Yellowstone National Park for the U.S. Engineer Office to document and exhibit their work on roads and a bridge.[12] Here she stood within a long tradition, stretching back to pioneering photographers such as William Henry Jackson, Timothy O'Sullivan, and Carleton E. Watkins, inherently commenting on their earlier records through the very act of repetition.

Johnston also recorded the open-pit iron mining operations in the Mesabi Range in northern Minnesota owned by the Carnegie Steel Company in 1903.[13] Her photographs of the iron ore region focus on the ravaged land. In her photograph entitled, "Mining at the Mesabi Range, Sixty Miles from

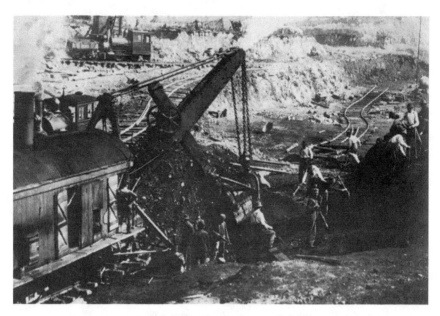

FIGURE 18. Mining at the Mesabi Range, Lake Superior, 1903

the North Shore of Lake Superior," Johnston employed picturesque tech-
niques for the composition of her image. A bulldozer juts into the fore-
ground at an angle, and nearby miners all direct their attention to the in-
complete meandering railroad ahead of them. Beyond where the railroad
ends is a large expanse of rolling fields that has not yet been gouged for
mining. The waiting miners, the steam engine just behind the bulldozer,
and the unfinished railroad in the foreground contrast with the natural
landscape in the background. Johnston focused on a transitory moment of
the mining activity to question the environmental impact of the open-pit
iron mining operations.

Johnston's description of her visit to the Pennsylvania coal mines is simi-
lar to her images of the Mesabi Range in northern Minnesota, suggesting
that a richly varied American landscape is being made homogenous. Her
approach was to present her subjects as members of families and communi-
ties. For example, in her article on the Pennsylvania coal mines she included
information about their surroundings and the requirements of their daily
work. Her viewpoint, impressionistic and wide-ranging in scope, is that
of an amiable travel writer. Just as in her Mammoth Cave series, Johnston

confided as one concerned individual to another, no different from any other unsophisticated traveler. Without dismissing her refined aesthetic sensibilities, she described in layman's terms the loveliness of the eastern Pennsylvania anthracite coal formations while following the Schuylkill River to its headwaters in the mountains. Then as the river narrowed and the water became shallower, she observed evidence of the mines:

The natural beauty of this country is very striking, and as the black waters show we are nearing our journey's end. The outlines become rugged, with sharp cuts, and long, deep valleys interlying green, precipitate slopes. While distinctly a mountainous country, its altitudes, as mountains are counted, are still moderate, and never arid, but clothed from crest to valley in the most beautiful verdure. The ancient forests have long since disappeared,—*into the mines*—being replaced in the wooded parts by a luxuriant growth of young trees, while the more open country is covered by a profusion of laurel and rhododendron, and carpeted with masses of fern and velvet moss. Deep ravines draped in trailing vines, the bold outcrop of jagged rocks, the streams, again translucent, flowing over uneven, stony beds, all possess an inherent picturesqueness which is fast disappearing under the relentless onslaught of this utilitarian age.

The sharp contrast between the natural beauty of the country and the devastation these delvers in the earth are working is vividly forced upon us as we reach the crest of a high ridge and catch our first glimpse of the somber outlines of the succession of collieries, mining patches, and towns, stretching away far up the valley. In point of fact, nothing could be more grimly ugly than the result of thus turning wrong side out a green earth lined with black.

As a matter of course, everything and everybody is black. Great, unsightly frame buildings,—the coal breakers,—dingy with dust and smoke, rise awkwardly, entrenched behind huge banks of dirt and culm, while the small cottages and rude wooden shanties of the miners cluster drearily about the outskirts. Black streams, whose waters are pumped from the mines, drained over the dirt banks, and thus charged with poisonous acids absorbed from the culm, wash sluggishly through the bottom lands, killing all vegetation in their path and leaving the dead trees like gaunt and glistening skeletons, standing knee deep in a waste of gritty black mud.[14]

Johnston's mining photographs are comparable to the work of Lewis Wickes Hine (1874–1940). Like the photography of Hine, Johnston's photographs and text celebrate the energy and deftness of laborers. The miners are shown at close range, so that they appear physically coordinated, strong, and courageous, in light of the dangerous work that they daily carry out. While Hine dwelled on their individual activities, Johnston avoided the issue of whether they should be working at all, and tactfully downplayed the danger of their work to their health. Her photographs instead show the overall unwholesomeness of mining operations.

Johnston's photograph of the Mesabi Range, unlike the Pittsburgh photographs Hine took seventeen years later, ties the workers closely to the landscape. Hine conveyed more of a social connection, celebrating the physicality of the laborers' actions such as pouring steel. In Hine's later *Men at Work* series, the status of the laborers is elevated as professionals so that each worker stands statuesquely above the city as the focus rather than his achievements or his surroundings. The contrived gestures, resembling Jacques-Louis David's *The Death of Socrates*, were designed to engage the viewer as if watching a performance. Hine's 1932 book containing these photographs celebrating work served as a teaching tool, offering instruction on the appreciation of the aesthetic values of cities and industrial areas. A supporter of Dewey's pedagogical theories, he believed that the images would be received as works of art through the act of reception by the viewer. Hine's sensibility was given further credibility by the early appreciation of his photography beginning in 1938, when Beaumont Newhall, then a museum curator, called attention to the broader aesthetic quality of Hine's work and the wider context of the artist's ambitions. Newhall eventually was to become the first major historian of photography to use the term "documentary photography" to describe Hine's work, thus recognizing and in some ways laying out the classical standards for an appreciation of this now both artistic and sociopolitical enterprise.[15]

Newhall would eventually include examples of Lewis Hine's photography in his vintage history of photography. Johnston's early documentary photography did not receive the same kind of recognition by the Museum of Modern Art; and although today her work is often recognized as documentary in character, her photographs of the Great Lakes region and the Pennsylvania coal mines are omitted from most surveys. The reasons for

this neglect are various and have been touched upon. Leaving behind more soothing, traditional, picturesque landscapes limited the reception of her more modern, scientifically observed, documentary photographs. Furthermore, she downplayed the moral superiority of the laborers essential to Hines's more classically inspired documentation by illustrating their destruction of the environment. Describing the landscape and cultural life of its inhabitants tended to detract from, or at least minimize, any consideration of her photographs as conventional art or documentary photography, particularly when featured in a family magazine rather than in a museum or established art journal. Neither did Johnston emphasize more traditionally acceptable abstract points of beauty, as did Hine. She instead exposed the reader to the bleaker reality and truth of the images.

Noting Everything

Johnston's travel-writing approach is common to all of her work, although to a lesser degree in her later garden and architectural photography. Johnston frequently took many pictures of one subject and would jot down notes about the history and physical description of a location as well as other related observations and thoughts. In the case of her later specialty in garden photography, Johnston's extensive notes would be used by magazine editors for their own articles to be accompanied by Johnston's photographs. Her photographs of the Great Lakes region, for example, include many more than the twenty-two finally published in *Demorest's*.[16] While on assignment she took about two hundred shots, including images of tourist activities, North American Indians, a lighthouse at St. Clair Lake, scenes on St. Mary's River, and the dock at Mackinac Island. As with the Smithsonian scientists from whom she received her initial training, she was a stickler for accuracy and keenly interested in completing a truly scientific record of what she encountered.

These documentary aims sometimes digressed from Johnston's concern for the traditional picturesque yet were allowed to coexist in her landscape photography. Travel writing was a method Johnston used to engage her reader and explore a region so that scientific precision could be subtly tempered by her concern for the environmental destruction she often witnessed. Without drifting into the voice of an omniscient professional expert, she

often empathized with the tourist and used principles of the picturesque to create adventurous visual perspective and balance in her compositions. Her text too is varied and extensive, without overemphasizing moral outrage.

Other photographs Johnston took to accompany her magazine articles are some of the most abstract and modernist compositions she would ever make. She could seek a kind of abstract beauty in industrial landscapes as much as Walker Evans. For example, in one of her photographs six identical pump-houses are shown located just above a horizontal band of rectangular brine springs. In another photograph, an alley of covers placed over a salt crop take on the characteristics of decorative patterning. Men are seen at work in various stages of salt production but also as foils to the flat surfaces of their surroundings. The realities of a seemingly mundane occupation are elevated through the aesthetically pleasing abstract stature of the series. The article harkens back to the realism of Johnston's early work and the more sociological cast of her series on workers and education. The industrial landscape, however, is not as grimly portrayed as other industrial regions she depicted due to the modernist overtones of the photographs with abstract patterns on the landscape created by machinery and industrial buildings.

The Architecture of Gardens

Johnston's correspondence with writer Julia Magruder, as well as her work for McKim, Mead and White just after the turn of the century, makes it clear that architectural and garden photography not only were becoming more fashionable and in demand but that Johnston herself saw inspirational opportunities in these areas for her own work. Johnston admitted that she had been interested in portraiture in Washington until it became commercial and too stressful. With the daily newspaper staff "looming ominously," she and her new partner and close friend, Mattie Edwards Hewitt, came to New York at the request of architects such as John Carriere and Charles McKim, who already knew of her work in Washington, D.C. One of Johnston's and Hewitt's first commissions in New York came from John M. Carriere, the architect of the New Theatre and later the New York Public Library. In 1913, Johnston and Hewitt opened a photographic studio at 536 Fifth Avenue. For the next four years, Johnston and Hewitt would

work together, collaborating in the field of architectural and garden photography. As Johnston herself explained:

> I wanted to specialize and Mrs. Hewitt wanted to help. We looked over the field and decided that there was great work to be done in photographing beautiful homes. Almost our first commission came from John M. Carriere, the architect of the New Theatre. . . . We try to enter into the spirit of every building that we photograph, for every one has character.[17]

Frances Benjamin Johnston's partnership with Mattie Edwards Hewitt would stem from a shared outlook. Hewitt, like Johnston, was restless. In a letter Hewitt wrote to Johnston in 1901, when she was beginning to learn photography, she described the isolation she felt in her marriage. Her husband, she said, was "land crazy" at home but seemed healthy on his trips scouting government land. She, on the other hand, stayed close to home and had plenty of time on her own to take pictures of farm animals such as chickens and cats, and she was fascinated by their movement. Johnston and Hewitt recognized that they as women were not participating actively enough in the preservation of their environment, and they forged a link on this issue. Both were to become established photographers of a more traditional woman's world, consisting of gardens and private estates rather than more rugged tourist spots, such as Yellowstone National Park and Mammoth Caves, or heavily industrialized areas. While at first both Hewitt and Johnston wished to photograph places where women could be actively engaged in their natural surroundings, Johnston continued to uphold tourist sensibilities, which Hewitt highly valued.[18]

Another part of Johnston's desire to move to New York may have been to be closer to what was clearly becoming the commercial center of American photography during that period. Stieglitz's gallery was located only a few blocks away from her own studio on Fifth Avenue. The studio of news photographer Jessie Tarbox Beals (1870–1942) was located at 292 Fifth Avenue, across from Stieglitz's gallery. Other photographers with portrait studios on Fifth Avenue included Gertrude Kasebier (1852–1934), Ben Yusef, Rudolph Eickemeyer (1862–1932), and the successors to the firm of Napoleon Sarony (1821–96). As one critic of the time observed, "There is glamour over Fifth Avenue, New York, such as is over no other photographic center in America."[19] Many of these photographers, like Johnston and Hewitt

who followed in the same tradition, maintained fashionable portrait businesses, photographing members of New York society as well as wealthy visitors to the city. A number of useful contacts were made by Johnston and Hewitt during this period, particularly with architects whom they knew often from art circles, and this diverted their focus gradually from portraiture. Subsequent work featured the buildings of Carriere and his partner, Hastings; the famous firm McKim, Mead and White; Bertram G. Goodhue; John Russell Pope; Charles A. Platt; Cass Gilbert; and Grant LaFarge; there were also commissions with commercial operations such as the City National Bank and the extensive real estate holdings of the North German Lloyd Company. But Johnston's and Hewitt's principal emphasis remained on country estates, many owned by clients or friends of clients including those of John Pierpont Morgan, John J. Astor, and Mrs. Harry Payne Whitney, all among the leading figures in New York society.

From the early 1900s through the mid 1920s, Johnston's personal connections, made early in a career filled with ambassadors and other official diplomats, gave her wide access to places, especially the official and eventful landscapes of Washington, D.C. Her connections also opened doors to private gardens and estates throughout the United States and in Europe. Most of the garden landscapes initially were locations around New York and in the Mid-Atlantic states.

Experimenting with color processing which she learned during her visit with the Lumieres in 1905, Johnston increasingly applied this to garden photography to make some of the first autochromes ever produced. Johnston's and Hewitt's publicity flyer advertised that color records should be made "when the garden is in each season's perfection of bloom."[20] It is clear that Johnston applied this axiom in her photographs.

But the main problem with the autochrome process was that the colors, of equal intensities, tended to compete with each other, diminishing the overall unity and harmony of the flowers within compositions. Most publications at this time used black and white images more often for printing reasons, and Louise Shelton's publication, *Beautiful Gardens in America*, included only a few token autochromes. Johnston too was more able to suggest aspects of color through the use of light and shadow combinations in black and white prints. This was one of Johnston's talents that would

serve her well when taking her photographs of buildings, at this time and at a later period.

After the partnership of Mattie Edwards Hewitt and Frances Benjamin Johnston ended in 1917, just as it was becoming well established, Hewitt would continue photographing gardens and estates mostly for magazines through the 1930s. It appears that personal disagreements brought a break between Johnston and Hewitt. The implicit suggestion is that it was a possible lovers' quarrel, though the exact nature of the two women's relationship remains obscure. They also had professional disagreements, since Johnston altered her career after the abrupt and final termination of their partnership.

Both Hewitt and Johnston continued their separate careers in photography. Their joint projects, however, would continue to make an impact long after their separation in 1917. For example, as a result of the efforts of the members of the Southampton, Long Island, Garden Club, Johnston's photographs, made while a partner with Hewitt, were put into the form of lantern slides. Johnston incorporated these into a series of lectures on American gardens. She clearly had benefited from her association with Hewitt in their mutual exploration of garden and estate photography. Much of Johnston's knowledge about horticulture and the history and folklore of gardens dates to the period of their partnership.

Lectures and Slide Shows Nationwide

While working with Hewitt, Johnston began her own collection of close to one hundred garden books, later claiming to "know the garden and flower shelf of every second-hand book store in the country."[21] Landscape publications such as those by Gertrude Jekyll (1843–1932), Edwin Landseer Lutyens (1869–1944), and Mrs. Schuyler Van Rensselaer (1851–1934) informed the traditional picturesque aesthetic of Johnston's photographs. In keeping with the gardens of the English Romantic period, garden designs were promoted in such widely read publications as H. Inigo Triggs's *Formal Gardens in England and Scotland* (1902), Rose Standish Nichols's *English Pleasure Gardens* (1925), and Francis King's *Chronicles of the Garden* (1925). American landscape architect Charles A. Platt's *Italian Gardens* of 1894 initiated his

own work at Faulkner Farm in Brookline (1897), featuring parterres, topiary, architectonic features, statuary, and terraces interconnected by formal steps, paths, and sight lines. For Platt, the typical Italian villa was an intricate combination of indoor and outdoor space, architecture and landscape architecture, carefully placed to achieve a naturalistic setting. Johnston's photographs depict the same values that Platt believed were epitomized in Italian villa designs: those of harmony, balance, and proportion.[22]

Johnston took notes from these garden books and many others, and by 1920 she was touring the United States giving lectures and showing her nearly one hundred lantern slides to garden clubs and other organizations fostering civic improvement, art, and literary study. As she further wrote in 1920, "I endeavor to present the best sources of information on a wide range of subjects relating to gardens and flowers."[23] These lectures and slide shows were both a means of personal and artistic expression and an important part of her income. Johnston and the garden community she relied upon were careful about expenses. More organized than the earlier photographic art communities, they continually communicated to each other so that the personal and professional needs of Johnston, as well as those commissioning her to take pictures and lecture, would be met. Typically, she would stay as a guest at some prominent local garden enthusiast's home.

While relying on some of her older work as well as the products of the impressive period of collaboration with Hewitt, Johnston continued as an active garden photographer. She often encountered new clients during her travels. She also was well placed to receive commissions from the growing professional community in landscape architecture and garden design. Her usual charge was $10 for a finished 8-inch x 10-inch print and for one standard size hand-colored lantern slide record. She required of her clients a minimum order of no less than ten photographs, and about $100 plus travel expenses from her studio in New York. She told her clients of her requirements beforehand so they would know what to expect:

> As to the time required, the first day in any locality should be given to a general survey of all the gardens to be photographed, and a schedule worked out on the basis of the number of slides and pictures desired by each subscriber. . . . In any garden center, one subscriber sends me on to the next. . . . Frequently my clients put me up over night to save time and effort.[24]

A Return to the Old World

In 1925, Johnston returned to Europe for a seven-month stay. There, she built upon her growing specialty, photographing gardens and landscapes—in this case, "mainly the Spanish castles, Italian palaces and French chateaux of the Vanderbilts, Astors, Whitneys and Goulds."[25] Johnston would exhibit 150 prints of her European photographs in a private show entitled "In Old World Gardens" following her return. This was mounted first at the Ferargil Galleries on 37 East 57th Street and later at the Brooklyn Botanical Garden. These shows emphasized her growing reputation in this fairly specialized area. She continued her lecture and exhibition circuit throughout the 1920s, and her photographs and articles on gardens remained in great demand among monthly and weekly magazines such as *Munsey's, Vogue, Town and Country, Arts and Decoration, House Beautiful, Studio*, and *Home and Field*. As she reached the age of sixty, Johnston's career was finally well established. Not really a part of the 1920s avant-garde, she appealed to the American mainstream through leading art and women's journals.

She continued her travel-writing approach to promote the landscapes she portrayed. By 1924, Johnston had developed the idea of publishing *A Garden Guide to Europe* and by January of 1927 claimed to have had chapters one and two "well on the stocks."[26] Although this publication was not realized due to the high expenses involved, Johnston managed to incorporate much of her research into her lectures. She afterward would place more emphasis on her photographs published frequently in magazines and on her lectures. Yet she still relied heavily on her writing. Captions Johnston provided for each of her photographs—for example, those published in *Town and Country* during the late 1920s—were usually three pages, single-spaced, and included information about the history, physical description, and aesthetic experience of the site.

The book that Johnston had hoped to publish was intended to be similar to Edith Wharton's *The Italian Villas and Their Gardens* (c. 1904), which expressed an appreciation for Italian landscape design similar to Johnston's. Johnston had photographed Wharton's home for *Town and Country* in July of 1927, and this photograph was later used for publicity purposes by Wharton's publishers, D. Appleton and Company.[27] Johnston enjoyed Wharton's book and claimed, two years before she would photograph

Wharton's home, that "to the layman nothing has yet appeared to take the place of Ms. Wharton's delightful book."[28] To write *Italian Villas and Their Gardens*, Wharton had researched books in four languages dating back to the seventeenth century, publications that were also well known to Johnston. Wharton's book included biographical sketches of about sixty historically significant garden architects and an examination of villa gardens accompanied with sketches. However, any potential collaborative project involving gardens was never brought to fulfillment for Johnston. Her own reputation would be made mainly with more local subject matter, though her interests in European gardens, especially Italian ones even in the United States, remained strong. Furthermore, Johnston would focus less on the lives of landscape architects and more on the history of the garden sites.

Wharton, Johnston, and other essentially conservation-minded Americans at the turn of the century were attracted especially to the utility and beauty of Italian villas and the ways that Renaissance garden ideals generally expressed harmonious relationships between the lives of the occupants, architecture, and natural surroundings. For example, members of the Senate Park Commission—Frederick Law Olmstead, Jr., Charles McKim, Daniel Burnham, and the famous American sculptor Augustus St. Gaudens—traveled to Europe during this time to better understand how to revive the 1791 L'Enfant Plan in Washington, D.C.[29] Johnston also believed Americans needed to discover European "Old World" gardens for themselves. Italian gardens of the Renaissance formed the foundation of landscape design. These had important implications for landscape design in England two centuries later and eventually, via English gardening ideals, on North America as well.[30]

Civic Values of Gardens

Johnston's typical garden photographs incorporated architecture as a significant component of the landscape. In her lecture notes Johnston explained that the formal garden of an Italian villa and surrounding landscape formed one complete pictorial composition along with ivy-covered tool sheds and outbuildings. Believing that Italian gardens were aesthetically relevant to the American public, she envisioned citizens nobly cultivating flower borders and pruning young shrubbery within their small suburban plots. Tending a

garden was elevated to "giving an enclosure a livable quality in combination with the beauty and charm of the garden ideal, a series of pictures painted with growing things carefully related and set in their proper frames."[31]

Johnston's garden photographs and lectures were part of a general suburban movement focusing on the private American garden. This interest was galvanized in the 1910s, when Johnston first began taking pictures of gardens as a specialty, though there are certainly earlier antecedents as well. The 1910s were marked by a growing number of gardening manuals and books, mainly emphasizing what might be considered regional types of gardens. A strong sense of purpose was suggested in many of these publications, and many had the qualities of tracts. Robert B. Cridland, in *Practical Landscape Gardening* published in 1918, explained that the art of landscape and garden design helped homeowners as well as their neighbors better enjoy their surroundings. This was accomplished through the creation of vistas and pathways to make provisions for pets, walks, and drives. He considered that gardens, as expressions of the tastes and personalities of homeowners, should be planned thoughtfully as true reflections of owners' sensibilities. Furthermore, gardens were to be shared with others as a way of spiritually refreshing the community.[32] Louise Shelton, author of *Beautiful Gardens in America* first published in 1915, explained that when people appreciated the beauty of plants, they were reminded implicitly of the values of gardeners, such as joy, peace, stillness, simplicity, truth, finding sanctuary and a place for dreaming, labor rewarded, hope, trust in the source of life, and harmony with the universe. Through gardening and an appreciation of gardening, Shelton stressed that one could "seek the simpler life many are now craving—one of creation and nurturing."[33]

As did Cridland and Shelton, Johnston believed that gardens, like beauty, were moral necessities rather than idle luxuries or displays of status. In her lectures, she emphasized that gardens "rounded-out" existence.[34] American gardens furthermore were distinguished as being more practical than European ones as they often included herbs and flowers used for brewing teas and for children's medicine, and boxwoods used for bleaching linen. Here again Johnston demonstrated her profound interests in antiquarianism, folklore, and early American history—the very interests that would lead her eventually to her study of early American buildings as well as their landscape settings.[35]

Johnston, along with many other garden writers, believed that a beautiful garden would, in turn, help to inspire stewardship in a broader sense. A garden was seen as a microcosm of the larger world, and caring for it was a first step toward protecting national assets and increasing the value and interest of the whole community. Shelton's text featuring Johnston's photographs encouraged Americans to make their own gardens so that in their variety and quantity gardens could embody the poetic and artistic sense of America. Gardeners could sustain plants that were metaphors "for the combined dreams of the many minds which gradually evolved them."[36]

In her lectures and other garden club activities, Johnston emphasized that gardens were active community pursuits rather than retiring individual pastimes. The main proponents of this approach to gardening were members of the Garden Club of America for whom Johnston would take some of her most important historic photographs. Johnston became a mouthpiece of this national organization, and garden club members became a large part of her audience. They helped to push for beautification as well as early conservation legislation. Members of various garden clubs also helped select photographs used in Shelton's book. They appreciated Johnston's photographs so much that in the revised edition of 1924, they substantially increased the number of photographs taken by Johnston. As Louise Shelton explained in the preface of her book, the revision was necessary in part due to the higher quality of photographs available. Photographs chosen by garden club members also included those of Johnston's colleagues to a lesser extent, including Mattie Edwards Hewitt and Jessie Tarbox Beals.[37]

The Garden Club Movement

Johnston's approach to garden photography reflected the aspirations and philosophy of the Garden Club of America. Membership in America's first garden club, organized in Athens, Georgia, in 1891, soon extended to "every lady in Athens who might be interested in growing anything, from a cabbage to a chrysanthemum."[38] At their meetings the first year, the women listened to lectures from horticulturalists and exchanged cuttings and seeds to experiment within their own gardens. Pioneer flower shows, as they were referred to at the time, were intended to publicize to others not necessarily in the group the precision and artistry involved in flower, fruit, and vegetable gardening.[39]

Activities of the Garden Club of America emphasized preserving the gardens and scenic heritage of the Old South, and the care of trees and plants also meant fostering civic improvements and the cultural enhancement of their communities. One writer for the *Athens [Georgia] Banner* in 1891 perceived that while the newly formed club members had little to do with "reforming the tariff of the republic, by raising their home supplies and teaching the folly of over-production of cotton, they can have much to do with raising the price of cotton."[40] It was generally recognized that those in the garden clubs, as wives and mothers of the town's most established and well-endowed families, had a great deal of social and political influence. Members locally and nationally became involved in tree conservation; garden therapy; the founding of botanical gardens; the publication of garden books; early historic architectural preservation efforts; the landscaping of schools, universities, and other public buildings; scholarships for college students; and pioneering scenic and conservation legislation including regulation of outdoor advertising.

The garden club movement grew enormously during the 1910s and 1920s, when Johnston herself was most involved in this aspect of her career. The aim of the Garden Clubs of America was to mount a well-organized, strongly supported, and essentially grassroots effort overall to protect and maintain the nation's scenic character in the broadest sense so that activities promoting the conservation of the natural environment and the restoration of historic buildings and landscapes were mandatory. Johnston would continue to depend on this national organization as well as local chapters and individual garden club members throughout her later career. When she began her architectural recording project in 1927, it was generally garden club members to whom she turned for advice and assistance.

American garden photography received more recognition as an art form with the increase in gardening activity beginning in the early twentieth century. In a 1917 *Touchstone Magazine* article, Johnston explained the relationship of gardens to the fine arts in this way:

Gardening has been called one of the most sensitive of the fine arts, and the making of a garden as near as a man may get to the exercise of divine powers. If art be an expression of beauty, then gardenmaking should be ranked among the fine arts, for gardens touch the imagination as surely as

a picture or modeled figure. . . . But a decade ago America had, properly speaking, no gardens, and therefore of course no paintings or photographs of them. The most wonderful thing about America's gardens is the interest that has so swiftly sprung up in gardenmaking as a fine art.[41]

Garden photography promoted and recorded gardens as art. Photographs, published in popular magazines and books, made private gardens accessible to anyone, regardless of whether he or she owned property. Photography was repeatedly praised by writers and critics as an indispensable tool for those desiring guidance in home improvement.

Johnston's photography and lectures focused on what is now commonly referred to as the City Beautiful Movement, a movement that advocated the reclamation of urban backyards as community gardens. Owners of old estates in the course of renovation were encouraged to donate their old plants, shrubs, and trees to beautify the grounds of newly built homes. People generally believed that growing gardens and transplanting flowers promoted neighborliness and friendliness. Slogans of garden clubs included: "Let us have backs to our houses as well as fronts."[42] In Robinson, Illinois, anyone actively interested in street trees, backyard flowers, window boxes, house plants, aquaria, and "green spots" was eligible for membership and urged to attend garden club meetings. The Robinson Beautiful Movement, as this ad hoc organization was labeled, reflected the community's concern for locally adapting principles of the City Beautiful Movement. Johnston kept files of clippings such as these, demonstrating her own adherence to the same creed. Her correspondence with and work for landscape architects, architects, and planners who were involved in beautifying towns and cities show that she was responsible for many successful landscape projects.[43]

Beautiful Gardens in America

Johnston and Hewitt's earliest photographs of gardens throughout the United States were printed in the original 1915 edition of Shelton's *Beautiful Gardens in America* and later in magazines. The two photographers supplied over half of the illustrations for the 1924 revised edition of Shelton's survey of American gardens. Supplying the book with twenty-nine photographs, Jessie Tarbox Beals also turned to garden photography during this time, first for real estate agents and then particularly for wealthy patrons in the

late 1920s. The commission for Shelton represented a major breakthrough for Johnston and Hewitt, marking what might be considered the mature period of their collaboration, before it ended in 1917. The photographs of garden features, vistas, and ornamental plantings represent their shared traditional or Victorian genteel aesthetic approach. In these photographs Johnston's more traditional preoccupations with quiet beauty and domestic pleasures come to the fore.

The gardens that Johnston photographed were lavish, meticulously maintained scenic properties, mainly belonging to wealthy estates. Shelton's book was intended for a large audience, one whose members might not ever own an estate but who could at least appreciate the view vicariously and perhaps incorporate some of the design and gardening ideas into their own backyards. Johnston took 93 of the 195 photographs showing gardens in 25 states. Seen together in Shelton's book, they express a kind of American landscape mythology, with each state or region representing certain patriotic sentiments more than any shared types of plants, climate, growing season, or topography. New England was emphasized for its ties with England through Pilgrim settlement. The author's hope that the Atlantic Coast "promises to become almost a continuous garden by the sea from New Jersey to Maine" expressed an increasingly popular Colonial Revival attitude that focused on an idealized understanding of New England colonial life for a more unified cultural and national identity.[44]

The rest of the nation was considered at a disadvantage. Of all the southeastern states, Virginia was given the most attention with twelve photographs, and its historic ties with the more pleasure-loving, less puritanical Episcopalians were noted. Other southern states as well as the midwestern states were included briefly. The Rocky Mountain region was omitted because, as Shelton explained, with the exception of Denver, Colorado, "this part of the country, as a rule, is not in its nature open to the cultivation of gardens."[45] Always the appearance and number of gardens correlated with the cultural significance of a place. If the region was perceived to have relatively little historic value, then its natural environment was less desirable for gardening.

California, on the other hand, maintained the aura of an exotic paradise because of its perfect garden climate; its associations with the American western frontier, the New Eden, and Promised Land; and its ties with the

Old World, particularly with the Mediterranean region. Similar to nineteenth-century American landscape paintings depicting migrations to the West, Shelton maintained the mythology of this region with the inclusion of thirty-one photographs of California gardens, almost as many as those in Massachusetts. The final section of Shelton's project ends with one photograph of a garden in British Columbia, added for its attraction to England. Just as America was formed through its separation from England, the implication is that it still requires inspiration from the motherland to become properly fulfilled.[46]

Responding to Aesthetic Traditions

Johnston preferred the imagery of her photographs to resemble pastoral landscapes in keeping with traditional European and American landscape models. Each of her garden photographs was designed to convey a unified image about America. Although they represented various regions, the gardens patterned after European models, particularly Italian and English gardens, were similar in style, just as the industrial landscapes she photographed had a sameness about them. Her own discovery and veneration of European garden landscapes typified a common traditional nineteenth-century American attitude. European gardens and landscapes, and art generally, were perceived by American artists, landscape architects, and planners as superior to those in America.

Johnston, like many other American painters and photographers, tried to forge an American identity while looking to European art for education and inspiration. The generic qualities of Johnston's garden photography were a reflection of traditional American landscape art, which adopted a variety of European classical sources, often without considering local physical and historic contexts. The creation of a distinctly American artistic identity, a major aim of artists in the twentieth century, also had been a primary motivation for nineteenth-century American landscape painters such as Asher Brown Durand (1796–1886), who advocated the direct use of the American outdoors for realistic landscape paintings. His 1855 series of letters published in *The Crayon*, probably the most significant and influential art periodical of the mid-nineteenth century, had a significant impact on the sensibilities of both artists and the public.[47]

Just as landscape painting in America gained prominence as an art form

during the nineteenth century, because it showed an idealistic alternative to actual industrial areas that gradually were replacing more pristine landscapes, pictorial photography likewise gained acceptance as an art through the use of traditional picturesque imagery. Johnston's early twentieth-century garden photographs, as opposed to her late nineteenth-century documentary photographs of rather bleak landscapes in magazines, served as a traditional escape from urban areas and landscapes affected by industrialization. The outdoor places she photographed were considered to be more acceptable for women to visit and even manage, a domain clearly missing in her earlier documentary photographs of less beautiful, industrial landscape scenes.

For artists such as Charles Herbert Moore, the precise presentation of tranquil scenes, such as in his pen and ink drawing entitled *Pine Tree* (1868), became more important than any painted landscapes expressing the human will or ego, in modern, post-Freudian terms. Recording natural history as carefully as possible, Moore thought that observing the minute details of small specimens was a way of communing with nature and losing one's self or being. His sketches of Yellowstone, the first visual records of this area, were reworked by Thomas Moran into a series of fourteen black-and-white wash paintings. Wood engravings made from these were published in *Scribner's Monthly* one year after Moore visited Yellowstone. Moran's paintings of Yellowstone, in turn, were significant for developing national support for the formation of the National Park Service.

Other American landscape painters such as Albert Bierdstadt also answered the public demand for accurate pictures of a distinctly American landscape imbued with more Romantic overtones. Photographers attached to government survey teams as well as individual entrepreneurs of the 1860s and 1870s, including Carleton Watkins, William Henry Jackson, E. O. Beaman, Eadweard Muybridge, and John K. Hillers, showed the West as an unpopulated wilderness ripe for exploration and settlement. These American photographic images, even more than the Moran paintings, were seen by a large public, and through publications and purchases of the West survey photographs, all helped as well to sustain national support for the idea of setting aside wilderness areas through the formation of the National Park Service, an event closely followed by Johnston who saved newspaper clippings and attended scheduled events.[48]

The wilderness pictures, common features in many middle-class homes by the early twentieth century, allowed Americans to look on the West with patriotic endearment. The entrepreneurship of artists depicting western landscapes was in keeping with Johnston's own albeit less adventurous business approach to photography when she first began to specialize in garden photography. More important, she appreciated the national scope of their conservation efforts. As a landscape activist herself, she hoped that her garden photographs would likewise be seen by a large public, who would then mobilize their efforts to preserve landscapes outside designated wilderness—places that still were not being perceived or protected as landscapes because they were considered populated rural and industrial areas. Johnston's picturesque records of gardens, depicting the overall scene more than minute details, hence underscored the work of the Garden Club of America.[49]

William Sturges, an architectural historian who was another member of the same artistic group as Charles Herbert Moore known as the Society for the Advancement of Truth in Art, would be one of the first to encourage the systematic documentation of American colonial architecture. This systematic attention to recording in detail would be valued by Johnston as well, and it could be argued that her distant connection with Moore was more than a coincidence. The Society for the Advancement of Truth in Art, based on the aesthetic principles of artist and art critic John Ruskin (1819–1900), stressed the importance of landscape as works of art and the importance of seeing nature directly in order to record it. This group would influence as well the work of many late nineteenth-century American surveyors, geologists, and accompanying landscape photographers.[50]

Many in the artistic world saw no real differences between the verisimilitude of Charles Herbert Moore's drawings and the accurate detailed views captured in photographs. The Society for the Advancement of Truth in Art, more than lauding the qualities of accurate and detailed paintings, promoted photography as an artistic medium. However, the goals of art and science by the end of the nineteenth century were perceived by many to be diametrically opposed. Since photography could render nature objectively, it was seen as a more useful scientific tool and therefore was considered less seriously as an artistic process. Visual replication of the world in turn was gradually left behind by American landscape painters, many of whom

wanted to show more imagination in their art—the art in nature that photography could not depict. The gardens Johnston photographed, and Louise Shelton wrote about, emphasize the imagined perception of the American landscape as a large grouping of distinct cultural regions more than a scholarly concern for information about individual plants. As a result, overall impressions of the visual world and how one responds emotionally to art in nature mattered more for Johnston in her photographs. This same kind of traditionally picturesque aesthetic orientation would be characteristic of the photography of Stieglitz and the Photo-Secessionists, who themselves attempted to break away from mere representation. Johnston, again, would straddle the line between verisimilitude and atmospheric and psychological effects.[51]

Picturesque Qualities of Garden Photographs

Johnston's photographs illustrating picturesque qualities of a garden emphasize deep perspective. She photographed long pathways so that they become the central focus. Ordered symmetry of compositions further enhances the grandeur and vastness of garden landscapes, such as in the autochrome photograph of "Mariemont," the estate of Mr. and Mrs. Thomas Emery in Newport, Rhode Island.[52] Flowers layered in size, backed by taller shrubs, line each side of the central grassy walk. The emphasis of Johnston's photograph is not on the spontaneous individual response to smells and colors of flowers but on the overall effect of the garden design. In her black and white photograph of "Thorndale," the estate of Mr. and Mrs. Oakleigh Thorne of Millbrook, New York, the centered grass walkway is lined by meticulously pruned boxwoods and small trees[53] (figure 19). The partially obscured hillside at the end of the path appears hazy in the distance. Johnston used the vista at the end of the path to draw in the viewer, but the garden is a place requiring observation more than walking.

Another technique Johnston employed in her garden photography is the use of focal points to create interest within long, straight paths. These pull the viewer into Johnston's pictures and into the landscape visually. For example, in her photograph of "Willowbank," the estate of Mrs. Joseph C. Bright in Bryn Mawr, Pennsylvania, Johnston focused on a fountain in the distance for the center of her composition[54] (figure 20). The fountain in the

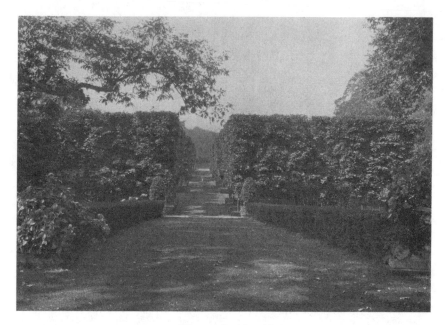

FIGURE 19. Thorndale, New York, c. 1920

background is framed in the foreground by a canopy of flowering shrubs. A horizontal row of flowers just behind a still, rectangular pool forms the base of this frame, obstructing the threshold. Leaves and flowers are reflected in the water. In addition to creating a distant focal point within the central clearing, Johnston made use of alternating light and shadow as a means of moving the viewer forward. This technique relates to window views of forest interiors whereby space is compressed as the foreground and the distant background become telescoped. To enhance visual interest, Johnston typically photographed architectural and sculptural features to one side, creating a diagonal interplay between the foreground and background, a technique she also employed for her images of Yellowstone National Park and the Mesabi Range. In her garden photography, however, the diagonal arrangement simply provides aesthetic balance and closure within her compositions.

Johnston received recognition for the picturesque qualities of her garden photography. In 1921, Hildegarde Hawthorne, a writer for *The Touchstone and The American Art Student Magazine*, had high praise for Johnston's photographs of California gardens:

No picture by man can give such color [as those found in California gardens]. Only hints and suggestions may be achieved. But somehow, in the photographs of gardens taken in that magic land by Frances B. Johnston . . . a quality of that color is found. In these delicate and rich brown tones, these gradations of light and shade, you feel the radiance and the glow, the hot sunlight, the veils of green. Gardens are, with Miss Johnston, a passion. She spends her life photographing them, talking about them, chanting their litany of loveliness. How richly she suggests the mystery of the open door leading into the gloom beyond the gold of the sun, the glimmer of foliage. How she catches the careless art of curving bough, framing a picture of enchantment, the nobility of mounting stairs, the contrasts of mass and mass. She is an artist, an artist in color as well as in form, and certainly to any of us who know the beauty of California's gardens, the splendor of color, Miss Johnston gives in her pictures a thrill, recalls a gorgeous memory.[55]

The Universal Garden

A comparison of Johnston's garden photography with that of other contributors to Shelton's book and to Winifred Starr Dobyns's *California Gardens* (1931) helps to highlight Johnston's point of view and photographic aims, despite the fact that all of the photographs of Italianate gardens featured in Shelton's and Dobyns's books have a number of similarities. The black and white photographs in these publications, emphasizing symmetry and geometric order, show a detachment from nature and life. The contrived, manmade environments, furthermore, are generic, so that a garden from Pasadena, California, easily could be mistaken for one in South Hampton, Long Island. Johnston, in particular, concentrated on the universality of the gardens as a corrective to modern life. She took the viewpoint of a pedestrian to explore small-scaled features using the same travel-writer sensibilities of her earlier landscape photographs. More important than any local life or the individual experience of enjoying the natural environment is the classical imperative.

Similarities among the photographs in both Shelton's and Dobyns's books reflect the generic character of the gardens portrayed in magazines and books to promote the work of landscape architects who designed them,

FIGURE 20. Willowbank, Bryn Mawr, Pennsylvania, c. 1920

such as the restored gardens at the turn of the century and of the 1920s featured in one of the most important works of the period, *Historic Gardens of Virginia*, published by the James River Garden Club in 1923 and other Garden Club publications such as *The Garden History of Georgia* (1933). Wealthy American clients, familiar with gardens of Italy, France, Spain, and England, publicized their travels by imitating the gardens they had visited. In their desire to share in the cultured language of classical architecture and gardens that had previously been reserved for monarchs and the landed gentry, upper- and upper-middle-class estate owners mostly ignored the historic significance of their own landscapes and garden designs that would be more sensitive to local climactic and cultural conditions.[56] In her book *California Gardens* (1931), Winifred Starr Dobyns summed up these preferences:

> Overnight palaces and villas seem to spring into being on barren hills and in wooded canyons. Within a short year a garden will blossom where yesterday only greasewood and scrub oak clothed the ground. Wealth and art together have been employed to lay out many of California's gardens.[57]

Contemplating Personal and Public Spaces

Johnston understood this cultural aristocratic viewpoint to a degree. Nurtured during the genteel period of the late nineteenth century, Johnston showed in her portraiture of Washington society that she was familiar and even comfortable with the certain cultural restraint and propriety of elitism. In following a certain prescribed aesthetic model, Johnston conveyed the sensibilities of the wealthy estate owners and of the landscape architects they commissioned.

Johnston's photographs of California gardens for Shelton's publication presented these places so that more information about the expansive gardens appears in one of her photographs than in those of the other photographers featuring the same gardens in Dobyns's book. For example, her views of the DeWitt Parshall estate in Montercito included a photograph of a set of three reflecting pools spaced apart to resemble a canal.[58] To create a deep perspective Johnston focused on the rectangular masonry pools, in much the same way she typically photographed walkways. Sprawling

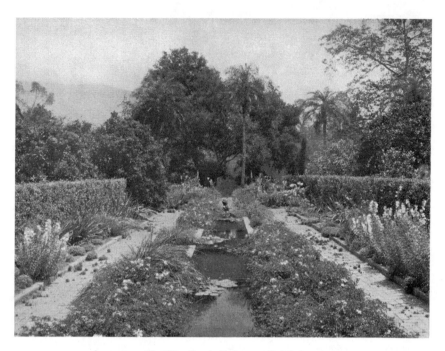

FIGURE 21. DeWitt Parshall Estate, California, c. 1923

ground cover flanks either edge of the pools, which are in turn flanked by masonry walkways. A flower border outlining the walkways is contained by a manicured shrub hedge behind it. Beyond the three pools is a small centered statue, with tall trees behind it in the far distance.

Another view of this garden, also in Dobyns's book, is a photograph by James Walter Collinge showing another rectangular pool from a diagonal perspective.[59] At the expense of deep perspective, symmetry, and formality, Collinge placed the entire pool closer in the foreground, conveying a more intimate picture of water lilies adorning one corner of the surface. More than Johnston, he showed another concern of the cultural gentry: that of refuge and intimacy. Johnston, more concerned with the overall appearance of the gardens, emphasized contrasts within the garden to create aesthetic harmony in her composition. Typical devices included the balancing of natural plant life and architectonic features, which suggests the contrasting qualities of intimacy and grandeur, foreground and background, horizontal and vertical.

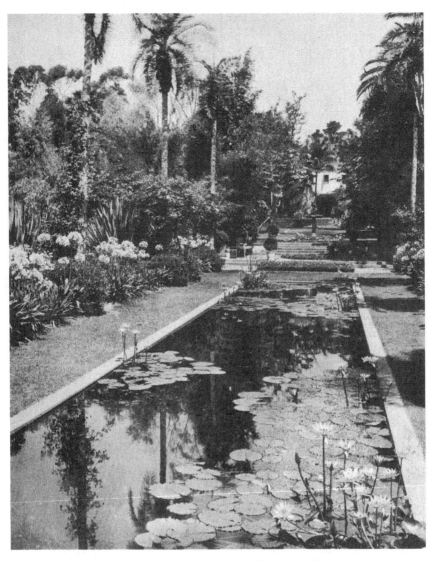

FIGURE 22. DeWitt Parshall Estate, California (Collinge), c. 1923

The more complicated subtlety of Johnston's approach can be seen best in her photograph of the estate of Mr. and Mrs. John S. Severance in Pasadena, California.[60] Johnston's view of the pool, taken at an angle to maximize the amount of detail in the foreground as well as the background, ensured the greatest amount of visibility of the estate grounds. A column overgrown with a flowering rose vine stands nearest in the foreground to the left, echoed by two columns less clearly seen in the distance across the pond. All but one end of the pond can be seen, including the hazy distant trees behind the garden wall. While the view suggests an expansiveness, the actual pool is quite cloistered, surrounded by walls and arcades. Furthermore, sunlight on the roses makes them shine in the black and white photograph. A shadow of a fence is cast across the still water containing water lilies as well as shadows of decorative grillwork located along the masonry edge at the base of the column. The iron fence atop the masonry garden wall and trees and sky of the background are reflected in the water as well. While focusing on the illusions of the garden expressed through its artistry, Johnston remained attentive to the physical reality.

Hiller's photographs of the Severance estate pond included in the Dobyns publication do not share the same subtlety of artistic vision[61] (figure 24). Hiller pictured the pool frontally from first one and then the other side in separate photographs. He clearly preferred closer views of the pond, taken at an angle to focus on the grottoed garden wall at one end and an arcade on the other. Unlike Johnston's photograph, Hiller's photograph shows minimal interplay of light and shadow, little variety of textures and forms, and no creative placement of objects to attain a more aesthetically interesting composition.

Johnston's photographs show a preference for plant life within the gardens, and architectural components are less prominently presented than in other photographers' versions of the same garden. For example, the balanced arrangement between architecture and plants is apparent in Johnston's photograph of a pool at "Las Tejas," the estate of Mr. and Mrs. Oakleigh Thorne in Montecito, California.[62] Unlike Collinge, who photographed this scene for Dobyns's book,[63] Johnston avoided the inclusion of the statues on top of masonry pedestals by focusing more closely on the pool. The shrubs, rather than the statues behind the pool, form a visual entrance as gateposts.

FIGURE 23. Severence Estate, California, c. 1923

FIGURE 24. Severence Estate, California (Hiller), c. 1923

Johnston used architectural features to frame the composition of her garden photographs for a predominant view of the landscape beyond. Her emphasis on the view of the landscape, rather than specific plants or architectural features, is in keeping with her previous landscape, portraiture, and news photography. For example, in another photograph of the Thorne estate designed as a winter home by Helen Thorne for herself and her husband in Montecito, California, the vantage point from within an archway centers on the large, rectangular pool beneath a terraced landscape, a series of axially organized garden rooms created with hedges, the central space being left open[64] (figure 25). At the top of the terraced hill stands another arcaded masonry building reflecting the southern façade. A barely discernible mountain in the far distance and the sky can be viewed through the archway. The mirror reflection of imagery creates a panoramic expansiveness and suggests a kind of cosmic harmony. Johnston's photograph about repose presents a sense of timelessness within a highly altered, artificial, and controlled landscape. The tightly controlled manmade garden environment is not simply an achievement over nature. Apart from the arches facing each other, the role of architecture is relatively slight, and the structural qualities of the garden, as a geometric and ordered environment detached from the viewer in shades of black, gray, and white, and the play of light on its components are emphasized. The Italian Renaissance classical ideals of order, clarity, simplicity, harmony, and proportion are evoked by the formal architecture of plants. Nature is being idealized.[65]

Similar to other rich amateurs of the time, Helen Thorne's eclectic tastes were based on her travels abroad. Her extensive gardens included a wildflower field, a small masonry gazebo with brick arches and fifteenth-century Romanesque-style columns from southern France, a knot garden, a heliotrope garden, a Spanish garden, a Japanese garden, a rock garden, orange and apricot orchards, and a small cactus garden, created later by Anne Stow-Fithian. While her garden types were as elaborate and varied as an Imperial Roman villa, Thorne's garden designs showed restraint and control. She staked out the two principal gardens herself with a theodolite she taught herself how to use, and she practiced water conservation by using drought-resistant shrubs and minimal planting of grass. Johnston focuses on the harmoniousness of the formal gardens within the surrounding environment, and no single component of the photograph dominates another.

FIGURE 25. Thorne Estate ("Las Tejas"), Montecito, California, c. 1923

Rather, parts such as the terraced hedges, the arcades, and the mountains and sky reflected in the water are repeated visually as a continuous whole.

A comparison of Johnston's garden photographs with those of Eugene Atget shows how both photographers shared similar concern for the junctures between personal and public spaces and how a place can remain intimate and solitary, as in Johnston's photograph of Willowbank showing a statue in the distance, framed by the canopy of trees on either side of a straight pathway and her photograph of the Thorne Estate showing reflections of trees separated by a waterway in a still pond in the foreground. Vantage points include the archway and distant end of the waterway where there appears to be a small building. Even though Johnston's garden landscapes are more manmade and well kept while Atget's are more rustic and overgrown, the similarities of their composition show a shared concern for the individual, reflection of thought, and inner peace.[66]

Returning to Historic Landscapes

Johnston's turn-of-the-century imagery of gardens appears geometric and ordered, detached from the viewer in shades of black, gray, and white. The gardens are tightly controlled, manmade environments celebrated as achievements over nature, much in keeping with the Renaissance spirit. Johnston gradually moved away from the picturesque presentation of these gardens located throughout the nation to portray more historically accurate landscapes in the South. For example, in her photograph of the Hayes House in Edenton, North Carolina, she focused on the wide-open gate in the foreground[67] (figure 26). Shadows of trees mark the dirt road beyond the gateway that leads to the main house in the distance. Partially obscured by shrubs and trees, the house appears in harmony with nature.

Ruins, traditionally used in art, are used similarly by Johnston in both her garden and architectural photographs to present the ongoing conflict between nature and culture, the victory of time over human efforts, the decay and impermanence of the built world, within authentic historic contexts. While the use of ruins in the turn-of-the-century gardens Johnston previously photographed were modern structures designed to evoke the past of Italy, the ruins presented as part of the Carnegie architectural survey undertaken in the 1930s have a history of their own. For example, in Johnston's

FIGURE 26. Hayes House, Edenton, North Carolina, c. 1936

architectural photograph of the former Saint Philip's Church in Brunswick Town on Cape Fear River, Brunswick County, North Carolina, the picturesque brick ruins appear luminescent in dappled sunlight. Through a round-arched doorway flanked on either side by rectangular openings that serve as a gateway, the forest is clearly visible.[68]

Johnston's focus on vines, like ruins, was another use of the picturesque to evoke historic character as well as to emphasize the physicality and vulnerability of structures such as the tower of the Chapel of the Cross in Chapel Hill, North Carolina;[69] the porch of the Weaving House, located in Watauga County, North Carolina;[70] and one side of the porch at Harrietta Plantation.[71] Other landscape photographs by Johnston, particularly in Stoney's book *Plantations of the Carolina Low Country* (1938),[72] feature historic plantings and grounds, such as the well-manicured lawn and shrubs, and the live oaks forming the Double Avenue at Medway; the rice field at Mulberry, which is framed in the foreground by the trunk of an old tree; and a close-up view of a large magnolia shrub at Magnolia Gardens.[73]

FIGURE 27. St. Philips Church, Brunswick County, North Carolina, c. 1936

Johnston's emphasis on the well-tended plants and carefully preserved natural environment imply that a way of life has been necessary for these landscapes to exist, and her photographs show how the past has changed over time.

Johnston's eventual change of focus to historic buildings in their landscape settings was a response to her own recognition of the limitations, or even the logical shortcomings, of newly created gardens as a subject for her photography. The historic garden landscapes that Johnston would photograph for the Carnegie Survey usually were inheritances that had the regular care of one family line and often consisted of more varied, native arrangements. Johnston's later photographs of historic architecture show more traditionally picturesque landscapes that truthfully document the South and reveal a more sensitive balance between humankind and the natural environment, because a historic context has been allowed to exist.

Historic Architecture

JOHNSTON SAW THE historic buildings and architecture of the South as fading reminders of the past, disappearing quickly before her eyes, and she conceived of her job as "hurrying on the road ahead of the march of neglect and progress."[1] Her allusion to Sherman's march to the sea suggests a personification of architecture as the victim of another kind of war. Her concern is with the buildings themselves, and issues of class, gender and race become irrelevant.

For Johnston, recording architecture was a kind of portraiture. Accumulated representations of historic buildings were especially significant as portraits of a cultural heritage. She thought that such representations were necessary for the understanding of America's cultural heritage. At an informal talk at the University of North Carolina art gallery on March 21, 1937, Johnston quoted from the introduction of the book *Houses in America* by Ethel Fay and Thomas P. Robinson:

> When you build a house, you make a record of yourself, and experts in houses can tell by the house you build and live in what kind of a person you are. . . . The story of houses is the story of the people that made them. The history of a country could be written from the study of its houses. It would be a better history than the ones written from a study of wars, because it would tell about people when they were creating things and not when they were destroying them.

Such a history has not been written, but the materials that help to make it are being collected. . . . Houses have ancestors just as people have, especially good houses. A good house does not boast of its ancestors, it just cannot help showing that it has them and who they are.[2]

The significance of Johnston's architectural photography within the context of early twentieth-century interests in American history and architecture was Johnston's desire to increase public awareness and call attention to what she saw as a pressing social need. Her aim was to make a lasting record of buildings that were threatened with demolition or neglect. She emphasized that her photographs, besides serving as a more strictly academic architectural record, could be used by craftsmen to reproduce historic details.

A major, if not the most important, aspect of Johnston's work is her record of historic architecture in the southeastern United States. Towns and cities in this region, including Fredericksburg, Virginia, and St. Augustine, Florida, were places where citizens began to make important strides in preserving older buildings and whole historic districts, such as in Charleston, South Carolina, and New Orleans, Louisiana, where historic preservation efforts in the region essentially began. Johnston's architectural record of the South was unprecedented in the number of historic buildings that were systematically surveyed in a region that covered nine states. It was this architectural work that set Johnston apart from other photographers of her time.

Early American Restoration Efforts

In Johnston's time, the official architecture and the houses of wealthier architectural clients were still dominated by European standards, both in design and historical references. This, of course, reflected a long-standing native prejudice. Colonial architecture was scorned for its primitive character and lack of adherence to traditional European academic standards. The American architectural profession was slow to change its outlook, and it remained married to European precedence well into the late nineteenth century. Most American architects, trained particularly at the Ecole des Beaux-Arts, accepted the necessity of traditional architectural training, with the hope that their profession would come to be considered a fine art, not

just a business. Architecture, above all, was meant to be tasteful, improving, and fashionable. As a result, buildings dating to the seventeenth and eighteenth centuries, viewed as unsuitable for modern use, were frequently pulled down to make way for newer, more up-to-date buildings.[3]

In the mid 1890s, Johnston first became acquainted with the Colonial Revival movement, an outgrowth of a new pride in America's past, and began to collaborate with the architects and antiquarians who promoted a reexamination of early American architecture, particularly Federal and Georgian buildings. She received commissions from Bertram G. Goodhue, John Russell Pope, Charles A. Platt, Grant LaFarge, Charles McKim, and others responsible for what were then recently constructed (though now historic) houses on private estates. In many ways this work served as a referral for her later work funded through Carnegie grants, teaching her techniques and helping her sort out worthwhile approaches from less useful ones. The New York–based architectural firm of McKim, Mead and White would use Johnston's photographs of the White House and other key Washington, D.C., buildings for restoration purposes as early as 1903. These included photographs of the Washington Monument, Lincoln Memorial, the Capitol, and the Octagon house designed by William Thornton in 1798–1800. The 1901–02 McMillan Commission, headed by the Chicago architect Daniel Burnham, developed a new neoclassical plan for the capital's monumental center, extending and reasserting Pierre Charles L'Enfant's original scheme. The restorations, initiated with Johnston's photographs and directed by the New York architectural firm, were to play an important part of the new plan. During the same period, McKim, as president of the American Institute of Architects (AIA), oversaw the acquisition of the Octagon House as the AIA national headquarters.[4]

At the same time that antiquarian organizations began to recognize and preserve older buildings, American architects began to methodically examine their own historic architecture. This was particularly true in the Northeast, where architects such as Richard Upjohn both examined older buildings, many dating to the seventeenth century, and incorporated elements of their design in their own work. Events such as the Centennial Exhibition, which featured several examples of colonial architecture and popularized the nascent Colonial Revival movement,[5] further helped to promote an appreciation of older buildings.

Johnston's professional photographs of buildings were commissioned by homeowners, builders, and architects after 1900, when it became more common for professional photographers to be commissioned for architectural purposes. Her work of the early 1900s, however, was often overshadowed by the architectural drawings of architects, particularly those of the leading American architectural firm of McKim, Mead and White. Their drawings were used in the well-known *White Pine Series* published between 1915 and 1924, which Johnston used and cherished.

Johnston and Hewitt moved to New York City in 1913 to photograph newly constructed private houses, a specialty that they recognized was becoming increasingly in demand. According to Johnston, the two women "looked over the field and decided that there was great work to be done in photographing beautiful homes."[6] However, the architectural photography of Johnston, and Hewitt during this period, is not as well known as their garden photography. Even Johnston herself would come to recognize this time of her life as a period when she specialized in garden photography due to her involvement with garden clubs and magazines that stressed fashionable gardens and interior design more than architecture. Johnston's early architectural photographs received little recognition from the architects whose work she featured, mostly because they were struggling for recognition themselves. In promoting their architectural drawings these architects downplayed the importance of landscape in their designs—a significant feature in Johnston's own architectural photographs, which would separate her work from that of other architectural photographers. Johnston's architectural photography of the early 1920s, published in magazines such as *House Beautiful*, *The Architect*, and *Town and Country*, featured the work of architects such as Frank C. Farley, Albert Harkness, Woody B. Wood, Edmund Gilchrist, and William Lawrence Bottomly, the latter also known particularly for his restoration work in Washington. All were architects who incorporated traditional elements into their designs and who have become recognized for their adherence to traditional forms and historic precedent.[7]

Johnston's approach encouraged other women photographers, many of whom began their training and careers during the 1880s when new opportunities were becoming available to them. Women were as interested as men in pursuing architectural photography, as Johnston well knew. Her

future partner Hewitt initially approached her about getting started in this specialty as a potentially fruitful line of business. She wrote to Johnston in 1901:

> Do you suppose any of the magazines or weeklies would want pictures of the Worlds Fair grounds, unfinished work on the buildings in progress, laying of cornerstones. . . . Wish I knew who to address on the subject.[8]

A Miss T. W. Blake sent a portfolio of her photographs for Johnston's inspection and wrote her asking if she would be interested in landscape and architectural photography. Blake wanted to be included in Johnston's *Ladies' Home Journal Magazine* series on American women photographers. Mary Paschall, one of the photographers featured in Johnston's 1900 exhibit, wrote to Johnston that she was interested in photographing buildings for the local county historical society.[9]

Focus on Southern Architecture

In the summer of 1926, Johnston agreed to go on a tour of a number of places in Delaware, Maryland, Virginia, Ohio, South Carolina, North Carolina, Tennessee, Kentucky, and Pennsylvania as part of an assignment to photograph well-known and less well-known gardens for *Town and Country* magazine. The magazine's art director, Mrs. Augusta Owen Patterson, advanced Johnston $600 in return for photographs and texts to be mailed back to the magazine's headquarters in New York City. This was a sizable sum for Johnston and represented an important commission. It was during this trip that Johnston became more interested in the colonial architecture of the southeastern states, an area of photographic expertise with which she later became strongly identified. As she explained:

> It was through my travels after gardens that I noticed the fine old houses which figured so importantly in colonial history and which are falling to wrack and ruin unhonored and unsung.[10]

During a stop in Fredericksburg, Virginia, Johnston met Helen Devore, who strongly appreciated her ideas on gardens and her interest in what would now be called historic preservation. She commissioned Johnston to photograph Chatham, her estate just outside the city limits that she recently

had restored. Johnston expanded this single commission into a proposal for a more extensive photographic survey of the historic architecture of the Fredericksburg and the Old Falmouth region. The photographic project would take three summers to complete. It signaled Johnston's initiation into the tradition of systematic architectural recording surveys and a new commitment to this area of photographic specialization.

Johnston's architectural recording project resulted in a small but comprehensive exhibit that was first held at the Fredericksburg Town Hall. A member of the Women's National Press Club, Johnston made certain that her work received coverage in the national media. She mailed sets of the photographs to be used as Sunday features to the *Washington Star, Baltimore Sun, Philadelphia Ledger, Boston Transcript* and *Richmond Times-Dispatch*. Through subsequent publicity, the Fredericksburg exhibit was eventually shown at the Library of Congress. There, her work attracted the attention of administrators from the University of Virginia; Dr. Leicester Bovine Holland, first incumbent of the Chair of Fine Arts at the Library of Congress; and the Librarian of Congress, Herbert Putnam, along with several members of Congress.[11]

Laying a National Foundation

An early historic preservationist, Dr. Leicester Bovine Holland, who was also the chairman of the American Institute of Architects Committee on Preservation of Historic Buildings and a member of the American Institute of Architects Charleston committee, was very impressed with Johnston's work. Preparing her first survey for more permanent storage with a noticeable commitment to being accurate and methodical, Johnston listed negatives, prints, and enlargements; estimated costs and cash received; cataloged and filed all the films; and put index numbers on the record proofs. She added a card index, as she explained in a letter to Helen Devore that summer, "so it will be easy to identify for future reference any individual photograph."[12] This effort had an immediate impact upon Holland. Expressing interest in her earlier garden photographs as well, he asked Johnston to donate over 5,000 negatives to the Library of Congress to form the beginnings of what would soon be called the Pictorial Archives of Early American Architecture:

FIGURE 28. Johnston in her office

I don't know whether you realize how particular an interest your gift has for me. In the days when I practiced architecture it has been my fortune to lay out gardens now and then, though I never had the actual care of one, and to me it is one of the most fascinating phases of architecture. I was even heard saying enthusiastically to compile a book! I hope you'll let me see some of your material sometime soon![13]

This gift was intended by Johnston to form a national foundation for the study of early American architecture and garden design. Her initial series of approximately 5,000 negatives would be the actual and figurative predecessor of the Historic American Buildings Survey (HABS), which began in 1934. Johnston would be the single greatest individual contributor to the collections of architectural photographs at the Library of Congress, eventually donating approximately 20,000 photoprints (including silver gelatin and cyanotype proofs), 37,000 glass and film negatives, 1,000 lantern slides, 17 tintypes, and a few autochromes as well as her camera, typewriter, and her papers, which are now preserved on 37 microfilm reels.[14]

Johnston was not alone in her interest in preserving examples of American architecture, or in a broader sense, in acquiring an appreciation of the qualities and textures of older buildings and their surroundings. Such avid antiquarianism was widespread among her contemporaries, especially those with whom and in many cases for whom she worked. In an important way Johnston's work represented the culmination of many years of antiquarian interest. Late nineteenth-century preservation efforts tended to hinge upon the associative values of historic buildings with important colonial events and people. This interest in preserving sites of veneration can be said to have formed the core of preservation activities, especially at the time when Johnston first evidenced an interest. In 1929, for example, she helped to raise funds during "Stratford Sport Day" to embellish the grounds and gardens at Stratford, General Robert Lee's birthplace.[15] Three years later, Fiske Kimball would ask Holland if he had funds for Johnston to take photographs of Stratford for him before he began restorations there. As Kimball explained,

If it is true, it perhaps would be very fine and suitable to spend some of it in having her make some views of Stratford in its picturesque decay and before my devastating hand as restorer is laid upon it. Do let me hear from you on this point.[16]

Kimball understood the significance of Johnston's photographs for restoring historic architecture at a time when ideological elements were valued over the substance of architectural history itself.

The Association for the Preservation of Virginia Antiquities

Increasingly in the early twentieth century, historic preservation efforts tended to spread beyond interests in patriotic causes toward a more enveloping sense of what was significant in history. The main thrust of this newer interest was a growing recognition of the importance of historic architecture. Johnston's own intents naturally extended in the same directions, due both to her own professional interests and those of her clients. Her attention focused on the South, which was her home region. The Association for the Preservation of Virginia Antiquities, founded in the spring of 1888, was an important organization for Johnston's work, particularly in her photographic survey of Fredericksburg, the home of George Washington's mother. The first large private preservation group to be founded in the South after the Civil War, it too centered its attention on historical events. Overall, however, its interest was broader in scope, including both individual examples of architecture and whole historic towns and regions within the state. Unlike other private organizations in which Johnston was involved, membership was not based on genealogy. After initiating the project in Williamsburg, members of the association focused on the preservation of Jamestown. Then, at the turn of the century, they focused their work more on the Richmond area. Johnston would rely on her association with this organization to petition the Carnegie Corporation for funding for her surveys in Virginia and in Charleston, South Carolina, and in fact she photographed in Charleston during the 1920s before receiving any funding from Carnegie. These photographs would be featured in Samuel Stoney's book, *Plantations of the Carolina Low Country*, which was published in 1939 as a limited edition of 1,500 copies.[17]

Johnston's photographs of the historic architecture of Fredericksburg, Virginia, and the surrounding area were innovative for emphasizing the significance of regional architecture. The Fredericksburg survey constituted one of the first comprehensive photographic records of the historic architecture of any town. Johnston was given a great deal of credit at the time

for her exhibition and collaborated as a photographer with author Henry Irving Brock on the book *Colonial Churches in Virginia*, which was published in 1930.[18] Forty photographs chosen from 150 negatives were reproduced to illustrate Anglican churches throughout the state. Brock, who would become a well-known reporter on preservation efforts in Virginia for the *New York Times*, stressed that these religious buildings were significant for inspiring leaders of the Revolutionary War. Johnston's photographs, if only through association with Brock's text, served as patriotic mementos as much as architectural records, a viewpoint that was popular with much of the American public during this period. The photographs of more local architectural styles and local adaptations of English-derived buildings reflected, as Brock put it, "the cultural power of a balanced and homogeneous civilization."[19]

The Restoration of Williamsburg

These sentiments provide insights into Johnston's own changing orientation. Johnston could be said to have long appreciated the history and character of the United States. She had strong links to patriotic organizations, and she clearly enjoyed antiques and historic places. Like her contemporary Electra Havemeyer Webb, the famous collector of Americana, Johnston was interested in turning away from European standards and adopting local ones. Unlike her colleagues, she was aware that American architecture had a variety of more regional traditions that required considerable research. By the mid 1930s, Johnston's interest in the history and culture of America, at once conservative and progressive, had come to dominate her life and work. Photography and historic preservation became a common cause.[20]

The most significant historic preservation project of the early twentieth century—and one that would have important repercussions for Johnston's work—was the ambitious effort begun by the Reverend William Archer Rutherford Goodwin in 1926 to preserve the remains of Virginia's eighteenth-century capital of Williamsburg. Goodwin, who served as the rector of the Bruton Parish Church, revered Williamsburg and its surroundings as the birthplace of the United States, or as he called it, "the Cradle of the Republic."[21] Williamsburg was seen as an opportunity to preserve not just a single building but the way of life of another era. As with Skanse

in Stockholm, Sweden, a folk museum created in the 1890s, a restored Williamsburg was seen as an opportunity for Americans to confront and learn from their past. As Goodwin explained:

> The spirit of the days of long ago haunts and hallows the ancient city and the homes of its honored dead; a spirit that stirs the memory and fires the imagination; a spirit that will, we trust, illumine the judgment of those who have entered upon this rich inheritance of the past and lead them to guard these ancient landmarks and resist the spirit of ruthless innovation which threatens to rob the city of its unique distinction and its charms.[22]

The restoration of Williamsburg would represent the beginnings of a truly national interest in historic preservation during the 1920s as a result of affluent benefactors such as John D. Rockefeller, Jr., and later Henry Ford and Alfred Dupont. Williamsburg stood as a striking success and would set the pattern for countless other communitywide efforts, particularly during 1930. The Massachusetts-based architectural firm of Perry, Shaw and Hepburn was brought in to provide technical assistance. Contractors, historians, archaeologists, furniture experts, draftsmen, landscape architects, and engineers all eventually were involved in the enterprise. This essentially was the first time that such a diverse group of professionals had worked collaboratively on such a large-scale project, beginning a tradition of interdisciplinary effort that would characterize historic preservation activities up until today. Interestingly, Holland, Johnston's champion at the Library of Congress, was involved directly in the early work at Williamsburg, a factor that affected his later programs at the Library, including the Pictorial Archives of American Architecture. The Williamsburg project was the crucible for many important ideas on American architecture and its preservation.

The Williamsburg restoration would prove to be much more than a restoration of a particular town. It was the beginning of the first national effort to study American architecture in detail. Johnston's own work in Virginia provided a parallel. However, as she discovered, the Williamsburg architects and historians were less interested in how things appeared at the time—the physical evidence—than how they might have looked originally. Her photography, therefore, had little application. Historians, adhering to their traditional role, saw the buildings as documents. Their concept of interpretation was to publish, and the buildings were seen as little more than

depositories for information about colonial history. Likewise, the main objective of the archaeological work was the discovery of architectural data rather than any investigation into the lifestyle of the colonial community.

Nonetheless, Johnston understood the significance of Williamsburg as a model for the preservation of older buildings and knew from her discussions with magazine editors that it would be a worthwhile commission. Williamsburg, if nothing else, represented an unprecedented achievement in the size of the area being preserved and in the number of scholarly professionals and the amount of funding involved. Unlike the Williamsburg historians, however, Johnston recognized the cultural and historic importance of the buildings themselves, and she sought to document them for publicity purposes. She had been photographing gardens and estates for numerous magazines when she wrote a proposal in the autumn of 1928 to William G. Perry of the Perry, Shaw and Hepburn architectural firm to photograph Williamsburg. In response, Perry explained that Dr. Goodwin already had "a very large number" of photographs, approximately two hundred taken of the existing town. In this way he turned down Johnston's proposal flatly while revealing his own limited understanding of the value of architectural documentation.[23]

Johnston nonetheless would be involved shortly afterward in documenting an aspect of Williamsburg for Henry Brock's 1930 book on Virginia churches. To take her photograph of the Bruton Parish church, Johnston requested that a number of dead trees be removed from the graveyard in order that they not obstruct the views (figure 29). Soldiers had cut many of the old trees near churches to use for firewood, and according to Brock, the remaining dead trees were historic evidence of military occupation. Johnston's request that they be removed shows that her regard for picturesque landscape was greater than any visual reminders of military history. Williamsburg landscape architect Arthur A. Shurcliffe responded in a letter dated July 1930 that, as the corporation's official landscape architect, he had no actual authority over the parish graveyard. However, one week later he reconsidered, writing to Johnston, "Mr. Cole, a vestry member, says that trees that stand in the way of a good photograph will be taken down."[24] This correspondence between Johnston and Shurcliffe, however, contradicts Johnston's photograph of the church pictured in Brock's book, which includes an ivy-covered tree stump.[25] Taken from the graveyard, Johnston's

photograph shows the tree stump forming a triad of prominently positioned monuments along with the church steeple and a gravestone. The inclusion of the stump, in relation to the church steeple and gravestone, could be seen as a visual reminder of the fact that historic preservation activities are preoccupied with sustaining the memory of war, as Brock emphasized in his text.

Still hoping to be involved in the Williamsburg project, Johnston sent her proofs of the Bruton Parish Church to Shurcliffe, along with clippings about her Fredericksburg exhibition in Washington, D.C. The image of the church was significant since it was considered a spiritual center that helped to inspire the restoration of the former capital. After Williamsburg, the work of Shurcliffe, as well as Charles Gillette, Umberto Innocenti of New York, and Thomas Sears of Boston, ensured that garden restorations would continue to coincide with architectural restorations, a practice that Johnston herself had supported. The architectural firm of Treanor and Fatio soon became interested in Johnston's photographs for their own files, too. Other architects involved in restoration work began to approach Johnston for assistance.

The Williamsburg restoration of the mid 1930s became a symbol of success for preservationists throughout the country due to the magnitude of the corporation's educational programs, the attraction of the site to tourists, and its overall economic success and stability. Williamsburg helped to popularize American history, made architectural restoration an interesting subject, and even altered the way many Americans spent their leisure time, which now included visiting sites that were both enjoyable and educational. The concept of the large outdoor museum, which in the United States originated with Williamsburg, would continue to be developed during the 1930s and 1940s in such places as Henry Ford's Greenfield Village, near Detroit, Michigan; the Farmers' Museum in New York; and Old Sturbridge in Massachusetts. While these museums involved even less pure restoration work than Williamsburg, they all combined to promote an understanding of history through buildings. Similar projects, in this case centering on older buildings, occurred at places such as at Deerfield, Massachusetts, where preservation efforts dated back as early as the 1890s, but were more enthusiastically undertaken after 1930 following the Williamsburg exam-

FIGURE 29. Bruton Parish Church, Williamsburg, Virginia, c. 1927

ple. In the early 1930s, Charleston and New Orleans both adopted historic preservation ordinances, in the case of the latter notably to promote the preservation of the Vieux Carre district.[26] In South Carolina and Louisiana, Johnston would play some part, helping to document Charleston as early as 1929 and later joining architects in recording efforts in New Orleans and elsewhere in Louisiana. She saw her work as part of the process, providing the basic groundwork upon which other decisions about preserving buildings and, more generally, landscapes could be made.

Restorers at the time who shared Johnston's aims provided a foundation of experience for other preservation efforts. Excavations elsewhere in Virginia, for example, were reflective of a new archaeological interest in seventeenth-century buildings. Milton L. Grigg wrote to Johnston about the Weyanoke restoration in 1931: "Excavations are revealing a 'finesse' in planning and grouping of buildings which six months ago I would have sworn was impossible in seventeenth-century Virginia."[27]

The Carnegie Survey

In the early 1930s, Johnston wrote to Holland and to Edmund S. Campbell, head of the Department of Architecture at the University of Virginia, asking for their help in promoting her architectural survey work. Her hope was that they and others might petition the Carnegie Corporation to provide support for a more complete record of historic buildings throughout Virginia. In 1932, in response to Johnston's request, Campbell wrote to Dr. Frederick Keppel, president of the Carnegie Corporation of New York, about the high quality of Johnston's work. Others who wrote to Keppel on Johnston's behalf included Perry, Shaw, and Hepburn, the architects responsible for the Williamsburg restorations; architectural historian Fiske Kimball; and members of the Virginia Library Association, the library at the College of William and Mary, and state historical institutions at Richmond. All emphasized the significance of Johnston's work for places that had never been surveyed.[28]

Keppel was already acquainted with Johnston's work by the time he was contacted by Campbell regarding funds. At the request of an intermediary for the Carnegie family, Johnston had sent Keppel her 1905 photographs

of Andrew Carnegie to be used by the painter Mr. Richard S. Merryman, who had been commissioned to paint his portrait. Johnston's photograph of Carnegie was originally taken to form a more complete record of leading businessmen in New York for the St. Louis Public Museum's receiving collection at the St. Louis World's Fair. Keppel wrote Johnston that the photographs of Carnegie had been received, and he said he would like to pass them on to Mr. Burton Hendrick for the biography of Carnegie he was writing.[29] This correspondence helped lay the groundwork for Johnston's efforts in Virginia, and the strategy worked. Campbell and Holland finally approved a project that would be sponsored jointly by the University of Virginia and the Library of Congress. Johnston had offered to create a separate collection of five hundred prints at the University of Virginia School of Fine Arts for a total of $1,000. The School of Fine Arts collection would eventually include a total of about 1,200 photographs from the Virginia survey. The remaining $2,500 of the initial grant was to support six months of fieldwork focusing on Virginia buildings, mainly domestic architecture. At the age of sixty-nine, Johnston would receive her first grant from the Carnegie Corporation.[30] Following further negotiations, it was decided that she would place her files on deposit at the Library of Congress but that she would remain the owner of the collection. The material, nonetheless, would be made available for study through the Division of Fine Arts, which was managed by Holland.[31]

After the 1929 stock market crash, Johnston was extremely fortunate to be supported with back-to-back grants from the Carnegie Corporation throughout the Depression. She wrote to Holland in June of 1930 that she anticipated being reimbursed before the end of 1931 for at least part of her work.[32] By 1932 Johnston had already taken over 1,000 negatives, completed over the past five years in sixty-seven of one hundred Virginia counties—a sizable beginning on the project.[33] Eventually, the Carnegie-sponsored project would represent the scholarly equivalent of Williamsburg at a statewide level. Johnston would complete a photographic survey of Virginia and introduce such now long-accepted practices as meticulous photographic logs, the use of United States Geologic Survey Quadrangle sheets and other maps, and detailed inventory forms. It was her intent to apply some of the work of Williamsburg on a broader scale, suggesting opportunities for preservation throughout the state and nation.

The 1851 French Historical Monuments Commission

Holland, Johnston's primary sponsor and champion for the Carnegie project, was not only head of the Division of Fine Arts at the Library of Congress but also a Fellow of the American Institute of Architects (AIA) and chairman of its national historic buildings committee. He saw the Pictorial Archives of Early American Architecture and the Carnegie Survey of the Architecture of the South as part of a tradition of large-scale recording projects of historic architecture extending back into the previous century. In developing the photographic collections at the Library of Congress, he wrote:

> We are enabled to build up a magnificent body of pictorial records, comparable to the Archives de la Commission des Monuments Historique of the French government, by a most natural development of what has been already started, without establishing any new foundation or seeking any new grant.[34]

Holland here refers to the 1851 Commission des Monuments Historique, or the French Historical Monuments Commission, a department of the French government, which employed five of France's leading photographers to each record a region of the nation's endangered architectural heritage. Their subject matter was primarily medieval remains. This documentation effort, carried out during the reign of Napoleon III as part of his ambition both to preserve and modernize France, was the first large-scale architectural documentary project to use photography as the principal medium and the first major photographic project sponsored by a government.[35]

The photographers involved in the 1851 project were Hippolyte Bayard, O. Mestral, Henri Le Secq des Tournelles, Edouard-Denis Baldus, and Gustave Le Gray, each of whom made his own special contribution to the evolving field of photographic recording. Typically, each would photograph a structure in its entirety and then record significant details much the way traditional books of architectural views and elevations approached the subject. Although the three hundred negatives and prints resulting from the project were filed away without being reproduced or published, the photographs were used individually for the restoration of architectural elements and whole buildings, much as Johnston's photographs would be used by

American architects almost five decades later. It has been suggested that one of the reasons the photographs were not published may have been that the images ran contrary to the restoration philosophy of Eugene Emmanuel Viollet-le-Duc, inspector of Ancient Monuments. Le-Duc favored returning historic buildings to their supposed original appearance, even if this meant replacing younger parts of the building that were in fact in good condition. The primary aim of the project, however, is more likely to have been essentially archival from the beginning, and it is not clear whether the commission ever intended to publish the results. Whatever the reasons for the failure to publish, it seems that the work never received in its own time the attention that it deserved or the recognition that has more recently been given to the project. Johnston knew of the effort, though there is no documentation of whether she saw any of the resulting work. However, it is very likely that she was familiar with the work of the French Commission photographers, in particular that of Gustave Le Gray, Henri Le Secq, and Edouard-Denis Baldus, all of whom began their architectural recording careers with the project.[36]

Virginia and Beyond

While working in Virginia, Johnston established what would be her routine for conducting regional surveys. She researched each region and devoted considerable time to studying published books on local history and architecture. Also, she consulted maps and unpublished documents in anticipation of what she would encounter. She always contacted local historians and architects, homeowners, and community leaders for leads. Once in the field, she researched historical records, such as deeds and old plats, to verify the dates and owners of buildings. In Virginia alone, Johnston traveled at least 25,000 miles, taking more than 1,000 photographs, and often producing as many as twelve views of one house. If the weather and road conditions were good, Johnston later explained that she could make fifteen to twenty exposures a day.[37]

Johnston worked on the Virginia survey periodically from 1933 to 1935. In 1936, upon completion of the project, 125 photographs out of a total of 2,500 negatives representing five years of work were exhibited at the Virginia Museum of Fine Arts in Richmond beginning on March 28 of that year. The museum announcement read:

These old buildings, many of them gone or crumbling rapidly away, represent the first and probably the finest artistic achievements of the Old Dominion. The Virginia Museum wishes extravagantly that it were possible to move them bodily within the protection of its own walls. Failing this manifest impossibility, Miss Johnston's photographs present an excellent alternative.[38]

This was only the first of several exhibitions resulting from the Carnegie Survey. Through exhibitions, coverage by the national media, and Johnston's innovative publicity ventures, Johnston's photographs quickly became well known.[39] As a result of the 1936 Richmond exhibit, for instance, the Metropolitan Museum of Art in New York, which already had begun a collection of Johnston's garden photographs eight years earlier, purchased two hundred to three hundred prints of Virginia historic architecture in addition to Johnston's photographs of the White House.[40] Soon, the first Virginia exhibition was purchased by the Virginia Museum of Fine Arts, with a personal donation of $1,000 from Keppel, where it would form the core of the museum's permanent collection of architectural photographs. With the cooperation of the Virginia Chamber of Commerce, about 150 to 200 of Johnston's photographs were made into a traveling exhibition. Johnston gave illustrated lectures sponsored by committees of the Garden Club of Virginia throughout the state. These were publicized by articles accompanying Johnston's photographs of historic buildings and landscapes. The various magazines and newspapers promoting her work included *Arts and Decoration*, the *Spur*, the *New York Herald-Tribune*, *Boston Transcript*, *Baltimore Sun*, and others. Johnston also compiled a pictorial locator map of Virginia showing historic monuments and estates, which she knew would pay for itself. Johnston would use additional grant money to file and index the photographs. In fact, the filing system used for the University of Virginia School of Architecture library came to be used at the Library of Congress as a result of Johnston's involvement with the transmission of her work.[41]

Johnston's photographic survey of historic Virginia architecture was a success for everyone connected with it. What had begun as a personal freelance photographic project centered on a privately owned estate had become a statewide documentation project, sponsored by one of the world's

largest philanthropic organizations. Johnston used her Fredericksburg photographs as a model to initiate surveys in other regions. For example, she discussed with A. Lawrence Kocher of the American Institute of Architects (AIA) the possibility of conducting a similar survey of "Old Charleston" under the aegis of a local group. As she explained to Kocher, Johnston envisioned the Charleston survey as a traveling exhibition to be used subsequently for publicity and fund-raising:

> Such a project has been in my mind and heart for quite a long time. I am not only very desirous of adding a representative unit covering this region for Dr. Holland's department under the Carnegie Fund grant, but I also have prospect commissions from various New York publications for special features covering recent construction in the South, so that I am now making tentative plans for a motor trip through the Carolinas to Charleston and Savannah in February.[42]

Only partially successful in her Charleston bid, Johnston always looked for opportunities and made the most of them. AIA members formed an advisory committee within the institution to work with a local group of Charlestonions to preserve early architecture of the city but would not finance Johnston since there were already photographs on this subject— "about a half dozen" one member speculated.[43] Still, Johnston was on record as identifying the need. Her failure to get the full support of the AIA would lead her to her later, far more successful bid with the Carnegie Corporation to carry out the same kind of work throughout the southern states. This work would be much larger in scale than the Virginia survey but would still include precise location maps and individual index cards.

Plantations of the Carolina Low Country

It was in Charleston that Johnston had her greatest immediate impact and that her formula for combining art exhibits with historic preservation propaganda worked most effectively. Her 1930 publication, *Historic Houses of Virginia and Charleston, South Carolina*, consisting of photographs she had taken in the mid 1920s before she received Carnegie funding, came to the attention of Milby Burton of the Charleston Museum and of Robert Whitelaw, director of the Gibbes Memorial Art Gallery and the Carolina

Art Association, both of whom were committed to preservation activities in Charleston. Two hundred photographs of Charleston historic buildings, forty-eight of which had been previously published and filed at the Library of Congress, were exhibited at the Gibbes Art Gallery from November 8 through December 6, 1937. The photographs, some of which had been taken before Johnston received funding from the Carnegie Corporation of New York, were shown under the auspices of the Carolina Art Association and the Charleston Museum. About thirty-four of these photographs were, in turn, reproduced in the *Charleston News and Courier* and the *Charleston Evening Post* to gain additional publicity, both for exhibits and local preservation efforts. Johnston wrote to Keppel on the usefulness of the Charleston photographs. They were now important, she explained, to local historical and art organizations, especially in that they were "now closely linked with plans for future restorations under present consideration."[44]

Johnston's efforts in Charleston both coincided with and helped to spur the work of national and local historic preservationists. Through her influence, Robert N. S. Whitelaw, director of the Carolina Art Association since 1931, was able to receive a Carnegie grant in 1937, four years after Johnston had begun receiving Carnegie funds. Whitelaw used the money to modernize the Gibbes Memorial Art Gallery and launch a successful membership drive for the Carolina Art Association, so that two years later it had 2,420 members and an annual budget of $50,000.[45] Whitelaw went to Waldo G. Leland of the American Council of Learned Societies, who already had financed Johnston's work as early as March of 1936.[46] Again, Johnston's efforts helped Whitelaw receive a grant in 1938, making it possible for the Carolina Art Association to publish *Plantations of the Carolina Low Country*.[47] The book was originally to have been illustrated with photographs and diagrams that had been researched in the mid 1920s, when Johnston took photographs of Charleston for her book *Historic Homes of Virginia and Charleston, South Carolina*. Whitelaw used part of the money for Johnston to take additional photographs, and these, as well as some of her earlier photographs, were included in the publication, which became an instant classic.[48]

Interestingly, publication was delayed for several months due to prior copyright claims. Some of the photographs that Whitelaw had chosen for publication had been published in the *Architectural Record*, which two

years earlier had featured an issue on Historic American Buildings Survey (HABS) photographs including a number taken by HABS photographers in Louisiana. The *American Museum of Art*, a magazine published monthly by the American Federation of Arts, also had publication rights to some of the photographs.[49] Encouraged that her work was being considered for publication by both architects and artists, Johnston wrote to Whitelaw that she would like him to hold the prints until the January issues of both magazines appeared.[50] Johnston hoped that the magazine articles would encourage the publication of Stoney's book.[51] Now considered one of the most popular publications showcasing her architectural work, it has been reprinted in eight revised editions. The most recent one, published in 1989, is an unabridged republication of the seventh edition and is a joint publication of Dover and the Carolina Art Association.

The Beginnings of the Historic American Buildings Survey

Johnston's work in Virginia provided an important precedent for the HABS program. Initiated in the spring of 1933, HABS began to provide relief for unemployed architects. HABS architects shared ideas and preservation tips under the auspices of this program, and the effects over the next two decades would be enormous in the number of historic buildings and whole districts documented. Between November 1933 and March 1934, HABS put 772 architects to work and produced over 5,000 sheets of measured drawings of 880 sites and structures throughout the United States. By 1941, the Library of Congress had received over 23,000 measured drawings and 25,000 photographs, representing over 6,000 sites. In 1947 alone, the Library received orders for over 14,000 copies of HABS records. Johnston's stress on research and documentation of historic buildings directly influenced the role of the HABS program. Her work, as a model for federal survey and inventory projects, helped to popularize historic preservation through the publication and exhibition of her photographs. Johnston also worked directly with HABS photographers and delineators and gave preservation tips informally on the job based on over forty years of her photographic experience.[52]

Johnston's work under the Carnegie grant was watched and strongly supported by architects and historians of the National Park Service, then as today the leading governmental body promoting what has become known

as historic preservation. The restoration of Williamsburg, and particularly Johnston's parallel Carnegie-funded photographic survey of Virginia, had direct impact on national preservation legislation and federal work programs. The passage of the American Historic Sites and Buildings Act in 1935, the first comprehensive federal legislation to affect the preservation of buildings and sites, further ensured that buildings would be recognized for their artistic and representative significance as well. This federal legislative act greatly encouraged inventories of sites and materials in the field of American history and the acquisition of private property for preservation purposes. Increasingly, the boards of national and local historical societies consisted of professionally qualified historians and architects. Historic preservation activities generally became more scholarly ventures. Furthermore, the scope of preservation broadened so that regional organizations began to form with the aim of surveying and preserving on a state level rather than concentrating on individual structures and isolated sites.

The influence of the architectural profession, partially a reflection of the changing demands of their clients during the 1930s, was responsible for placing more emphasis on architecture than on landscape. An example is Johnston's documentation of Mount Vernon in 1937 for *American Architect* magazine. This narrowed focus would have repercussions elsewhere, including for Johnston's publications on the early architecture of various regions in the South, many of which were originally intended to be about gardens as well. Therefore, gardening would become increasingly the domain of garden clubs. Johnston, nonetheless, would try to straddle the interests of both architects and garden club members.[53]

Johnston later became active as a member of the Thornton Society in Washington, D.C., an advocacy group put together by HABS founder Charles E. Peterson, in this case to help press for preserving the work of a single architect. Johnston's work in the early to mid-twentieth century, however, was most heavily sponsored by and was bound up mostly in the activities of more established historic preservation and patriotic organizations. Many of these, including the Daughters of the American Revolution and the Colonial Dames of America, were dominated by active and often influential women. These groups endeavored to save historic places associated with traditionally recognized early American leaders and events of American history. Johnston herself would become active in a number of these orga-

nizations, in particular the Daughters of the American Revolution, whose headquarters were located near the Corcoran Museum in Washington, D.C. Both a progressive and a conservative, Johnston found no contradiction in devoting time to patriotic causes as well as numerous scholarly and artistic efforts. It was all part of the same work for her. Johnston would be given more support from Virginia, again largely as a result of organizational initiative and pressure. For example, in 1935 she made prints for the Association for the Preservation of Virginia Antiquities of gardens that she had photographed earlier for the Virginia State Conservation Commission. Scholarly organizations such as the Association for the Preservation of Virginia Antiquities were important for supporting Johnston's work in new directions such as the documentation of historic landscapes.[54]

Documenting historic landscapes as well as buildings was emphasized by William Sumner Appleton, who was responsible for forming the Society for the Preservation of New England Antiquities (SPNEA) in Boston in 1910. Appleton believed in maintaining the character of all historic buildings and sites, regardless of who had occupied them. Based on the ideas of John Ruskin and William Morris, the regional private organization offered advice to historic preservation societies throughout the United States, particularly those in New England and elsewhere in the Northeast. However, SPNEA ideals would have an impact beyond New England, including on organizations in the South with which Frances Benjamin Johnston would later interact. The success of Johnston's own work was based on the powerful support of organizations headed by people who were already aware of New England antiquities and of the need to document historic architecture outside of the New England region. Johnston's long-term relationships with Frederick Keppel, president of the Carnegie Corporation; Verne E. Chatelain, assistant director of the National Park Service; Waldo G. Leland, secretary of the American Council of Learned Societies; and Laurence Vail Coleman, director of the American Association of Museums ensured that her work would receive public recognition through exhibitions and publications.[55]

It is clear, however, that the architectural significance of buildings was appreciated in the South even before the highly recognized efforts of Appleton. For example, the Tulane University School of Architecture, from its beginnings in 1907 three years before the founding of SPNEA, encouraged the

study and recording of Louisiana's historic architecture. Johnston's own work would parallel the efforts of Tulane University in the 1930s. Members of the Association for the Preservation of Virginia Antiquities also shared a concern for the preservation of representative examples of architecture in their state, helping Johnston in her research efforts, as we have seen. The emphasis of these historical organizations on regional survey work appealed to Johnston, who also advocated that landscapes be given equal attention with historic architecture. By appealing to the art establishment as well, Johnston ensured that the landscapes depicted in her architectural photographs would receive serious attention.[56]

Johnston typically targeted libraries and art galleries to exhibit her photographs. In these contexts, they were accepted both as works of art and as records of historic buildings. For Johnston, of course, there was no difference. Six exhibitions were held in 1937 financed by Johnston alone. In Maryland, Johnston displayed her photographs in three large street windows of the Enoch Pratt Free Library to draw attention to her project. Eventually a collection of approximately four hundred to five hundred 8 x 10 photographs of historic Maryland architecture was made available for the archives of the Maryland Room in the Pratt Library. These included, as was Johnston's practice, precise keyed location maps and individual index cards. Her photographs were also displayed at the Baltimore Museum of Art, where they reached a wider, more artistically informed audience. As usual, funds were provided by the Carnegie Corporation for the subsequent purchase of the Maryland photographs by the museum, and these formed the basis of a permanent study collection of Maryland architecture.[57]

Photography as Civic Educator across the South

Johnston's concern throughout was that her photographs should have an impact beyond mere artistic appreciation. Of paramount concern for her was the idea that the photographs might help local citizens to become more appreciative of the historic architecture in their own regions. Her work in St. Augustine well demonstrates what was to become the typical process for Johnston. Verne Chatelain—who had provided statewide assistance for Johnston's work in Virginia while he was assistant director of the National Park Service—now as director of the St. Augustine Historical Society in-

vited Johnston in December of 1936 to take pictures of historic buildings in St. Augustine. This time, some of the funding was provided by the ancillary Carnegie Corporation of Washington through Dr. John C. Miriam after Miriam spoke with Johnston's supporters Keppel and Leland. The Carnegie Corporation of New York, again through Keppel, provided an additional $500. The St. Augustine Historical Society, in turn, exhibited Johnston's 125 photographs of about forty historic buildings at the Ponce de Leon Hotel in January of 1937.[58] Dr. John C. Merriam, president of the Carnegie Corporation of Washington, stressed to the St. Augustine Chamber of Commerce that Johnston's photographs were important as good publicity for the city:

> I have felt that Miss Johnston's photographs and the work which she is doing showing things of interest and beauty in St. Augustine, are of great importance. We need exact records, detailed pictorial presentations, and also the evidence of what is beautiful and interesting.[59]

Verne Chatelain, director of the St. Augustine Historical Society, agreed. He also stressed the impact of the exhibit and Johnston's work on historic preservation efforts in the city. Johnston's photographs were used by those involved in the historical restoration of St. Augustine to promote the passage of restoration bills and zoning ordinances. Chatelain explained to Johnston:

> As to my own plans, I hope to be here until the final drafting of the Zoning Ordinances, which we have been working on for the past two to three months. The state legislation passed five restoration bills, all that we asked for, and fifty thousand dollars, so that whole-hearted state cooperation is now fully assured.[60]

Photographing Louisiana

Johnston returned to Washington after her work in Charleston for her exhibit of Carnegie Survey photographs at the U.S. National Museum. There she was urged by Lawrence Vail Coleman, director of the American Association of Museums, to take her collection to New Orleans. Johnston herself chose the historic Cabildo next to St. Louis Cathedral on the square

of the Vieux Carre as the site of her May 1937 exhibition because she believed an "art museum should be the proper setting"[61] for the show. James J. A. Fortier, president of the Louisiana State Museum who managed the Cabildo gallery, wrote Johnston five months later that greater interest in the Louisiana State Museum was directly "attributable to your presence."[62] Again, Johnston had managed to both exhibit her art and promote a larger cause, in this case the preservation of New Orleans. That same year New Orleans became the second historic district in the United States.

In New Orleans, Johnston worked assiduously to bring the community together for the implementation of a historic preservation plan similar to the one in Charleston. Active in New Orleans even before she moved there to live after the Vieux Carre had become a historic district, she recognized and fully appreciated the historic distinctiveness of the city. Visiting in 1937, Johnston, who was seen as a celebrity at the time, told Harnett T. Kane of the *New Orleans Item*:

> In the old French Quarter, there flourishes something that has no American counterpart. There is a certain kinship among Charleston, St. Augustine and your city. But New Orleans surpasses them in rare beauty of iron work, of outdoor and indoors arts and crafts in a romance of aspect and spirit, of character and charm that are unique in America.[63]

Johnston's initial visit to New Orleans was followed, as usual, by a larger project. The next year, 1938, Johnston began making preparations to begin her photographic survey of Louisiana. At the time she was planning to publish a book on North Carolina architecture as well. Louisiana architect and HABS administrator Richard Koch assisted Johnston by providing an itinerary for her in order to make a systematic record of the plantation houses along the Mississippi Delta. While in New Orleans she attended a meeting of the local chapter of the American Institute of Architects and witnessed Koch receiving an AIA fellowship as the regional director of the HABS program. During her project, Koch let Johnston check his records for locations to photograph.

Two years later, after the HABS program had been suspended in Louisiana, Koch wrote Johnston, asking if she would exhibit her Louisiana photographs in New Orleans at the Arts and Crafts Club.[64] Koch was a photographer, too, and some of his photographs had been used as part of a

HABS exhibition held in the same building a short time before. Possibly remembering Koch's fellowship, Johnston accepted his invitation after having spent $2,000 of her own money to cover expenses for the North Carolina project.

Johnston was a pioneer in recognizing the importance of an architectural inventory as a first step in the preservation process as it would be understood today. She realized that a survey would help to identify significant structures, together with problems facing a district. The final inventory would also be useful, she realized, in attracting attention and then financial and, ultimately, legislative support. Noted architectural scholar Talbot Hamlin would echo Johnston's position in 1940, arguing for the necessity of a good inventory in New Orleans. The New Orleans community, however, was slow to take either Johnston's or Hamlin's advice; and it would be many years before a comprehensive inventory would be completed, long after passage of the first ordinance in 1937.[65]

Belle Grove

Johnston's photography outside the city limits of New Orleans offers a valuable record of Louisiana plantations, some of which no longer exist, such as Belle Grove. Johnston emphasized the grandeur and reserve of Belle Grove, a Greek Revival plantation house located in Iberville Parish, Louisiana, an area commonly known as part of the Lower Mississippi Valley. The grandeur of the building is evident in the large scale and the richness of the classical architecture. The reserve is apparent in the landscape setting, particularly in the way trees shade and partially obscure the side of the building.

Originally built for John Andrews, a wealthy Virginian who moved to Louisiana to grow sugarcane, the seventy-five room mansion was part of a larger estate that included a sugar house, stables, and race tracks. John Andrews's sugarcane fortune was lost during the Civil War, and he sold the estate to Henry Ware in 1867. After crop failures at the turn of the century and the collapse of the local sugar market caused by competitive international markets, the sugar house, stables, and racetrack were demolished. The plantation house remained empty after the Ware family finally left in the early 1920s, was allowed to deteriorate, and then in 1952, burned to the ground.[66]

Johnston took thirteen photographs of the main house at Belle Grove on at least two different occasions. The first set of photographs was made in 1938. Then, in 1944, Johnston returned to Louisiana to photograph the plantation a second time.[67] The thirteen photographs show Belle Grove from various positions to present the maximum information possible about the structure—its size and form, and the location of the building surrounded by trees behind a grassy field. Compared to the other photographs Johnston made of this estate, here she emphasizes the illuminated front entrance of the principal façade viewed from an angle.

The two-story plantation house, built in 1857 on a brick foundation, has walls constructed of plastered and stuccoed brick, with the lower walls comprising a raised basement coursed to resemble stone. The well-lighted colonnade seen on the left side of the photograph, also of plastered brick, consists of four fluted columns. The back sides of the columns bounce the light of the façade toward the ceiling of the porch. The hand-carved Corinthian capitals, made from durable cypress wood, were applied in four sections around the brick cores of the columns, and then gilded. The columns support a full entablature and pediment. A cantilevered balcony supported by modillion brackets projects from the second floor behind the columns. Smooth pilasters separate the Palladian-inspired door and full-length windows located along the first and second floors of the wall behind the columns of the principal façade. Symmetrically arranged, the central door and two windows, formerly louvered, include frames and bracketed entablatures. The front entrance is reached by a central sixteen-step stairway flanked by a series of two large paneled wing walls.[68]

In Johnston's portrait of the stately mansion, a three-quarter view of the plantation house from eye-level emphasizes three-dimensional, sculptural qualities of the building such as its freestanding fluted columns and balcony. This photograph sensitively captures the overall character of the building including signs of weathering and decay. Paint can be seen peeling along the steps and edges of the floor, and cracks have formed along the side of the wall beneath the column of the side porch behind the tree in the foreground.

While the Belle Grove plantation great house is portrayed as a decaying but enduring mansion, Johnston's photographs accurately record architectural details of the building, too. For example, Johnston uses hazy bright

FIGURE 30. Belle Grove Plantation, Iberville Parish, Louisiana, 1938

light that casts shadows but does not obscure the intricate details. Contrasts of light and shade emphasize details such as the columns, balcony, door, windows, and bracketed entablatures so that they are fully understood although not totally in view. The openings of the windows and doors behind the columns, for instance, are not fully seen, so that more emphasis is given to the bracketed entablature above them. Likewise, the front porch bathed fully in sunlight becomes the principal focus of the photograph, adding formality to the view. The side porch on the right, partially hidden behind a tree and in shadow, is similar to the front portico in that it too has four fluted columns with Corinthian capitals and a cantilevered balcony supported by modillion brackets projecting from the second floor behind the columns. Shown from a distance, the side porch is subordinate to the main sunlit entrance. The trees along the right side of the house (not pictured) create shadows, and the tree in view, located in front of the side porch shadowed by the other trees, also obstructs a full view of the house on the

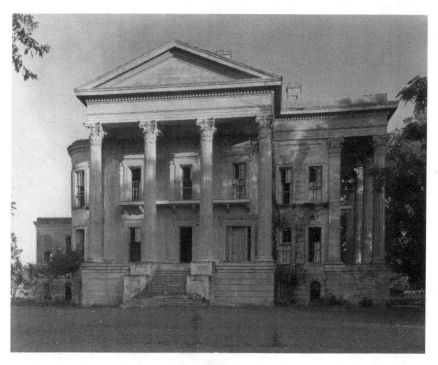

FIGURE 31. Belle Grove Plantation, Iberville Parish, Louisiana, 1938

right side. An additional sense of space is achieved by a large presence of sky. Trees frame the left and right edges of the house.

Another photograph by Johnston of Belle Grove presents the great house in a more formal manner. Although both photographs show the main northwestern façade of Belle Grove, this elevation view emphasizes proportions of fully visible window and door openings on the front portico rather than the architectural details. Neither is light used in the elevation view to express the character of the building. The side portico on the right, while dappled by the shadows of leaves, is not obstructed by the presence of any trees. The photograph showing the front façade from an angle depicts more landscape features, and emphasizes the prominence of the front portico.

Two other photographs by Johnston both show the side portico from the left corner but at different times of day and in different years, one as the building existed in 1938 and the other in 1944. The eye-level view focuses halfway up the raised foundation. A comparison of these two photographs shows that Johnston emphasizes in the second photograph how the

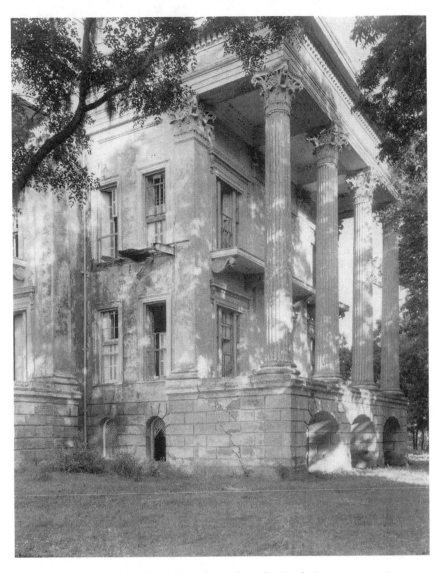

FIGURE 32. Belle Grove Plantation, Iberville Parish, Louisiana, 1938

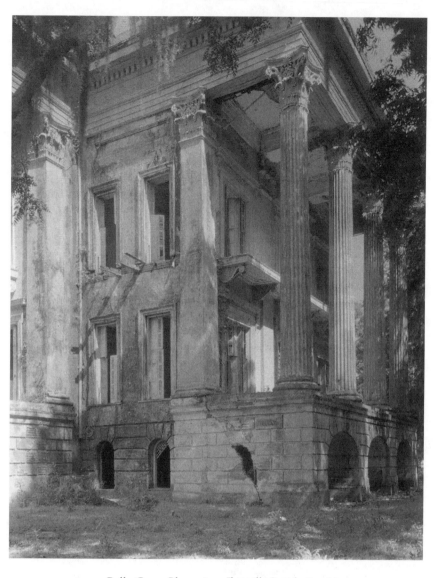

FIGURE 33. Belle Grove Plantation, Iberville Parish, Louisiana, 1944

building has deteriorated over time.[69] The crack along the edge of the northeast end of the portico beneath the columns has been allowed to develop into a large hole. Lattice has been removed from one of the archways below the windows in the bottom left section of the photograph, located next to the northeast corner of the house. Directly above on the second floor, wood from the remains of a side balcony has also been removed or fallen off. The 1944 photograph showing darker shadows was obviously made not only during a later period but also toward the end of a day, indicating the twilight of the plantation building's decay.

Johnston's thirteen photographs of Belle Grove, which comprise an extensive architectural survey of the estate on two different occasions, reveal a maximum amount of information. Three-quarter views emphasize sculptural qualities of architectural details such as fluted columns, Corinthian capitals, modillion brackets supporting a cantilevered balcony, and bracketed entablatures. The more formal elevation views Johnston took of Belle Grove emphasize proportions of windows, doors, and walls. Through sophisticated use of lighting and point of view, Johnston illuminates the monumental scale of the classical architecture within the spacious landscape.

North Carolina Survey

Johnston's photographic survey of North Carolina began in the spring of 1936. She had received lists of buildings to photograph from Mr. R. Marsh, an architect for HABS from Charlotte, North Carolina; Thomas T. Waterman, assistant architect working for HABS through the National Park Service in Washington, D.C.; Albert Newsome, professor of American history at Chapel Hill; Professor Howard Odum of the Institute for Research in the Social Sciences at Chapel Hill; and Professor William Boyd of Duke University. After receiving a Carnegie grant totaling $3,500 for that year, Johnston traveled to North Carolina and took approximately one hundred photographs of historic buildings along the eastern coast. That summer she toured North Carolina a second time and took 275 more photographs. By the following March, with money from a fifth Carnegie grant, she took about 370 more photographs of North Carolina historic buildings and made 180 enlargements for an exhibit at the Chapel Hill art museum. These enlargements were not framed or placed under glass but were tacked

to the display walls. The 16 x 20 photographs were placed on mounts, 23 inches by 28 inches. Only one half of them could be hung due to limited space. After making 250 more negatives, using lists made available to her by Mrs. Lyman Cotton of the North Carolina Historical section of the university library, Johnston exhibited one hundred enlargements at an exhibit in Persons Hall on the University of North Carolina campus. Seventy 16-inch by 20-inch enlargements were bought by John Sprunt Hill of Durham, North Carolina for $500 and given to the University of North Carolina library.

Through publicity of her work in journals, Johnston had numerous contacts in North Carolina. At the University of North Carolina at Chapel Hill, Mrs. Lyman Cotten helped direct Johnston's tour of North Carolina by arranging for Johnston to exhibit her photographs on campus in 1937 and to give informal talks for additional publicity.[70] The photographs from this university campus exhibition were then bought by patrons and given to libraries at both the University of North Carolina and Duke University. These exhibitions were funded by Johnston since the grant money covered only the travel costs and photography. That same year, Mr. and Mrs. Charles Cannon of Cannon Cotton Mills, interested in the publication of Johnston's photographs as an architectural monograph, provided Johnston with $600 to take two hundred photographs of western North Carolina.[71] Johnston's last Carnegie grant in 1938 allowed her to travel in August to the mountainous area of western North Carolina so that she could prepare a small exhibit of her photographs in Blowing Rock under the patronage of Mrs. Cannon. At that time, William T. Couch, director of the University of North Carolina Press, expressed interest in publishing a book featuring photographs of early North Carolina architecture.[72]

By September of 1938 Johnston's photographs represented more than forty counties throughout the entire state. Meanwhile in early 1939, Couch published what was considered the first systematic documentation of North Carolina historic architecture. Published by the state Garden Club as well, the book, entitled *Old Homes and Gardens of North Carolina*, featured gardens as well as old homes. The governor wrote the foreword. Dr. Archibald Henderson, a math professor and historian, wrote the text, and Bayard Wootten, a prominent North Carolina pictorial photographer, contributed one hundred from her collection of over five hundred photographs. The

book was considered to be beautiful and evocative, according to a book review in the *New York Times*. However, only 1,000 copies were printed, each autographed by then North Carolina governor Clyde R. Hoey, and the book was not reprinted. Interestingly, Johnston was included in a long list of names within the acknowledgments as one who had done historical research in an effort to make the book as accurate as possible. Johnston included an announcement of its publication in her papers now held in the Library of Congress.

Leland, who had already helped to finance Johnston's progress in Charleston and New Orleans, agreed that the American Council of Learned Societies would help finance a second book on North Carolina historic architecture. This time the focus would be on architecture exclusively and not gardens. Thomas Tileston Waterman, then employed by the National Park Service as a historical architect, agreed to provide the text. By the time he was assigned the task of writer, he was indefinitely on leave without pay due to the suspension of the HABS program and had begun working privately for architects as well. Although he admitted he could not afford much time, he wrote the text with the assistance of Johnston. During this time, Johnston printed and edited her files of about eight hundred photographs and edited her files as well, between trips throughout Georgia to take pictures, although she would not receive a Carnegie grant the following year. She thought that she would need an additional $2,500 in 1939 to cover Waterman's costs. At this point she had five publishers interested in the North Carolina project. For the resulting book, a total of 350 pages with 100 pages of text, she provided 244 photographs chosen from 700 to 800 negatives on file for about 40 counties. Partially financed by the Colonial Dames of America due to the support of Mrs. Cannon, who was an active member of the Garden Club as well, *The Early Architecture of North Carolina* was published by the University of North Carolina Press in 1941 and reviewed widely by art and architectural journals. The work, bound 12.5 inches by 9 inches, sold for a retail price of $10. Only six years later, the university press would publish the work a second time.[73]

Of all her publications, Johnston considered *The Early Architecture of North Carolina* to be her "very own."[74] While other publications featuring her architectural photographs turned out to be collaborations, with Johnston mainly as photographer, she managed the research, finances, writ-

ing, overall design, and publishing as well the photography for the North Carolina book. Johnston relied on a large number of people in North Carolina to guide her research and received lists of an unprecedented number of historic buildings to photograph. Professors, architects, librarians, and wealthy patrons all helped her make contact with people who wanted to see and purchase her work. Within five years, not only did she survey historic buildings throughout the state but she was also able to collaborate with local historians, librarians, and architects and to promote her work through exhibits and magazine articles, which led to the publication under her direction.

Collaborative efforts between writers and photographers were common for the publication of documentary photography from the mid 1930s through the 1940s. Pictures and text by this time had taken on separate functions, as writing was associated more with everyday journalism and photographs more with art. This distinction improved the professional status of photographers in much the same way that visual conventions set by late nineteenth-century photographers had earlier distinguished their work from other types of less intentionally artistic photographs. Known as an art photographer early in her career, Johnston understood the economic benefits of this reputation for her later architectural photography. After the turn of the century, she increasingly relinquished her official role as a writer so that the public would perceive her photographs more easily as art. But she liked being able to explain her own photographs and continued to lecture throughout the 1930s. The texts of others often changed the meaning of her photographs, and at times her position on landscape was given less emphasis than she would desire, as in Brock's 1930 publication. While Johnston supported the more scholarly approach of historical architects, she felt more comfortable being affiliated with members of garden clubs and traditional women's organizations that supported her interests as well as her work. These women's groups provided Johnston with moral support and shared her active concern for environmental issues more generally. It was only natural, then, that the North Carolina book would be partially financed by the Colonial Dames of America and that Johnston would feel most attached to her North Carolina architectural publication for the Regents of the Daughters of the American Revolution.

Johnston's photographs in the North Carolina publication, such as those

of the Cooleemee-Hairston House, Playmakers' Theatre, and Chapel of the Cross, demonstrate the range and depth of her understanding of significant landmarks in that state.

Cooleemee-Hairston House

Johnston emphasized the lyrical, pictorial, and romantic qualities of Cooleemee-Hairston House located at the center of a 12,000-acre plantation in Davie County, North Carolina, where nearly two hundred slaves once lived and raised corn and tobacco (figure 34). Land for Cooleemee Plantation was acquired by Captain Peter Hairston, an American Revolution soldier from Henry County, Virginia. In 1817 he bought several tracts located on the Yadkin River in Davie County from General Jesse A. Pearson for $20,000.[75] The name of the plantation, already Cooleemee by this time, may have originated with the Creek Indian place encamped by Pearson during a military campaign. The wealthy owners of the plantation, Major Peter W. and Columbia Stuart Hairston, had their builders copy directly from a design published in 1847 in William Ranlett's *The Architect*, the most influential nineteenth-century architecture book in North Carolina. This derived plan of a prototype, known as an "Anglo-Grecian Villa," had in turn been illustrated in the January 1850 issue of *Godey's Lady's Book*.[76]

Work on the house began by 1853 after completion of the plank road from Fayetteville to Bethania, commonly known as the Appian Way of North Carolina. This road facilitated construction of the house as well as eased the expense of getting produce to market. Peter Hairston hired the experienced Davidson County contractors John W. Conrad and John W. Williams to build the house and employed his own slaves to dig the clay for bricks. Many of the other materials, including the elaborate woodwork, were obtained elsewhere. The mahogany handrail, columns, and carved trim of the stairway Johnston photographed were shipped from Philadelphia to Wilmington, North Carolina, for example, and then hauled up the plank road by oxcart to Fayetteville. Construction of the house was completed in 1855 and cost over $10,400. Captain Peter Hairston never lived at Cooleemee, but on his death in 1832 he willed the estate to his great grandson, Peter Wilson Hairston, the builder of the present Cooleemee house. In 1849, Peter Wilson

Hairston married and the couple moved to Cooleemee. The plantation has remained in the family and is presently owned by Peter Hairston III.

The plantation house, with its commanding view of the Yadkin River from a rural hilltop site, shows the influence of the Classic and Romantic Revivals, both picturesque Victorian styles that epitomized Downing's ideals about rural architecture.[77] For followers of Downing, the goal of architectural design was to elevate public morality through the depiction of stability and prosperity. In fact, Cooleemee Plantation, with its geometric massing and expansive plan, is a significant representation of a full-blown villa in mid-nineteenth-century North Carolina. The house is set upon a low foundation of dressed granite above a full finished basement of random fieldstone. The wide architecture, frieze, and dentil cornice extends completely around the house and frames the tympanum of each pediment. One-story verandahs supported by different types of columns are located within the angles of the building, one supported by Doric columns on the east façade, the other supported by Ionic columns on the west façade. The porch facing the carriage road has the more simple columns. The Ionic columns support the verandah facing the less formal, more private view on the main west façade.

The plan of the Cooleemee house is emphatically three-dimensional—that of a Greek cross with four equal wings radiating from the central core. The core consists of a spiral cantilevered staircase ascending three stories from the central hall, covered by a glazed octagonal cupola. The end of each wing of the two-story stuccoed brick building has a pedimented gable with a bay window on the first floor. Above these bay windows are paired arched windows situated along the second floor.[78]

Johnston's view of the evenly lit Cooleemee-Hairston mansion encompasses the front of the house, the L-shaped porch, and the octagonal lantern, or cupola. The stability and grandeur of the antebellum piedmont mansion are emphasized by the symmetry of the photograph, so that the semicircular bay windows extending from either end of the west and south wings and the cupola flanked by brick, heavily molded, capped chimneys form a triangle. The sides of the theoretical triangle are in a sense encased within the pavilions, sloping down from the cupola to the bay windows. The pavilions add stability and grounding to this triangular component of the building. Another triangle counterbalances the dramatic ascendance of

the cupola formed by the two-story high pediments of each wing above and the central entrance below. This upside-down triangle is further accentuated downward by the concave, L-shaped building and one-story verandah. Johnston's focus on the central core of the building, where the two wings meet in both interior and exterior views, features the cupola that contains a spiral staircase. Likewise, the verandah anchors the building by visually repeating the overall shape of the house as well as the detailing, such as the denticulation of the cornice, at a lower height and on a smaller scale.

Johnston used the Cooleemee landscape to soften the loftiness and monumentality of the expensive mansion. A worn brick pathway in the foreground leads the viewer to the front steps of the porch located in the middle ground. Johnston allowed a large treeless limb to remain in the foreground because it only slightly obscures the house and serves as a constant reminder of its surroundings. The tree trunk remains out of view just to the left of the picture. The leafless limbs and the leaves on the lawn suggest that the photograph was taken in late autumn. Furthermore, the diagonal positioning of the thin limbs draws attention to the vertical and horizontal lines of the wing on the left side of the photograph.

Other diagonals in Johnston's photograph add more perspective. The entrance walkway enters the photograph from the left side, while being diagonally lit from the right side. Shadows of the two columns projected onto the left side of the house balance the composition of the photograph by visually increasing the vertical thrust of the structure. Johnston's sophisticated manipulation of exposure to light allows only some parts to be in full sunlight so that "duplicated" parts of the house are in shadow. For example, one pedimented gable is sunlit, the other in shadow. One side of the wing is lit, the other side is not. This visually compelling lighting scheme retains information about each section of the house without repetition. The relevant parts are evenly lit so that the house remains in full view. Even when other photographers have managed to duplicate the viewpoint of Johnston's photograph, her elaborate lighting scheme remains unique.

The expansive plan of the Cooleemee-Hairston House and the emphatic three-dimensionality of its architectural style are the main focus of Johnston's photograph. The geometric massing on all four sides is represented by the symmetry of the L-shaped verandah of the main west façade as well as the prominence of the central cupola. Johnston's sensitive light-

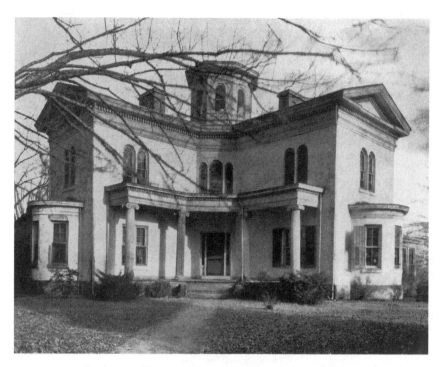

FIGURE 34. Cooleemee-Hairston House, Davie County, North Carolina, c. 1936

ing treatment allowed for the essential features to remain in full view. The vertical bands of shadow and light furthermore add to the verticality of the building so that it appears monumental and grand. The lyricism and romanticism expressed in Johnston's photograph underscores the sophistication of the Cooleemee-Hairston House as a piedmont North Carolina villa with an elegant combination of Greek Revival and Italianate detail.

Playmakers' Theatre or Smith Hall

The Greek Revival, particularly in the South, reached its most significant expression in American college campus architecture. As Catherine Bishir has eloquently noted, "It embodied the classical curriculum and Greco-Roman tradition to which most colleges and academies aspired, lent an air of authority and venerability to many newly established institutions, and evoked the spirit of democracy and the broadening of higher education."[79] Growing prosperity enabled the establishment of more than twenty

colleges in North Carolina between 1850 and 1860. During this time, the Greek Revival style was important for the design of new buildings as well as changes and additions to older ones.[80] The University of North Carolina at Chapel Hill was chartered in 1789 and the first cornerstone of its oldest building put in place by 1793. Smith Hall, completed in 1850, was an elegant version of the Greek Revival temple form. In 1848, the student debating societies first proposed construction of a building that would be used as a campus ballroom. One year later, university leaders proposed that a library and meeting hall be added to the design plans of the same building. Alexander Jackson Davis of New York City, who had already designed and altered other buildings on the campus during the 1830s as part of its comprehensive development and improvement, planned to build a structure eighty feet long with a portico supported by four Corinthian columns at one end. After meeting with the university president, David Swain, Davis made the plan larger by forty feet. Influenced by Latrobe's work on the United States Capitol forty years earlier, Davis replaced the typical Roman acanthus leaves on the capitals of the Corinthian columns with a wheat and cornhusk design and had these individually rendered capitals carved in New York. The originality of Davis's Greek Revival form was part of an effort to group a number of buildings visually so that the portico complements the monumental pilastered sides of a nearby building known as Old East, the oldest building on campus. Both are simple rectangular buildings without architectural pretensions, similar in proportion and design. The contractor of the library, which now serves as the Playmakers' Theatre, was Captain John Berry of Hillsborough, designer and builder of the Orange County courthouse built in 1844. Johnston acknowledged Berry's work, noting that the columns on Playmakers Theatre appeared to be truncated and did not show the correct proportions usually found in Davis's work. Attracted to the Greek Revival style—many of her photographs show Greek Revival buildings—Johnston understood the significance of the Greek Revival for architecture in the South. She was familiar with the typical classic proportions and recognized any deviant forms.

Located at the University of North Carolina campus in Chapel Hill, Smith Hall, or Playmakers' Theatre as it has been known since 1925, is three bays wide by fourteen bays long. Each bay along its length is marked by an unfluted pilaster, which Davis called a pilastrade, and every other bay

FIGURE 35. Playmakers' Theatre or Smith Hall, Chapel Hill, North Carolina, c. 1936

is punctuated by a window. The one-story building is approached by the main entrance located at the west gabled end. Typical of Greek Revival detailing, a large, central, paired wooden door has a transom above of six fixed panes. Two niches with surrounds are located on either side of the doorway. The portico with antae at the corners consists of fluted, Corinthian-like columns with capitals that have the modified wheat and cornhusk designs. The porch ceiling is deeply coffered. The columns support a full entablature, upon which rests a pediment with each of its sides supported by eaves extending along all four sides of the building.

Johnston's elevation view of Playmakers' Theatre is a direct and emphatic statement about the essential purpose of the Greek Revival style for collegiate buildings. Her presentation of the theatre pictured in *The Early Architecture of North Carolina* focuses on the gabled end façade consisting of the principal entrance encased by a rubble masonry wall, which may have been part of Davis's design or a later addition. The porch itself has three steps along the full end and sides of the portico. The columns are only on the front of the portico. There is a slight angle allowing the right side of the roof to be seen, perhaps to allow for minimal distortion and for more thorough disclosure of its overall form and shape. This nearly complete elevation viewpoint, similarly used by Walker Evans to portray more modest vernacular buildings of the South, allowed Johnston to focus on the most essential Greek Revival detailing of the Playmakers' Theatre: the recessed portico and surrounds of the doorway, so that even the fixed glass panes of the transom are distinguishable. Furthermore, none of the surrounding buildings compete for attention, as they do in perspective views of the same building.[81] Johnston's portrait of the theater gives the collegiate building more presence, formality, and personality. The building appears as grand and monumental as possible at close range.

The traditional, classical east façade that Johnston chose as the focus of Playmakers' Theatre is framed by its natural surroundings. A single vine that has climbed up the column farthest to the left stretches across the entablature of the building. Shrubs are situated at either side of the façade and two along to the right of the front. Leaves on the shrub suggest that the picture was taken during spring, summer, or early autumn. The sunlight is coming from the southeast, so that the photograph must have been taken

sometime in the morning. Shadows strongly illuminate the fluted columns and dentils of the pediment, and shadow from the portico extends along the front façade just above the doorway so that no significant architectural details are obscured.

Johnston's architectural portraits typically consist of the principal façades of well-known buildings, as if these frontal views were in a sense anthropomorphic. Johnston revered each building she photographed, and the photograph of Playmakers' Theatre, located on the university campus where her first book was published, is no exception. The portrait of the theater illuminates its individuality and character within its landscaped setting. Superficial details and surrounding buildings do not clutter the scene. Rather, Johnston has chosen a tighter frame so that the most essential feature of the building, predominantly the portico, becomes the primary dramatic interest. Natural light gracefully underscores the three-dimensionality of the architectural details on the principal façade, such as the fluted columns and denticulation along the entablature. The raking light along the left side of the façade centers the photograph, leading to the door as the central focus, just as the light on the front steps leads likewise to the portico. Johnston's point of view, furthermore, is level to the principal façade so that we meet its "gaze" squarely, more like an old friend.

Chapel of the Cross

Johnston's architectural photographs in her North Carolina publication include portraits of Gothic Revival buildings such as the Chapel of the Cross Episcopal Church at 304 East Franklin Street in Chapel Hill, North Carolina. Like the Greek Revival style, the Gothic Revival was another style that had special relevance for the South. It was promoted by Episcopal Church leaders in an attempt to reform and strengthen their denomination by emphasizing religious experiences and inspirational feelings more than rituals. According to the teachings of A. W. Pugin, Gothic Revival architecture was designed to renew virtues that were in keeping with those espoused by the medieval church. The Episcopal Church in North Carolina encouraged the use of the Gothic Revival after the 1817 organization of the diocese.[82]

William Mercer Green, chaplain at the state university, was inspired by

FIGURE 36. Chapel of the Cross, Chapel Hill, North Carolina, c. 1936

the 1842 construction of St. James Church in Wilmington, North Carolina, designed by Thomas U. Walter.[83] Chaplain Green was responsible for the founding of the Chapel of the Cross and for choosing its architect. He also later supplied the brick used for its construction. Green obtained a similar but simpler plan to that of the Wilmington Church from Walter for the Chapel of the Cross, which was completed six years later in 1848. Walter, who designed many Gothic Revival churches including others in the South, charged $25 for the plan, two elevations, and a section of the chapel. The elevation drawing shows that the church included Gothic Revival detailing such as a square symmetrical crenellated tower, a rectangular nave, buttresses on each corner of the gable roof, and tall windows with lancet arches and patterned trefoil designs above lead glass panes.[84]

Although the church was criticized one year after it was built by a correspondent of the *New York Ecclesiologist* for its painted and marbled woodwork, superficial decorations, and the absence of a chancel,[85] Johnston celebrates the local adaptations of this increasingly popular style. Waterman's text refers to the Chapel of the Cross as "an example of good Neo-Gothic design,"[86] and the caption to Johnston's photo includes the information that the church was built by slaves and contained an old slave gallery.[87] Johnston's treatment of local nuances is not only evident in the way she credited local architects for adapting the design and guiding the construction of the building but also in the way in which she emphasized idiosyncratic uses of the building to make it seem more like a portrait. By emphasizing in the text that the church was built by slaves she placed the building in the historic context of traditional southern culture. Slavery was an essential component of traditional high-class society, and one had to be wealthy to own slaves.

Furthermore, nature is being allowed to embellish the architectural design to show the harmonious presence of God, a notion expressed in the writings of John Ruskin. In Johnston's photograph of the Chapel of the Cross, the vines symbolize the coexistence between nature and a manmade construction while visually obstructing its presence. Although ivy can be destructive to a building, the vines are also an emphatic statement about the endurance of the original building over time since no exterior alterations of the building could take place without the ivy being removed. Johnston depicts what she perceives is most important about the building: the origi-

nal antebellum construction of the church rather than later additions. She does not show Hobart Upjohn's design of a more imposing Gothic Revival church built in 1925 next to the smaller Chapel of the Cross, because she is not interested in how expression of the mature Gothic Revival parish church changed over time. She is more interested in the timeless qualities of the original building and how it has aged. The ivy that has been allowed to creep over the entire brick façade is a reminder of how nature intervenes and takes over manmade constructions.

Johnston also shows an appreciation for the details of the building itself, such as the brick patterning, the glass panes, wooden panels of the front door, and ironwork of the door handle—all of which are clearly delineated in her photograph. Not obscured by the ivy, these architectural components are in fact the only parts of the church that are visible. In keeping with Gothic Revival principles made popular by Ruskin in England and the United States, Johnston shows how God, in a sense, is being expressed in these details.

The angle and lighting that Johnston used in this photograph allow the Gothic tower to become the central focus. Johnston took the picture from the northwest so that the newer addition is not visible, nor any trees in the front yard. Rather than using an elevation view, Johnston showed the tower in a three-quarter view, which makes the tower appear three-dimensional. Johnston achieved this by taking the picture from the northwest so that the front façade can be viewed separately from the rest of the building, which was added later. The point of view, furthermore, emphasizes the central position of the square, symmetrical, crenellated tower and other aspects that were part of the original mid-nineteenth century plan. The picture was taken in mid morning, as the light appears to be coming from the northeast. From this camera position and time of day, the front façade appears to be evenly lit, with subtle shadows falling along the prominently viewed southwest side of the tower, which further emphasizes its three-dimensionality. The light on the top left corner of the tower is balanced by the light on the lower right corner, so that the overall composition remains fully balanced. Sunlight coming from the right side of the picture illuminates the brickwork of the turrets and the wooden louvered screen of the tower and makes the ivy below appear thick. The lack of focus on the left side of the original church structure puts more emphasis on the tower so that it ap-

pears as if enveloped in a hazy glow not unlike that seen in Frederick Evans's nineteenth-century photographs of English cathedrals.[88]

The Early Architecture of Georgia

Johnston's survey of historic architecture in Georgia began in the late 1930s. In December of 1938 she asked for another Carnegie grant to go to Georgia and then Alabama, thinking that she would need about $1,000 to conduct research in each state. With the money she received, she took between three hundred and four hundred negatives in Georgia. Margaret Mitchell wrote from Atlanta that she was "very busy following the train of *Gone with the Wind*" and could not give much advice about where Johnston could receive lists of historic buildings to photograph. She suggested instead that Johnston meet Mrs. Louise Hayes, the state historian of Georgia, and Mrs. Ruth Blair, secretary of the Atlanta Historical Society of Savannah. She also advised Johnston to stop in small towns and talk to editors of newspapers and members of garden clubs. She believed that Washington and Thomasville, as well as Milledgeville were exceptional places to photograph.[89] By the end of 1939 Johnston had received an additional $500 to complete her photography of Georgia. Soon afterward, she exhibited her Georgia photographs. Seventy photographs of picturesque Savannah were shown in that city's Telfair Gallery, and 150 prints were prepared for the Association for the Preservation of Savannah Landmarks.

Johnston first began talking about her desire to publish a book on Georgia historic architecture at this time because she believed her survey of historic Georgia buildings was significant both for the growth of landscape studies and historic preservation. By the time she had about seven hundred negatives in her files she interested Professor Bush Brown, regional director of HABS for Georgia, as well as E. Walter Burkhardt, a professor of architecture, in the project. Beginning in 1944, Johnston wrote to Edward Vason Jones, a Savannah architect, regarding a possible collaboration on the Georgia project.[90] Her subsequent letters to Jones show her enthusiasm in making plans for her accumulated photographs of Georgia. In her memorandum to Jones of November 12, 1944, she stressed that Hubert B. Owens, founder of the University of Georgia School of Environmental

Design, be consulted about possible connections in Athens, Georgia.[91] She also suggested that Duncan Burnet and a Miss Hollingsworth be contacted about receiving collections of photographic records for the Georgia State University Library and that Lamar Dodds, director of the University Art Museum, as well as Miss Hollingsworth be contacted to discuss the purchase and display of enlargements of her Georgia photographs at the University Art Museum.[92] In the end, Jones was unable to make good on his apparent original intention to collaborate on the book, and Johnston turned to Owens as a possible substitute. In 1949, while he was head of the Department of Landscape Architecture at the university, Owens finally agreed to the collaboration.[93]

It is not entirely clear how Johnston first met Owens or why she considered him for the proposed Georgia project. It is possible that she first contacted him before the beginning of the Georgia part of the Carnegie Survey in 1938. Although she had previously taken photographs of gardens throughout the country for magazines and Garden Club of America books, it appears that she took few, if any, photographs of gardens in Georgia and wished to find out about gardens to photograph in that state. Owens would have been acquainted with Johnston's garden photography from magazines and books. Shelton's *Beautiful Gardens in America* (1915), which consisted of 195 photographs including 93 of Johnston's, was a standard text in the University of Georgia's fledgling Landscape Architecture Department, at least by the 1930s. Owens also worked with many garden clubs, whose members would have been familiar with Johnston's work.

Owens's letter to Johnston of June 30, 1949 (see n. 78) provides some insights into his viewpoint as well as suggesting some of his limitations. He thought he could write the historical background, which he believed should be the principal part of the text, but he had reservations since he believed Johnston's records were not complete enough for publication. First, he thought that she omitted several significant towns such as Covington, Oxford, Marietta, Clarksville, and Rome. Furthermore, he found a large number of unidentified records that were also missing dates of construction and information about the original owners. A third reason for Owens's reluctance to become involved was that he wished that the book could be about gardens as well as houses. One month later, Paul Chapman, associate dean of the College of Agriculture, wrote to the University of North

Carolina Press about the possibility of a book on the "old homes and gardens of Georgia, primarily houses." Oblivious to Owens's desire for more information about gardens, Chapman stressed that anything on gardens would be incidental.[94]

One and one half years after Paul Chapman's letter, Lambert Davis, director of the University of North Carolina Press, was still in touch with Owens and Johnston to pursue the publication of the Georgia book. In his letter of January, 31, 1951 to Johnston, who was now eighty-seven years old, Davis explained that the Georgia book "represents a chance to tap a practically virgin market."[95] In addition, he explained that Owens was still interested in writing the text and told Johnston to collect all of her Georgia photographs and provide each with a caption.

Shortly afterward, the process seems to have broken down for uncertain reasons. On May 16, 1951, Davis wrote to Johnston that Owens would be sending all of her Georgia photographs to her residence, then at the Arts Club in Washington, D.C.[96] Davis met her there shortly afterward and arranged for an introduction to Frederick Nichols, a young architect and architectural historian at the University of Virginia. Terms between Johnston and Nichols and the University of North Carolina Press were further agreed upon. Davis wrote to Johnston again on January 10, 1952, to say that Nichols was to receive a royalty of 2.5 percent of the retail price of all copies sold for writing the text and captions; Johnston was to receive 15 percent for her photographs.[97] Unfortunately, she died two months later on March 16, 1952, at the age of 88, long before the project could be finished. *The Early Architecture of Georgia*, still one of the standard works on Georgia architecture and a model for subsequent statewide studies, was finally published in 1957. Hubert Owens clearly can be numbered among those who appreciated Johnston's work and what it represented. He would continue to publish and to promote the cause of historic preservation until his death in the 1980s.[98]

Lucy Cobb Institute

Johnston's photographs for the Georgia publication, including the Lucy Cobb Institute, reveal that she was aware of the significant landmarks in that state and that she understood their most salient features (figure 37).

The Lucy Cobb Institute was one of three notable women's academies established in Georgia during the nineteenth century.[99] The boarding school was built in 1858, two years after eight acres of land were purchased for a girls' high school in the Cobbham district of Athens by its Board of Trustees. The first class of students included about seventy-five women. Originally called the Athens Female High School, it was renamed to commemorate Lucy Cobb, the young daughter of the major donors, Thomas Reade Rootes Cobb and Marion Lumpkin Cobb, who had died of scarlet fever at the age of thirteen while the school was under construction.

Thomas Cobb became the principal fund-raiser for the school after his sister Laura Cobb Rutherford wrote an anonymous 1854 newspaper article urging Athenians to facilitate higher learning for young women in the South. After the first principal of the school, Mrs. A. E. Wright, left, followed by many of the students who appreciated her work there, Miss Mildred Rutherford became the new principal, president, director, and one of the teachers. Under the direction of Rutherford for the next forty years, the school prospered and soon ranked among the finest girls' schools in the nation, particularly in the liberal arts.[100]

In the early years of the school's existence, classes were held in the main building. At the turn of the century, Alumni Hall and Margaret Hall were built at the rear and a gymnasium was added. The Lucy Cobb Institute was used at various times as a girls' dormitory, office space, university classroom space, sorority housing, and storage space. In 1931 the school was closed due to financial problems and subsequently its buildings were donated to the University of Georgia. These were not badly deteriorated by the time of Johnston's visit in 1936, just five years after they fell into disuse.[101]

Johnston's photograph of the Lucy Cobb Institute, typical of her architectural photography, presents the maximum information possible about the structure in a lyrical way. The size and form of the building are emphasized. The vines along the front porch, dappled in sunlight, add to its character. To make the Lucy Cobb Institute appear three-dimensional, Johnston displayed its front façade at an angle and also made extensive use of light and shadow by taking the picture in the late morning of an autumn day. Viewed from an angle at the level of its raised foundation, the principal façade is almost completely seen. The photograph appears to have been taken in the early part of the day since sunlight is coming from the east, and the front of

FIGURE 37. Lucy Cobb Institute, Athens, Georgia, c. 1938

the façade is clearly lit. The tree limbs in view in the foreground are missing some of their leaves.

Located at 200 North Milledge Avenue in Athens, Georgia, the building is 135 feet long, 60 feet wide, and three stories high. As in her other portraits of significant high-style buildings, Johnston focuses on the entire façade from a close proximity to emphasize simultaneously the overall massiveness and character of the place embodied through rich architectural detail.

The type of the camera as well as the large format of the prints allowed Johnston to show the building at full height from a relatively close view. The three-story building has walls constructed of stucco over plastered brick. A full-façade hip-roofed porch, adorned with decorative cast iron, extends along the principal façade of the first floor. Johnston's photo indicates that the porch, later enclosed with fixed glass panes, rests on stucco piers. A central balustrade staircase ascends to the central front entrance. Greek Revival details include a rectangular transom above and on the sides of the door while the ornate pilasters supporting an entablature are detailed with an antherion motif. Entablatures are found over all windows, with the exception of those opening onto the verandah, which are twelve-over-twelve, and six-over-six. The projecting entablature below the center of the six-bay third story throws delicate shadowing along the second floor. These shadows emphasize three-dimensional qualities of the detailing such as the denticulation above the second-story windows and bracketed entablatures of the full-length windows on the third floor, otherwise not visible in full sunlight.

Johnston's viewpoint stresses the informality and warmth of the Lucy Cobb Institute even though no one is present in her photograph. Leaves of the vines that had grown into the delicate cast-iron posts are distinguishable, glittering in the sun. Typically picturesque symbols of age, the clearly delineated vines indicate that the building has aged gracefully without deterioration. All of the architectural details in the foreground can be viewed precisely as well, and yet the overall size and form of the front façade are emphasized. As a result, the portrait of the Lucy Cobb Institute is distinctive in the way the building appears monumental and dignified, situated within a mature landscaped setting.

Comparison of Johnston's Georgia, North Carolina, and South Carolina Books

The Early Architecture of Georgia (1941), with a text written by Thomas Waterman, closely resembles *The Early Architecture of North Carolina* (1957), by Frederick Nichols, in its layout, overall design, and subject matter. Both books were published by the University of North Carolina Press under the direction of different editors, and it is clear that the North Carolina book set the precedent for the text and photography of the Georgia book, which was published sixteen years later. Both have about the same number of photographs. In the North Carolina book, half are full exterior views and the other half are sections of building interiors and exteriors showing architectural details at a closer range. In the Georgia book, the numbers of exterior and interior views are skewed a bit differently in each chapter. Another slight difference between the publications is that a few of the photographs in the Georgia book were taken by other photographers.

Numerous photographs of doorways, mantels, corner constructions, cornices, porticos, and other elements or details by Johnston are included in both *The Early Architecture of North Carolina* and *The Early Architecture of Georgia*. They total more than those in previous publications containing Johnston's architectural photography, including Samuel Stoney's *Plantations of the Carolina Low Country* (1938). The photographs chosen for the North Carolina and Georgia books were planned to correspond to the texts of the publications, although in the case of the Georgia book, Johnston herself did not always decide this correspondence. Stoney, on the other hand, does not dwell on architectural details but has a greater chronological framework. To address architectural trends, he discusses buildings in terms of their date of origin and includes historical anecdotes about original settlements and how past occupants lived, along with occasional references to distinctive architectural features. Stoney's seventy-six-page text also contains considerable detail showing that the regional geography and climate in the Carolina Low Country were suited for plantation life and how rice cultivation developed the region economically and politically.

Nichols's and Waterman's greater emphasis upon architectural details allows them to concentrate more on building materials, house plans, and the way certain building techniques came about historically. Theirs are more strictly architectural histories than broad social histories of the respective

states. Also, both authors group the architecture more thematically than Stoney. Rather than listing the buildings chronologically, they group them by broad architectural types within geographic areas. For example, both include the domestic architecture of the coastal and piedmont regions as well as a section on public buildings that includes forts, churches, and university buildings. This thematic system is reflected in the kinds of architectural photographs included in these books.

Johnston's photographs in Nichols's Georgia book and in Waterman's North Carolina book are almost purely architectural in subject matter and emphasis, although landscapes and people are occasionally presented for scale and context. Always, the focus is on the architectural features and on the quality and character of surfaces. In her photograph of the doorway of the Michael Braun Town House in Salisbury, North Carolina (figure 38), for example, the viewpoint is from below so that the mottled granite steps are in the foreground, their lighter color contrasting with and balancing the dark paneled door above.[102] In the same photograph, all of the door surrounds are in view, framed by the ceiling above and the steps below. Johnston uses the sunlight reflecting in the windows to outline the decorative leaded glazing. The strap-work ornament in the pilasters is also outlined. The photograph of the stairway at the Graham House, near Beatties Ford Plantation, N.C. (figure 39), also included in Waterman's book is shown as merely a segment, so that the dark balustrade against the white wall becomes almost an abstract design.[103] Here Johnston is less interested in a sense of place or setting. Rather, the wood-carved embellishment along the sides of the risers, the graceful curve of the balustrade, and the simplicity of the slender banisters and rail become the true subjects of her photograph. Architecture becomes, in a sense, divorced from social context and is represented as pure form and texture.

Whereas Johnston tended to use a wider angle focus for the plantations of the Carolina Low Country, the more modest domestic architecture of the tidewater and piedmont regions required a more specific focus so that details would not be lost. Also, ceilings and rooms are smaller than in the South Carolina plantation homes. The narrower emphasis and tighter framing seems more modern and comes closer to the type of architectural photographs that Jack Boucher would later execute for the Historic American Buildings Survey, beginning in 1958. This type of photograph

FIGURE 38. Michael Braun House, Salisbury,
North Carolina, c. 1936

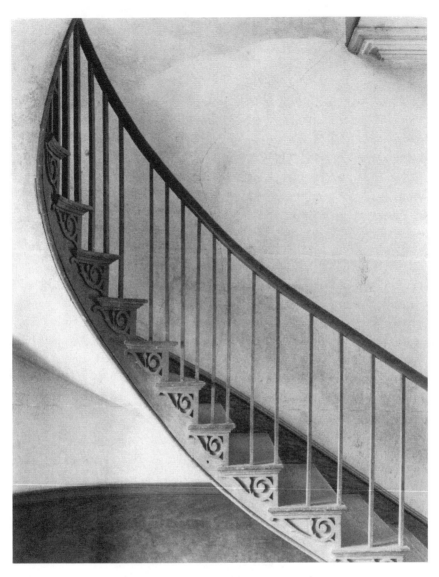

FIGURE 39. Graham House stairway, Lincoln County,
North Carolina, c. 1936

is also suggestive of the more modernistic photography of Walker Evans, who used form and texture in older buildings to create almost abstract compositions and patterns. Some of Johnston's photographs share in this aesthetic. *The Early Architecture of Georgia* contains photographs of such features as a gazebo in Macon ("Gazebo at Overlook"),[104] ironwork of the front stairs at the Clanton-Vaison House in Augusta,[105] a cast-iron harbor light in Savannah,[106] and a dilapidated outbuilding entitled "Quarters" at Brook Hill Plantation, Sharon Road, near Washington, Georgia.[107]

The variety of architecture Johnston photographed shows that she was sensitive to all kinds of historic architecture, both high style and vernacular. Johnston stated that the prominent homes of colonial America had already "been photographed often and well."[108] She photographed some of the great mansions of the South, but she also devoted a great deal of time to the less well-known and more neglected vernacular architecture. The North Carolina book, in particular, has a strong emphasis on more modest colonial architecture, and the majority of Johnston's photographs here reflect what Holland describes in the foreword as more "homespun" architecture not derived from European models. Johnston's tighter focus allows architectural details to remain clearly visible—for example, the entrance hall of Smallwood-Ward House;[109] the porch detail on the Maxwell Chambers House;[110] and the window, portico, and rear elevation of Prospect Hill.[111] These photographs document features, albeit deteriorated and unpainted, that make each building unique. Other photographs involving cross sections include pictures of doorways, fireplaces, corners, cornices, porticoes, windows, stairs, ironwork, and chimneys seen from a variety of vantage points that are best for displaying as many of the features as possible. For example, in the photograph of the Smallwood-Ward House Entrance Hall, New Bern, Craven County, Johnston took the photograph so that the archway of the entrance hall frames the stairway in the distance. The overall plan is visible as well as the fine details of the woodwork. In Johnston's photograph of Little Manor (or Mosby Hall), she focuses on the exquisite details of the doorway.[112]

Of the total number of photographs by Johnston selected for Stoney's book, half are interior shots, mostly fireplaces and stairways. A much smaller percentage of Johnston's photographs include exteriors of outbuildings and church interiors, exteriors, and ruins. A few of the photographs are simply

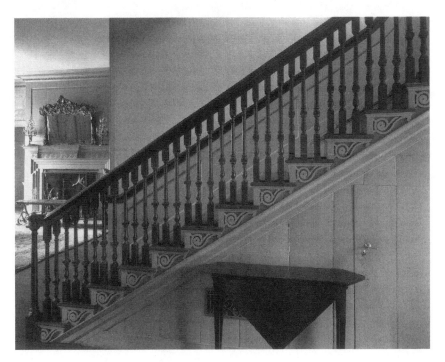

FIGURE 40. Entrance hall at Fenwick Hall, Johns Island,
South Carolina, c. 1938

landscapes without any buildings at all. Johnston's photographs in Stoney's book, such as those of Hanover, St. James Church, Harrietta Rice Field, and Fenwick Hall, reveal representative characteristics of her overall style. She shows buildings close enough in the foreground to illuminate textures and other architectural details. Yet they are far enough away that they can be viewed in their entirety within their indoor or landscaped settings.

Careful attention to the framing of interior views is maintained allowing for a balanced composition of dark and light elements evenly weighted from one side to the other. For example, in Johnston's photograph of the entrance hall of Fenwick Hall, a doorway that opens onto a living room mirror and fireplace on one side of a diagonal stairway balances out a dark drop-leaf table in the foreground.[113]

Sometimes the balancing of lights and darks and geometric sizes and shapes creates somewhat modernist, abstract, flat compositions that counteract actual spatial depth. For example, the interior of St. James Church, Goose Creek, is one of Johnston's more interesting photographs due to its

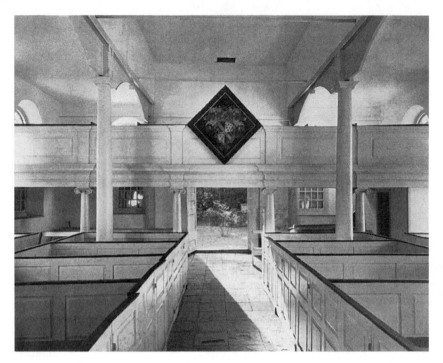

FIGURE 41. St. James Church interior, Goose Creek,
South Carolina, c. 1938

striking lighting effects. Indirect light, appearing from the windows and
open entrance at the rear of the church, streams in at an angle to illuminate
the square paving stones, the square paneling of the pews, and the balcony.
The slightly ajar pew doors to the left of the center of the photograph create
shadows on the paneling. A dark diamond-shaped coat of arms at the cen-
ter of the balcony, the lines of the pews, the paving stones, and the raking
light all direct the viewer's gaze toward the landscape that is visible at the
rear.[114]

Johnston's most successful architectural photographs, created with long
depths of field characteristic of large format cameras that can handle long
exposures, have a wide tonal range and are fully in focus so that all architec-
tural details are clearly visible. In *Plantations of the Carolina Low Country*,
the vantage points used in the photographs of Drayton Hall and of the
northeast room of Fenwick Hall allow for a greater amount of area to be
shown than would be possible using elevation views. The photograph of the

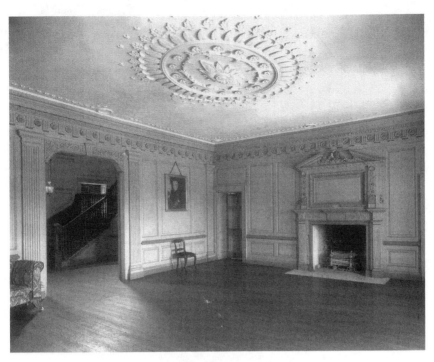

FIGURE 42. Entrance hall of Drayton Hall, Charleston,
South Carolina, c. 1938

entrance hall of Drayton Hall encompasses the central ceiling medallion,
the intricate paneling of two walls, the fireplace, and a door left slightly ajar
in order to be clearly outlined by the light behind it.[115] Beyond the entrance,
light streaming through the jalousies located behind the staircase provides
a horizontally patterned backdrop, highlighting the vertical pattern of the
balustrade. In the photograph of the stairway in the room behind the en-
trance hall, Johnston illuminates the grandeur and spaciousness of the hall,
a characteristic that cannot be conveyed by the elevation views shown in the
architectural drawings.[116]

The photograph of Drayton Hall stairway, taken just below the landing
of the double staircase,[117] manages to include the greatest range of views.
Parts of three rooms can be seen as well as close-ups and distant shots of the
decorative stairwell. This view provides a parallel to the architectural draw-
ings, which show the overall elevation as well as details of the balustrade
and elaborate course of modillions beneath it (figure 43). In Johnston's pho-

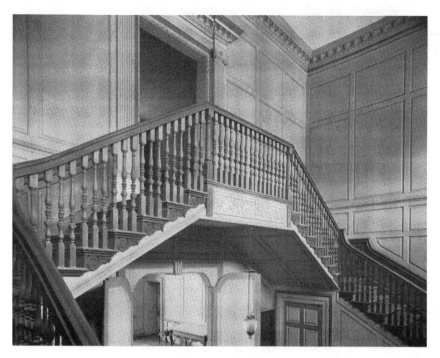

FIGURE 43. Drayton Hall stairway, Charleston,
South Carolina, c. 1938

tograph of Fenwick Hall, she captures a similar kind of spaciousness by ma-
nipulating her vantage point so that the convex mirror above the fireplace
reflects the stairway across the room (figure 44). To avoid an elevation shot
and prevent glare and reflections, Johnston allowed her camera on its tripod
to be seen in the mirror, reminiscent of the reflection of the subjects in Jan
Van Eyck's famous 1434 portrait of Giovanni Arnolfini and his bride.[118]

Unlike Johnston's books that were eventually published on the historic
architecture of North Carolina and Georgia, *Plantations of the Carolina
Low Country*, covering fifty-five historic estates and churches dating from
1686 through 1878, also includes the photography of Ben Judah Lubschez,
another photographer who took his first photographs for Stoney's book in
the late 1920s. The original number of Lubschez prints were reduced from
sixty-one to fifty-five between editions, and the number of Johnston's pho-
tographs increased from sixty to seventy-one prints so that there would be a

FIGURE 44. Fenwick Hall, northeast room, Johns Island,
South Carolina, c. 1938

FIGURE 45. Boone Hall Plantation, Mt. Pleasant,
South Carolina, c. 1938

total of 150 illustrations in Stoney's book. The monuments in varying states of decay and preservation that both Johnston and Lubschez photographed are representative of architectural styles that span more than two hundred years, dating from the colonial period to the late nineteenth century.

Johnston did not miss opportunities to take what George Francis Hogan has called "portraits" of the houses, photographs that would show their individuality and character rather than being mere pictures.[119] She defines the essence or personality of a building, while most photographers settle for its overall appearance. While Lubschez often portrays porches as tunnels framing landscapes beyond, most of his photographs do not dwell on architectural features but show buildings at a distance. Nor do his featured buildings have much sense of modeling or spatial depth, with the exception of his views of porches. Johnston's photograph of a slave village entitled "Boone Hall (1843), Negro Street" illustrates how she emphasizes the uniqueness of each building even when many similar structures stand

nearby. One gabled structure is pictured in the foreground so that the textures of the brick and clay-tiled roof are in focus. Part of a second and third structure, identical in appearance, can be seen in the background so that the setting is apparent.[120]

The North Carolina book has more stylistic unity than the Low Country book because Johnston spearheaded the project and because only her photographs were used. While Stoney's book evolved over a decade, the North Carolina book took only five years from the time the first photographs were taken to its publication date. Also, there are over three times more of Johnston's photographs in the North Carolina book. Yet her style changed little over the course of the Carnegie Survey from the late 1920s through the late 1930s.

Comparision with Bayard Wootten

Another contemporary photographer of historic architecture in the South, Bayard Wootten, took photographs of some of the same historic buildings as Johnston. She visited Charleston in 1932, three years after Johnston's visit. Like Johnston, Wootten gave lectures with a slide projector at garden clubs and women's groups in South and North Carolina. Also, Wootten organized photography exhibits to publicize her work in the same way Johnston did. At the age of sixty-four, nine years younger than Johnston, Wootten considered Stoney's *Charleston: Azaleas and Old Bricks* (1937) her crowning achievement because it featured sixty-one of her photographs. Johnston's achievements, however, would continue to grow after her collaboration with Stoney as she photographed architecture in other southern states, including North Carolina and Georgia.

Charleston: Azaleas and Old Bricks, with the text written by Stoney, is similar in layout and subject matter to *Plantations of the Carolina Low Country*; however, a substantial number of the sixty-one photographs by Bayard Wootten in the Charleston book capture the picturesque ambience of the city without featuring buildings, notably in "Cooper River Water Front," "Street Crier," and "Flower Woman."[121] These Wootten photographs are atmospheric scenes, contrasting with Johnston's more informative landscape scenes and portraits. For example, in a comparison of Wootten's and Johnston's versions of "Magnolia Gardens," Johnston focuses on the flowers and leaves of the azalea shrub, framed by a live oak draped with Spanish

FIGURE 46. Magnolia Gardens azaleas, South Carolina, c. 1938

FIGURE 47. Magnolia Gardens azaleas (Bayard Wootten), c. 1938

moss (figure 46). A fragment of the pathway is pictured toward the bottom right corner of the photograph. Wootten instead focuses on the dirt path dappled by the shadows of azaleas and live oaks on either side and shows the woods more generally (figure 47).

It may seem at first glance that some of Wootten's interior views are more artistic than some of Johnston's, because Wootten's images usually show a greater sense of depth—for example, in her photograph of a drawing room at Ingleside showing parts of two walls, a carpet on the floor, the curved lines of an elaborate ceiling ornament, and a painting on a far wall. Johnston's photograph of the same drawing room differs because it is a direct frontal view showing the wall with fireplace and mantel, windows, and decorative molding. To base a general assessment of artistry on such an isolated comparison, however, would be a mistake. Elsewhere Johnston uses a similar vantage point within drawing rooms to show expansive interior views, such as in the small drawing room of Drayton Hall and the Drayton Hall entrance hall.

Johnston's photographs in *The Early Architecture of North Carolina* can be compared to Wootten's photographs in *Old Homes and Gardens of North Carolina* (1939), since Wootten's book, which does not include as much text, is the first volume to attempt a systematic documentation of many historic North Carolina homes and therefore is in many ways a direct predecessor to Waterman's text. Like Johnston, Wootten considered herself to be an artist. Moreover, Wootten knew and had the support of many of the same people in North Carolina as Johnston had for the publication of her photographs, particularly garden club members and university faculty. Hence, both photographers' books have a similar purpose: to promote the preservation of the past and to beautify the environment. A comparison of Wootten's and Johnston's artistic photographs, however, shows that Johnston placed greater emphasis on architectural features and scholarly survey work. Johnston's photographs cover half a page or a full page, while Wootten's photographs, one per page, vary in size, and all are significantly smaller than the page, so that there are wide margins surrounding each image. Although each of Wootten's photographs depict a different building, Johnston includes several photographs devoted to some locations, including close-up views of parts of buildings such as stairways, doors, and mantels.

There are other differences between the two books as well. The text in Wootten's book, thirty-four pages in length, is a brief history of North Carolina settlements while the text in Waterman's has a much stronger architectural emphasis. Each photograph in the former is accompanied by a short description, one to four paragraphs long, of the house pictured, including its location, history of ownership and development, physical characteristics, and information about the surrounding landscape and gardens. The texts accompanying Johnston's photographs, on the other hand, focus on the various historic architectural features made visible in the illustrations.

About thirty-six of the photographs in each book show the same buildings, though naturally with somewhat different treatment. Of these photographs, Wootten's generally show the buildings farther in the distance, with greater emphasis on landscape and vegetation. Johnston's photographs of these same buildings tend to have closer views to emphasize the architectural presence. Façades are often cropped to avoid obstruction of trees as well as to dwell on the textures of surfaces, such as in Rosedale, Orton, Bellair, and the Hayes House. For example, in Wootten's view of Orton, the live oaks "drenched" with Spanish moss obscure the building; Johnston's closer view reveals more of the columns and front façade (figures 48 and 49). In the partial view, the trees frame or adorn the visible left window. Waterman's text further emphasizes the architectural qualities featured in Johnston's photograph, mentioning that the building has been much altered and that the balcony on the north side is of an exceptional type.

Although the architectural presence is emphasized in Johnston's photographs, she is just as interested as Wootten in artistic merit. While it is true that Johnston is far more often straightforward in her documentation, this does not mean that her photographs are less picturesque or artistic. In fact, Johnston frequently seems to be more articulate and less naïve than Wootten, and her more complicated architectural photographs show a very real concern for the formal elements of composition, including balance and symmetry and depth of field. She is interested in the texture of materials such as wooden shingles and sidings and brick chimneys as well as in the intricacy of architectural details, such as those surrounding stairways, doorways, and ceiling moldings, all of which her photographs render clearly.

Likewise, Johnston's interior shots of these details have a modernistic

FIGURE 48. Orton Plantation, Winnabow, North Carolina
(Bayard Wootten), c. 1939

feel, augmented by the frequent cropping of her images with apparent at-
tention to the balancing of light and shadow and the contrast between fore-
ground and background. For example, Johnston highlights the interplay
between the ironwork of the fence in the foreground and the design of the
railing in the portico in her photograph of Belo House. Wootten, on the
other hand, shows a closer view of the house without featuring the fence at
all.

Comparing the photographs of Wootten and Johnston in their two
books is useful in documenting renovations and other changes that took
place between 1939, when Wootten's photos were published, and 1941,
when Johnston's photos were published. For example, the porch featured in
Wootten's photograph of Burnside had been dismantled by the time John-
ston photographed the same building. In Johnston's view of Cedar Grove,
the trees have been removed from the yard. Wootten's view of Burgin House
shows the house before any restoration took place. Johnston shows how the
windows have been replaced so that they are smaller and no longer touch
the floor. Also, the doorway has been changed and the surrounding col-
umns replaced by fluted pilasters.

FIGURE 49. Orton Plantation, Winnabow, North Carolina, c. 1936

FIGURE 50. Brothers House, Winston Salem, North Carolina
(Bayard Wootten), c. 1939

In exceptional cases, Wootten and Johnston picture images of the same building from the same vantage point. When this occurs, the photographs naturally have more in common. For example, in their views of Mill Hill, the only difference is that different sides of the front façade are presented in their three-quarter views. Also, in Wootten's photograph sheep can be seen in the foreground. Likewise, in their identical views of Brothers House, the only difference seems to be in the time of day the pictures were taken, as evidenced by the different shadowing. In Wootten's view, the dark shadow of the adjacent building not pictured can be seen on the ground. In Johnston's view, this shadow falls on the end façade of the building shown.[122]

Reflecting the Human Experience

In the tradition of architectural recording, only a few of Johnston's architectural photographs undertaken for the Carnegie Survey include images

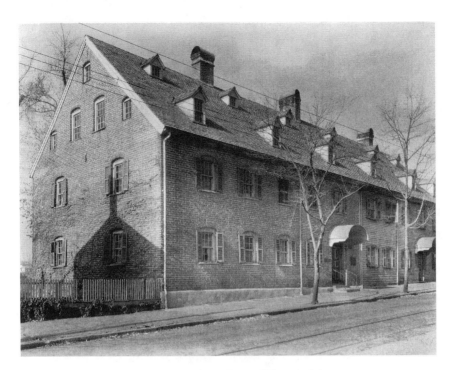

FIGURE 51. Brothers House, Winston Salem,
North Carolina, c. 1936

of people to emphasize historic architecture as a human environment. Architectural details, such as porches and doorways, and objects such as chairs and tables are visible remains of the human presence, revealing clues about the ways in which people live. Rarely, Johnston includes people for a sense of scale and human interest, similar to the ways in which Walker Evans pictured people within architectural settings.

One of Johnston's few architectural photographs that include people in the original 1938 edition of Stoney's book is a view of the south and west façades of Hanover, one of the more modest residences included in this published collection[123] (figure 52). Sometime between the decade when architectural drawings of the same residence were made and the time Johnston's photograph was taken, a full hip porch was added along the front south side of the two-by-five bay, two-storied house. The porch, which rests on brick piers, has a simple horizontal board railing, approached by an open wood stairway.

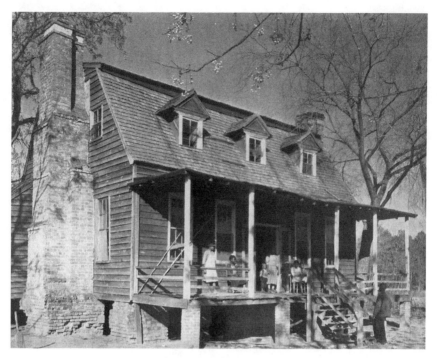

FIGURE 52. Hanover Plantation, St. John's Berkeley Parrish,
South Carolina, c. 1937

Johnston's photographic series of Hanover[124] is characteristic of tradi-
tional genre paintings, conveying anecdotes about relationships, simple
morals about making one's way in the world, and of societal responsibili-
ties through easily comprehended gestures. In this way, the people are pre-
sented not only for scale and perspective but also for character, not unlike
their use in Walker Evans's photographs "House and Billboard in the Black
Quarter, New Orleans, Louisiana" (1936),[125] which shows a family look-
ing over a second story balcony of their house, and "Houses in the Black
Quarter, Atlanta, Georgia" (1936),[126] one version showing three boys sitting
with their legs dangling over the edge of a porch. In these photographs,
porches are vital as places where families and friends can visit and relax,
look out, and be watched. Similarly, in Johnston's photograph more about
the building is implied through gestures and poses of the inhabitants. Six
children sit or stand on the porch with their mother at the doorway while
she holds the hand of the youngest child. The father, wearing a coat, stands

at the bottom of the stairs looking up at his wife and children, with his right foot placed on the bottom step, ready to walk up the stairs to meet them the moment after the photograph is taken.

In addition to recording information about the building materials at Hanover, such as the unpainted clapboard siding, the deteriorating brick chimney, and wooden shingles, Johnston has shown how the porch functions for the family as an outdoor living room where people can relax and converse. Also Johnston's photograph dwells on the surroundings. Limbs on the trees in the foreground and by the east side of the house have no leaves. A cleared field farther to the east is barely seen but visible enough to identify the residence as a working farm.

Showing how the house within its landscaped setting was used is beyond the scope of the floor plans and elevations drawn by Frank E. Seel and measured by architect and historian Albert Simons of Hanover's exterior north façade and south façade, and those of the four sides of the entrance hall. The photograph also adds information about the young family living there.

When people are shown in *The Early Architecture of North Carolina*, the structure and use of architecture are also emphasized. For example, the only person included in the North Carolina book is an elderly gentleman sitting in a rocking chair on the ground floor of the double-deck porch of Duncan House, located in Beaufort (figure 53). His dark figure, the doorway, the windows, the chairs, porch swing, and the interior space of the porch under the shadow of a front yard tree visually emphasize the lower deck of the porch, seen from ground level, as an extension of the home's interior to the public street. The patterns of the porch ceiling rafters above and the coffering on the ceiling below provide a subtle backdrop to the columns and porch railing. The photograph of this gentleman was included by Johnston for aesthetic reasons as well as to show how the porch functions.

Other photographs that show people to emphasize historic architecture as a more human environment include the Great Oak at Middleton Place showing two people in front of a tree mostly for a sense of scale and perspective in Stoney's *Plantations of the Carolina Low Country*, and of two young girls looking out of the entrance of the spring house of Hill Plantation, included in Nichols's *The Early Architecture of Georgia* (figure 55). Interestingly, such photographs have not been included in more recent editions of the

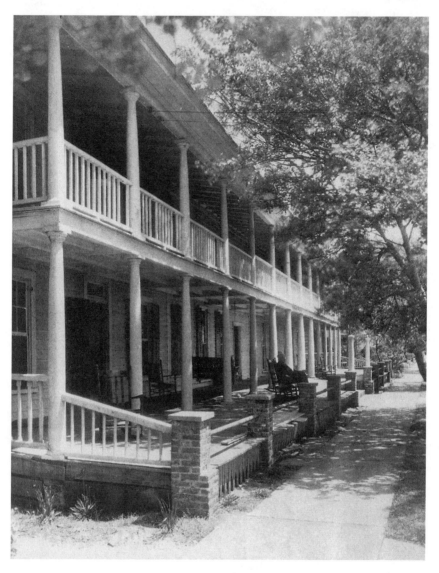

FIGURE 53. Duncan House, Beaufort, North Carolina, c. 1936

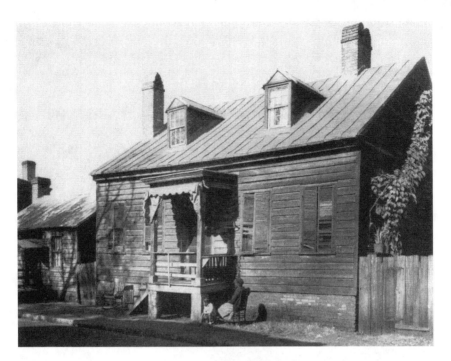

FIGURE 54. 312 Gaston Street, Savannah, Georgia, c. 1939

Low Country book, most likely due to the increasing emphasis on architecture. However, architectural photographs including people have remained in reprints of Nichols's book, such as one of a woman and child sitting in their front yard in Savannah,[127] a gentleman looking at fresh produce on a vending cart also in Savannah,[128] a woman gazing out while leaning against one of the porch posts of her cabin in Milledgeville,[129] a man drawing water at the wellhouse of Woods Plantation,[130] and the aforementioned view of two young girls looking out the entrance of the spring house of Hill Plantation.[131] These human figures, used essentially as props, emphasize the functions of historic elements, suggesting that the buildings are not mere artifacts but useful structures and sites requiring continued care.

Historic Landscapes

Historic plantings and grounds photographed by Johnston are particularly prevalent in Stoney's book, such as the well-manicured lawn and shrubs

FIGURE 55. Spring house at Hill Plantation, Georgia, c. 1939

and the live oaks forming the Double Avenue at Medway;[132] the rice field at Mulberry,[133] which is framed in the foreground by the trunk of an old tree; and a close-up view of an azalea shrub at Magnolia Gardens.[134] Johnston's emphasis on the well-tended plants and carefully preserved natural environment imply that a way of life has been necessary for these landscapes to exist. Including the depiction of modern equipment, Johnston's photographs also show how historic landscapes have changed over time.

Photography of the type Johnston admired was first eloquently championed by Peter Henry Emerson (1856–1936) in his book *Naturalistic Photography for Students of Art* (1889), which emphasized the use of simple equipment for taking and developing pictures to reproduce landscapes that would be seen rather than imagined and contrived. Johnston's photograph of Harrietta Rice Field displays the same picturesque characteristics of atmosphere, placid water, and quiet, domesticated fields as Peter Henry Emerson's "Gathering Water Lilies." Both show an infatuation with the

FIGURE 56. Harrietta Plantation, McClellanville,
South Carolina, c. 1937

landscape of the rural marsh.[135] Johnston's composition, like Emerson's, focuses on an empty boat docked in the water to emphasize that the present estate, formerly a flourishing rice plantation involving large investments in land, mills, and slaves, is no longer active. Similar subject matter, pictorial qualities, and compositional features are used to depict the human presence within landscape. The boats closest in the foreground are shown at a diagonal to create a greater sense of perspective. A horizontal boat ramp just behind the boat breaks up Johnston's composition by separating the foreground from the background. A deep perspective is retained in the way the distant naturalistic background, void of manmade features, can be clearly viewed. In a sense, the ramp serves to separate the built environment, the empty boat, and the ramp, from nature—the marshland in the background.

In Emerson's photograph, a gentleman is rowing the boat while a younger boy gathers the water lilies from the top of the water. Tall reeds form a barrier behind the boat giving greater emphasis to the action in the foreground. Emerson's photograph, as part of a collection of forty platinum prints made in East Anglia, records the amphibious lives of the marsh dwellers. Johnston's empty boat, on the other hand, suggests a lack of action commented upon by Stoney. The involvement of humans in the landscape is merely suggested without their visible inclusion.[136]

Furthermore, Stoney comments on the lack of activity at the Harrietta plantation. Although the house was built in 1797, no one lived in it until 1858. Nonetheless, the plantation home at Harrietta was considered part of a successful rice plantation, and the rice planter's home was built with a direct view of the fields. Families generally shuttled between the town and plantation, living between them and holding interest in both.[137]

The End of Johnston's Life in New Orleans

Late in her life, Johnston was formally recognized by various national institutions for her lifelong contributions to historic preservation and photography. In 1945, one year after Johnston moved to a house she bought at 929 Dumaine Street in the Vieux Carre section of New Orleans, she was made an honorary member of the American Institute of Architects

in Washington, D.C., for her photographic documentation of historic American architecture. At the Louisiana State Museum eight months later, the Louisiana chapter of the AIA noted Johnston's contributions as "an eminent layman, distinguished citizen, having signally contributed to the advancement of the profession of architecture of the United States."[138] Her photographs were exhibited at the Library of Congress in 1947 to mark the convention of the newly formed National Council for the Preservation of Historic Sites and Buildings, and Johnston became an associate member of the Executive Board of the National Council for Historic Sites and Buildings to coordinate with the National Trust. Johnston donated the White Pine series and her issues of *Pencil Points* to the National Council for Historic Sites and Buildings in Washington in 1949. Three years later on March 16, 1952, Johnston died at her home in New Orleans while preparing photographs for the book about the early architecture of Georgia, which was eventually published posthumously, and for a project on the lower Mississippi River region that was never realized.

CHAPTER 5

How Frances Benjamin Johnston's Contribution Shaped Architectural and Photographic Preservation in the United States

Johnston's Technique

IT IS DIFFICULT TO UNDERSTAND exactly what about Johnston's method makes her photographs of historic architecture uniquely valuable as visual documents. Later in life Johnston tended to downplay the intricacies of her technique by casting herself as someone who did not care for technical matters. At the age of eighty-five, when interviewed for a *Life* magazine article, she proudly claimed: "There was nothing retiring in my disposition. I wore out one camera after another, and I never had any of those fancy gadgets. Always judged exposure by guess."[1] Johnston's glib remarks are typical of the adept professional who appears to make a task effortless when in fact its intricacies are numerous; but they also hint at her concern for the subject matter and the ultimate purpose of the photographs over and above the works themselves. The recording of historic architecture and how much historic architecture can be revealed in a photograph interested her more than did the technicalities of the medium itself, which she thoroughly un-

derstood. For example, she wrote about her underground photographic expedition at Mammoth Cave in Kentucky: "As to the difficulties, disasters, but ultimate triumph of the photographic campaign, when I sought to vanquish the archenemy darkness with flashpowder, it is too long a story."[2] Yet she is known as one of the innovators in lighting due to her early use of magnesium powder.[3] What interested her more during the cave expedition was how much she could convey her impressions to others through text and photography.

Although Johnston at times stated publicly that she approached exposure times intuitively, she was in fact very precise about lighting and viewpoint in her architectural photographs. She made sure that lighting conditions were exactly the way she thought they should be:

I won't make a picture unless the moon is right, to say nothing of the sunlight and shadow! Most of the time I have to be excruciatingly patient waiting for the light to get precisely right. Sometimes I have a tree cut down, a stump removed, or a platform erected to get the proper perspective. I have shot pictures from on top of boxcars, and loaded trucks. If I'm in a city street, I often call the police to hold up or detour traffic while I photograph a place. When I photograph an interior . . . I usually shoo the family out, lock the door and buckle down to business.[4]

Johnston obviously was proud of her ability to assert herself to get a picture the way she wanted it. Her care in manipulating the image before taking a picture differed radically from the approach of modernist photographers, who preferred to manipulate their images during the developing process and to publicize their techniques as original. Adhering to traditional aesthetic principles of composition and design, Johnston preferred natural light and no retouching to stress the realism of her frequently outdoor images. Her freedom as an artist and photographer was bound up with the accuracy of her presentation. The technical and intellectual process that went into the photograph, therefore, was less significant to her self-image than was the subject matter that she portrayed. Johnston used an eight-by-ten-inch view camera with the shutter speed "slowed way down."[5] A long exposure on large format glass plate negatives allowed for long depths of field and rich textural detail in light and shaded areas. Johnston maintained that she was an exponent of the "straight" style of photography, leaving what she

called trick angles to Margaret Bourke-White and surrealism to Salvador Dali.[6] Using a term Stieglitz first coined, Johnston late in her life made analogies between her photography and Stieglitz's to emphasize that the pictorial qualities of her work were indeed similar to his own. While earlier in her life she would have disdained this association with Stieglitz's term because it was used to promote his image as an original artist, Johnston nonetheless later understood the necessity of establishing her work as art for her own success. For Johnston too, straight photography meant occasionally manipulating point of view so that she could employ a particular angle or view for her photograph. She made judgments spontaneously in order to take pictures, a practice that Sadakichi Hartmann referred to in 1904 as "composition by the eye."[7]

The view camera that Johnston used was considered the best type of camera in its day for architectural photography. Her use of it followed well-established conventions. As architectural photographers such as W. X. Kincheloe and L. Whitney Standish have explained, a sturdy, fully equipped view camera had a rising, sliding, and tilting front as well as a swing and tilting back so that adjustments could be easily manipulated. Also, it could adapt without change to lenses of all practical focal lengths, since the lens was not permanently mounted. Kincheloe's explanation of the view camera adds insight to the complicated process that Johnston and others had to manage whenever a picture was taken.[8] To set the camera level, the photographer had to first raise the front as high as the lens definition or camera adjustment would permit and then tilt the whole camera upward until the building was correctly placed. To prevent the effect of the building seeming to fall forward, it was then necessary to manipulate the swing-back until the back of the camera was exactly vertical. Afterward, the focus had be centered, and then the diaphragm turn was closed until the definition was "good all over the plate."[9]

Although Johnston did not publicly analyze or debate the complexities involved in her photographic approach, she well understood aesthetic concerns and mastered a wide variety of technical problems in order to make significant contributions throughout her career ranging from her earliest images of Washington, D.C., buildings to her photographs of historic architecture taken during the last fifty years of her long life. Johnston was one of the first photographers to popularize the importance of architectural

preservation at a time when it was not even considered an issue in much of the United States. Also, as one of the first American photographers specializing in the field, Johnston had the opportunity to help set the standards that came to govern architectural photography in the United States. Both architectural preservation and standard setting for accuracy of architectural recording were innovations in the United States that Johnston helped make possible through her adherence to traditional principles of architectural recording dating back to the architectural drawings of Renaissance architects such as Filippo Brunelleschi (1377–1446) and Leone Battista Alberti (1404–72).[10]

Johnston's photographs of historic architecture adhered to these principles and helped to develop a canon of architectural recording in this country. Her photographs included perspective views and some elevations as well as interior details now understood as the basic components of a photographic record of buildings. Johnston's architectural photography also augmented and replaced some older and often labor-intensive means of representation. She was driven to complete photographic surveys of historic vernacular architecture in nine southern states because she knew that neglected buildings often became lost. Johnston considered her photographs the next best thing to restoring or preserving buildings themselves, and she deplored many of the so-called improvements as much as buildings' dilapidation. Johnston's earlier photography focused on the classical buildings of Washington, D.C., that the architects commissioning her sought to emulate. She gradually turned to the photography of vernacular historic buildings, turning away from the prominent colonial mansions that continued to draw other photographers. Instead, she looked for neglected seventeenth- and eighteenth-century buildings of an everyday sort, which she called "primitives." For Johnston, farmhouses, mills, log cabins, country stores, taverns, and inns were historic evidence of colonial life, too.[11]

Elevation and Perspective Views

Johnston's approach to architectural recording differed from that of nineteenth-century French photographers,[12] particularly in her use of two traditional views to render different kinds of architectural information: the elevation and the perspective. Elevations show one side of a typical struc-

ture. The viewpoint is strictly of the front façade, and the vanishing point is centered to avoid perspective distortion. The context of the building is generally not illuminated so as to obtain a clear, uncluttered focus of the façade itself, which appears two-dimensional; in this way the linear outlines of architectural details and proportions of the façade can be precisely distinguished. The three-dimensional modeling of surfaces, typically obtained in drawings through ink washes, could be achieved in photography through subtle manipulation of light and shadow.

Johnston only occasionally presented such carefully construed elevation views of buildings. Examples include her elevation views of the house of Postmaster General John Wanamaker and of the United States Mint in Philadelphia, both published in 1890. Johnston also took elevation views of the White House in 1893, including the north door, the main public entrance, and the north façade seen from across the street (figure 5).[13] Relying on the elevation view, she could illuminate the overall spatial dimensions of these official places. In her later architectural photography, Johnston would use elevations to depict church interiors and significant interior architectural details within homes, such as fireplaces, doorways, and stairways. Otherwise, she would tend to avoid a frontal view for more realistically rendered perspectives.

Johnston's use of the elevation to depict the interior of St. James Church at Goose Creek, South Carolina, is striking for its combination of traditional architectural recording and modernist qualities (figure 41). Johnston uses natural light to enhance the physical presence of the interior. Indirect light appears from behind the open entrance at the rear of the church and streams inside at an angle. More indirect light comes from either of the side splayed windows. Johnston emphasizes the importance of the outdoors for the existence of the church by showing that the interior can be seen only if the windows and doors are open. The square paving stones of the center aisle repeat the square paneling of the pews and balcony. The slightly ajar pew doors create shadows on the paneling. A dark, diamond-shaped coat of arms at the center of the balcony above the door, the lines of the pews, the paving stones, and the raking light all direct the viewer toward the landscape.

Johnston used perspectives more than any other approach, and this gradually became a more popular approach for architectural photographers generally, because they were easier to photograph and provided a more com-

plete record of buildings. Perspectives were often used by Johnston to emphasize the relationship of a building to its street or other setting, such as in her urban scenes of St. Augustine and New Orleans, and demonstrate an affinity with the work of Charles Marville (1816–79?).

Traditional Photographic Surveys of Historic Architecture

The tradition of photographic surveys of historic architecture began in Europe. For fifteen years Marville was the official photographer for Emperor Napoleon III's modernization of Paris, and he photographed medieval streets and buildings slated for demolition by chief designer and lieutenant George-Eugene Baron Haussmann (1809–91). While the modernization program proved to be a disaster for historic buildings, it was a boon to the photographic recording enterprise of artists such as Atget, Marville, and others interested in depicting historic architecture. Marville's final project became the most complete systematic street-by-street documentation of a city up to that time. This survey would have been familiar to Johnston, as well as to Holland at the Library of Congress.[14]

Interestingly, Marville's recording effort, which included new boulevards and modern buildings replacing ancient streets and monuments, as well as historic buildings, is now one of the main documentary sources for nineteenth-century Parisian buildings. The recording effort was for the first time, however inadvertently, brought to the fore within a systematic framework. Marville's collodion-plate photographs emphasized the historic texture of the city and the vitality of communities that resided there by depicting physical evidence of people's work and everyday lives. Focusing attention on historic buildings on both sides of a street, the streets as well as the buildings become the subjects of his photographs. The eye-level viewpoint reproduces the experience of a pedestrian, furthering the illusion of being on the site. Johnston occasionally used this viewpoint as well to portray historic buildings in the South. For example, in her photograph of 312 Gaston Street, West, in Savannah, Georgia, a woman and her child sit in front of their house bordering a sidewalk[15] (figure 54). In the foreground of Johnston's composition, a shadow is cast by a house that stands across the street, outside the frame. Rather than showing the vitality of street life that Marville typically documented, Johnston presents the inhabitants sitting in their small front yard. The woman has her view blocked, facing the floor

of the raised porch, while the child, who sits next to one of the brick piers, appears more as an extension of the porch foundation. A vacant rocking chair oddly placed at the foot of the porch staircase blocks entry to the deteriorating townhouse, which has closed windows and shutters. It is not entirely clear to present-day viewers whether the building is meeting the needs of the residents.

Johnston's documentation of historic architecture in the South, unlike Charles Marville's recording project of 1864 and other locally and nationally sponsored documentary projects, was not prompted by sudden changes or an explicit propaganda for slum clearance or renewal. Yet her photographs are similar in that they too depict problems associated with the upkeep of historic buildings. Thomas Annan of Glasgow, commissioned in 1868 by the Trustees of the Glasgow City Improvements Act to photograph the historic Glasgow area famous for its unhealthy slums, included more people in his photographs than other architectural survey photographers.[16] Like Johnston, Annan was not a social reformer, although his images, and hers, are in the social documentary tradition comparable to those of John Thomson, Jacob Riis, and Lewis Hine.[17] Annan and Johnston conveyed information about the buildings that in turn said something about those who lived in them.

Fifteen years after the Glasgow City Improvement Trust commissioned Annan's photographs to justify their urban renewal project, the Society for Photographing Relics of Old London hired Henry Dixon to record historic buildings.[18] Here the connection to Johnston's project fifty years later is even stronger. Dixon's 1879 documentary project was the first to be used to block the destruction of older buildings, just as Johnston's architectural photographs, funded through the Carnegie Corporation, were intended to increase public awareness of historic American architecture. Dixon concentrated on known historic sites, including rare half-timbered buildings, old coaching stations, hotels, pubs, and churches. Calling attention to their rustic character and picturesque antiquity, his series anticipates many of the attributes of Johnston's later photography, which also celebrates the ordinary and conveys a sense of age, decay, and presence, much in the spirit of both eighteenth-century romanticism and late nineteenth-century respect for these qualities, a point of view expressed most completely by the art and social critic John Ruskin. Johnston's photographs would in many

ways repeat the qualities of Dixon's, though applied in the "old" part of the New World, the South. She, too, attempted to convey a traditional culture that no longer exists by recording its visible remains. She was interested in the changes that occurred to buildings, the evocation of time, and the contributions that each generation had made or not made to the subjects. Like Dixon, then, her photographs had a romantic quality, colored by an antiquarian's interests. But also like Dixon, she was systematic, a truly scientific recorder.

Another photographer whose style is similar to Johnston is Eugene Atget, the late nineteenth-century and early twentieth-century Parisian photographer who left such a telling record of the city's buildings and residents.[19] Like Johnston, Atget was something of a romantic, an antiquarian in spirit who had a taste for systematic recording, although he did not have one sponsor. A major difference between Atget's and Johnston's architectural recording was that Johnston, sponsored mainly by the Carnegie Corporation, could be more methodical and comprehensive. Atget, on the other hand, had many different clients, all of whom had varying documentary interests as painters, architects, set designers, wealthy amateurs, and archivists. In fact, some of Atget's photographs of architectural features were later discovered by modernists, and he was discussed, despite his desire to remain separate from the avant-garde, in terms of the modernist tradition. However, Atget's intentions were aligned more closely with those of Johnston. He, too, wished to meticulously record the architectural details, buildings, and streets of a place, to capture a world infused with nostalgia. Johnston's later photographs suggest a similar preoccupation. On the one hand systematic and scientific, her photographs are also affectionate portraits. These include her records of abandoned country estates as well as her later survey of New Orleans, itself very much in the Atget tradition in the way in which the images express deep emotion through light and shadow. Johnston wanted both science and romance. This tension contributes to the positive qualities and ambiguities that constitute her art.

Johnston's photographs of historic architecture in the South could also be tied directly to those of George Barnard (1819–1902), official photographer of Sherman's Civil War campaign.[20] Well known in Johnston's early years, Barnard's photographs provided an important precedent for Johnston's work. The southern vernacular buildings photographed by Johnston show

signs of deterioration similar to those in the architectural views that Barnard captured, and she often intimated that the decay of buildings due to indifference and neglect was comparable to destruction caused by the ravages of war. Both Barnard and Johnston used picturesque compositions to impose aesthetic order so that harmony is stressed over chaos. Deteriorating architectural features, clearly rendered, are viewed within peaceful landscapes so that more emphasis is placed on the overall solid presence of the buildings and the relationship of people to their landscapes.

Barnard and Johnston, from clearly different motivational stances, tended to prefer "primitive"—what would now be termed *vernacular*—homes. Perspectives were more suitable to both photographers because the modest structures that they photographed lacked the intricate surface articulation so typical of more high-style architecture. Barnard's photograph of "The John Ross House in Rossvile, Georgia" (c. 1864),[21] one of the earliest known documentations of historic vernacular architecture in the South, anticipates Johnston's own use of low vantage point, regional subject matter, and the inclusion of people in the frame. The low viewpoint in Barnard's photograph makes the farmhouse appear more monumental while bringing the viewer closer to the poverty of its inhabitants and the dilapidation of the structure itself. People standing or sitting on the front porch add a human dimension to the view and provide a sense of scale. Loose clapboards hang haphazardly along the eaves and gable end. Scattered tree trunks that have been cut down litter the yard.

Landscape Painting

For Johnston, architectural preservation was a problem that had to be addressed by occupants as well as architects. Ultimately, her architectural photographs were intended to promote the preservation of neglected areas. Emphasizing picturesque qualities of the South to show it as a civilized place, she wanted the colonial buildings she portrayed to look like they still were, or easily could be, inhabited within a kind of Arcadian landscape.

Johnston's own reliance on the picturesque aesthetic to depict traditional landscapes had been standard for photographers of American colonial architecture since the middle to late nineteenth century, and the appreciation of colonial architecture itself could be said to have been bound up with and

implicitly colored by landscape painting traditions. The colonial American style was perceived to be more in harmony with its surroundings than more modern architecture. Richard Upjohn, speaking at the third annual American Institute of Architects convention in 1870, stated that he was especially impressed by the way in which Colonial builders "regarded the law of harmony between a building and its surroundings." He further urged landscape painters of the National Academy to make pictures of these old houses "that will be buried in oblivion in the course of another century, unless faithful records are kept of them by all hands."[22] According to historian William B. Rhoads, this was the first time a professional architect had considered colonial architecture in a positive light. Johnston, a young girl when Upjohn gave his speech, appreciated colonial buildings all her life.[23]

At the time Upjohn spoke, landscape painters had begun documenting colonial architecture in such works as Benjamin West's "Penn's Treaty with the Indians," showing seventeenth-century houses; William S. Mount's "Long Island Farmhouses" (1854–59); Eastman Johnson's series on Mt. Vernon (1857); and Edward Lamson Henry's painting entitled "Westover" (1865), showing the famous Lee mansion in Virginia. More than any other nineteenth-century artist, Henry portrayed colonial buildings with precise historical accuracy based on his large collection of drawings, prints, and photographs and his own sketches, and he would serve as an advisor in the restoration of Independence Hall in 1875 in recognition of his visual expertise, one decade after he painted Westover.[24] Johnston would continue to share Henry's painterly sensibilities, colonial subject matter, and concern for precise historical accuracy in her landscape and architectural photographs.

Conventions of Architectural Publications

The organization and overall tone of Johnston's architectural publications essentially followed the conventions of earlier studies of colonial buildings, including early American house pattern books like Asher Benjamin's *The American Builder's Companion* (1806) and Minard Lafever's *Modern Builder's Guide* (1833), and more recent architectural books such as *Early Rhode Island Houses* (1895) and *Early Connecticut Houses* (1900) by Norman M. Isham and Albert F. Brown, *White Pine Series* by Frank Wallis (1915),

Dwelling Houses of Charleston by Alice Ravenel Huger Smith and Daniel Elliott Huger Smith (1917), and Fiske Kimball's *Domestic Architecture of the American Colonies and of the Early Republic* (1922). While none of these publications are comprehensive documentations of the historic architecture of a region, they initiated widespread study of historic American architecture and its development, particularly in the most significant early colonial settlement areas of the Northeast. The support of established scholars and architectural historians such as Kimball and Isham inspired Johnston to develop her own model for architectural inventory and publications.[25] These scholars understood the basic American conventions for recording architectural data. For example, Isham and Brown personally measured and sketched plans and sections of twenty-nine historic Connecticut houses in a tradition similar to that of European architectural drawings. Their freehand drawings are based upon actual measurements, yet their lines appear looser and more naïve than those of typical architectural drawings. Some of Isham and Brown's drawings rely on perspective views, with picturesque details such as iron gratings inside fireplaces, flames from the fireplace, smoke coming out of chimneys, and occasionally a simple stick-like silhouetted figure.[26] For each of the twenty-nine houses represented by architectural drawings in Isham and Brown's *Early Connecticut Houses*, architectural details are featured such as overhangs, lean-tos, entrances, staircases, moldings, and posts to illustrate examples of regional construction and development. Exterior views taken from a perspective viewpoint were based on photographs, but no photographs were mentioned in their book. Trees and shrubs surround the buildings, a connection also in keeping with traditional perspective drawings. Lines indicating wood graining, as well as the texture of brick, stone, and shingles, resemble the drawing techniques of Ruskin and later of Arthur Leighton Guptill, reflecting changing drawing traditions of the late nineteenth and early to mid-twentieth centuries.[27]

Johnston would be most directly influenced in her photographic survey of Southern vernacular architecture by Frank Edwin Wallis's *White Pine and Architectural Monograph Series*.[28] In her opinion, it was "the outstanding pictorial record of all that is best in early New England architecture,"[29] including Mid-Atlantic and Southern states such as New York, Pennsylvania, New Jersey, Delaware, Maryland, and the Carolinas. The complete files used for the series comprised 6,000 negatives, only a small number of which were

published in the monographs. The innovativeness of the series consisted in its large architectural photography collection. Johnston was impressed with the manner in which the *White Pine Series* recognized architectural photographers such as Julian Buckley, John Wallace Gillies, Kenneth Clark, and Arthur Chaskell. For the first time, architectural photographers were being considered "craftsmen, who made this publication unrivaled in distinction."[30] She wished, however, that more of the architectural photographs had been featured.

Johnston had her own copies of the *White Pine Monographs* and asked Henry Brock to keep them in his New York studio "where they can't be sold or opened" while she was taking architectural photographs in Williamsburg in 1930.[31] Johnston used the series to explain to others the motives behind her own work and kept it as a model while working on the Carnegie Survey and subsequent architectural publications. Recognizing its significance, Johnston believed that it should be available for public reference. Five years after her work in Williamsburg, she encouraged Holland to purchase the monographs for the Library of Congress. Holland agreed that it was a worthy series but said that for the time being it was not affordable due to budget constraints. In 1949, Johnston donated her series, as well as her issues of *Pencil Points*, the predecessor to the architectural journal *Progressive Architecture*, to the National Council for Historic Sites and Buildings located in Washington, D.C. This donation helped to start the Council's reference collection.[32]

Johnston also appreciated the architectural drawings, sketches, and photographs of *The Dwelling Houses of Charleston, South Carolina* published in 1917 by Alice Ravenel Huger Smith and Daniel Elliot Huger Smith.[33] Used to illustrate the historic architecture of Charleston, where Johnston herself would record several years later, the Huger Smith record followed the usual conventions of architectural recording: the plan, elevation, and perspective views. The architectural drawings, made for the project by local architect Albert Simons, included plans and measured elevations of mantels, doors, and entrance halls. Other architectural publications featuring Johnston's work would include architectural drawings made by Simons and other architects.

By the turn of the twentieth century, those publications by Isher and Brown, the Huger Smiths, and especially Kimball relied on photography

as well as drawings to illustrate colonial architecture regionally. Most of these early photographs followed established conventions of architectural photography, including the elevation view, first emphasized by French photographers of the mid-nineteenth century, and the most frequently used perspective to convey a greater sense of spatial depth and environmental setting. This tendency was in many ways an extension of the earliest American architectural recording efforts. Sometimes, scholarly publications of this period reserved the perspective view for sketches, such as those drawn by Alice R. Huger Smith in *Dwelling Houses of Charleston, South Carolina.* These sketches were admired by Johnston for their "romantic flavor," and she at one time had hoped that her own photographs would provide impetus for a reissue of their publication, which she considered "one of the richest mines of architectural history in the country," because it had a more scientific, "architectural slant."[34] The photographs taken by St. J. Melchers included in the original Huger Smith volume made use of elevation and perspective views mainly to show interior views of rooms with a focus on fireplaces, doors, stairways, windows, and furniture arrangements.

Johnston admired the freehand sketches of the Huger Smith book, which in some ways resemble her own photographs. Both Johnston's photographs and the Huger Smith drawings convey larger impressions of a town from various angles to illustrate how the buildings relate to each other. The lines of the drawings, like Johnston's photographs, show textures and shadows. While Johnston enjoyed the picturesque quality of the Huger Smith drawings, she also understood the importance of rendering architecture precisely, and her 1930s photographs became typical architectural renderings of this period. The main incentive for these early twentieth-century architectural publications had been to ensure greater accuracy in the Colonial Revival style and to make certain that colonial designs would endure even if the original buildings were destroyed. Publications such as that of the Huger Smiths would ultimately provide a reference for those faced with decisions about changes within historic districts. However, systematic documentation of historic American buildings for more purely scholarly purposes would not occur on a large scale until 1927 when Johnston began her own work in Virginia.[35]

American architectural historical publications, such as those of Kimball, Wallis, the Huger Smiths, and others, prepared the way for Johnston's more

thorough and systematic documentation by expressing the need for uniform and accurate records of all historic American architecture. Often, the authors discussed the limitations of their own documentary efforts. None of these early projects, the authors admitted, were comprehensive inventories, but they constituted studies of what were considered representative buildings to illustrate the development of planning and building techniques in various early settlements. Isham and Brown, for example, selected twenty-nine buildings in three colonial areas within Connecticut. All recognized, however, that much more should be done. Kimball commented in his preface that there were too few thorough studies, calling the work of Isham and Brown and the Huger Smiths "pioneering examples."[36]

Largest Photographic Survey of a Region

The architectural photographs of Johnston would be the first systematic effort to photograph a wide range of historic buildings. Documenting the early architecture of nine states was an unprecedented project that took Johnston over twelve years to complete. She admitted in the acknowledgment of *The Early Architecture of North Carolina* that "the research was all pioneering in an unexplored field where there was no precedent to follow."[37] In a letter, Waterman noted, regarding Johnston, that

> as an architect and antiquarian there is no other photographer in this country who is so eminently fitted for the recording of architecture, old and new. . . . In the field of colonial architecture her surveys are of startling magnitude covering the state of Virginia in a more comprehensive manner than I believed possible.[38]

The photographs of Louisiana-born Clarence John Laughlin (1905–85) resembled Johnston's portraits of historic architecture through the use of large formats to incorporate a wealth of architectural detail about each plantation, presented picturesquely in landscaped settings. Laughlin's photographs of eighteenth- and nineteenth-century Louisiana architecture, taken between 1947 and 1952, were funded partially by the Carnegie Corporation of New York and administered by the Library of Congress after Johnston had completed her own survey. The collection of Laughlin's photographs at the Library of Congress, approximately 750 prints of about 124 plan-

tations, houses, and monuments and 150 pages of typescript data, is the incomplete portion of a project that was intended to comprise 8,000 prints and the preparation of two monographs.[39] While Laughlin, as a long-term resident, was more intimately familiar with the historic buildings and landscape of Louisiana he did not possess the same scholarly interest or the activist approach to historic preservation that enabled Johnston to finish her survey.[40]

Johnston took photographs of historic buildings between 1927 and 1943, including those of historic streets in Charleston, St. Augustine, and New Orleans as well as scattered farms and outbuildings throughout North Carolina, South Carolina, Georgia, Maryland, Virginia, Alabama, Mississippi, and Louisiana. Nearly all of the resulting images, over 10,000 prints measuring eight inches by ten inches, were eventually deposited in the Library of Congress, which administered most of the grants Johnston received and which also received the negatives of the Carnegie Survey of the Architecture of the South upon Johnston's death. Many of Johnston's best-known and most significant images are included in publications, and due to the careful process of selection, many of these represent photographs that she herself most valued. Johnston also publicized the historic architecture of the South nationally through the inclusion of her photographs in well-known classic studies such as Talbot Faulkner Hamlin's *Greek Revival Architecture*.

Johnston's architectural photographs are also portraits. She followed in the steps of great architectural recorders such as Annan and Dixon. She also reflected the more idiosyncratic photographic homages of Eugene Atget. In her precision and her ability to focus on individual elements, she showed an implied awareness of modernist tenets. Some of the photographs, as suggested, compare directly to Evans's studies of weathered houses and features. Nonetheless, she remained true to her purpose: to create a lasting record of varying examples of American architectural history. Her task was modern only in the sense that it represented a personal project and exploration, much as Atget's own project now appears modern, though he too claimed to have a more conventional set of aims for his own survey of Paris in the 1920s.

Johnston might not have recoiled at the idea of a photograph being merely a commodity to have in a gallery. Yet she believed that her photo-

graphs were primarily records. They were skillfully taken and developed, with careful attention to composition and lighting. Technically outstanding, her photographs are often used today as illustrations for books and articles on American architectural history. But Johnston's purpose went beyond immediate or subsequent publication, or even the creation of a lasting record. She took pictures of old buildings to promote their preservation and to restrain development that would infringe upon historic buildings and historic districts. In this she remained very much a figure of the nineteenth century, imbued with social purpose and a sense of mission and duty.

CHAPTER 6

Conclusion

FRANCES BENJAMIN JOHNSTON's work had a lasting impact on her times. Through the early studies of nationally recognized sites such as the White House, her studio photography, her photojournalism, her studies of American gardens and landscapes, and most significantly, her unprecedented record of the historic architecture of the American South, she altered how Americans perceived themselves and their surroundings. As one of the first women photojournalists at work during a time when photography was being defined as an art, she was the first to photograph newsworthy events such as Dewey's signing of the peace protocol with Spain and she was the last photographer to photograph McKinley before his assassination. Her explanations of sites, such as her Mammoth Cave series or her record of Pennsylvania coal-mining villages, gave meaning and stature to these places through her research of culture and history as well as her presentations of their picturesque settings. The unprecedented documentation of the Hampton Institute and the Washington, D.C., public schools demonstrated her support of contemporary institutions designed to improve American society and to make it more democratic.

Johnston's greatest contribution is her legacy of architectural photographs in publications and in the collection at the Library of Congress. It was her architectural work that set her apart from many of her contemporaries and colleagues—and it is for this that she is best recognized today. Drawing on her experience as a commissioned photographer of estates

and estate gardens, she brought a new sensibility to the art of architectural recording. Her architectural photographs are innovative in the scholarly comprehensiveness of the surveys undertaken. Her inventory of historic buildings covering Virginia, Maryland, North Carolina, South Carolina, Florida, Mississippi, Alabama, Louisiana, and Georgia resulted in an extraordinary number of images that are still used today due to their high degree of precise detail and aesthetic value.

Throughout the course of a career that lasted over sixty years, Johnston made more than 20,000 negatives of historic structures and their surroundings. She applied traditional methods to her work, relying on perspective views, elevations, and details. Yet her photographs are aesthetically innovative. Johnston emphasized salient features of architectural styles and showed how character is imparted across the ravages of time. Capturing the picturesque characteristics of weathering and decay, she used light to best emphasize architectural characteristics: bright blank surfaces for Neoclassical and Federal buildings; high contrasts for Georgian architecture with its proclivity toward deep relief and contrasting forms and values. Johnston's portrayal of historic architecture usually included the landscaped settings. The fields, gardens, trees, and surroundings of country properties all played a part in her compositions. They frame the architecture and in their maturity provide a historic as well as a traditional, picturesque context. Always, she returned to the human scale and the social meanings of buildings. Always, too, there was intention in her art: to convey a sense of the beauty and dignity of aging and often neglected architecture. This is particularly true of her photograph of the Lucy Cobb Institute, for example, in the way she focused on the vine-covered porch where people can sit and converse while fully illuminating the front façade in its entirety.

In what ways then is Johnston's work traditional? And how is it innovative? Some aspects of her vocation were traditional. She saw herself as a straightforward documentarian, though clearly her artistic and compositional concerns still show through. She was methodical and empirical, to a degree, as can be seen in the way each photograph of Belle Grove gives additional information about the estate. Increasingly as her career progressed, she chose to operate in a traditional milieu, avoiding avant-garde circles. She wished to stay connected to family and friends, keeping in mind her place in society. Johnston was active in organizations that we now accept as

traditional if not conservative—the Daughters of the American Revolution and the Garden Club of America, for instance. She took photographs of traditional architecture, attempting to document buildings and at the same time to extol their virtues and fight for their preservation. Overall, she was an early historic preservationist and believed old buildings represented touchstones of continuity in an often fast-changing world. They enshrined the labor and values of Americans from past generations. Thus, for example, in her photograph of the Chapel of the Cross, she shows only the original part of the building and not the more modern addition to the east.

Johnston's art was also traditional in intent. She sought above all to capture a scene, to provide a reliable representation of an object or subject. Trained as a portrait photographer, she tried to record every detail and brought to her work a portrait photographer's eye for the personalities of her subjects. She shot her old buildings lovingly and sensitively, using lighting and composition to express the less-tangible quality of mood. Ultimately, Johnston was aware that these photographs would remain when many of the buildings were no longer in existence. They must therefore be judged to a high technical standard, based on how well they convey a sense of materials, scale, and proportion; how well they are composed on the plane of the paper; how well elements read through varied lighting values; and even how well they are exposed and printed.

Johnston's photographs, using such criteria, stand apart from those of her contemporaries such as Collinge or Waterman. Her photograph of the Cooleemee-Hairston House, furthermore, is superior to others taken from the same location by more recent photographers, and it is included in well-known classics, such as those by Talbot Faulkner Hamlin. Johnston's photographs do in fact tell the story well. We perceive the surroundings, the materials, and the design. It is perhaps a testimony to the skillfulness of her work that it also exceeds the quality of most current work and that it is still used today so frequently in standard texts and articles on American architecture.

The clarity and consistent artistry of Johnston's photographs are simply extensions of a skill and sensitivity, something learned through practice. Her innovations exist in the selection of her subject matter: traditional architecture of the South covered extensively throughout nine states. Her work was innovative in what it said about American architecture and American

history—for the view it gave of abandoned older buildings, sitting as near ruins in the countryside or neglected on city streets. There is something modern about such a methodical study. Almost like a piece of conceptual art, her work subjected the repertoire of the built environment to detailed analysis, categorization, and cataloging. At the Library of Congress, her buildings line up like trophies, put away in folders, cross-referenced, and archived.

But her innovations extend beyond this—beyond a mere program of thoroughness. She captured the right light at the right time, establishing correspondences between the composition of her work and the implicit aesthetic characteristics of her buildings: direct and formal for classical architecture, oblique and informal for vernacular buildings, bright and flat for Neoclassical architecture, deep and in high contrast for Georgian Baroque. She subtly suggests the atmosphere of places, the dust on the drives, the heat coming off the fields, the cooling shade of trees. Time and often neglect become part of her work. The buildings are subjects caught in a moment, often precariously. We understand the functions of her buildings, their relationships to the people who inhabit and inhabited them. They provide tranquil moments upon which to reflect on the passage of time and the meaning of buildings and art.

Johnston attempted to change society through her art. She called attention to the plight of mining families; she complimented the accomplishments of young African American students and apprentices; and she attempted to underscore the signature of a fast-vanishing heritage—the architecture of colonial and early twentieth-century America. In a way, this seems again to be a traditional or conservative aspect of her work. On the other hand, it points to clearly progressive trends in art, especially those of environmental artists. Like them, Johnston never wanted her art to remain within gallery walls but rather intended it to have an impact on the world.

Johnston's legacy is manifold. She was a pioneer in recording historic architecture, single-handedly founding the Pictorial Archives of Early American Architecture at the Library of Congress and providing a model for the 1935 American Historic Sites and Building Act, the immeasurably successful architectural recording efforts of the Historic American Buildings Survey, and local Chamber of Commerce activities promoting historic architecture for tourism. She was a tireless and committed activist as well,

working with garden clubs, patriotic organizations, and historical societies to save older buildings and protect historic sites in cities such as Charleston, St. Augustine, and New Orleans. Her photographs provided—and continue to provide—a lasting and singular record of older architecture.

Appendix

Where Johnston's Work Resides

THE GREATEST CONTRIBUTOR of architectural photographs to the Library of Congress is Frances Benjamin Johnston. Besides these photographs, she gave her diaries, correspondence, speeches, manuscripts, notes, maps, financial papers, and newspaper and magazine articles to the Library. Known as the Frances Benjamin Johnston Papers, these were received by the Prints and Photographs Division of the Library and then transferred to the Manuscripts Division in 1960–1962. A microfilm edition of these papers, a total of thirty-seven reels, was thoroughly examined for this study and is available for purchase from the Library's Photoduplication Service, or may be requested through the Library's Interlibrary Loan Division.

Johnston also gave copies of all the photographs she made during her lifetime (between c. 1888 and 1947) to the Prints and Photographs Division of the Library of Congress. This collection of images, now known as the Frances Benjamin Johnston Collection, includes photographs she collected as well. Among the photographic materials are approximately 20,000 photographs including silver gelatin and cyanotype proofs, 37,000 glass and film negatives, 1,000 lantern slides, 17 tintypes, and some autochromes. Also included in the collection are photo albums, scrapbooks, architectural and other drawings, business cards, newspaper clippings, and Johnston's camera and typewriter.

Besides the Frances Benjamin Johnston Collection of photographs there is the Carnegie Survey of Architecture of the South, also housed in the Prints and Photographs Division of the Library of Congress. This collection consists of photographs and the corresponding negatives of historic American architecture Johnston took between 1927 and 1943. Funded by

the Carnegie Corporation, Johnston systematically took photographs of early southeastern architecture covering nine states. The Library of Congress acquired prints of the negatives, a total of nearly 8,000 prints, and received the negatives upon Johnston's death.

The first acquisition of the Pictorial Archives of Early American Architecture (PAEAA) included the photographs Johnston took in 1927 of the Fredericksburg and Falmouth, Virginia, area for an architectural survey. Begun in 1930, the PAEAA within ten years consisted of over 10,000 negatives solicited from donors throughout the country. The Library of Congress first began to systematically collect photographs documenting early American architecture and design with the establishment of this collection.

Images made by Frances Benjamin Johnston are arranged by subject, and each group has been given a call number (LOT number order). Descriptions of each call number are available in the Library of Congress computer catalog and from the Library of Congress Prints and Photographs Division. Photographic products can be ordered in person, by mail, or by computer from the Photoduplication Service at the Library.

Johnston's own work set precedents for many of the photographs found in other photographic collections housed at the Library of Congress, including the Historic American Buildings Survey (HABS), the Historic American Engineering Record (HAER), and the Farm Security Administration/Office of War Information Collection (FSA/OWI). Johnston worked occasionally alongside HABS photographers, and HABS photographers sometimes helped her survey work by providing lists of historic buildings to visit. The Historic American Buildings Survey and the Historic American Engineering Record are collections of documentary measured drawings, photographs, and written historical and architectural information for over 17,000 structures and sites in the United States and its territories. The survey began in 1933 with the purposes of recording architectural monuments and providing unemployment relief. The United States Department of the Interior is responsible for the administration of these surveys and creates the records that are then transferred to the Library of Congress. The American Institute of Architects and the American Society of Civil Engineers serve in an advisory capacity for HABS and HAER. Printed catalogs of the collections and publications as well as copies of HABS and HAER materials are available. The Farm Security Administration/Office of War Information Collection,

with most of the photographs taken between 1935 and 1942, was transferred to the Prints and Photographs Division of the Library of Congress from the Office of War Information in 1944, which had been administered by the Department of Agriculture before 1942. Approximately 75,000 FSA/OWI reference prints have been arranged by geographic region and subject in a way that makes them convenient to use in tandem with HABS materials.

Besides the major collections at the Library of Congress, there are much smaller collections of Johnston's photographs at other institutions such as the Baltimore Museum of Art, the University of Virginia library, the Virginia Museum of Art, Duke University, the Enoch Pratt Free Library, the Art Institute of Chicago, the Carnegie Institute in Pittsburgh, the University of North Carolina at Chapel Hill, the Metropolitan Museum of Art and the Museum of Modern Art in New York City, the California Museum of Photography, photographs of Louisiana at the Louisiana State Museum Visual Arts Collection, and portraits at the Huntington Library Photograph Collection in San Marino, California. The availability of Johnston's photographs at these numerous institutions throughout the country has made her work accessible and familiar to the American public.

Johnston's photographs, sometimes credited and sometimes not, are still often used to illustrate books and articles on the history of American architecture. Johnston first published her architectural photographs of Washington, D.C., during the 1890s in magazines such as *Demorest's Family Magazine* and *Harpers' Weekly*. Books substantially illustrated with Johnston's photographs that were published at the time she was taking them or soon after her death include her own *The White House* (1893), Brown's *History of the United States Capitol* (1900 and 1903, reprinted in 1970), her book *Historic Houses of Virginia and Charleston, South Carolina* (Broadside, 1930), *The Early Architecture of North Carolina* (1941), her book *Tales Old Houses Tell* (1942), Lawrence William Bottomley's *Great Georgian Houses of America* (2 volumes, 1933 and 1937, reprinted in 1970), Henry Irving Brock's *Colonial Churches in Virginia* (1930), Samuel Gaillard Stoney's *Plantations of the Carolina Low Country* (1938, reprinted a total of eight times including in 1989), Samuel Gaillard Stoney's *Architects of Charleston* (1945), Thomas Waterman's *The Mansions of Virginia: 1706–1776* (1945), Talbot Faulkner's *Forms and Functions of Twentieth-Century Architecture* (1952), and Frederick Doveton Nichols's *The Architecture of Georgia* (1957). More recent architec-

tural history books that contain Johnston's photographs include the series by Mills Lane published in the 1980s, which covers the historic architecture of South Carolina, North Carolina, Georgia, Mississippi, Alabama, and Louisiana. Marcus Whiffen's *American Architecture Since 1780: A Guide to the Styles* (1981) is another more recent publication. Johnston's photographs of the White House have been used in Perry Wolff's *A Tour of the White House with Mrs. John F. Kennedy* (1962), in which Johnston is compared to Mrs. Kennedy due to their common interest in photography as well as their intimate knowledge of Washington society. Robert Gamble included Johnston's photographs in a HABS publication entitled *The Alabama Catalog: HABS. A Guide to the Early Architecture of the State* (1987). *Eyes of the Nation: A Visual History of the United States* includes Johnston's photographs as well as some of the other visual collections at the Library of Congress. All of these publications, some of which are standard texts for scholars of American architectural history and historic preservation, have increased Johnston's exposure, making her work more familiar to architects and architectural historians.

Johnston's landscape photography can be found in several of the above-mentioned architectural history books. The major source of her earlier photographs showing gardens is Louise Shelton's *Beautiful Gardens in America* (1915, 1924) in which she provided 93 of 195 photographs. This book was a standard text for institutions offering courses in landscape architecture including the Landscape Architecture Department at the University of Georgia in Athens. Johnston also publicized her landscape and garden photography in magazines such as *Demorest's Family Magazine* (1890s), *The Touchstone and the American Art Student Magazine* (1917), *Country Life* (1918), and *Town and Country* (1920s). These publications spread information about how the gardens of wealthy homeowners looked, and the aesthetically pleasing garden photographs in them set new precedents for aspiring middle-class homeowners. A more recent publication that includes Johnston's garden photography is *California Gardens: Creating a New Eden* (1994) by David C. Streatfield. Her landscape photography thus continues to be used today to document gardens of American estates from the 1920s.

Johnston's earlier work in portraiture, artistic studies, and photojournalism was widely received by the American public through magazines and books as well. Her more widely published photographs include portraits

of Admiral Dewey, President Taft, President McKinley, and the Roosevelt family in *Leslie's Weekly*, *Saturday Pictorial Review*, *Harpers' Weekly*, *Collier's Weekly*, *Young People's Weekly*, *Ladies' Home Journal*, and *Our Junior Citizens*. Photographs of Tuskegee Institute were published in the books *Up from Slavery* (1901), *Working with the Hands* (1904), and *Tuskegee and Its People: Their Ideals and Achievements* (1905), all by Booker T. Washington. The photographs of the Washington, D.C., schools were originally published in booklets entitled *The New Education Illustrated* (1900–01) by Edith Westcott.

While Johnston's work was widely disseminated during her life through newspapers, magazines, and books, it was the rediscovery of her photography for the Hampton Institute in the mid-1960s by Lincoln Kirstein that catapulted Johnston's career as an artist, a little over one decade after her death. Mostly, Kirstein's publication of Johnston's Hampton photographs has ensured that her work is remembered today. Lincoln Kirstein, an active member of the Museum of Modern Art Junior Advisory Committee since the 1930s, previously had made sure that the work of photographers such as Eduard Steichen, Bernice Abbott, and Walker Evans was exhibited at the museum, and Johnston's work was eventually shown at a time when there was still little general support for a reassessment.

Since the publication of *The Hampton Album* (1966), Johnston's Hampton photos have been mentioned if not reprinted in more recently published photographic survey books. Within the past decade, there have been various publications documenting the art of women too, and Johnston's work is often included. For example, in Jane Gover's book *The Positive Image: Women Photographers in Turn of the Century America* (1988), Gover explains how women first became involved in photography. She discusses photographers such as Alice Austen, Emma Farnsworth, Eva Watson-Schutze, Mary A. Bartlett, Mary and Frances Allen, and others not previously mentioned in survey books as well as the better known photographers Gertrude Kasebier and Johnston, whose work were not included in survey books until more recently. Toby Quitslund provides a well-researched chapter for Josephine Withers's book, *Women Artists in Washington Collections* (1979) about Johnston's work for the 1900 Exposition in Paris. A biography with a greater focus on Johnston's personal life is Bettina Berch's *The Woman Behind the Lens: The Life and Work of Frances Benjamin Johnston, 1864–1952* (2000).

Notes

CHAPTER 1. *Introduction*

1. Frances Benjamin Johnston, "What a Woman Can Do with a Camera," *Ladies' Home Journal* 14 no. 10 (September 1897): 6–7.

CHAPTER 2. *Professional Development and Early Work*

1. This photograph, entitled "The Rebel," is in the Frances Benjamin Johnston Collection, PPDLC, LC-USZ62-64301.

2. Hunter. Frances Benjamin Johnston Papers, MDLC, Reel 24, Container 31, pp. 36–40.

3. Ibid.

4. Johnston listed the following sources as ones that she used to trace her family history: John Taylor, *History of Ten Churches*; J. H. Spencer, *History of the Baptists in Kentucky*; Lewis Collins, *History of Kentucky*; and George W. Rounck, *History of Lexington, Kentucky*. Bibliography, October 15, 1942, Frances Benjamin Johnston Papers, MDLC, Reel 32, Container 43, p. 137.

5. J. T. Adams, ed., *Dictionary of American History* (New York: Charles Scribner's Sons, 1940), 10. Letter from Frances Benjamin Johnston to the Daughters of the American Revolution Regents, Lexington, Kentucky Chapter, August 1, 1942, Frances Benjamin Johnston Papers, MDLC, Reel 15, Container 19, p. 290. Johnston applied for membership in the Daughters of the American Revolution (DAR) on February 15, 1892.

6. Lincoln Kirstein, "A Note on the Photographer," *The Hampton Album* (New York: Museum of Modern Art, 1966), 53.

7. For more extended accounts of female American artists at the French salons and academies, see Elizabeth Brown, "American Paintings and Sculpture in the Fine Arts Building of the World's Columbian Exposition, Chicago, 1893" (Ph.D. diss., University of Kansas, 1976), 284–85; Catherine Fehrer, "New Light on the Academie Julian and Its Founder (Rudolphe Julian)," *Gazette des Beaux-Arts* 103 (1984): 207–16; Katherine de Forest, "Art Student Life in Paris," *Harper's Bazaar* 33 (July 7, 1900): 628–32; Mary Alice Heekin Burke, *Elizabeth Nourse, 1859–1938: A Salon Career* (Washington, D.C.: National Museum of American Art, 1983); Geraldine Rowland, "The Study of Art in Paris," *Harper's Bazaar* 36 (September 1902): 756–61; Charlotte

Yeldham, *Women Artists in Nineteenth Century France and England*, 2 vols. (New York: Garland, 1984); Theodore E. Stebbins, Carol Tryen, and Trevor Fairbrother, *A New World: Masterpieces of American Painting 1760–1910* (Boston: Museum of Fine Arts, 1983), 160–61; and Helene Barbara Weinberg, *The American Pupils of Jean-Leon Gerome* (Fort Worth: Amon Carter Museum, 1984), 91, 93, and n. 6.

8. The Washington Art Students' League also was referred to as the Art Students' League. See Clarence Bloomfield Moore, "Women Experts in Photography," *Cosmopolitan* 14 (March 1893).

9. Art Students' League 1885 Constitution. Frances Benjamin Johnston Papers, MDLC, Reel 24, Container 31, pp. 1–2.

10. Moore, "Women Experts," passim.

11. Frances Benjamin Johnston Collection, PPDLC, Photograph number LC-J698-8744.

12. "Art Students at Work," *Washington Post*, October 16, 1888, Frances Benjamin Johnston Papers, MDLC, Reel 29, Container 39, p. 180. There is no evidence to support the article's claim that Johnston devoted much of her time to crayon portraits. Johnston's papers show that she worked with pencil and ink, too, such as to illustrate some of her earliest newspaper articles. It is also known that she studied painting and drawing there. See *The Macmillan Biographical Encyclopedia of Photographic Artists and Innovators* (New York: Macmillan, 1983), 310–11.

13. Susan Hunter, "The Art of Photography: A Visit to the Studio of Miss Frances Benjamin Johnston," c. 1895. Frances Benjamin Johnston Papers, MDLC, Reel 24, Container 31, pp. 36–40.

14. Moore, "Women Experts," 556.

15. Hunter, "The Art," no page numbers.

16. Leila Mechlin, "Art Life in Washington," *Records of the Columbia Historical Society* 24 (1922): 175. See also Elizabeth A. Tompkins, "Literary Washington," *Cosmopolitan* 8, no. 1 (November 1889): 191–200. On how women painters have confronted hostility from academicians and their exclusion from art classes, see Linda Nochlin, "Why Have There Been No Great Women Artists?" *Art News* 69, no. 9.

17. Letter from Everett Warner to Miss Moser, daughter of James Henry Moser, a later instructor at the Corcoran School of Art. "Correspondence of the Corcoran Gallery," December 3, 1890, Archive of American Art, Smithsonian Institution, Microfilm Reel 260, Frame 352. Quoted from Allan Thomas Marsh, "Washington's First Art Academy, The Corcoran School of Art, 1875–1925," (Ph.D. diss., University of Maryland, 1983).

18. Marsh, "Washington's First Art Academy," 9–34.

19. Ibid.

20. Ibid.

21. See Diary entry, January 10, 1911, Frances Benjamin Johnston Papers, MDLC, Reel 12, Container 1, p. 71. See also *Catalogue of the Paintings in The Corcoran Gallery of Art* (Belmont: A. W. Elson, 1913), 7–11, and *Art Notes*, June 1895, Frances Benjamin Johnston Papers, MDLC, Reel 29, Container 39, p. 254.

22. Constance McLaughlin Green, *Washington Village and Capital, 1800–1878* (Princeton: Princeton University Press, 1962), 339–62.

23. Ibid.

24. Paul Vanderbilt, "Frances Benjamin Johnston, 1864–1952," *Journal of the American Institute of Architects* (November 1952): 224–28.

25. For this article Johnston received $3. In an article about this event, she is described as "about fifteen years old," "shy," "bit of a colleen," and "a little Washington school girl" who had "come into print quaintly and gracefully." Actually, Johnston was closer to eighteen years old at this time. Frances Benjamin Johnston Papers, MDLC, Reel 3, Container 4, p. 500.

26. William Welling, *Photography in America: The Formative Years 1839–1900* (Albuquerque: University of New Mexico Press, 1978), 303.

27. Beaumont Newhall, *The History of Photography* (New York: Museum of Modern Art, 1982), 141–64.

28. Margaret Bisland, "Women and Their Cameras," *Outing* 17 (October 1890): 38. See also Johnston, "What a Woman Can Do with A Camera." Johnston herself saved an article entitled "Women as Photographers" written by Bisland in *The Illustrated American*, June 6, 1891. Frances Benjamin Johnston Papers, MDLC, Reel 33, Container 44, p. 222. Other articles written in the late nineteenth century about women and photography include Richard Hines, Jr., "Women and Photography," *American Amateur Photography*, 11 (March 1899): 118; Marion Foster Washburne, "A New Profession for Women," *Godey's Magazine* 134, no. 800 (February 1897): 123–28; "A Woman's Success as a Photographer," *The Amateur Photographer* 2 (December 5, 1884): 142; Elizabeth Flint Wade, "The Camera as a Source of Income Outside the Studio," *Photographic Times* 24 (June 8, 1894): 358; "The Camera Has Opened a New Profession for Women," *New York Times* (April 20, 1912): 12; Mary Patten, "The Photographer," in Catharine Filene, *Careers for Women* (Boston: Houghton Mifflin, 1920), 72; J. H. Parsons, "Women as Photographers," in M. L. Rayne, *What Can a Woman Do?* (Detroit: F. B. Dickerson, 1884), 127; and Giles Edgerton, "Is There a Sex Distinction in Art? The Attitude of the Critic toward Women's Exhibits," *The Craftsman* 14 (June 1908): 239–51.

29. United States Census Office, *Twelfth Census, 1900, Occupations* (Washington, D.C.: Government Printing Office, 1904), iii.

30. Stephen H. Horgan, "Photography for the Newspapers," *Philadelphia Photographer* 23, no. 269 (March 6, 1886): 140–42.

31. See Jessie Tarbox Beals, "My First Photograph," *Photo-Era* 48 (May 1922): 263–64.

32. Horgan, "Photography for the Newspapers," 141.

33. Thomas W. Smillie, "Smithsonian Institution. History of the Department of Photography," July 24, 1906, Smithsonian Institution Archives, Washington, D.C., Record Unit 55, Series 5, Box 20, pp. 3–8.

34. "History of the Section of Photography of the Smithsonian Institution: Its Establishment and Early Activities," 1965, Smithsonian Institution Archives, Washington, D.C., Record Unit 55, Series 5, Box 20, File 21.

35. Letter from Thomas W. Smillie to Frederick W. True, December 29, 1899, Smithsonian Institution Archives, Washington, D.C., Record Unit 55, Series 5, Box 20, File 21.

36. Hunter, "The Art of Photography," no page numbers; see also Moore, "Women Experts in Photography."

37. E.g., G. Brown Goode, letter of introduction for Frances Benjamin Johnston [from Thomas Smillie], July 26, 1890, Frances Benjamin Johnston Papers, MDLC, Reel 3, Container 4, p. 511.

38. In 1897, Smillie wrote to his younger protégé, "I am glad you are out on the ocean—Now please do not go out of your way at all to collect for the museum. You know that the museum is very ungrateful." Letter from Thomas W. Smillie to Frances Benjamin Johnston, July 15, 1897, Frances Benjamin Johnston Papers, MDLC, Reel 4, Container 5, p. 607.

39. Frances Benjamin Johnston, "Uncle Sam's Money," *Demorest's Family Magazine* (December 1889–January 1890).

40. Frances Benjamin Johnston, "The Executive Departments of Government," *Cosmopolitan* 9, no. 6 (October 1890): 645–55, and *Cosmopolitan* 9, no. 7 (November 1890): 36–47.

41. Frances Benjamin Johnston, "The White House," *Demorest's Family Magazine* (May 1890); "In the White House," *Harper's Weekly* (March 4, 1893); *The White House* (Washington, D.C.: Gibson Brothers, 1893); Frances Benjamin Johnston, "Students in the Art of War," *The Illustrated American* 15, no. 227 (June 23, 1894): 725–29.

42. Frances Benjamin Johnston, "Through Coal Country," *Demorest's Family Magazine* (March 1892); "The Evolution of a Great Exposition," *Demorest's Family Magazine* (April 1892); "Mammoth Cave by Flashlight," *Demorest's Family Magazine* (March 1893). The latter was also subsequently published in book form: *Mammoth Cave . . . by Flash-Light* (Washington, D.C.: Gibson Brothers, 1893).

43. Frances Benjamin Johnston, "The Foreign Legations of Washington," *Demorest's Family Magazine* (pts. 1–4, April–July 1893); "A Day at Niagara," *Demorest's Family Magazine* (August 1893); "Small White House Orchids," *Demorest's Family Magazine* (June 1895).

44. See Thomas W. Smillie, "Smithsonian Institution. History of the Department of Photography," July 24, 1906, Smithsonian Institution Archives, Washington, D.C., Record Unit 55, Series 5, Box 20, pp. 3–8, and "History of the Section of Photography of the Smithsonian Institution: Its Establishment and Early Activities," 1965, Smithsonian Institution Archives, Washington, D.C., Record Unit 55, Series 5, Box 20, File 21.

45. "Historical Photograph Collection," p.7, National Zoological Park, *Smithsonian Institution Telephone Book 1992*, 140–41.

46. Julia Magruder, "The Evolution of a Home Studio," *The House Beautiful* 18, no. 6 (November 1905): 11–13; see also Hunter, "The Art of Photography."

47. "Washington Women with Brains and Business," *Washington Times*, April 21, 1895, Frances Benjamin Johnston Papers, MDLC, Reel 29, Container 39, p. 244. See also Julie K. Brown, *Contesting Images: Photography and the World's Columbian Exposition* (Tucson: University of Arizona Press, 1994).

48. See Martin W. Sandler, *American Image: Photographing One Hundred Fifty Years in the Life of a Nation* (Chicago: Contemporary Books, 1989), 14.

49. Laurie Anne Baty, "Photographers of Washington D.C. 1870–1885" (M.A.

thesis, George Washington University, 1979), 25. Johnston is not mentioned in the directories cited.

50. Ibid.

51. Susan Hunter, "Miss Frances Benjamin Johnston: America's Camera Laureate," 1904 article, Frances Benjamin Johnston Papers, MDLC, Reel 24, Container 31, p. 50.

52. "Capital Society Notes," *Pittsburgh Post*, May 26, 1895, Frances Benjamin Johnston Papers, MDLC, Reel 29, Container 39, p. 252.

53. I. Edwards Clarke, *Washington Post*, February 22, 1882, Frances Benjamin Johnston Papers, MDLC, Reel 33, Container 44, pp. 122–23.

54. Ibid.

55. Frances Benjamin Johnston, "The Executive Departments of the Government," *Cosmopolitan* 9, no. 6 (October 1890): 645–55; *Cosmopolitan* 10, no. 7 (November 1890): 36–47; Frances Benjamin Johnston Papers, MDLC, Reel 35, Container 47, pp. 95–100. List of portraits, Frances Benjamin Johnston Papers, MDLC, Reel 28, Container 38, p. 5.

56. Booker T. Washington, "The Successful Training of the Negro," *World's Work* (August 1903): 3731–51.

57. See "Art and Photography at the Cosmos Club," *Washington Times*, May 15, 1895, Frances Benjamin Johnston Papers, MDLC, Reel 29, Container 39, p. 250.

58. See Letter from George Grantham Bain to Frances Benjamin Johnston, February 14, 1893, Frances Benjamin Johnston Papers, MDLC, Reel 4, Container 4, p. 20. George Grantham Bain letters to Frances Benjamin Johnston, January 8, 1893, and January 9, 1893, Frances Benjamin Johnston Papers, MDLC, Reel 4, Container 4, pp. 6 and 7. In the letter of January 8, 1893, he asks Johnston for silver prints of the White House. The next day he wanted a photograph of the Blaine residence. For more on Bain, see also Emma H. Little, "The Father of News Photography, George Grantham Bain," *Picturescope* 20 (Autumn 1972): 125–32.

59. Frances A. is listed as Mrs. Anderson D. Johnston in *U.S. Congress; Congressional Directory, Forty-fifth Congress* (Washington, D.C.: Government Printing Office, 1879), 92–93.

60. *Buffalo Illustrated Express*, September 23, 1901, Frances Benjamin Johnston Papers, MDLC, Reel 6, Container 7, p. 106. Letter from L. B. Jones of Kodak Company to Frances Benjamin Johnston, October 11, 1901, Frances Benjamin Johnston Papers, MDLC, Reel 6, Container 7, p. 170.

61. *The Capital*, January 27, 1894, Frances Benjamin Johnston Papers, MDLC, Reel 29, Container 39, p. 195.

62. *Pathfinder*, January 20, 1894, Frances Benjamin Johnston Papers, MDLC, Reel 29, Container 39, p. 195.

63. Frances Benjamin Johnston, "Homeward Bound with Admiral Dewey: Life Aboard the Flagship *Olympia*," *Harper's Weekly* (September 1899): 990; *Collier's Weekly* (September 23, 1899) and (September 30, 1899), Frances Benjamin Johnston Papers, MDLC, Reel 35, Container 46, pp. 138–49.

64. Letter from Ida Tarbell to Frances Benjamin Johnston, October 10, 1899, Frances Benjamin Johnston Papers, MDLC, Reel 6, Container 7, p. 374. The

year before, Tarbell had written an article accompanied by illustrations including a photograph Johnston had taken of President McKinley. Ida Tarbell, "President McKinley in War Times," *McClure's Magazine* 11, no. 3 (July 1898): 208–24.

65. Harnett T. Kane, "New Orleans Architecture Is Being Saved in Pictures," *Sunday Item-Tribune, New Orleans*, May 22, 1938, Frances Benjamin Johnston Papers, MDLC, Reel 29, Container 40, p. 585.

66. Letter from E. D. Shaw of *Boston Journal* to Frances Benjamin Johnston, September 5, 1899, Frances Benjamin Johnston Papers, MDLC, Reel 6, Container 7, pp. 357–66. Letter from Lothrop Publishing Company to Frances Benjamin Johnston, September 1899, Frances Benjamin Johnston Papers, MDLC, Reel 6, Container 7, pp. 362–65. Letter from Veerhoff's Galleries to Frances Benjamin Johnston, September 12, 1899, Reel 6, Container 7, p. 366.

67. Robert Doty, *Photo-Secession: Stieglitz and the Fine-Art Movement in Photography* (New York: Dover, 1978), 19. See also Newhall, *The History of Photography*, 141–64.

68. *Washington Evening Star*, April 18, 1891, Frances Benjamin Johnston Papers, MDLC, Reel 29, Container 39, p. 181.

69. See Letter from S. H. Griffith to Frances Benjamin Johnston, February 14, 1889, Frances Benjamin Johnston Papers, MDLC, Reel 3, Container 4, p. 508

70. See Doty, *Photo-Secession,* and Newhall, *The History of Photography*.

71. *Sun*, May 26, 1891, Frances Benjamin Johnston Papers, MDLC, Reel 29, Container 39, p. 182.

72. See Toby Quitslund, "Her Feminine Colleagues: Photographs and Letters Collected by Frances Benjamin Johnston in 1900," in Josephine Withers, *Women Artists in Washington Collections* (College Park: University of Maryland and the Women's Caucus for Art, 1979), 100–101, 141; Catharine Weed Ward, "Amateur Photography," *American Amateur Photography* 5 (August 1893): 363; and Catharine Weed Ward, "Women in Photography," *American Amateur Photographer* 8 (March 1896): 96.

73. Susan Hunter, "Miss Frances Benjamin Johnston: America's Camera Laureate," 1904, Frances Benjamin Johnston Papers, MDLC, Reel 24, Container 31, p. 45.

74. Letter from H. Snowden Ward to Frances Benjamin Johnston, December 29, 1893, Frances Benjamin Johnston Papers, MDLC, Reel 4, Container 4, p. 112.

75. C. Jane Gover, *The Positive Image: Women Photographers in Turn of the Century America* (Albany: State University of New York Press, 1988), 68–85.

76. Frances Benjamin Johnston, "The Evolution of a Great Exposition," *Demorest's Family Magazine* 28, no. 6 (April 1892): 319–28. Frances Benjamin Johnston Collection, PPDLC, Lot 2959 includes seventy-four prints of the 1893 Exposition, taken between 1891 and 1893. See also Peter Bacon Hales, *Constructing the Fair: Charles Dudley Arnold and the World's Columbian Exposition* (Chicago: Art Institute of Chicago, 1993), and Hales, *Silver Cities: The Photography of American Urbanization, 1839–1915* (Philadelphia: Temple University Press, 1984).

77. *Washington News*, June 6, 1894, Frances Benjamin Johnston Papers, MDLC, Reel 28, Container 39, p. 230.

78. Letter from Virginia C. Meredith to Frances Benjamin Johnston, April 30, 1895, Frances Benjamin Johnston Papers, MDLC, Reel 4, Container 4, p. 260.

79. See Frances Benjamin Johnston, "Some Homes under the Administration: Levi P. Morton, VP," *Demorest's Family Magazine* 26, no. 9 (July 1890): 513–20.

80. Frances Benjamin Johnston, "Some Homes under the Administration: Sen. Hearst of California," *Demorest's Family Magazine* 26, no. 12 (October 1890): 713–20.

81. Frances Benjamin Johnston, "Some Homes under the Administration: John Wanamaker, Postmaster General," *Demorest's Family Magazine* 26, no. 10 (August 1890): 579–86.

82. *Washington Post*, June 10, 1894, Frances Benjamin Johnston Papers, MDLC, Reel 29, Container 39, p. 231.

83. "Art and Photography at the Cosmos Club," *Washington Times*, May 15, 1895, Frances Benjamin Johnston Papers, MDLC, Reel 29, Container 39, p. 250. Initially, Johnston had taken the photograph for painters to use, a common practice to eliminate subsequent sittings for those having their portraits painted. See Gover, *The Positive Image*, 34–85.

84. "Art and Photography," Frances Benjamin Johnston Papers, MDLC, Reel 29, Container 39, p. 250.

85. Newhall, *The History of Photography*, 141–64.

86. Letter from Eugene Lee Ferguson to Frances Benjamin Johnston, July 30, 1902, Frances Benjamin Johnston Papers, MDLC, Reel 6, Container 7, p. 460.

87. Newhall, *The History of Photography*, 141–64.

88. Ibid.

89. Letter from Alfred Stieglitz to Frances Benjamin Johnston, August 22, 1896, Frances Benjamin Johnston Papers, MDLC, Reel 4, Container 5, pp. 397–98.

90. *Washington Post*, November 1, 1896, Frances Benjamin Johnston Papers, MDLC, Reel 29, Container 39, p. 262.

91. Letter from Art Editor of *Black and White* journal to Frances Benjamin Johnston, September 27, 1897, Frances Benjamin Johnston Papers, MDLC, Reel 4, Container 6, p. 679.

92. *The Photogram*, October 1897, Frances Benjamin Johnston Papers, MDLC, Reel 29, Container 39, p. 265.

93. Letter from Charles I. Berg to Frances Benjamin Johnston, August 3, 1897, Frances Benjamin Johnston Papers, MDLC, Reel 4, Container 5, p. 623.

94. Letter from Alfred Stieglitz to Frances Benjamin Johnston, June 1, 1898, Frances Benjamin Johnston Papers, MDLC, Reel 4, Container 6, pp. 24–25. See also Letter from Alfred Stieglitz to Frances Benjamin Johnston, July 21, 1898, Frances Benjamin Johnston Papers, MDLC, Reel 4, Container 6, p. 65.

95. Letter from Alfred Stieglitz to Frances Benjamin Johnston, June 1, 1898, Frances Benjamin Johnston Papers, MDLC, Reel 4, Container 6, pp. 24–25.

96. Letter from Alfred Stieglitz to Frances Benjamin Johnston, July 21, 1898, Frances Benjamin Johnston Papers, MDLC, Reel 4, Container 6, p. 65.

97. Jean Prinet and Antoinette DiLasser, *Nadar* (Paris: Armand Colin, 1966), 115–16.

98. See Prinet and DiLasser, 115–16.

99. Johnston, "What a Woman Can Do with a Camera," 7.

100. William Innes Homer, *Pictorial Photography in Philadelphia: The Pennsylvania Academy's Salons, 1898–1901* (Philadelphia: Pennsylvania Academy of the Fine Arts, 1984), 15.

101. William M. Murray, "Miss Frances B. Johnston's Prints," *Camera Notes* 2, no. 4 (1898–9): 167–68.

102. Johnston, "What a Woman Can Do with a Camera," 6–7.

103. *Philadelphia Times*, November 6, 1898, Frances Benjamin Johnston Papers, MDLC, Reel 29, Container 39, p. 274.

104. *Leeds Mercury*, November 26, 1898, Frances Benjamin Johnston Papers, MDLC, Reel 29, Container 39, pp. 275–78.

105. Naomi Rosenblum, *A World History of Photography* (New York: Abbeville Press, 1984).

106. Letter from Amelia Van Buren to Frances Benjamin Johnston, June 7, 1900, Frances Benjamin Johnston Papers, MDLC, Reel 19, Container 24, p. 325.

107. *Leeds Mercury*, November 26, 1898, Frances Benjamin Johnston Papers, MDLC, Reel 29, Container 39, p. 275.

108. Letter from Alfred Stieglitz to Fred Holland Day, March 31, 1899, quoted in Estelle Jussim, *Slave to Beauty: The Eccentric Life and Controversial Career of F. Holland Day, Photographer, Publisher, Aesthete* (Boston: David R. Godine, 1981), 137.

109. *Photo Era Magazine* (April 1899).

110. William Innes Homer, *Alfred Stieglitz and the Photo-Secession* (Boston: Little, Brown, 1983), 46–47.

111. Letter from Walter P. Stokes to Frances Benjamin Johnston, 1899, Frances Benjamin Johnston Papers, MDLC, Reel 5, Container 6, p. 270.

112. Letter from Robert Redfield to Frances Benjamin Johnston, March 15, 1900, Frances Benjamin Johnston Papers, MDLC, Reel 5, Container 6, pp. 467–69.

113. Letter from Robert Redfield to Frances Benjamin Johnston, July 24, 1899, Frances Benjamin Johnston Papers, MDLC, Reel 5, Container 6, pp. 316–17.

114. See Anne B. Fehr and William Innes Homer, "The Photographic Society of Philadelphia and the Salon Movement," in William Innes Homer, *Pictorial Photography in Philadelphia, The Pennsylvania Academy's Salons 1898–1901* (Philadelphia: Pennsylvania Academy of Fine Arts, 1984), 7–9. See also Doty, *Photo-Secession*, 14.

115. Letter from Charles I. Berg to Frances Benjamin Johnston, October 11, 1899, Frances Benjamin Johnston Papers, MDLC, Reel 5, Container 7, p. 378.

116. See letter from Frederick K. Lawrence to Frances Benjamin Johnston, January 23, 1900, Frances Benjamin Johnston Papers, MDLC, Reel 5, Container 7, p. 431.

117. Letter from Ellen Henrotin to Frances Benjamin Johnston, April 11, 1900, Frances Benjamin Johnston Papers, MDLC, Reel 5, Container 7, p. 495.

118. Letter from Alfred Stieglitz to Frances Benjamin Johnston, June 8, 1900, Frances Benjamin Johnston Papers, MDLC, Reel 5, Container 7, p. 565.

119. The abundance of women photographers at the turn of the century becomes

even more apparent when Clarence Bloomfield Moore's list of women photographers is added to the list of women photographers included in Johnston's exhibit and subsequent articles for the *Ladies' Home Journal*. Moore included different people, with the exception of Emma Justine Farnsworth. Clarence Bloomfield Moore, "Women Experts in Photography," *Cosmopolitan* 14 (March 1893): 580–90; Amy S. Doherty, "Frances Benjamin Johnston, 1864–1952," *History of Photography* 4, no. 2 (April 1980): 106–7.

120. For uncertain reasons, the collection of photographs by American women that Johnston assembled, the earliest major collection of its kind, would never be exhibited as a set in the United States. However, Johnston personally kept a large number of the photographs that were either exhibited in Paris or were sent by photographers but not selected. According to Quitslund ("Her Feminine Colleagues," p. 98), about thirty-five of the photographs are now in the Smithsonian Institution. Johnston may have given these to Smillie during the time he directed photographic activities there. The rest of the photographs, totaling over ninety-five, along with letters from twenty-six of the photographers participating in the exhibit, were eventually included in Johnston's donation to the Library of Congress in 1947. Paul Vanderbilt mentions that there are approximately seventy-five photoprints representing the 1900 exhibit on the work of women photographers in the Library of Congress. According to Vanderbilt, Johnston originally had two hundred prints representing the work of thirty photographers at the 1900 Exposition in Paris. Paul Vanderbilt, *Guide to the Special Collections of Prints and Photography in the Library of Congress* (Washington, D.C.: U.S. Government Printing Office, 1955), 88. According to Doherty ("Frances Benjamin Johnston"), the discrepancy in the actual number of photographs Johnston collected and displayed at the 1900 Paris Exposition and the location of the photographs comprising the collection today may indicate that the collection was in fact not given serious attention in the early part of the twentieth century. Nonetheless, these photographs remain an important document of early American art photography and of Johnston's role in helping to identify and call attention to a growing number of women photographers. On this issue see also "Photographic Exhibition," *New York Herald*, January 21, 1901, Frances Benjamin Johnston Papers, MDLC, Reel 29, Container 40, p. 297; letter from Jules Boeufve to Frances Benjamin Johnston, December 1, 1904, Frances Benjamin Johnston Papers, MDLC, Reel 7, Container 9, pp. 591–92; *Post Express*, February 21, 1901, Frances Benjamin Johnston Papers, MDLC, Reel 29, Container 40, p. 294; *Washington Post*, February 14, 1905, Frances Benjamin Johnston Papers, MDLC, Reel 29, Container 40, p. 339; letter from Helen Nash, November 21, 1899, Frances Benjamin Johnston Papers, MDLC, Reel 5, Container 6, p. 390; and letter from Robert Redfield to Frances Benjamin Johnston, March 15, 1900, Frances Benjamin Johnston Papers, MDLC, Reel 5, Container 6, pp. 467–69.

121. See "List of Exhibitors and No. of Prints," Diary for 1900 of Mrs. Anderson D. Johnston, Frances's mother, Frances Benjamin Johnston Papers, MDLC, Reel 3, Container 3, pp. 1–2. See also Quitslund, "Her Feminine Colleagues," 97–109, and Doherty, "Frances Benjamin Johnston," 107.

122. See Quitslund, "Her Feminine Colleagues," 97–109.

123. See letters from B. F. Johnson to Frances Benjamin Johnston, January 25, 1900, and February 19, 1900, Frances Benjamin Johnston Papers, MDLC, Reel 5, Container 7, pp. 438, 448. See also Edith C. Westcott. *The New Education Illustrated*, with photographs by Frances Benjamin Johnston, issued semi-monthly (Richmond: B. F. Johnson, 1900–1901). PPDLC, Lot 2749 for photographs of Washington, D.C., School Survey; Lot 2962 for photographs of Tuskegee Normal and Industrial Institute, Alabama; Lot 11051 for photographs of Hampton Normal and Agricultural Institute, Hampton, Virginia.

124. Pete Daniel and Raymond Smock, *Talent for Detail: The Photographs of Miss Frances Benjamin Johnston, 1899–1910* (New York: Harmony Books, 1974), 100–110.

125. John Higham, *Strangers in the Land: Patterns of American Nativism 1860–1925* (New York: Atheneum, 1968), 173.

126. Thomas J. Schlereth, *Victorian America: Transformations in Everyday Life 1876–1915* (New York: HarperCollins, 1991), 243–69.

127. Michael Greenhalgh, *The Classical Tradition in Art* (New York: Harper and Row, 1978), 11–15, 223–33.

128. See Lincoln Kirstein, "Introduction," *The Hampton Album* (New York: Museum of Modern Art, 1966), 5–11.

129. Booker T. Washington, ed., *Tuskegee and Its People: Their Ideals and Achievements* (New York: D. Appleton, 1905), 131.

130. Booker T. Washington, *Up from Slavery* (Boston: Houghton Mifflin, 1901). In fact, Johnston's photographs helped to establish Washington's career. For more information about Washington and his impact on schooling in the South, see Raymond W. Smock, ed., *Booker T. Washington in Perspective: Essays of Louis R. Harlan* (Jackson: University Press of Mississippi, 1988); Theodore R. Mitchell, "Rural and Agricultural Education," in Charles Reagan Wilson and William Ferris, co-eds., *Encyclopedia of Southern Culture* (Chapel Hill: University of North Carolina Press, 1989), 264–65; James D. Anderson in Harvey Kanator and David Tyack, eds., *Work, Youth and Schooling: Historical Perspectives on Vocationalism in American Education* (Stanford: Stanford University Press, 1982); Charles William Dabney, *Universal Education in the South*, 2 vols. (Chapel Hill: University of North Carolina Press, 1936); Paul Gaston, *The New South Creed: A Study in Southern Mythmaking* (New York: Knopf, 1970); Carl F. Kaestle, ed., *Pillars of the Republic: Common Schools and American Society, 1780–1860* (New York: Hill and Wang, 1983); A. C. True, U.S. Department of Agriculture, *Miscellaneous Publications*, no. 15, 1923; C. Vann Woodward, *Origins of the New South, 1877–1913* (Baton Rouge: Louisiana State University Press, 1951).

131. Letter from Thomas J. Calloway to Frances Benjamin Johnston, February 23, 1900, Frances Benjamin Johnston Papers, MDLC, Reel 6, Container 7, p. 450.

132. Letter from Thomas J. Calloway to Frances Benjamin Johnston, May 15, 1900, Frances Benjamin Johnston Papers, MDLC, Reel 6, Container 7, p. 540. Lincoln Kirstein, "A Note on the Photographer," 55.

133. Ibid.

134. Booker T. Washington, *Working with the Hands* (New York: Doubleday, Page, 1904).

135. See Mark N. Aronson, "The Old Versus the New School and the 1901 Salon," in Homer, *Pictorial Photography in Philadelphia*, 21–26.

136. Letter from Eva Watson-Schutze, July 25, 1901, Frances Benjamin Johnston Papers, MDLC, Reel 6, Container 7, pp. 64–65.

137. Gertrude Kasebier, "To Whom It May Concern," *Camera Notes* 3 (January 1900): 121–22.

138. Letter from Hudson Chapman to Frances Benjamin Johnston, October 26, 1901, Frances Benjamin Johnston Papers, MDLC, Reel 6, Container 7, p. 191.

139. Letter from Alfred Stieglitz to Frances Benjamin Johnston, March 18, 1904, Frances Benjamin Johnston Papers, MDLC, Reel 7, Container 9, pp. 453–54.

140. Letter from Frances Benjamin Johnston to Miss Irene Stewart, Reference Librarian, Carnegie Institute Library, Pittsburgh, November 18, 1923, Frances Benjamin Johnston Papers, MDLC, Reel 9, Container 11, p. 211.

141. Capital Camera Club leaflet, 1904, Frances Benjamin Johnston Papers, MDLC, Reel 34, Container 46, pp. 260–61.

142. Ibid.

143. *Washington Post*, January 20, 1904, Frances Benjamin Johnston Papers, MDLC, reel 29, Container 40, p. 337.

144. Letter from Alice Fiske to Frances Benjamin Johnston, April 13, 1903, Frances Benjamin Johnston Papers, MDLC, Reel 7, Container 9, p. 46; Letter from Alice Fiske to Frances Benjamin Johnston, March 17, 1904, Frances Benjamin Johnston Papers, MDLC, Reel 7, Container 9, pp. 440–41; Alexander Alland, *Jessie Tarbox Beals: First Woman News Photographer* (New York: Graphic Press, 1978), 45.

CHAPTER 3. *Landscape and Gardens*

1. Frances Benjamin Johnston, "Garden Photography as a Fine Art: Illustrated by Rare Photographs of Beautiful Gardens," *The Touchstone and the American Art Student Magazine* 2 (December 1917): 278–87; see Frances Benjamin Johnston Collection, PPDLC, Lot 11734 and 11738, for photographs of studio and home in Washington, D.C.

2. Frances Benjamin Johnston Collection, PPDLC, Lot 9805 for photographs of Johnston on board a ship in 1905. Lot 11733 includes photographs of Johnston, Kasebier, Rodin, and Antoine Lumiere, the father of Auguste and Louis, during her 1905 travels in France; other photographs taken between 1890 and 1925 include sites in England, France, Germany, Austria, Belgium, Italy, Switzerland, Netherlands, and places in the Middle East.

3. Frances Benjamin Johnston Collection, PPDLC, Lot 11727 and Lot 12645, for photographs of Washington, D.C., architecture and views, and Maryland architecture and gardens; Frances Benjamin Johnston Collection, PPDLC, Lot 11739 for photographs of Yellowstone National Park, Washington, and California showing images of landscapes and beach scenes; Lot 11742 for photographs of Bermuda; Lot 11746 for photographs of Castle Hill estate near Charlottesville, Virginia; Lot 9809 for photographs of Johnston's 1903 visit to Denver, Colorado including images of a lake; Lot 9803 for photographs of Johnston aboard a ship in 1905; Lot 12372

for photographs of boats on water, lighthouse at St. Clair Lake, and river scenes, all of the Great Lakes Region taken in 1903; Lot 11729 for photographs of estates, gardens, architectural and landscaping elements, Santa Barbara Mission, landscapes with flowers including a field of poppies, all taken in California c. 1903–23; Frances Benjamin Johnston Collection, PPDLC, Lot 3222 and Lot 12371 for Johnston's collection of artistic photographs by other photographers; Frances Benjamin Johnston Collection, PPDLC, Lot 8864, for photographs of watercolors by L. R. Miner.

4. For more on the picturesque, see Uvedale Price, *An Essay on the Picturesque* (Hereford: Printed Privately, 1794), n.p.; Richard Payne Knight, *The Landscape: A Didactic Poem*, 2nd ed. (1795, Farnborough, 1972), 286; Walter John Hipple, *The Beautiful, The Sublime, and The Picturesque in Eighteenth-Century British Aesthetic Theory* (Carbondale: Southern Illinois University Press, 1957); Christopher Hussey, *The Picturesque: Studies in a Point of View* (New York: G. P. Putnam's Sons, 1927); Nikolaus Pevsner, "The Genesis of the Picturesque," *The Architectural Review*, 96 (November 1944): 139–46; and C.L.V. Meeks, "Picturesque Eclecticism," *The Art Bulletin*, 32 (September 1930): 226–35.

5. Letter from U.S. Fish Commission to Frances Benjamin Johnston, April 9, 1891, Frances Benjamin Johnston Papers, MDLC, Reel 3, Container 3, pp. 546–47.

6. See letter from George Eastman to Frances Benjamin Johnston, April 14, 1891, Frances Benjamin Johnston Papers, MDLC, Reel 3, Container 3, pp. 549–50; letter from J. Stanley Brown to Frances Benjamin Johnston, April 27, 1891, Frances Benjamin Johnston Papers, MDLC, Reel 3, Container 3, p. 558; and letter from William E. Curtis, Bureau of American Republics to Frances Benjamin Johnston, September 29, 1891, Frances Benjamin Johnston Papers, MDLC, Reel 3, Container 3, pp. 626, 674.

7. Frederick W. True, William H. Holmes, and George P. Merrill, "Report on the Exhibit of the U.S. National Museum at the Pan-American Exposition, Buffalo, New York," June 30, 1901, 216–18. See also letter from David R. Francis to Frances Benjamin Johnston, August 4, 1905, Frances Benjamin Johnston Papers, MDLC, Reel 8, Container 10, p. 108.

8. Letter from Rachel Lloyd to Frances Benjamin Johnston, April 1892, Frances Benjamin Johnston Papers, MDLC, Reel 3, Container 4, p. 713.

9. See chapter 2, n. 40 above.

10. See letter from Albert S. Bickmore to Frances Benjamin Johnston, May 25, 1893, Frances Benjamin Johnston Papers, MDLC, Reel 4, Container 4, p. 48, and letter from United States Geological Survey Library to Frances Benjamin Johnston, June 1893, Frances Benjamin Johnston Papers, MDLC, Reel 4, Container 4, p. 78.

11. Johnston, "Mammoth Cave by Flashlight," *Demorest's Family Magazine* 28, no. 8 (June 1892): 7.

12. See letter from H. Melultheren, U.S. Engineer Office to Frances Benjamin Johnston, December 2, 1903, Frances Benjamin Johnston Papers, MDLC, Reel 7, Container 9, pp. 257–58.

13. See letter of introduction from T. Guilford Smith, Manager of Sales, Carnegie Steel Company Sales Office, July 6, 1903, Frances Benjamin Johnston Papers,

MDLC, Reel 6, Container 9, pp. 177–78; for photographs of the Great Lakes region see Frances Benjamin Johnston Collection, PPDLC, Lot 12372.

14. Frances Benjamin Johnston, "Through the Coal Country with a Camera," *Demorest's Family Magazine* 28, no. 5 (March 1892): 260.

15. Beaumont Newhall, "Documentary Approach to Photography," *Parnassus* 10 (March 1938): 3–6; on Hine's work see Alan Trachtenberg, *Reading American Photographs: Images as History Mathew Brady to Walker Evans* (New York: Noonday Press, 1990), 164–230.

16. For photographs of Great Lakes region see Frances Benjamin Johnston Collection, PPDLC, Lot 12372.

17. Miss Impertinence, "They Photograph the Smart Set," *Vanity Fair* (n.d.): 18–19, quoted in Doherty, "Frances Benjamin Johnston," 108.

18. See "Matters of Interest to Women," *New York Times*, April 20, 1913, Frances Benjamin Johnston Papers, MDLC, Reel 29. Container 40, p. 357.

19. Edward L. Wilson, *Wilson's Photographic Magazine* 37 (April 1900): 152.

20. Publicity Flyer, Frances Benjamin Johnston Papers, MDLC, Reel 9, Container 11, p. 45.

21. Letter from Frances Benjamin Johnston to Mr. Barron, October 14, 1923, Frances Benjamin Johnston Papers, MDLC, Reel 9, Container 11, p. 203; a list of books Johnston used from the Rochester Public Librarian to Frances Benjamin Johnston, April 21, 1920, Frances Benjamin Johnston Papers, MDLC, Reel 9, Container 11, p. 37; a list of eighty-four books, published between 1874 and 1917, was presented to the Cleveland Museum of Art by Johnston, May 6, 1920: Frances Benjamin Johnston Papers, MDLC, Reel 9, Container 11, p. 39. See also Frances Benjamin Johnston, "Garden Photography as a Fine Art: Illustrated by Rare Photographs of Beautiful Gardens," *The Touchstone and the American Art Student Magazine* 2 (December 1917): 278–87; Frances Benjamin Johnston Papers, MDLC, Reel 35, Container 48, p. 178.

22. See Norman T. Newton, *Design on the Land: The Development of Landscape Architecture* (Cambridge: Harvard University Press, 1971), 372–84, and A. E. Hanson, *An Arcadian Landscape: The California Gardens of A. E. Hanson* (Los Angeles: Hennessey and Ingalls, 1985), 7–8.

23. Circular, December 9, 1920, Frances Benjamin Johnston Papers, MDLC, Reel 8, Container 11, p. 68.

24. Circular, March 22, 1922, Frances Benjamin Johnston Papers, MDLC, Reel 8, Container 11, p. 134.

25. Library of Congress Press Release #448.

26. Letter from Frances Benjamin Johnston to Helen Fogg, January 12, 1927, Frances Benjamin Johnston Papers, MDLC, Reel 10, Container 12, p. 17.

27. The book was preceded by an article in two installments: Edith Wharton, "Italian Villas and Their Gardens," *Century Magazine* 67 (November–December 1902): 21–33, 162–64, and *Century Magazine* 68 (October 1904): 884–902. See R. W. B. Lewis, *Edith Wharton: A Biography* (New York: Harper and Row, 1975), 116, 120–21.

28. Frances Benjamin Johnston lecture, "In Yesterday's Garden," c. 1925, Frances Benjamin Johnston Papers, MDLC, Reel 21, Container 27, p. 38. See also Edith Wharton, *The Italian Villas and Their Gardens* (New York: Century, 1904).

29. Johnston was acquainted with the members of this commission and with the most well-known landscape architects of Washington, D.C. She corresponded with them and took photographs of their buildings, landscapes, and sculptures. For photographs of Augustus Saint-Gaudens's Adams Memorial taken in October 1908, see Frances Benjamin Johnston Collection, PPDLC, Lot 11727. See also letter from the Office of Daniel Burnham, chief of construction for the World Columbian Exposition, to Frances Benjamin Johnston, March 11, 1892, Frances Benjamin Johnston Papers, MDLC, Reel 3, Container 4, pp. 699–700; letter from Frances Benjamin Johnston to Frederick Law Olmstead, Jr., August 7, 1926, Frances Benjamin Johnston Papers, MDLC, Reel 9, Container 12, p. 599; and letter from Frederick Law Olmstead, Jr., to Frances Benjamin Johnston, August 12, 1926, Frances Benjamin Johnston Papers, MDLC, Reel 9, Container 12, pp. 602–3.

30. See letter from Fletcher Steele to Frances Benjamin Johnston, August 30, 1926, Frances Benjamin Johnston Papers, MDLC, Reel 9, Container 12, p. 616; letters from Nellie Allen to Frances Benjamin Johnston, November 8, 1926, and November 16, 1926, Frances Benjamin Johnston Papers, MDLC, Reel 9, Container 12, pp. 635, 643; letter from Rose Greely to Frances Benjamin Johnston, March 14, 1928, Frances Benjamin Johnston Papers, MDLC, Reel 10, Container 12, p. 279; and letters from McKim, Mead, and White to Frances Benjamin Johnston, April 1, 1903, April 14, 1903, May 16, 1903, May 26, 1903, June 15, 1903, MDLC, Reel 7, Container 9, pp. 33, 51, 86, 95, 113.

31. Frances Benjamin Johnston lecture, "In Yesterday's Garden," c. 1925, Frances Benjamin Johnston Papers, MDLC, Reel 21, Container 27, p. 47.

32. Robert B. Cridland, *Practical Landscape Gardening* (New York: A.T. De La Mare, 1918), 9–10.

33. Louise Shelton, *Beautiful Gardens in America* (New York: Charles Scribner's Sons, 1924), 1–6.

34. See *The Illustrated Buffalo Express*, May 16, 1920, Frances Benjamin Johnston Papers, MDLC, Reel 29, Container 40, p. 402.

35. See Frances Benjamin Johnston garden lecture notes, Frances Benjamin Johnston Papers, MDLC, Reel 32, Container 43, p. 279.

36. Shelton, *Beautiful Gardens in America,* xvii–xviii, 1–11.

37. Ibid.

38. Mrs. Madison G. Nicholson, compiler, *Ladies' Garden Club* booklet (Athens: University of Georgia Printing Department, 1962), 4; originally from an *Atlanta Journal* article, June 2, 1938.

39. Ibid., 4–17.

40. *Athens* [Georgia] *Banner*, 22 (December 1891): no page number.

41. Frances Benjamin Johnston, "Garden Photography as a Fine Art: Illustrated by Rare Photographs of Beautiful Gardens," *The Touchstone and the American Art Student Magazine* 2 (December 1917): 278–87; in Frances Benjamin Johnston Papers, MDLC, Reel 35, Container 48, p. 178.

42. *New York Herald*, November 14, 1920, Frances Benjamin Johnston Papers, MDLC, Reel 29, Container 40, p. 409. *New York Times*, January 19, 1921, Frances Benjamin Johnston Papers, MDLC, Reel 29, Container 40, p. 412.

43. *Robinson Daily News*, April 4, 1922, Frances Benjamin Johnston Papers, MDLC, Reel 29, Container 40, p. 424. Norman T. Newton, *Design on the Land: The Development of Landscape Architecture* (Cambridge: Harvard University Press, 1971), 413–26.

44. Shelton, *Beautiful Gardens in America*, 7–9, 47–48, 199. The most photographed state in Shelton's book, consisting of 46 of a total of 195 images, was Massachusetts—referred to as the home of the Pilgrims, and the most fertile state with the greatest variety of gardens. Of the seventeen New York photographs (one belonging to the author), Long Island is listed separately as the most favored and most developed garden center of New York State, featuring Southampton, noted for its greater number of gardens than any other town in the state.

45. Ibid., 10. Briefly represented southern states include South Carolina (six photographs), Georgia (three), Florida (three), and Tennessee (one). Midwestern states include Missouri (one), Illinois (nine), Ohio (six), Michigan (eight), and Wisconsin (one).

46. See Norman T. Newton, *Design on the Land: The Development of Landscape Architecture* (Cambridge: Harvard University Press, 1971), 372–84; and Hanson, *An Arcadian Landscape*, 7–8.

47. See Asher Brown Durand, "Letters on Landscape Painting," *The Crayon*, 1–8 (January–November, 1855).

48. The establishment of the National Park Service in the 1870s to preserve the American wilderness represented the American government's and the American public's desire to protect and visit unblemished wilderness. This romanticism had been channeled by landscape activists, such as geologist Ferdinand V. Hayden, into the practical mobilization of public moral commitment. Art historian Joshua C. Taylor called the Yellowstone Act of 1872 and the subsequent growth of the National Park Service "the government's first major alliance with art." Joshua Taylor, *America as Art* (Washington, D.C.: Smithsonian Institution Press, 1976), 130. See also Barbara Novak, *Nature and Culture: American Landscape Painting, 1825–1875* (Oxford: Oxford University Press, 1980), 95. For a discussion of the formation of the National Park Service, see Horace M. Albright, *Origins of the National Park Service* (Philadelphia: Eastern National Park and Monument Association, 1971); Hiram Martin Chittenden, *The Yellowstone National Park* (Cincinnati: University of Oklahoma Press, 1917); William Henry Jackson, *Time Exposure* (New York: Cooper Square, 1970); and Weston J. Naef and James N. Wood, *Era of Exploration: The Rise of Landscape Photography in the American West, 1860–1885* (Boston: New York Graphic Society, 1975).

49. Anne Morand, "Introduction," *The Art of Yellowstone 1870–1872* (Tulsa: Thomas Gilcrease Museum Association, 1983), 4–15.

50. Taylor, *America as Art*, 108–116.

51. See Elizabeth Lindquist Cook, *The Influence of Photography on American Landscape Painting, 1839–1880* (New York: Garland, 1977), 159–178.

52. Shelton, *Beautiful Gardens in America*, plate 4.

53. Ibid., plate 88.

54. Ibid., plate 162.

55. Hildegarde Hawthorne, "Color in California: Photographs of Frances Benjamin Johnston," *The Touchstone and American Art Student Magazine* 8 (January 1921): 276–79.

56. Davyd Foard Hood, "Georgian Revival Architecture," in Charles Reagan Wilson and William Ferris, eds., *Encyclopedia of Southern Culture* (Chapel Hill: University of North Carolina Press, 1989), 69–71.

57. Winifred Starr Dobyns, *California Gardens* (New York: MacMillan, 1931), 15.

58. Shelton, *Beautiful Gardens in America*, plate 252.

59. Dobyns, *California Gardens*, plate 23.

60. Shelton, *Beautiful Gardens in America*, plate 241.

61. Dobyns, *California Gardens*, plate 8.

62. Shelton, *Beautiful Gardens in America*, plate 242.

63. Dobyns, *California Gardens*, plates 16, 17.

64. Shelton, *Beautiful Gardens in America*, plate 243.

65. See David C. Streatfield, *California Gardens: Creating a New Eden* (New York: Abbeville Press, 1994), 109–13. See also Helen S. Thorne, "When an Easterner Gardens in the Golden West," *Garden Magazine* 21 (April 1921): 178–80, and Elizabeth deForest, "Old Santa Barbara Gardens and How They Came to Be," *Pacific Horticulture* 38 (Winter 1977–78): 34.

66. For Atget's work, see Molly Nesbit, *Atget's Seven Albums* (New Haven: Yale University Press, 1992).

67. Thomas T. Waterman, *The Early Architecture of North Carolina* (Chapel Hill: University of North Carolina Press, 1941) 155.

68. Ibid., 254.

69. Ibid., 266.

70. Ibid., 2.

71. Samuel Gaillard Stoney, illustrations by Frances Benjamin Johnston, *Plantations of the Carolina Low Country* (Charleston: Carolina Art Association, 1938), 193.

72. Stoney, *Plantations of the Carolina Low Country.*

73. Ibid., 91, 107, 233.

CHAPTER 4. *Historic Architecture*

1. Harnett T. Kane, "New Orleans Architecture Is Being Saved in Pictures," *Sunday Item-Tribune, New Orleans*, May 22, 1938, Frances Benjamin Johnston Papers, MDLC, Reel 29, Container 40, p. 585.

2. Ethel Fay and Thomas P. Robinson, *Houses in America*, quoted in lecture transcript, March 21, 1937, Frances Benjamin Johnston Papers, MDLC, Reel 31, Container 43, p. 302.

3. Louisa Tuthill, "History of Architecture from the Earliest Times" (Philadelphia, 1848), cited in Fiske Kimball, *Domestic Architecture of the American Colonies and of*

the American Republic (New York: Dover, 1922; reprint, 1966), xvii. See also Leland Roth, ed., *America Builds: Source Documents in American Architecture and Planning* (New York: Harper and Row, 1983), 22–23; Arthur Drexler, ed. *The Architecture of the Ecoles des Beaux-Arts* (New York: Museum of Modern Art, 1977); and Henry Hope Reed, *Beaux-Arts Architecture in New York: A Photographic Guide* (New York: Dover, 1988).

4. See letter from Charles F. McKim to Frances Benjamin Johnston, May 16, 1903, Frances Benjamin Johnston Papers, MDLC, Reel 7, Container 9, p. 86; letter from McKim, Mead and White to Frances Benjamin Johnston, April 1, 1903, Frances Benjamin Johnston Papers, MDLC, Reel 7, Container 9, p. 33; letter from McKim, Mead and White to Frances Benjamin Johnston, April 14, 1903, Frances Benjamin Johnston Papers, MDLC, Reel 7, Container 9, p. 51; letter from McKim, Mead and White, May 16, 1903, Frances Benjamin Johnston Papers, MDLC, Reel 7, Container 9, p. 86; letter from McKim, Mead and White to Frances Benjamin Johnston, May 26, 1903, Frances Benjamin Johnston Papers, MDLC, Reel 7, Container 9, p. 95; letter from McKim, Mead and White to Frances Benjamin Johnston, June 15, 1903, Frances Benjamin Johnston Papers, MDLC, Reel 7, Container 9, p. 113; and letter from McKim, Mead and White to Frances Benjamin Johnston, April 1, 1904, Reel 7, Container 9, p. 455. Johnston's photographs, in turn, were used as basic documentation for these institutional restorations. In 1929 Johnston gave Herbert Putnam, the Librarian of Congress, two copies of Glenn Brown's book *A Brief Description and History of the Octagon House*. See certificate from Putnam to Frances Benjamin Johnston, January 7, 1930, Frances Benjamin Johnston Papers, MDLC, Reel 11, Container 14, p. 148.

5. See Richard Upjohn, "The Colonial Architecture of New York and the New England States," *Archaeological Review and American Builders' Journal* (March 1870): 548; Vincent J. Scully, Jr., *The Shingle Style and the Stick Style: Architectural Theory and Design from Downing to the Origins of Wright* (New Haven: Yale University Press, 1955), 22–33; Leland Roth, ed., *America Builds: Source Documents in American Architecture and Planning* (New York: Harper and Row, 1983), 234 and plate 45; Walter K. Sturges, "Arthur Little and the Colonial Revival," *Journal of the Society of Architectural Historians* (May 1973): 147–63; William B. Rhoads, *The Colonial Revival*, vol. 1 (New York: Garland, 1977), 77–80.

6. Doherty, "Frances Benjamin Johnston," 108.

7. See Hunter, Frances Benjamin Johnston Papers, MDLC, Reel 24, Container 31, pp. 40–41. See also Frank Wallis, "The Colonial Renaissance," *White Pine Series* (February 1916), 3, and Charles Moore, *The Life and Times of Charles Follen McKim*, (Boston: Houghton Mifflin, 1929).

8. Letter from Mattie Edwards Hewitt to Frances Benjamin Johnston, November 21, 1901, Frances Benjamin Johnston Papers, MDLC, Reel 6, Container 8, pp. 236–38.

9. Letter from Miss T. W. Blake to Frances Benjamin Johnston, October 31, 1901, Frances Benjamin Johnston Papers, MDLC, Reel 6, Container 8, p. 199. Letter from Mary Paschall to Frances Benjamin Johnston, c. 1900, Frances Benjamin Johnston Papers, MDLC, Reel 20, Container 29, p. 645.

10. Frances Benjamin Johnston, interview with Mary Mason, WRC National Broadcasting Co., 2:30 p.m., February 12, 1936; Frances Benjamin Johnston Papers, MDLC, Reel 21, Container 27, p. 229.

11. See letter from Frances Benjamin Johnston to Helen Devore, June 25, 1928, Frances Benjamin Johnston Papers, MDLC, Reel 10, Container 13, p. 373; letter from Frances Benjamin Johnston to Mr. Goolrick of Fredericksburg, April 21, 1929, Frances Benjamin Johnston Papers, MDLC, Reel 11, Container 13, p. 10 (this letter concerns an article that Goolrick was to write to accompany Johnston's photographs in the aforementioned newspapers); and letter from Women's National Press Club to Frances Benjamin Johnston, Frances Benjamin Johnston Papers, MDLC, Reel 11, Container 13, p. 29.

12. Letter from Frances Benjamin Johnston to Helen Devore, August 15, 1929, Frances Benjamin Johnston Papers, MDLC, Reel 11, Container 13, p. 71.

13. Letter from Leicester Bovine Holland to Frances Benjamin Johnston, November 1, 1929, Frances Benjamin Johnston Papers, MDLC, Reel 11, Container 13, p. 110.

14. See C. Ford Peatross, "A Rich Vein in the Mother Lode: HABS in the Library of Congress," in C. Ford Peatross, ed., *Historic America: Buildings, Structures, and Sites* (Washington, D.C.: Library of Congress, 1983), 241. See also Library of Congress Finding Aid, "Papers of Frances Benjamin Johnston," October 1983, Ref: C-378.

15. Letter from Frances Benjamin Johnston, Publicity Committee from Colonial Inn, Middleburg, Virginia, Frances Benjamin Johnston Papers, MDLC, Reel 11, Container 13, p. 119.

16. Letter from Fiske Kimball to Leicester B. Holland, November 22, 1932, Frances Benjamin Johnston Papers, MDLC, Reel 11, Container 14, p. 366.

17. See letter from Frederick Keppel to Frances Benjamin Johnston, December 10, 1932, Frances Benjamin Johnston Papers, MDLC, Reel 11, Container 14, p. 369.

18. Henry Irving Brock, *Colonial Churches in Virginia,* (Richmond: Dale Press, 1930).

19. Ibid., 14.

20. See Aline B. Saarinen, *The Proud Possessors: The Lives, Times and Tastes of Some Adventurous American Art Collectors* (New York: Vintage Books, 1968), 287–306.

21. Quoted from James Marston Fitch, *Historic Preservation: Curatorial Management of the Built World* (New York: McGraw-Hill, 1982), 221–24. See also Charles B. Hosmer, Jr., *Preservation Comes of Age: From Williamsburg to the National Trust, 1926–1949* (Charlottesville: University Press of Virginia, 1981), 1:11.

22. W. A. R. Goodwin, *Bruton Parish Church and Its Historic Environment* (Petersburg, Virginia, 1907), quoted in Charles B. Hosmer, Jr., *Preservation Comes of Age: From Williamsburg to the National Trust, 1926–1949* (Charlottesville: University Press of Virginia, 1981), 1:12.

23. Letter from William G. Perry to Frances Benjamin Johnston, October 11, 1928, Frances Benjamin Johnston Papers, MDLC, Reel 10, Container 13, p. 450.

24. Letter from Arthur A. Shurcliffe to Frances Benjamin Johnston, July 22, 1930,

and July 29, 1930, Frances Benjamin Johnston Papers, MDLC, Reel 11, Container 14, pp. 185 and 187. See diary entries of November 1933, Frances Benjamin Johnston Papers, MDLC, Reel 2, Container 2, pp. 168–71. See also Arthur A. Shurcliffe, "City Plan and Landscaping Problems of the Restoration of Colonial Williamsburg," *Architectural Record* 78 (December 1935): 382–86.

25. Brock, *Colonial Churches in Virginia*, 11.

26. On these efforts see the works of Fitch and Hosmer cited in n. 21 above.

27. Letter from Milton L. Grigg to Frances Benjamin Johnston, March 17, 1931, Frances Benjamin Johnston Papers, MDLC, Reel 11, Container 14, p. 241.

28. See letter from Frances Benjamin Johnston to Leicester B. Holland, May 20, 1930, Frances Benjamin Johnston Papers, MDLC, Reel 11, Container 14, p. 175, and letter from Frances Benjamin Johnston to Edmund S. Campbell, June 5, 1932, Frances Benjamin Johnston Papers, MDLC, Reel 11, Container 14, p. 307.

29. Letter from Frederick Paul Keppel to Frances Benjamin Johnston, Frances Benjamin Johnston Papers, MDLC, Reel 11, Container 14, p. 315. See also letter from Carnegie's personal secretary to Frances Benjamin Johnston, April 14, 1905, Frances Benjamin Johnston Papers, MDLC, Reel 8, Container 10, p. 7.

30. Letter from Frederick Keppel to Frances Benjamin Johnston, January 26, 1933, Frances Benjamin Johnston Papers, MDLC, Reel 11, Container 14, pp. 383–85. Letter from Edmund S. Campbell to Frederick P. Keppel, October 14, 1932, Frances Benjamin Johnston Papers, MDLC, Reel 11, Container 13, p. 351. Letter from Edmund S. Campbell to Frances Benjamin Johnston, October 26, 1932, Frances Benjamin Johnston Papers, MDLC, Reel 11, Container 13, p. 354.

31. See letter from Frances Benjamin Johnston to Herbert Putnam, January 1, 1930, Frances Benjamin Johnston Papers, MDLC, Reel 11, Container 14, p. 145; Paul Vanderbilt, "Frances Benjamin Johnston, 1864–1952," *Journal of the American Institute of Architects* (November 1952): 226; letter from Paul Vanderbilt to Frances Benjamin Johnston, October 28, 1948, Frances Benjamin Johnston Papers, MDLC, Reel 16, Container 21, pp. 287–88; and letter from Frances Benjamin Johnston to Edmund S. Campbell, June 5, 1932, Frances Benjamin Johnston Papers, MDLC, Reel 11, Container 14, p. 307.

32. Letter from Frances Benjamin Johnston to Leicester Bovine Holland, June 28, 1930, Frances Benjamin Johnston Papers, MDLC, Reel 11, Container 14, p. 183; see letter from Frances Benjamin Johnston to Leicester B. Holland, March 1935, Frances Benjamin Johnston Papers, MDLC, Reel 12, Container 15, p. 31. The Carnegie Corporation was responsible for numerous grants given to Johnston's colleagues. For example, Holland's position as chair of the Fine Arts Division at the Library of Congress was established in 1929 by a gift of the Carnegie Corporation of New York. For more about the Carnegie Corporation, see Robert M. Lester, *Forty Years of Carnegie Giving: A Summary of the Benefactions of Andrew Carnegie and of the Work of the Philanthropic Trusts Which He Created* (New York: Charles Scribner's Sons, 1941).

33. See letter from Robert M. Lester, secretary of Carnegie Corporation, to Frances Benjamin Johnston, November 6, 1934, Frances Benjamin Johnston Papers,

MDLC, Reel 12, Container 15, p. 3; letter from Frances Benjamin Johnston to Robert M. Lester, December 16, 1934, Frances Benjamin Johnston Papers, MDLC, Reel 12, Container 15, p. 5.

34. Draft Manuscript of Leicester Holland, n.d., Frances Benjamin Johnston Papers, MDLC, Reel 37, Container 50, p. 43.

35. See Rodger P. Kingston, "Afterword: Max Belcher and the History of Architectural Documentary Photography," in Svend E. Holsoe and Bernard L. Herman, *A Land and Life Remembered: Americo-Liberian Folk Architecture* (Athens: University of Georgia Press, 1988), 152.

36. On the 1851 French Historical Monuments Commission project and its photographers see Cervin Robinson, *Architecture Transformed: A History of the Photography of Buildings from 1839 to the Present* (New York: Architectural League of New York, 1987), 20–24, and Naomi Rosenblum, *A World History of Photography* (New York: Abbeville Press, 1981), 100.

37. Zelda Branch, "Preserving a Nation's Architecture," *Christian Science Monitor* (11 November 1936): 12–13.

38. Quoted in Branch, "Preserving a Nation's Architecture," 13.

39. See, e.g., H. Haller, "A Magic Shadow Box in Maryland," *Baltimore Sun* (8 August 1937): 6–7.

40. Letter from Bessie Davis of the Metropolitan Museum to Frances Benjamin Johnston, March 9, 1928, Frances Benjamin Johnston Papers, MDLC, Reel 10, Container 13, p. 276. Letter from Alice Felton, Photograph Division of the Metropolitan Museum to Frances Benjamin Johnston, April 21, 1936, Frances Benjamin Johnston Papers, MDLC, Reel 12, Container 16, p. 351.

41. Letter from Frances Benjamin Johnston to John Lloyd, President of the University of Virginia, December 2, 1933, Frances Benjamin Johnston Papers, MDLC, Reel 11, Container 14, p. 502.

42. Letter from Frances Benjamin Johnston to A. Lawrence Kocher, January 9, 1931, Frances Benjamin Johnston Papers, MDLC, Reel 11, Container 14, pp. 232–33.

43. Letter from Mr. Kohn, American Institute of Architects, Washington, D.C., to Frances Benjamin Johnston, February 12, 1931, Frances Benjamin Johnston Papers, MDLC, Reel 11, Container 14, p. 239.

44. Letter from Frances Benjamin Johnston to Frederick Keppel, Frances Benjamin Johnston Papers, MDLC, Reel 13, Container 16, p. 59.

45. Letter from Robert N. S. Whitelaw to Thomas A. Stone, March 20, 1939, in Hosmer, *Preservation Comes of Age*, 1:254.

46. Letter from Waldo Leland to Frances Benjamin Johnston, March 13, 1936, Frances Benjamin Johnston Papers, MDLC, Reel 12, Container 15, p. 311.

47. Letter from Albert Simons to Mrs. Emerson, January 20, 1938, Hosmer, in *Preservation Comes of Age*, 1:255.

48. See letter from Frances Benjamin Johnston to Lawrence Coleman, American Association of Museums, April 21, 1937, Frances Benjamin Johnston Papers, MDLC, Reel 13, Container 16, p. 26.

49. "Archives of Colonial Architecture, Library of Congress," *American Magazine of Art* 24 (June 1932): 441–48.

50. Letter from Frances Benjamin Johnston to Robert Whitelaw, December 14, 1937, Frances Benjamin Johnston Papers, MDLC, Reel 13, Container 17, p. 221.

51. Letter from Frances Benjamin Johnston to Elizabeth Lawton, March 21, 1930, Frances Benjamin Johnston Papers, MDLC, Reel 11, Container 14, p. 163. See also letter from Frances Benjamin Johnston to Zelda Branch, June 25, 1947, Frances Benjamin Johnston Papers, MDLC, Reel 16, Container 20, p. 155.

52. See letter from H. M. Miller to Philip Stern, HABS Officer in Fredericksburg, Virginia, November 2, 1934, Frances Benjamin Johnston Papers, MDLC, Reel 11, Container 15, p. 551; letter from Professor Newsome to Frances Benjamin Johnston, April 18, 1936, Frances Benjamin Johnston Papers, MDLC, Reel 12, Container 16, p. 345; letter from Thomas Waterman to Frances Benjamin Johnston, October 21, 1936, Frances Benjamin Johnston Papers, MDLC, Reel 12, Container 16, p. 501; and C. Ford Peatross, "A Rich Vein in the Mother Lode: HABS in the Library of Congress," in C. Ford Peatross, ed., *Historic America Buildings, Structures, and Sites* (Washington, D.C.: Library of Congress, 1983), 249.

53. See letter from Frances Benjamin Johnston to Verne Chatelain, April 18, 1937, Frances Benjamin Johnston Papers, MDLC, Reel 13, Container 16, p. 20; letter from Frances Benjamin Johnston (addressee not indicated), September 15, 1937, Frances Benjamin Johnston Papers, MDLC, Reel 13, Container 17, p. 118; letter from Morley Williams to Frances Benjamin Johnston, November 17, 1937, Frances Benjamin Johnston Papers, MDLC, Reel 13, Container 17, p. 189.

54. Letter from Frances Benjamin Johnston to Mr. Dombrower, June 25, 1935, Frances Benjamin Johnston Papers, MDLC, Reel 11, Container 15, p. 105.

55. See letter from Frances Benjamin Johnston to Frederick Keppel, December 31, 1935, Frances Benjamin Johnston Papers, MDLC, Reel 12, Container 15, p. 227; letter from Waldo Leland to Frances Benjamin Johnston, March 13, 1936, Frances Benjamin Johnston Papers, MDLC, Reel 12, Container 15, p. 311; letter from Frances Benjamin Johnston to Waldo Leland, May 2, 1936, Frances Benjamin Johnston Papers, MDLC, Reel 12, Container 16, p. 368; letter from Frances Benjamin Johnston to Verne Chatelaine, November 25, 1936, Frances Benjamin Johnston Papers, MDLC, Reel 12, Container 16, p. 535; and W. Brown Morton III, "What Do We Preserve and Why?" in Robert E. Stipe and Antoinette J. Lee, eds., *The American Mosaic: Preserving a Nation's Heritage* (Washington, D.C.: United States Committee International Council on Monuments and Sites, 1987), 150–55.

56. See Samuel Wilson, Jr., "The Survey in Louisiana," in C. Ford Peatross, ed., *Historic America Buildings, Structures and Sites* (Washington, D.C.: Library of Congress, 1983), 26. See also letter from Frances Benjamin Johnston to Mr. Alden, January 24, 1938, Frances Benjamin Johnston Papers, MDLC, Reel 13, Container 16, p. 245.

57. See n. 44 above.

58. See Nathan Weinberg, *Preservation in American Towns and Cities* (Boulder: Westview Press, 1979). See also letter from M. H. Westberry, president, St. Augustine Chamber of Commerce, to Dr. John C. Merriam, president, Carnegie Corporation of Washington, January 15, 1937, Frances Benjamin Johnston Papers, MDLC, Reel 12, Container 16, p. 605.

59. Letter from John Merriam to M. H. Westberry, president of the St. Augustine Chamber of Commerce, January 19, 1937, Frances Benjamin Johnston Papers, MDLC, Reel 12, Container 16, p. 611.

60. Letter from Verne Chatelain to Frances Benjamin Johnston, September 24, 1937, Frances Benjamin Johnston Papers, MDLC, Reel 11, Container 15, p. 128.

61. Letter from Frances Benjamin Johnston to Lawrence Vail Coleman, April 21, 1937, Frances Benjamin Johnston Papers, MDLC, Reel 13, Container 16, p. 26.

62. Letter from James J. A. Fortier to Frances Benjamin Johnston, October 12, 1937, Frances Benjamin Johnston Papers, MDLC, Reel 13, Container 17, p. 147.

63. Harnett T. Kane, *New Orleans Item*, November 19, 1937, and August 4, 1939, quoted in Hosmer, *Preservation Comes of Age*, 1:303.

64. Letter from Richard Koch to Frances Benjamin Johnston, December 28, 1940, Frances Benjamin Johnston Papers, MDLC, Reel 14, Container 19, p. 568.

65. A building-by-building inventory of the type Johnston had advocated in the 1930s would not be completed until the early 1970s. See Olmstead report, February 1940, City Plan for Charleston, 1939–42, in Hosmer, *Preservation Comes of Age*, 1:260.

66. Clarence John Laughlin, *Ghosts along the Mississippi* (New York: American Legacy Press, 1961), 84–92. Mills Lane, *Architecture of the Old South: Louisiana* (Savannah: Beehive Press, 1980), 52.

67. Letter from Frances Benjamin Johnston to J. Frazer Smith, April 10, 1938, Frances Benjamin Johnston Papers, MDLC, Reel 13, Container 17, p. 300; Frances Benjamin Johnston to Leland on April 6, 1938, Reel 13, Container 16, pp. 288, 358. See also letter from Frances Benjamin Johnston to Edward Jones, September 4, 1944, MDLC, Reel 15, Container 20, p. 530.

68. For information on the building here described, see Laughlin, *Ghosts along the Mississippi*. There is an additional HABS photo of the house by Beal Chambers, taken in 1938.

69. Professor Robert Nix, University of Georgia, personal communication, August 4, 1995.

70. For more about Johnston's schedule of lectures, see letter from Frances Benjamin Johnston to Colonial Dames, December 30, 1938, Frances Benjamin Johnston Papers, MDLC, Reel 14, Container 18, p. 308. See also letter from Frances Benjamin Johnston to Dover, Delaware Garden Club, January 10, 1939, Frances Benjamin Johnston Papers, MDLC, Reel 14, Container 18, p. 518.

71. Letter from Frances Benjamin Johnston to Mr. and Mrs. Cannon, February 6, 1939, Reel 13, Container 18, p. 538.

72. Letter from W. T. Couch to Frances Benjamin Johnston, January 9, 1939, Frances Benjamin Johnston Papers, MDLC, Reel 13, Container 18, p. 517.

73. See letter from Waldo Leland to Frances Benjamin Johnston, January 24, 1939, Frances Benjamin Johnston Papers, MDLC, Reel 13, Container 18, p. 330. See also Manuscript of *Early Architecture of North Carolina*, Frances Benjamin Johnston Papers, MDLC, Reel 21, Container 27, pp. 232–401. For reviews, see *Apollo* 48 (August 1948): 43–5, *Architectural Forum* 76 (February 1942): 28, *London Studio* 26 [*Studio* 126] (August 1943): 64, and *Magazine of Art* 35 (April 1942): 144–45.

74. Letter from Frances Benjamin Johnston to the Daughters of the American Revolution Regents of Lexington, Kentucky Chapter, August 1, 1942, Frances Benjamin Johnston Papers, MDLC, Reel 15, Container 19, p. 290.

75. Catherine Bishir, *North Carolina Architecture* (Chapel Hill, North Carolina: University of North Carolina Press, 1990), 245–48.

76. William H. Ranlett, *The Architect* (New York: 1847), Design X, Plate 32, Volume 1. Reprinted in Catherine W. Bishir, Charlotte V. Brown, Carl R. Lounsbury, and Ernest H. Wood III, *Architects and Builders in North Carolina* (Chapel Hill: University of North Carolina Press, 1990), 142.

77. Ibid.

78. See Mills Lane, *Architecture of the Old South: North Carolina* (New York: Beehive Press, 1985), 214–219.

79. Ibid., 191–93.

80. Talbot Hamlin, *Greek Revival Architecture in America* (New York: Dover, 1944), 211–12.

81. See, for example, the photo by Tim Buchman in Bishir, *North Carolina Architecture*, 192 (Fig. 27), for an example of a perspective view of Playmakers' Theatre. While the other buildings are subordinate to the theatre, its individual personality or character is somewhat diminished compared to Johnston's architectural portrait.

82. The design used by the local builder of the church was based on Plates XI and XII in Bishop John Henry Hopkins, *Essay on Gothic Architecture* (Burlington, VT: Smith and Harrington, 1836). See Waterman, *The Early Architecture of North Carolina*, 247. See also Archibald Henderson, *The Church of Atonement and the Chapel of the Cross* (Publication 59, Church Missions Publishing Co., 1938), 36–43.

83. Walter (1804–1887) had been an apprentice to a master bricklayer, the craft of his father, before working in the 1820s for William Strickland. Strickland, a student of Philadelphia architect Benjamin H. Latrobe, was known for his work on government buildings—most notably the mint buildings in Philadelphia, Pennsylvania, New Orleans, Louisiana, and Charlotte, North Carolina. Walter became famous as the architect of classical structures in Washington, D.C., that he designed while serving as government architect from 1861 to 1876, including the large cast-iron dome of the United States Capitol. See Lane, *Architecture of the Old South, North Carolina*, 198–99.

84. Ibid.

85. See Bishir, *North Carolina Architecture*, 235.

86. Waterman, *The Early Architecture of North Carolina*, 247.

87. Ibid., 266.

88. See Newhall, *The History of Photography*.

89. Letter from Margaret Mitchell to Mr. G. B. Lorraine, March 18, 1937, Frances Benjamin Johnston Papers, MDLC, Reel 13, Container 16, p. 43.

90. Letter from Frances Benjamin Johnston to Edward Vason Jones, September, 6, 1944, Frances Benjamin Johnston Papers, MDLC, Reel 15, Container 20, p. 530.

91. Memo from Frances Benjamin Johnston to Edward Vason Jones, November 12, 1944, Frances Benjamin Johnston Papers, MDLC, Reel 15, Container 20, p. 605.

92. Letter from Frances Benjamin Johnston to Edward Vason Jones, June 19, 1946, Frances Benjamin Johnston Papers, MDLC, Reel 16, Container 21, p. 172.

93. Letter from Hubert B. Owens to Frances Benjamin Johnston, June 30, 1949, Frances Benjamin Johnston Papers, MDLC, Reel 16, Container 21, p. 385.

94. Letter from Paul W. Chapman to Lambert Davis, July 29, 1949, Frances Benjamin Johnston Papers, MDLC, Reel 16, Container 21, p. 391.

95. Letter from Lambert Davis to Frances Benjamin Johnston, January 31, 1951, Frances Benjamin Johnston Papers, MDLC, Reel 16, Container 22, p. 511.

96. Letter from Lambert Davis to Frances Benjamin Johnston, May 16, 1951, Frances Benjamin Johnston Papers, MDLC, Reel 16, Container 22, p. 540.

97. Letter from Lambert Davis to Frances Benjamin Johnston, January 10, 1952, Frances Benjamin Johnston Papers, MDLC, Reel 16, Container 22, p. 582.

98. See, for example, Hubert B. Owens, *Personal History of Landscape Architecture in the Last Sixty Years 1922–1982* (Athens: University of Georgia Press, 1983).

99. Fran Thomas, *A Portrait of Historic Athens and Clarke County* (Athens: The University of Georgia Press, 1992), 64.

100. Ibid, 65.

101. See James K. Reap, *Athens, a Pictorial History* (Norfolk, Virginia: Donning, 1985), 60.

102. Waterman, *The Early Architecture of North Carolina*, 221.

103. Ibid., 215.

104. Nichols, *The Early Architecture of Georgia*, 209.

105. Ibid., 223.

106. Ibid., 260.

107. Ibid., 191.

108. Frances Benjamin Johnston interview with Mary Mason, WRC National Broadcasting Company, 2:30 p.m., February 12, 1937, FBJ Papers, MDLC, Reel 21, Container 27, p. 230.

109. Waterman, *The Early Architecture of North Carolina*, 76.

110. Ibid, 223.

111. Ibid., 114–16.

112. Ibid., 111.

113. Stoney, *Plantations of the Carolina Low Country*, 111.

114. Ibid., 113.

115. Ibid., 148.

116. Ibid., 114.

117. Ibid., 152.

118. Ibid., 122.

119. George Francis Hogan, "Portraits of Old Houses," *American Photography* (May 1940): 348.

120. Stoney, *Plantations of the Carolina Low Country*, 117.

121. This work, referred to in what follows as "the Charleston book," provides neither page nor plate numbers.

122. See Michael Brix and Birgit Mayer, eds., *Walker Evans' America* (New York: Rizzoli, 1991), 40.

123. Stoney, *Plantations of the Carolina Low Country*, 120.

124. Ibid., 108–110.

125. Brix and Mayer, *Walker Evans' America*, 41.

126. Ibid., 49.

127. Nichols, *The Early Architecture of Georgia* (Chapel Hill: University of North Carolina Press, 1957), 58.

128. Ibid., 92.

129. Ibid., 143.

130. Ibid., 187.

131. Ibid., 189.

132. Stoney, *Plantations of the Carolina Low Country*, 91.

133. Ibid., 107.

134. Ibid., 233.

135. See P. H. Emerson, *Life and Landscape of the Norfolk Broads* (London: S. Low, Marston, Searle, and Rivington, 1886), plate 10.

136. See Newhall, *The History of Photography*, 141.

137. Stoney, *Plantations of the Carolina Low Country*, 24–25, 71–73.

138. Quoted in John C. L. Andreassen, "Frances Benjamin Johnston and Her Views of Uncle Sam," *Louisiana History* 1, no. 1 (Winter 1960): 130–36. See also letter from Louise T. Hays to Mayor of Savannah, December 23, 1947, Frances Benjamin Johnston Papers, MDLC, Reel 16, Container 21, p. 221; letter from Ronald F. Lee to Frances Benjamin Johnston, March 20, 1947, Frances Benjamin Johnston Papers, MDLC, Reel 16, Container 20, p. 116; letter from Ulysses S. Grant, president, to Frances Benjamin Johnston, October 7, 1947, Frances Benjamin Johnston Papers, MDLC, Reel 16, Container 21, p. 187; letter from C. A. Briggs to Frances Benjamin Johnston, October 25, 1947, Frances Benjamin Johnston Papers, MDLC, Reel 16, Container 21, p. 195; and letter from Ulysses S. Grant to Frances Benjamin Johnston, February 24, 1949, Frances Benjamin Johnston Papers, MDLC, Reel 16, Container 21, p. 317.

CHAPTER 5. *How Frances Benjamin Johnston's Contribution Shaped Architectural and Photographic Preservation in the United States*

1. "Speaking of Pictures," *Life* (April 25, 1949): 14–16.

2. Johnston, "Mammoth Cave," 444–56.

3. See William Welling, *Photography in America: The Formative Years 1839–1900* (Albuquerque: University of New Mexico Press, 1987), 309–13.

4. Quoted in Kane, "New Orleans Architecture," Frances Benjamin Johnston Papers, MDLC, Reel 29, Container 40, p. 585. *Washington Post*, 30 June 1938, Frances Benjamin Johnston Papers, MDLC, Reel 29, Container 40, p. 587.

5. Johnston, "What a Woman Can Do," 6.

6. See Kane, "New Orleans Architecture," Frances Benjamin Johnston Papers, MDLC, Reel 29, Container 40, p. 585. *Washington Post*, June 30, 1938, Frances Benjamin Johnston Papers, MDLC, Reel 29, Container 40, p. 587.

7. Sadakichi Hartmann, "A Plea for Straight Photography," *American Amateur Photography* 16 (1904): 101–9. See also Sadakichi Hartmann, "On the Possibility of New Laws of Composition," *Camera Work*, no. 30 (1910): 39, and Newhall, *The History of Photography*, 167–97.

8. W. X. Kincheloe, "On Photographing Homes," *Photo Era* 50, no. 4 (April 1923): 177–84.

9. Ibid.

10. See Helen Powell and David Leatherbarrow, ed., *Masterpieces of Architectural Drawing* (New York: Abbeville Press, 1982), 68.

11. See Zelda Branch, "Preserving a Nation's Architecture," *Christian Science Monitor* (November 11, 1936): 12–13. Johnston's own life and her correspondence with homeowners of historic residences show that she understood the necessity of adapting buildings for modern use although this contradicted her aesthetic and philosophical sensibilities toward historic preservation. For example, Paul Kester and Kate Doggett, homeowners in Fredericksburg, Virginia, wrote to her that deaths in their families made them consider giving up the buildings associated with the deceased. Yet Johnston encouraged them to persevere lest other owners let the buildings fall into neglect or be destroyed. See Frances Benjamin Johnston, interview with Mary Mason, WRC National Broadcasting Co., 2:30 p.m., February 12, 1937, Frances Benjamin Johnston Papers, MDLC, Reel 21, Container 27, p. 229; letter from Paul Kester to Frances Benjamin Johnston, June 25, 1927, Frances Benjamin Johnston Papers, MDLC, Reel 10, Container 12, p. 137; letter from Kate Doggett to Frances Benjamin Johnston, January 20, 1928, Frances Benjamin Johnston Papers, MDLC, Reel 10, Container 12, pp. 239–40.

12. Nineteenth-century architectural photographers credited with developing the basic standards of what is considered the elevation photograph include Edouard-Denis Baldus (1813–82) and Gustave Le Gray (1820–82). See Cervin Robinson and Joel Herschman, *Architecture Transformed: A History of the Photography of Buildings from 1839 to the Present* (New York: Architectural League of New York, 1987).

13. See Frances Benjamin Johnston Collection, PPDLC, Lot 8861, for photographs of the U.S. Mint, Lot 11350 for photographs of the White House, and Lot 11727 for photographs of Washington, D.C., residences.

14. Robinson and Herschman, *Architecture Transformed*, 24–26.

15. Stoney, *Plantations of the Carolina Low Country*, 58.

16. See Rodger P. Kingston, "Afterword: Max Belcher and the History of Architectural Documentary Photography," in Svend E. Holsoe and Bernard L. Herman, *A Land and Life Remembered: Americo-Liberian Folk Architecture* (Athens: University of Georgia Press, 1988), 156.

17. Ibid.

18. Ibid.

19. See Nesbit, *Atget's Seven Albums*, 20–27.

20. Elaine Dunn, "George Barnard, Images of a Gentleman's War," in F. Jack Hurley, Nancy Hurley, and Gary Witteds, eds., *Southern Eye, Southern Mind: A Photographic Inquiry* (Memphis: Memphis Academy of Arts, 1981), 4–5.

21. George Barnard, *Photographic Views of Sherman's Campaign* (New York: George N. Barnard, 1866), 38.

22. Richard Upjohn, "The Colonial Architecture of New York and the New England States," *Archaeological Review and American Builders' Journal* (March 1870): 548.

23. William B. Rhoads, *The Colonial Revival*, vol. 1 (New York: Garland, 1977), 24–26; Elizabeth McCausland, *The Life and Work of Edward Lamson Henry, NA* (New York: Kennedy Graphics, 1970); Alan Gowans, "Painting and Sculpture," in Wendell D. Garett, *The Arts in America, the Nineteenth Century* (New York: Scribner, 1969), 218.

24. Rhoads, *The Colonial Revival*, vol. 1, 24–26.

25. Letter from Fiske Kimball to Leicester Holland, November 22, 1932, Frances Benjamin Johnston Papers, MDLC, Reel 11, Container 14, p. 366. Letter from Leicester Holland to Fiske Kimball, November 23, 1932, Frances Benjamin Johnston Papers, MDLC, Reel 11, Container 14, p. 366.

26. Norman M. Isham and Albert F. Brown, *Early Rhode Island Houses: An Historic and Architectural Study* (Providence, RI: Preston and Rounds, 1895). Norman M. Isham and Albert F. Brown, *Early Connecticut Houses* (New York, Dover, 1965; originally published 1900).

27. Guptill, editor of the journal *American Artist*, wrote numerous books published during the 1930s through the 1970s about how to sketch. These publications were the principal texts used in drawing classes during the mid-twentieth century. Arthur Leighton Guptill, *Freehand Drawing, Self Taught, with Emphasis on the Techniques of Different Media* (New York: Harper and Row, 1933). Arthur Leighton Guptill, *Sketching as a Hobby* (New York: Harper and Brothers, 1936). Arthur Leighton Guptill, *Color in Sketching and Rendering* (New York: Reinhold, 1935). Arthur Leighton Guptill, *Sketching and Rendering in Pencil* (New York: Reinhold, 1946). Arthur Leighton Guptill, *Pencil Drawing Step By Step* (New York: Reinhold, 1959). Arthur Leighton Guptill, *Rendering in Pen and Ink* (New York: Watson-Guptill, 1976).

28. Frank Edwin Wallis, *Old Colonial Architecture and Furniture* (Boston: G. H. Polley, 1887). Frank Edwin Wallis, *American Architecture, Decoration and Furniture of the Eighteenth Century* (New York: P. Wenzel, 1896). Frank Edwin Wallis, *An Architectural Monograph on Houses of the Southern Colonies* (Saint Paul: White Pine Bureau, 1916).

29. Letter from Frances Benjamin Johnston to Leicester Holland, June 20, 1935, Frances Benjamin Johnston Papers, MDLC, Reel 12, Container 15, p. 100.

30. Ibid.

31. Letter from Henry I. Brock to Frances Benjamin Johnston, April 25, 1930, Frances Benjamin Johnston Papers, MDLC, Reel 11, Container 14, p. 172. Letter from Frances Benjamin Johnston to Henry Brock, April 21, 1935, Frances Benjamin Johnston Papers, MDLC, Reel 12, Container 16, p. 58.

32. Letter from Ulysses S. Grant to Frances Benjamin Johnston, February 24, 1949, Frances Benjamin Johnston Papers, MDLC, Reel 16, Container 21, p. 317.

33. Alice Ravenel Huger Smith and Daniel Elliot Huger Smith, *The Dwelling Houses of Charleston, South Carolina* (New York: Diadem Books, 1917).

34. Letter from Frances Benjamin Johnston to Robert N. S. Whitelaw, January 7, 1941, Frances Benjamin Johnston Papers, MDLC, Reel 14, Container 19, p. 587.

35. See William R. Ware and Charles S. Keefe, eds., *The Georgian Period*, vol. 6 (New York: UPC Book Co., 1923), 272. See also W. Brown Morton III, "What Do We Preserve and Why?" in Robert E. Stipe and Antoinette J. Lee, eds., *The American Mosaic: Preserving a Nation's Heritage* (Washington, D.C.: United States Committee International Council on Monuments and Sites, 1987), 159–60, and letter from Frances Benjamin Johnston to Mr. A. Lawrence Kocher, January 9, 1931, Frances Benjamin Johnston Papers, Reel 11, Container 14, p. 232.

36. Fiske Kimball, *Domestic Architecture of the American Colonies and of the Early Republic* (1922; reprint, New York: Dover, 1966), xvii–xx.

37. Waterman, *The Early Architecture of North Carolina*, vii.

38. Letter from Thomas Waterman to Mr. Smith, June 15, 1934, Frances Benjamin Johnston Papers, MDLC, Reel 11, Container 15, p. 601.

39. Paul Vanderbilt, *Guide to the Special Collections of Prints and Photography in the Library of Congress* (Washington, D.C.: U.S. Government Printing Office, 1955), 95. Vanderbilt states that there are 7,648 film negatives, while the Library of Congress 1983 Finding Aid mentions only 7,248 negatives. See Paul Vanderbilt, *Guide to the Special Collections of Prints and Photography in the Library of Congress* (Washington, D.C.: U.S. Government Printing Office, 1955), 86.

40. Laughlin did manage to publish the following: Clarence John Laughlin, "Plantation Architecture in Louisiana," *Architectural Review* 101 (June 1947): 215–21; "Correction," *Architectural Review* 102 (December 1947): 212; and Clarence John Laughlin, *Ghosts along the Mississippi* (New York: American Legacy Press, 1987).

Bibliography

Archives

Prints and Photographs Division, Library of Congress, Washington, D.C.
Farm Security Administration/Office of War Information Collection (FSA/OWI)
Historic American Buildings Survey (HABS)
Historic American Engineering Record (HAER)
Pictorial Archives of Early American Architecture (PAEAA),
Frances Benjamin Johnston Collection
North Carolina Collection, University of North Carolina at Chapel Hill, North
Carolina
Wootten-Moulton Photographic Collection
Chicago History Museum, 1601 Clark Street, Chicago, Illinois
Dudley Arnold Collection

Books and Articles

Adams, J. T., ed. *Dictionary of American History*. New York: Charles Scribner's Sons, 1940.

Alland, Alexander. *Jessie Tarbox Beals: First Woman News Photographer*. New York: Graphic Press, 1978.

Andreassen, John C. L. "Frances Benjamin Johnston and Her Views of Uncle Sam." *Louisiana History* 1, no. 1 (Winter 1960): 130–38.

Ausherman, Maria. "Hubert B. Owens and Frances Benjamin Johnston: An Unlikely Collaboration." *Georgia Landscape* (Spring 1993): 2–3.

Barnard, George. *Photographic Views of Sherman's Campaign*. New York: George N. Barnard, 1866.

Baty, Laurie Anne. "Photographers of Washington D.C. 1870–1885." M.A. thesis, George Washington University, 1979.

Beals, Jessie Tarbox. "My First Photograph." *Photo-Era* 48 (May 1922): 263–64.

Berch, Bettina. *The Woman behind the Lens: The Life and Work of Frances Benjamin Johnston, 1864–1952*. Charlottesville: University Press of Virginia, 2000.

Bisland, Margaret. "Women and Their Cameras." *Outing* 17 (October 1890): 38.

————, ed. "Women as Photographers." *The Illustrated American*, June 6, 1891. Frances Benjamin Johnston Papers, MDLC, Reel 33, Container 44, p. 222.

Bottomley, William Lawrence, ed. *Great Georgian Houses of America*. Vol. 1. New York: Kalkhoff Press, 1933; and Vol. 2. New York: Scribner Press, 1937; reprint, New York: Dover, 1970.

Branch, Zelda. "Preserving a Nation's Architecture: Pictorial Archives of Early American Architecture." *Christian Science Monitor*, November 11, 1936, 12–13.

Brix, Michael, and Birgit Mayer, eds. *Walker Evans' America*. New York: Rizzoli, 1991.

Brock, Henry Irving. *Colonial Churches in Virginia*. Richmond: Dale Press, 1930.

Brown, Elizabeth. "American Paintings and Sculpture in the Fine Arts Building of the World's Columbian Exposition, Chicago, 1893." Ph.D. diss., University of Kansas, 1976.

Brown, Glenn. *History of the United States Capitol*. 2 Vols. Washington, D.C.: Government Printing Office, 1900 and 1903; reprint, New York: Da Capo Press, 1970.

Brown, Julie K. *Contesting Images: Photography and the World's Columbian Exposition*. Tucson: University of Arizona Press, 1994.

Burke, Mary Alice Heekin. *Elizabeth Nourse, 1859–1938: A Salon Career*. Washington, D.C.: National Museum of American Art, 1983.

Butler, Susan. "How Do I Look? Women Before and Behind the Camera." *Photo Communique* 9, pt. 3 (Fall 1987): 24–35.

Camera Notes: Official Organ of the Camera Club of New York. 6 Vols. Index by Kate Davis, 1897–1903; reprint, New York: Da Capo Press, 1978.

Campbell, Edward D. C. "Black Prism White Lens: Frances Benjamin Johnston's Turn-of-the-Century Photographs Showed the White Victorian Ideal of Hampton and Tuskegee Institutes." *Southern Exposure* 23, no. 1 (Spring 1995): 12–19.

Catalogue of the Paintings in the Corcoran Gallery of Art. Belmont: A. W. Elson, 1913.

Chamberlain, Samuel. *Fair Is Our Land*. New York: Hastings House, 1942.

Clarke, I. Edwards. "Review of Original Portraits of Washington" *Washington Post*, February 22, 1882.

Collins, Kathleen, and Ann Wilsher. "Ars Longa, Vita Brevis: The Adams Memorial." *History of Photography* 12, pt. 1 (January–March 1988): 41–3.

Cook, Elizabeth Lindquist. *The Influence of Photography on American Landscape Painting, 1839–1880*. New York: Garland, 1977.

Cotton, Jerry W. *Light and Air: The Photography of Bayard Wootten*. Chapel Hill: University of North Carolina Press, 1998.

Cridland, Robert B. *Practical Landscape Gardening*. New York: A. T. De La Mare, 1918.

Dabney, Charles William. *Universal Education in the South*. 2 vols. Chapel Hill: University of North Carolina Press, 1936.

Daniel, Pete, and Raymond Smock. *A Talent for Detail: The Photographs of Miss Frances Benjamin Johnston 1899–1910*. New York: Harmony Books, 1974.

Davidov, Judith Fryer. *Women's Camera Work: Self/Body/Other in American Visual Culture*. Durham, N.C.: Duke University Press, 1998.

Dobyns, Winifred Starr. *California Gardens.* New York: Macmillan, 1931.

Dodd, William Edward. *The Old South: Struggles for Democracy.* New York: Macmillan, 1937.

Doherty, Amy S. "Frances Benjamin Johnston, 1864–1952." *History of Photography* 4, no. 2 (April 1980): 107.

Doty, Robert. *Photo-Secession: Stieglitz and the Fine-Art Movement in Photography.* New York: Dover, 1978.

Edgerton, Giles. "Is There a Sex Distinction in Art? The Attitude of the Critic toward Women's Exhibits." *The Craftsman* 14 (June 1908): 239–51.

Fehr, Anne B., and William Innes Homer. "The Photographic Society of Philadelphia and the Salon Movement." In William Innes Homer, *Pictorial Photography in Philadelphia, the Pennsylvania Academy's Salons 1898–1901.* Philadelphia: Pennsylvania Academy of Fine Arts, 1984.

Fehrer, Catherine. "New Light on the Academie Julian and Its Founder (Rudolphe Julian)." *Gazette des Beaux-Arts* 103 (1984): 207–16.

Fisher, Jay M. "The Photographs of Frances Benjamin Johnston." *Baltimore Museum of Art Catalogue.* Baltimore: Baltimore Museum of Art, 1942.

Fitch, James Marston. *Historic Preservation: Curatorial Management of the Built World.* New York: McGraw-Hill, 1982.

Foster, Kathleen A., and Cheryl Leibold. *Writing about Thomas Eakins.* Philadelphia: University of Pennsylvania Press, 1989.

Friedman, Jean E., ed. *Our American Sisters: Women in American Life and Thought.* Lexington: D. C. Heath, 1987.

Gamble, Robert. *The Alabama Catalog: HABS. A Guide to the Early Architecture of the State.* Tuscaloosa: University of Alabama Press, 1987.

Gaston, Paul. *The New South Creed: A Study in Southern Mythmaking.* New York: Knopf, 1970.

Glenn, Constance W., and Leland Rice. *Frances Benjamin Johnston: Women of Class and Station.* Long Beach: California State University Art Museum and Galleries, 1979.

Gover, C. Jane. *The Positive Image: Women Photographers in Turn of the Century America.* Albany: State University of New York Press, 1988.

Green, Constance McLaughlin. *Washington Village and Capital, 1800–1878.* Princeton: Princeton University Press, 1962.

Greenhalgh, Michael. *The Classical Tradition in Art.* New York: Harper and Row, 1978.

Guimond, James. "Frances Johnston's Hampton Album: A White Dream for Black People." *American Photography and the American Dream.* University of North Carolina Press, 1991, 21–53.

Guptill, Arthur Leighton. *Color in Sketching and Rendering.* New York: Reinhold, 1935.

———. *Freehand Drawing Self-Taught, with an Emphasis on the Techniques of Different Media.* New York: Harper and Brothers, 1933.

———. *Sketching as a Hobby.* New York: Harper and Brothers, 1936.

———. *Sketching and Rendering in Pencil.* New York: Reinhold, 1946.

Haberstich, David E. "Photographs at the Smithsonian Institutions: A History." *Picturescope* 32, no. 1(Summer 1985): 4–11.

Hacker, Louis M. *The World of Andrew Carnegie, 1865–1901.* Philadelphia: J. B. Lippincott, 1968.

Hales, Peter Bacon. *Silver Cities: The Photography of American Urbanization, 1839–1915.* Philadelphia: Temple University Press, 1984.

———. *Constructing the Fair: Charles Dudley Arnold and the World's Columbian Exposition.* Chicago: Art Institute of Chicago, 1993.

Hamlin, Talbot Faulkner. *Architecture through the Ages.* New York: G. P. Putnam & Sons, 1940.

———. *Forms and Functions of Twentieth-Century Architecture.* New York: Columbia University Press, 1952.

———. *Greek Revival Architecture.* London: Oxford University Press, 1944.

Hartmann, Sadakichi. "A Plea for Straight Photography." *American Amateur Photography* 16 (1904): 101–09.

———. "On the Possibility of New Laws of Composition." *Camera Work* no. 30 (1910): 23–26.

Havice, C. "In a Class by Herself: Nineteenth Century Images of the Women Artist as Student." *Women's Art Journal* 2, pt. 1 (Spring–Summer 1981): 35–40.

Hawthorne, Hildegarde. "Color in California: Photographs of Frances Benjamin Johnston." *The Touchstone and American Art Student Magazine* 8 (January 1921): 276–79.

Hess, Thomas, and Elizabeth Baker, eds. *Art and Sexual Politics.* New York: Collier Books, 1975.

Higham, John. *Strangers in the Land: Patterns of American Nativism 1860–1925.* New York: Atheneum, 1968.

Hines, Richard, Jr. "Women and Photography." *American Amateur Photography* 11 (March 1899): 118.

Hofstadter, Richard, William Miller, and Daniel Aaron. *The United States, the History of a Republic.* Englewood Cliffs, N.J.: Prentice Hall, 1957.

Homer, William Innes. *Alfred Stieglitz and the Photo-Secession.* Boston: Little, Brown, 1983.

———. *Pictorial Photography in Philadelphia, the Pennsylvania Academy's Salons 1898–1901.* Philadelphia: Pennsylvania Academy of Fine Arts, 1984.

Horgan, Stephen H. "Photography for the Newspapers." *The Philadelphia Photographer* 23, no. 269 (March 6, 1886): 140–42.

Hosmer, Charles B., Jr. *Preservation Comes of Age: From Williamsburg to the National Trust, 1926–1949.* 2 Vols. Charlottesville: University Press of Virginia, 1981.

Huger Smith, Alice Ravel, and Daniel Elliot. *The Dwelling House of Charleston, South Carolina.* New York: Diadem Books, 1917.

Hunter, Susan. "The Art of Photography: A Visit to the Studio of Miss Frances Benjamin Johnston," c. 1895, Frances Benjamin Johnston Papers, MDLC, Reel 24, Container 31, pp. 36–41.

Hurley, Forrest Jack, Nancy Hurley, and Gary Witteds, eds. *Portrait of a Decade: Roy*

Stryker and the Development of Documentary Photography in the Thirties. Baton Rouge: Louisiana State University Press, 1972.

———. *Southern Eye, Southern Mind.* Memphis: Memphis Academy of Arts, 1981.

Ingalls, Zoe. "Ground-breaking Photographs of American Women." *Chronicle of Higher Education* 37, no. 10 (November 7, 1990): 872.

Isham, Norman Morrison, and Alfred F. Brown. *Early Connecticut Houses.* 1900; reprint New York: Dover, 1965.

———. *Early Rhode Island Houses: An Historic and Architectural Study.* Providence: Preston and Rounds, 1895.

James, Thomas L. "The Evolution of the Safe Deposit Company." *Cosmopolitan* 12, no. 1 (November 1891): 27–36. Frances Benjamin Johnston Papers, MDLC, Reel 35, Container 47, pp. 111–18.

Johnston, Frances Benjamin. "About Wine in Midi, France" (August 1907). Frances Benjamin Johnston Papers, MDLC, Reel 21, Container 27, pp. 14–17.

———. "Castle Hill, Cobbham, Albermarle Co., Virginia. Estate of Annelie Rives." *Town and Country* (c. 1926). Frances Benjamin Johnston Papers, MDLC, Reel 21, Container 27, p. 99.

———. "Chatham Manor, Fredericksburg, Virginia." *Town and Country* (October 31, 1926). Frances Benjamin Johnston Papers, MDLC, Reel 21, Container 27, p. 205.

———. *Collier's Weekly* (September 23, 1899).

———. *Collier's Weekly* (September 30, 1899).

———. "A Day at Niagara." *Demorest's Family Magazine* (August 1893).

———. "Description of Delano Residence, 22445 Street, Washington D.C." *Town and Country* (1927). Frances Benjamin Johnston Papers, MDLC, Reel 21, Container 27, p. 120.

———. "Diplomatic Marriage." *Harper's Weekly* (April 7, 1894): 327–28.

———. "Dobe Trophy House." *Country Life* (August 1919): 54–56.

———. "Eagle's Perch Abroad." *Harper's Weekly* (May 18, 1907): 726–30.

———. "The Evolution of a Great Exposition." *Demorest's Family Magazine* 28, no. 6 (April 1892): 319–28.

———. "The Executive Departments of the Government." *Cosmopolitan* 9, no. 6 (October 1890): 645–56.

———. "The Executive Departments of the Government." *Cosmopolitan* 10, no. 7 (November 1890): 36–47.

———. "The Foremost Women Photographers of America." *The Ladies Home Journal* (January 1901–January 1902).

———. "The Foreign Legations at Washington." *Demorest's Family Magazine* Parts 1–4 (April–July 1893).

———. "From the Depths of the Crystallized Sea." *Demorest's Family Magazine* 29, no. 4 (February 1893): 195–200.

———. "Gardens in City Environments." *New York Sun*, December 19, 1922.

———. "The Gardens of a Garden Spot." *Santa Barbara Community Life* (September 1923).

———. "Garden Photography as a Fine Art: Illustrated by Rare Photographs of Beautiful Gardens." *The Touchstone and the American Art Student Magazine* 2 (December 1917): 278–87.

———. *Gas Logic* 31, no. 1 (January 1922). Frances Benjamin Johnston Papers, MDLC, Reel 35, Container 47, p. 238.

———. "Gertrude Kasebier, Professional Photographer." *Camera Work* 1 (January 1903): 20.

———. *The Hampton Album*. Introduction by Lincoln Kirstein. New York: Museum of Modern Art, 1966.

———. *Historic Homes of Virginia and Charleston, South Carolina*. (no city): Broadside, 1930.

———. "Homesteads of the Old South." *Town and Country* (October 12, 1941). Frances Benjamin Johnston Papers, MDLC, Reel 21, Container 27, p. 140.

———. "Homeward Bound with Admiral Dewey: Life aboard the Flagship Olympia." *Harper's Weekly* (September 1899).

———. "House of the Turk, New Orleans." *Town and Country* (c. 1927). Frances Benjamin Johnston Papers, MDLC, Reel 21, Container 27, p. 136.

———. "How Old Is the Garden?" (n.d.) Frances Benjamin Johnston Papers, MDLC, Reel 32, Container 43, pp. 275–79.

———. "In the White House." *Harper's Weekly* (March 4, 1893). Frances Benjamin Johnston Papers, MDLC, Reel 35, Container 47, pp. 124–36.

———. "In Yesterday's Garden." c. 1925. Frances Benjamin Johnston Papers, MDLC, Reel 21,Container 27, pp. 38–82.

———. "The Lighter Side of the Georgians: Eighteenth-Century Furniture in a Modern House." *International Studio* (April 1930). Frances Benjamin Johnston Papers, MDLC, Reel 35, Container 46, p. 60.

———. "Longwood Estate. Near Kenneth Square, Pennsylvania." *Town and Country* (n.d.). Frances Benjamin Johnston Papers, MDLC, Reel 21, Container 27, pp. 141–43.

———. "Mammoth Cave by Flashlight." *Demorest's Family Magazine* 28, no. 8 (June 1892): 444–56.

———. *Mammoth Cave . . . by Flash-Light*. Washington, D.C.: Gibson Brothers, 1893.

———. "Myron Hunt's Backyard." *Country Life* (March 1918): 50–51.

———. "Photograph of Alice Roosevelt." *Harper's Weekly* (February 1, 1902). Frances Benjamin Johnston Papers, MDLC, Reel 35, Container 47, p. 147.

———. "Photograph of Alice Roosevelt." *Saturday Pictorial Review* (February 8, 1902). Frances Benjamin Johnston Papers, MDLC, Reel 35, Container 47, p. 148.

———. "Photograph of Miss Alice Roosevelt." *Leslie's Weekly* 94, no. 2421 (January 30, 1902). Frances Benjamin Johnston Papers, MDLC, Reel 35, Container 47, p. 146.

———. "Photograph of Theodore Roosevelt." *Our Junior Citizens* 1, no. 17 (9 May 1903). Frances Benjamin Johnston Papers, MDLC, Reel 35, Container 47, p. 161.

———. "Photographing 'Uncle Remus.'" *Uncle Remus' Home Magazine* (June 1911).

———. "Portrait of William H. Taft and the President's Cabinet." *The American Magazine* 62, no. 6 (October 1906): Frontispiece, 614–22. Frances Benjamin Johnston Papers, MDLC, Reel 35, Container 47, pp. 173–76.

———. "President Roosevelt's Children with Pets." *The Ladies' Home Journal* (1902). Frances Benjamin Johnston Papers, MDLC, Reel 35, Container 47, p. 151.

———. "The Roosevelt Children and Their Pets." *Young People's Weekly* (October 18, 1902). Frances Benjamin Johnston Papers, MDLC, Reel 35, Container 47, p. 156.

———. "Small White House Orchids." *Demorest's Family Magazine* (June 1895).

———. "A Snapshot Immortalized in Bronze." (n.d.) Frances Benjamin Johnston Papers, MDLC, Reel 21, Container 27, pp. 4–5.

———. "Some Homes under the Administration: Mexican and Brazilian Ministers." *Demorest's Family Magazine* 29, no. 6 (April 1893): 331–38.

———. "Some Homes under the Administration: Levi P. Morton, VP." *Demorest's Family Magazine* 26, no. 9 (July 1890): 513–20.

———. "Some Homes under the Administration: Sen. Hearst of California." *Demorest's Family Magazine* 26, no. 12 (October 1890): 713–20.

——— "Some Homes under the Administration: Sen. Sawyer of Wisconsin." *Demorest's Family Magazine* 27, no. 2 (December 1890): 66–72.

———. "Some Homes under the Administration: John Wanamaker, Postmaster General." *Demorest's Family Magazine* 26, no. 10 (August 1890): 579–86.

———. "Some Women of Washington." *New York Times.* Pictorial Section, Part 1, July 2, 1905.

———. "Students in the Art of War." *The Illustrated American* 15, no. 227 (June 23, 1894): 725–29.

———. "Tad Lincoln's Playthings." (n.d.). Frances Benjamin Johnston Papers, MDLC, Reel 21,Container 27, p. 20.

———. *Tales Old Houses Tell.* Boston: Little, Brown, 1942.

———. "Through the Coal Country with a Camera." *Demorest's Family Magazine* 28, no. 5 (March 1892): 257–66.

———. Transcript of interview with Mrs. Graham, January 9, 1919. Frances Benjamin Johnston Papers, MDLC, Reel 33, Container 44, pp. 112–14.

———. "Uncle Sam as a Stamp-Maker." *Harper's Round Table* (June 11, 1895). Frances Benjamin Johnston Papers, MDLC, Reel 34, Container 46, p. 119.

———. "Uncle Sam's Money." *Demorest's Family Magazine* 26, no. 2 (Part 1, December 1889): 66–72. *Demorest's Family Magazine* 26, no. 3 (Part 2, January 1890): 131–38.

———. "What a Woman Can Do with a Camera." *The Ladies' Home Journal* (September 1897): 6–7.

———. "The White House." *Demorest's Family Magazine* 26, no. 7 (Part 1, May 1890): 385–91. *Demorest's Family Magazine.* 26, no. 8 (Part 2, June 1890): 449–58.

———. *The White House.* Washington, D.C.: Gibson Brothers, 1893.

———. "Young America in the White House." c. 1907. Frances Benjamin Johnston Papers, MDLC, Reel 21, Container 27, p. 26.

"Johnston's Photographs at the Library of Congress." *American Institute of Architects Journal* 8 (December 1947): 257–58.

Jussim, Estelle. *Slave to Beauty: The Eccentric Life and Controversial Career of Fred Holland Day, Photographer, Publisher, Aesthete.* Boston: David R. Godine, 1981.

Kaestle, Carl F., ed. *Pillars of the Republic: Common Schools and American Society, 1780–1860.* New York: Hill and Wang, 1983.

Kanator, Harvey, and David Tyack, eds. *Work, Youth and Schooling: Historical Perspectives on Vocationalism in American Education.* Stanford: Stanford University Press, 1982.

Kane, Harnett T. "New Orleans Is Being Saved in Pictures." *Sunday Item-Tribune, New Orleans,* May 22, 1938.

Kasebier, Gertrude. "To Whom It May Concern." *Camera Notes* 3 (January 1900): 121–22.

Kimball, Fiske. *Domestic Architecture of the American Colonies and of the Early Republic.* 1922; reprint, New York: Dover, 1966.

———, William Graves Perry, Arthur A. Shurcliffe, and Susan Higginson Nash. "The Restoration of Colonial Williamsburg in Virginia." Reprint, *Architectural Record* (December 1935): 359–458.

Lane, Mills. *Architecture of the Old South: Georgia.* Savannah: Beehive Press, 1986.

———. *Architecture of the Old South: Louisiana.* Savannah: Beehive Press, 1990.

———. *Architecture of the Old South: Mississippi and Alabama.* Savannah: Beehive Press, 1989.

———. *Architecture of the Old South: North Carolina.* Savannah: Beehive Press, 1985.

———. *Architecture of the Old South: South Carolina.* Savannah: Beehive Press, 1984.

———. *Architecture of the Old South: Virginia.* Savannah: Beehive Press, 1987.

Laughlin, Clarence John. "Plantation Architecture in Louisiana." *Architectural Review* 101 (June 1947): 215–21. "Correction." *Architectural Review* 102 (December 1947): 212.

———. *Ghosts along the Mississippi.* New York: American Legacy Press, 1987.

Leish, Kenneth W. *The White House.* New York: Newsweek, 1972.

Lester, Robert M. *Forty Years of Carnegie Giving: A Summary of the Benefactions of Andrew Carnegie and of the Work of the Philanthropic Trusts Which He Created.* New York: Charles Scribner's Sons, 1941.

Lindgren, James M. *Preserving Historic New England: Preservation, Progressivism and the Remaking of Memory.* Oxford, England: Oxford University Press, 1995.

Linley, John. *The Georgia Catalog: Historic American Buildings Survey.* Athens: University of Georgia Press, 1982.

Little, Emma H. "The Father of News Photography, George Grantham Bain." *Picturescope* 20 (Autumn 1972): 125–32.

Maddox, Jerald C. *The Pioneering Image: Celebrating 150 Years of American Photography.* New York: Universe Books, 1989.

Magruder, Julia. "The Evolution of a Home Studio." *The House Beautiful* 18, no. 6 (November 1905): 11–13.

Marsh, Alan Thomas. "Washington's First Art Academy, the Corcoran School of Art, 1875–1925." Ph.D. diss., University of Maryland, 1983.

Marsh, Kenneth F., and Blanche Marsh. *Athens: Georgia's Columned City*. Atlanta: Cherokee, 1979.

McClure, Alexander K., and Charles Morris. *The Authentic Life of William McKinley; Our Third Martyr President. Together with a Life Sketch of Theodore Roosevelt*. Washington, D.C.: W. E. Scull, 1901.

Mechlin, Leila. "Art Life in Washington." *Records of the Columbia Historical Society* 24 (1922): 175.

"Milestones: Frances Benjamin Johnston Obituary." *Time* (June 2, 1952): 79.

Miss Impertinence. "They Photograph the Smart Set." *Vanity Fair*, (n.d.): 18–19.

Mitchell, Dolores. "The New Woman as Prometheus: Women Artists Depict Women Smoking." *Women's Art Journal* 12 (Spring–Summer 1991): 3–9.

Moore, Clarence Bloomfield. "Women Experts in Photography." *Cosmopolitan* 14 (March 1893): 556.

Murray, William M. "Miss Frances B. Johnston's Prints." *Camera Notes* 2, no. 4 (1898–99): 167–68.

Nesbit, Molly. *Atget's Seven Albums*. New Haven: Yale University Press, 1992.

Newhall, Beaumont. "Documentary Approach to Photography." *Parnassus* 10 (March 1938): 3–6.

———. *The History of Photography*. New York: Museum of Modern Art, 1982.

Newton, Norman T. *Design on the Land: The Development of Landscape Architecture*. Cambridge: Harvard University Press, 1971.

"New York City Garden Club Shows Progress toward a 'City Beautiful.'" *New York Herald*, November 14, 1920. Frances Benjamin Johnston Papers, MDLC, Reel 29, Container 40, p. 409.

Nichols, Frederick Doveton. *The Architecture of Georgia*. Savannah: Beehive Press, 1976.

———. *The Early Architecture of Georgia*. Chapel Hill: University of North Carolina Press, 1957.

Novotny, Ann. "Alice Austen's World." *Heresies 3, Lesbian Art and Artists* (Fall 1977).

O'Toole, Patricia. "Frances Benjamin Johnston: Portfolio." *Civilization: The Magazine of the Library of Congress* 3, no. 3 (May 1, 1996): 62.

Owens, Hubert B. *Personal History of Landscape Architecture in the Last Sixty Years 1922–1982*. Athens: University of Georgia Press, 1983.

Panzer, Mary. "Frances Benjamin Johnston: Collecting in London, 1897." *History of Photography*, 24, no. 1 (Spring 2000): 54–57.

Parsons, J. H. "Women as Photographers." In M. L. Rayne. *What Can a Woman Do?* Detroit: F. B. Dickerson, 1884.

Patten, Mary. "The Photographer." In Catherine Filene. *Careers for Women*. Boston: Houghton Mifflin, 1920.

Peatross, C. Ford, ed. *Historic America Buildings, Structures and Sites*. Washington, D.C.: Library of Congress, 1983.

Peterson, Anne Elizabeth. "Frances Benjamin Johnston: Crusader with a Cause." *Historic Preservation* 32 (January 1980): 17–20.

"Photo Exhibition Promoted by the Yorkshire Affiliated Societies at Bradford City

Art Gallery." *Leeds Mercury* (November 26, 1898), Frances Benjamin Johnston Papers, MDLC, Reel 29, Container 39, p. 275.

"Photographs at Plaza Hotel Illustrated Lecture." *New York Times*, January 19, 1921. Frances Benjamin Johnston Papers, MDLC, Reel 29, Container 40, p. 412.

Powell, Helen, and David Leatherbarrow, ed. *Masterpieces of Architectural Drawing*. New York: Abbeville Press, 1982.

Powell, Richard, and Jack Reynolds. *To Conserve a Legacy: American Art from Historically Black Colleges and Universities*. Cambridge: MIT Press, 2000.

Prinet, Jean, and Antoinette DiLasser. *Nadar*. Paris: Armand Colin, 1966.

Przyblyski, Jeannene M. "American Visions at the Paris Exposition, 1900: Another Look at Frances Benjamin Johnston's Hampton Photographs." *Art Journal* 57, no. 3 (Fall 998): 60–68.

Quitslund, Toby. "Her Feminine Colleagues: Photographs and Letters Collected by Frances Benjamin Johnston in 1900." In Josephine Withers. *Women Artists in Washington Collections*. College Park: University of Maryland and the Women's Caucus for Art, 1979.

Reap, James K. *Athens: A Pictorial History*. Norfolk, Va.: Donning, 1985.

Rhoads, William B. *The Colonial Revival*. 2 Vols. New York: Garland, 1977.

Richards, Amy. "Women Poster Artists." *Demorest's Family Magazine* 32, no. 12 (October 1896): 667–72.

Riis, Jacob. "Mrs. Roosevelt and Her Children." *The Ladies' Home Journal* (August 1902). Frances Benjamin Johnston Papers, MDLC, Reel 35, Container 47, p. 152.

———. "Theodore Roosevelt, the Citizen." *Outlook* 75 (December 5, 1903): 788–96, 885–90, 940–47, 987–93. *Outlook* 76 (March 14, 1904): 24–33, 110–7, 166–71, 217–24, 275–79, 361–68, 408–15, 550–60, 647–54.

Robinson, Cervin, and Joel Herschman. *Architecture Transformed: A History of the Photography of Buildings from 1839 to the Present*. New York: Architectural League of New York, 1987.

Rockwood, George G. "The Vandyke Style of Portraiture." *Wilson's Photographic Magazine* 34 (August 1897): 340–41.

Rosenblum, Naomi. *A World History of Photography*. New York: Abbeville Press, 1984.

Rowland, Geraldine. "The Study of Art in Paris." *Harper's Bazaar* 36 (September 1902): 756–61.

Sandler, Martin W. *American Image: Photographing One Hundred Fifty Years in the Life of a Nation*. Chicago: Contemporary Books, 1989.

Schlereth, Thomas J. *Victorian America: Transformations in Everyday Life 1876–1915*. New York: HarperCollins, 1991.

Scully, Vincent J., Jr. *The Shingle Style and the Stick Style: Architectural Theory and Design from Downing to the Origins of Wright*. New Haven: Yale University Press, 1955.

Shaw, Renata V. *A Century of Photographs 1846–1946: Selected from the Collections of the Library of Congress*. Washington, D.C.: Library of Congress, 1980.

Shelton, Louise. *Beautiful Gardens in America*. New York: Charles Scribner's Sons, 1915.

—————. *Beautiful Gardens in America*. New York: Charles Scribner's Sons, 1924.

Smith, Alice Huger, and Daniel Elliott Huger Smith. *Dwelling Houses of Charleston, South Carolina*. New York: Diadem Books, 1917.

Smock, Raymond W. *Booker T. Washington in Perspective: Essays of Louis R. Harlan*. Jackson: University Press of Mississippi, 1988.

Snyder, Joel. *American Frontiers: The Photography of Timothy H. O'Sullivan, 1867–1874*. New York: Aperture, 1981.

"Speaking of Pictures." *Life* (April 25, 1949): 14–16.

Standish, L. Whitney. "The Technique of Photographing Architecture." *American Photography* 34 (November 1940): 804–14.

Stebbins, Theodore E., Carol Tryena, and Trevor Fairbrother. *A New World: Masterpieces of American Painting 1760–1910*. Boston: Museum of Fine Arts, 1983.

Stoney, Samuel Gaillard, and Beatrice St. Julien Ravenel. *Architects of Charleston*. Charleston: Carolina Art Association, 1945.

—————. *Charleston's Azaleas and Old Bricks*. Charleston: Houghton Mifflin, 1937.

—————. *Plantations of the Carolina Low Country*. Edited by Albert Simons and Samuel Lapham, Jr. Charleston: Carolina Art Association,1938; reprint, New York: Dover, 1989.

Streatfield, David C. *California Gardens: Creating a New Eden*. New York: Abbeville Press, 1994.

Tarbell, Ida. "President McKinley in War Times." *McClure's Magazine* 11, no. 3 (July 1898): 208–24.

The Macmillan Biographical Encyclopedia of Photographic Artists and Innovators. New York: Macmillan, 1983.

Thomas, Fran. *A Portrait of Historic Athens and Clarke County*. Athens: University of Georgia Press, 1992.

Tompkins, Elizabeth A. "Literary Washington." *Cosmopolitan* 8, no. 1 (November 1889): 191–200.

Trachtenburg, Alan. *Incorporation of America: Culture and Society in the Gilded Age*. New York: Hill and Wang, 1982.

—————. *Reading American Photographs: Images as History, Mathew Brady to Walker Evans*. New York: Hill and Wang, 1989.

True, A. C. In U.S. Department of Agriculture. *Miscellaneous Publications*, no. 15, 1923.

True, Frederick W., William H. Holmes, and George P. Merrill. "Report on the Exhibit of the United States National Museum at the Pan-American Exposition, Buffalo, New York, 1901." Annual Report. June 30, 1901.

U.S. Congress: Congressional Directory, Forty-fifth Congress. Washington, D.C.: Government Printing Office, 1879.

United States Census Office. *Twelfth Census, 1900, Occupations*. Washington, D.C.: Government Printing Office, 1904.

Upjohn, Richard. "The Colonial Architecture of New York and the New England States." *Architectural Review and American Builders' Journal* (March 1870): 548.

Vanderbilt, Paul. "Frances Benjamin Johnston, 1864–1952." *Journal of the American Institute of Architects* (November 1952): 224–28.

———. *Guide to the Special Collections of Prints and Photography in the Library of Congress.* Washington, D.C.: U.S. Government Printing Office, 1955.

Vogel, Hermann. *Photographic Times* 13 (August 1883): 403–4.

Wade, Elizabeth Flint. "The Camera as a Source of Income Outside the Studio." *Photographic Times* 24 (June 8, 1894): 358.

Wallis, Frank Edwin. *American Architecture, Decoration, and Furniture of the Eighteenth Century.* New York: P. Wenzel, 1896.

———. *An Architectural Monograph on Houses of the Southern Colonies.* Saint Paul: White Pine Bureau, 1916.

———. *How to Know Architecture: The Human Elements in the Evolution of Styles.* New York: Harper and Brothers, 1910.

———. *Old Colonial Architecture and Furniture.* Boston: G. H. Polley, 1887.

Washburne, Marion Foster. "A New Profession for Women." *Godey's Magazine* 134, no. 800 (February 1897): 123–28.

Washington, Booker T. "The Successful Training of the Negro." *World's Work* (August 1903): 3731–51.

———. *Tuskegee and Its People: Their Ideals and Achievements.* New York: D. Appleton, 1905.

———. *Up from Slavery; An Autobiography.* Boston: Houghton Mifflin, 1901.

———. *Working with the Hands.* New York: Doubleday, Page, 1904.

Waterman, Thomas Tileston. *Dwellings of Colonial America.* Chapel Hill: University of North Carolina Press, 1950.

———. *The Early Architecture of North Carolina.* Chapel Hill: University of North Carolina Press, 1941 and 1947.

———. *The Mansions of Virginia: 1706–1776.* Chapel Hill: University of North Carolina Press, 1945.

Watts, Jennifer A. "Frances Benjamin Johnston: The Huntington Library Portrait Collection." *History of Photography* 19, no. 3 (Fall 1995): 252.

Weems, Carrie Mae. *The Hampton Project.* New York: Aperture, 2000.

Weinberg, Helene Barbara. *The American Pupils of Jean-Leon Gerome.* Fort Worth: Amon Carter Museum, 1984.

Welling, William. *Photography in America: The Formative Years 1839–1900.* Albuquerque: University of New Mexico, 1987.

Westcott, Edith C. *The New Education Illustrated.* Issued semi-monthly. Richmond: B. F. Johnson, 1900–1901. (Only numbers 1–4 were published in one volume of the original sixteen booklets.)

Wharton, Edith. "Italian Villas and Their Gardens." *Century Magazine* 67 (November–December 1903): 21–33, 162–64. *Century Magazine* 68 (October 1904): 884–902.

———. *The Italian Villas and Their Gardens.* New York: Century, 1904.

Whiffen, Marcus. *American Architecture since 1780: A Guide to the Styles.* Cambridge: MIT Press, 1981.

Wiebe, Robert H. *The Search for Order 1877–1920.* New York: Hill and Wang, 1967.

Wilson, Charles Reagan, and William Ferris, co-eds. *Encyclopedia of Southern Culture.* Chapel Hill: University of North Carolina Press, 1989.

Wilson, Edward L., ed. *Wilson's Photographic Magazine* 37 (February 1900): 49. *Wilson's Photographic Magazine* 37 (April 1900): 152.

Wolff, Perry. *A Tour of the White House with Mrs. John F. Kennedy*. New York: Doubleday, 1962.

"Women with Brains and Business." *Washington Times*, c. 1895. Frances Benjamin Johnston Papers, MDLC, Reel 29, Container 39, p. 244.

Woodward, C. Vann. *Origins of the New South, 1877–1913*. Baton Rouge: Louisiana State University Press, 1951.

Wootten, Bayard. *Charleston: Azaleas and Old Bricks*, text by Samuel Gaillard Stoney. Boston: Houghton Mifflin, 1937.

———. *Old Homes and Gardens of North Carolina*, text by Archibald Henderson. Chapel Hill: University of North Carolina Press and Garden Club of North Carolina, 1939.

Yeldham, Charlotte. *Women Artists in Nineteenth Century France and England*. 2 vols. New York: Garland, 1984.

Interviews

Bedigian, Deena. Curator, Louisiana State Museum. New Orleans, Louisiana. Interview by telephone, 6 p.m. and 6:30 p.m., May 5, 1993.

Boucher, Jack. National Park Service. Washington, D.C. Interview by telephone, 1:30 p.m., November 22, 1991.

Goran, Abby. Acting Curator, Southeastern Architectural Archives at Tulane University Library. New Orleans, Louisiana. Interview by telephone, 10:55 a.m., September 11, 1992.

Nichols, Frederick Doveton. Architectural Historian, University of Virginia, Charlottesville, Virginia. Interview by telephone, 3 p.m., December 5, 1991.

Wilson, Samuel, Jr. Architect, New Orleans, Louisiana. Interview by telephone, 10:40 a.m., September 11, 1992.

Index